THE
FUTURIST
MOMENT

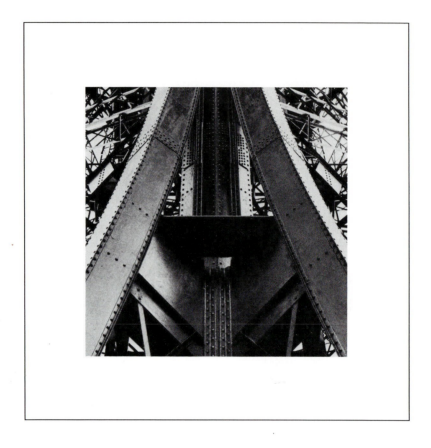

MARJORIE PERLOFF

THE FUTURIST MOMENT

Avant-Garde,
Avant Guerre, and the
Language of Rupture

THE UNIVERSITY OF CHICAGO PRESS

CHICAGO AND LONDON

MARJORIE PERLOFF is professor of English and
comparative literature at Stanford University. She is
the author of many articles and books, including
*The Dance of the Intellect: Studies in the Poetry of
the Pound Tradition* and *The Poetics of
Indeterminacy: Rimbaud to Cage.*

Published with the assistance of the J. Paul Getty Trust

Permission to quote from the following sources is
gratefully acknowledged:

Ezra Pound, *Personae.* Copyright 1926 by Ezra Pound.
Used by permission of New Directions Publishing Corp.
Ezra Pound, *Collected Early Poems.* Copyright 1976
by the Trustees of the Ezra Pound Literary Property
Trust. All rights reserved. Used by permission of
New Directions Publishing Corp.
Ezra Pound, *The Cantos of Ezra Pound.* Copyright
1934, 1948, 1956 by Ezra Pound. Used by
permission of New Directions Publishing Corp.
Blaise Cendrars, *Selected Writings.* Copyright 1962,
1966 by Walter Albert. Used by permission of New
Directions Publishing Corp.

The University of Chicago Press, Chicago 60637
The University of Chicago Press, Ltd., London

95 94 93 92 91 90 89 88 87 86 54321

Library of Congress Cataloging-in-Publication Data

Perloff, Marjorie.
 The futurist moment.

 Bibliography: p.
 Includes index.
 1. Futurism. 2. Arts, Modern—20th century.
I. Title.
NX600.F8P46 1986 700'.94 86-3147
ISBN 0-226-65731-0

For
DAVID ANTIN

CONTENTS

ILLUSTRATIONS

ABBREVIATIONS

AA Hal Foster, ed., *The Anti-Aesthetic: Essays on Postmodern Culture* (Port Townsend, Wash.: Bay Press, 1983).

AAF Ellendea Proffer and Carl R. Proffer, eds., *The Ardis Anthology of Russian Futurism* (Ann Arbor: Ardis, 1980).

ABC Ezra Pound, *ABC of Reading* (New York: New Directions, 1960).

AF Maria Drudi Gambillo and Teresa Fiori, eds., *Archivi del futurismo*, 2 vols. (Rome: De Luca, 1958–62).

AO Michael Fried, "Art and Objecthood," reprinted in *Minimal Art: A Critical Anthology*, ed. Gregory Batcock (New York: E. P. Dutton, 1968).

B *BLAST . . . review of the great English vortex*, nos. 1 and 2, a facsimile edition, ed. Bradford Morrow (Santa Barbara, Calif.: Black Sparrow Press, 1981). Unless otherwise noted, no. 1 is cited.

BR Wassily Kandinsky and Franz Marc, eds., *The Blaue Reiter Almanac*, New Documentary edition, ed. Klaus Lankheit, trans. Henning Falkenstein (New York: Viking Press, 1974).

C *The Cantos of Ezra Pound* (New York: New Directions, 1971).

CEP *Collected Early Poems of Ezra Pound*, ed. Michael John King (New York: New Directions, 1976).

CFS Kasimir Malevich, *From Cubism and Futurism to Suprematism: The New Painterly Realism*, in *RA*.

Coll Louis Aragon, *Les Collages* (Paris: Hermann, 1980).

DBR Wassily Kandinsky and Franz Marc, eds., *Der Blaue Reiter*, Dokumentarische Neuausgabe von Klaus Lankheit (Munich: R. Pier, 1965).

DPP Robert Motherwell, ed., *The Dada Painters and Poets* (New York: George Wittenborn, Inc., 1967).

EA Kasimir Malevich, *Essays on Art, 1915–1933*, ed. Troels Andersen, trans. Xenia Glowacki-Prus and Arnold McMillin, 2 vols. (Copenhagen: Borgen, 1968).

F Giovanni Lista, *Futurisme: Manifestes, documents, proclamations* (Lausanne: L'Age d'Homme, 1973).

FD Linda Dalrymple Henderson, *The Fourth Dimension and Non-Euclidean Geometry in Modern Art* (Princeton: Princeton University Press, 1983).

FM Umbro Apollonio, ed., *Futurist Manifestos*, trans. Robert Brain et al., Documents of Twentieth-Century Art (New York: Viking Press, 1973).

GB Ezra Pound, *Gaudier-Brzeska* (New York: New Directions, 1970).

GS Walter Benjamin, *Gesammelte Schriften*, ed. Rolf Tiedemann and Hermann Schweppenhauser (Frankfurt: Suhrkamp).

GV Roland Barthes, *Le Grain de la voix: Entretiens, 1962–1980* (Paris: Editions du Seuil, 1981).

Ill Walter Benjamin, *Illuminations*, ed. Hannah Arendt, trans. Harry Zohn (New York: Schocken Books, 1969).

Int *The Grain of the Voice: Interviews, 1962–1980*, trans. Linda Coverdale (New York: Hill and Wang, 1985).

IS Blaise Cendrars, *Inédits secrets*, ed. Miriam Cendrars, *OC*, vol. 16 (Paris: Le Club français du livre, 1969).

KT Velimir Khlebnikov, *The King of Time: Poems, Fictions, Visions of the Future*, ed. Charlotte Douglas, trans. Paul Schmidt (Cambridge, Mass.: Harvard University Press, 1985).

LE *Literary Essays of Ezra Pound*, ed. T. S. Eliot (New York: New Directions, 1954).

LRL Gerald Janecek, *The Look of Russian Literature: Avant-Garde Visual Experiments, 1900–1930* (Princeton: Princeton University Press, 1984).

M Howard N. Fox, *Metaphor: New Projects by Contemporary Sculptors (Acconci, Armajani, Aycock, Ewing, Morris, Oppenheim)*. (Washington, D.C.: Hirshhorn Museum and Sculpture Garden, Smithsonian Institution Press, 1982).

MF Giovanni Lista, ed., *Marinetti et le futurisme: Etudes, documents, iconographie*, Cahiers des Avant-Gardes (Lausanne: Editions L'Age d'Homme, 1977).

MPF Vladimir Markov, ed., *Manifesti y programmy russkikh futuristov/Die Manifeste und Programmschriften der Russischen Futuristen*, Slavische Propylaen (Munich: Wilhelm Fink Verlag, 1967).

Mu Group *Mu*, eds., *Collages, Revue d'Esthétique*, nos. 3–4 (Paris: Union Generale, 1978).

OAG Rosalind Krauss, *The Originality of the Avant-Garde and Other Modernist Myths* (Cambridge and London: MIT Press, 1985).

OC Blaise Cendrars, *Oeuvres complètes*, 16 vols., ed. Raymond
 Dumay and Nino Frank (Paris: Le Club français du livre,
 1968–71).
OHA Benedikt Livshits, *The One-and-a-Half-Eyed Archer*, ed. and
 trans. John E. Bowlt (Newtonville, Mass.: Oriental Research
 Partners, 1977).
P Ezra Pound, *Personae* (New York: New Directions, 1926).
PJ Ezra Pound, *Pound/Joyce: Letters and Essays*, ed. Forrest Read
 (New York: New Directions, 1967).
RA John E. Bowlt, ed. and trans., *Russian Art of the Avant-Garde:
 Theory and Criticism, 1902–1934* (New York: Viking Press,
 1976).
RF Vladimir Markov, *Russian Futurism: A History* (Berkeley and
 Los Angeles: University of California Press, 1968).
RS *The Writings of Robert Smithson*, ed. Nancy Holt (New York:
 New York University Press, 1979).
S F. T. Marinetti, *Selected Writings*, ed. R. W. Flint, trans. R. W.
 Flint and Arthur A. Coppotelli (New York: Farrar, Straus and
 Giroux, 1972).
SCW Antonio Gramsci, *Selections from Cultural Writings*, ed. David
 Forgacs and Geoffrey Nowell-Smith, trans. William Boelhower
 (Cambridge, Mass.: Harvard University Press, 1985).
SL *Selected Letters of Ezra Pound, 1907–1941*, ed. D. D. Paige
 (New York: New Directions, 1971).
SM Tristan Tzara, *Sept Manifestes Dada* (Utrecht: Jean-Jacques
 Pauvert, 1963).
SP *Selected Prose of Ezra Pound, 1909–1965*, ed. William
 Cookson (New York: New Directions, 1973).
ST Velimir Khlebnikov, *Snake Train: Poetry and Prose*, ed. and
 trans. Gary Kern (Ann Arbor: Ardis, 1976).
SW *Selected Writings of Blaise Cendrars*, trans. Walter Albert (New
 York: New Directions, 1962).
TE Roland Barthes, *La Tour Eiffel* (Lausanne: Delphire, 1964).
"TE" Blaise Cendrars, "La Tour Eiffel: A Madame Sonia Delaunay,"
 in *OC*.
TIF Luciano De Maria, ed., *Opere di F. T. Marinetti*, vol. 2: *Teoria
 e invenzione futurista* (Milan: Mondadori, 1968).
TO P. D. Ouspensky, *Tertium Organum: The Third Canon of
 Thought, a Key to the Enigmas of the World* (1911), rev. trans.
 by E. Kadloubovsky and P. D. Ouspensky (New York: Alfred
 A. Knopf, 1981).

TRF Wolf Dieter Stempel, ed., *Texte der Russischen Formalisten,*
vol. 2: *Texte zur Theorie des Verses und der poetischen Sprache*
(Munich: Wilhelm Fink, 1972).
TT Joseph Harriss, *The Tallest Tower: Eiffel and the Belle Epoque*
(Boston: Houghton Mifflin, 1975).
VM *The Complete Plays of Vladimir Mayakovsky*, trans. Guy
Daniels (New York: Simon and Schuster, 1968).
WB Susan P. Compton, *The World Backwards: Russian Futurist
Books, 1912–1916* (London: British Library, 1978).

PREFACE

I take my title from Renato Poggioli, who suggests in *The Theory of the Avant-Garde:*

> the futurist moment belongs to all the avant-gardes and not only to the one named for it . . . the so-named movement was only a significant symptom of a broader and deeper state of mind. Italian futurism had the great merit of fixing and expressing it, coining that most fortunate term as its own label. . . . the futurist manifestation represents, so to speak, a prophetic and utopian phase, the arena of agitation and preparation for the announced revolution, if not the revolution itself.

The revolution longed for by the poets and artists of the *avant guerre* never came, at least not in the form anticipated. Indeed, the utopian buoyancy of "les jeunes de la classe de 1915," as Apollinaire called them, soon gave way to the anarchic and nihilistic spirit of Dada and then to a renewed longing for transcendence, a longing that gave impetus not only to the Surrealist movement, with its emphasis on the occult, the visionary, the domain of dream, but also to the proto-Fascist strain that was to make late European and American Modernism so problematic.

In this context, the "Futurist moment" has a special pathos for us who live in the late twentieth century. For the "arena of agitation," as Poggioli calls it, produced a short-lived but remarkable rapprochement between avant-garde aesthetic, radical politics, and popular culture. "We exclaim," wrote Mikhail Larionov and Natalya Goncharova in their Rayonist Manifesto of 1913, "the whole brilliant style of modern times—our trousers, jackets, shoes, trolleys, cars, airplanes, railways, grandiose steamships—is fascinating, is a great epoch." And the same year Blaise Cendrars began one of his "elastic poems" with the line "Les fenêtres de ma poésie sont grand'ouvertes sur les boulevards."

A poetry whose windows are wide open to the boulevards—here is a program that points the way to our own urge to break down the boundaries between "world" and "text," between the reality out there and the art construct that re-presents it. As Robert Smithson was to

put it in his proposal for the projected Dallas–Fort Worth Regional Airport:

> Art today is no longer an architectural afterthought, or an object to attach to a building after it is finished, but rather a total engagement with the building process from the ground up and from the sky down. The old landscape of naturalism and realism is being replaced by the new landscape of abstraction and artifice.

Between the Rayonist manifesto and Smithson's "Aerial Art" falls the shadow of two world wars. Inevitably, the revival, in the past two decades, of such Futurist art forms as collage, manifesto, performance, artist's book, and sound poetry is less repetition than ironic allusion, providing us with such disillusioned or "cool" versions of Futurist poetic as Robert Smithson's *Nonsites*, John Cage's *Empty Words*, Jacques Derrida's *La Carte postale*, and Laurie Anderson's *Americans on the Move*.

"J'aime le romanesque," Roland Barthes remarked in a 1975 interview, "mais je sais que roman est mort." The desire for the "novelistic" without the constraints of the novel, the "poetic" that is no longer encased in the poem—it is surely our own postmodern urge to break down the centered, hierarchical orders of the past that makes the Futurist moment seem so appealing. For here, at the origins of a Modernism that was to turn increasingly elitist and formalist in its concern for self-sufficient structures and aesthetic distance, is the latent promise of an impure art world that might also be the place where we live. Thus collage, perhaps the central artistic invention of the *avant guerre*, incorporates directly into the work an actual fragment of the referent, thus forcing the reader or viewer to consider the interplay between preexisting message or material and the new artistic composition that results from the graft. If collage and its cognates (montage, assemblage, construction) call into question the representability of the sign, such related Futurist modes as manifesto, artist's book, and performance call into question the stability of genre, of the individual medium, and of the barrier between artist and audience. The *avant guerre* is also the time of *parole in libertà*—the visualization of the text that is neither quite "verse" or "prose," a text whose unit is neither the paragraph nor the stanza but the printed page itself.

Such formal ruptures reflect, of course, the larger desire of the Futurists to break down existing economic and political structures and to transcend nationalist barriers. The Europe of the *avant guerre* was a field of action whose center was Paris but whose circumference, by way of the French language, took in Petersburg as well as London and

New York. The world the Futurists knew could be traversed without a passport, using such new means of transportation as the automobile, the high-speed train, and, for short runs, even the airplane. It is emblematic of the movement that the Italian F. T. Marinetti published his 1909 manifesto in the Paris *Figaro*, that Umberto Boccioni and Robert Delaunay regularly exhibited in the Salons of Munich and Berlin, or that the Russian critic Zinaida Vengerova interviewed the "English Futurist" Ezra Pound for the Petersburg avant-garde journal *Strelets*.

But the internationalism of the *avant guerre* was as precarious as it was short-lived. Indeed, it is the tension between cosmopolitanism and a stubborn nationalism that gives the poetry and painting of the period its particular poignancy. Neither Blaise Cendrars (born Freddy Sauser) nor Apollinaire (born Wilhelm Apollinaris Kostrowitsky) were native Frenchmen, and yet both were zealous in their patriotism. Accordingly, although both had close friendships with the German artists and writers associated with *Der Blaue Reiter* and published articles and essays in Herwarth Walden's *Der Sturm*, neither expressed the slightest reservation when the war between France and Germany broke out. "This war," Cendrars declared to a friend, "fits me like a glove"—an ironic metaphor given that he was to lose his right arm in battle. And doubly ironic given that his great poem *La Prose du Transsibérien* (1913) had already punctuated its narrative of the cross-continental train journey with images of the war to come.

Such images do not really cohere, nor are they meant to. Central to collage is the refusal to suppress the alterity of elements temporarily united in its structure. Thus, what often passes today for artistic anarchy (poems that are not in verse, artworks in which one material poses as another, installations in which it is difficult to sort out the "real" from the "fictive," and books of "critical theory" that advance no logical argument) may perhaps be best understood as re-visions of the Vortex of 1913. But if the Vortex of the *avant guerre* was, in Pound's words, equivalent to "ENERGY," ours may well have less heat than light, less exuberance than irony and pastiche. The collage-piece unravels from the surface of the canvas, and we see that it is, after all, the flight coupon we thought we had lost.

This book was conceived as a kind of synchronic complement to my diachronic study of "anti-Symbolism," *The Poetics of Indeterminacy: Rimbaud to Cage* (1981). But in the course of working out the problematics of Futurism, I have also revised what I now see as too sharp a dichotomy between Symbolism and what I called the poetry of "the

other tradition." My aim here, in any case, is less to make distinctions than to explore the contours of a particular moment in our literary and art history, whose eruption has cast such a long shadow.

The reader should perhaps be warned what not to expect. This book is not a survey of Italian or Russian Futurism or of French Cubism or English Vorticism. There are already many such studies and I am in their debt. At the same time, I have a certain mistrust of *ism* studies, whose tendency is almost invariably to stress the uniqueness of the movement in question at the expense of its context. The historian of a given movement tends to trust empirical evidence perhaps too completely, assuming that if, say, Wyndham Lewis launched a vituperative attack against Picasso, then it must mean that Vorticism is quite distinct from Cubism. Or again, that if Tristan Tzara claimed that his manifestos had nothing to do with the earlier ones of Marinetti, then Dada is antithetical to Futurism. And so on.

Histories or surveys of a given movement do, however, have the advantage of breadth. I should have liked to include some discussion of Futurist music—for example, Luigi Russolo's "art of noises" or Mikhail Matyushin's score for the Malevich-Kruchenykh opera *Victory over the Sun*—but I decided not to largely because I lack the musical competence to discuss these phenomena intelligently. Again, I neglect the rich field of Futurist performance because to treat it adequately would take a book in itself. Michael Kirby's *Futurist Performance* (1971) is an excellent survey of the Italian theater works of the period. The collage aesthetic which is the subject of chapter 2 might also, of course, have been discussed with respect to photography, film, and dance. Here is a fruitful field for future research as is the role of sexuality in Futurist poetics. At this writing, the Italian feminist artist Monica Gazzo is preparing performance pieces based on Valentine de Saint-Point's *Futurist Manifesto of Lust* and Rosa Rosai's *A Woman with Three Souls*. And, as the superb 1980 exhibition The Avant-Garde in Russia, 1910–1930, at the Los Angeles County Museum of Art, implies, women artists—Natalya Goncharova, Lyubov Popova, Olga Rozanova, Varvara Stepanova—made a much greater contribution to Futurist painting, collage, and book illustration than did, say, Gabrielle Picabia and other women artists to Dada. Why this was the case remains to be investigated.

Because I have adhered fairly rigidly to my time frame, I have not included discussion of such American versions of *avant guerre* aesthetic as William Carlos Williams's *Kora in Hell*, Hart Crane's *The Bridge*, Joseph Stella's paintings, or Man Ray's "rayographs." For political and social reasons, the American response to Futurist poetic

was delayed by at least a decade, and by then, Futurist elements had been inextricably altered by their contact with Dada, as Dickran Tashjian points out in *Skyscraper Primitives* (1975). Pound's Vorticist poems and manifestos are a special case: because Pound was living in London in the early 1910s, he came into direct contact with the Italian, German, and French avant-garde.

In confining myself to the period when the European nations were on the brink of war, I have been able to note ideological currents that were quickly obscured as the prolongation of the war covered their traces. We take for granted today that World War I was the most futile war of all, a war fought in the trenches by men who had no choice but to fight and who died for no cause. The fact is, however, that until late in 1915, the war was celebrated by most of the poets and painters who enlisted as the culmination of a thrilling new adventure with technology; as the revolution that would remove the shackles of monarchy, papacy, and class structure. As Apollinaire put it in a short poem called "Oracles," "Le sifflet me fait plus plaisir / Q'un palais egyptien / Le sifflet des tranchées" (The whistle thrills me more / Than an Egyptian palace / The whistle of the trenches).

To understand the exhilaration that greeted the new technology—the power, for instance, to beam radio signals from the Eiffel Tower around the world—we must try to look at that world through the eyes of "les jeunes de la classe de 1915." I have, accordingly, narrowed the time frame and expanded the spatial one so as to do justice to the Futurist moment.

I began work on this book in 1981–82 with the help of a fellowship from the John Simon Guggenheim Memorial Foundation and completed it in 1985 with a Senior Fellowship for Independent Research from the National Endowment for the Humanities. To both institutions I am deeply grateful.

My personal debts are many. The following people read or discussed with me part or all the manuscript and made important—and varied—suggestions: Charles Altieri, Charles Bernstein, James E. B. Breslin, Gerald L. Bruns, Ronald Bush, Matei Calinescu, Monique Chefdor, James Clifford, Frederick Garber, Renée Riese Hubert, James Laughlin, Anna Lawton, Herbert Lindenberger, Jerome J. McGann, Peter Manning, Timothy Materer, Martin Meisel, Douglas Messerli, Jeanine Parisier Plottel, Laurence Rainey, Michael Riffaterre, Jerome Rothenberg, Richard Sieburth, Catharine R. Stimpson, James Thorpe, Arthur Vogelsang, and Lindsay Waters.

Christine Thomas and Jenny Tumas provided translations from the

Russian for chapter 4; Anthony Giles and Claude Rawson helped with
the translations of Roland Barthes in chapter 6. To Helena Weill, the
director of the University of California at Irvine Summer School Pro-
gram in Russian, and to her staff, "Masha" owes a special debt.
Vladimir Markov, the author of the leading study of Russian Futur-
ism, who is, fortunately for me, a colleague across town at UCLA,
provided advice and information about Russian artist's books, as did
Sarah Pratt of USC's Slavic department. In a similar vein, Robbert
Flick and Susan Rankaitis helped with the material on Robert Smith-
son in chapter 6.

Portions of the book in their earlier versions were tried and tested
on audiences at various universities and conferences: the Modern
Language Association meetings in 1982 and 1983, the American
Comparative Literature Association Triennial Conference in Santa
Barbara in 1983, the Modernism Conference held at the Claremont
Colleges in 1982 and organized by Monique Chefdor and Riccardo
Quinones, the Ezra Pound Centennial Conference organized by Car-
roll F. Terrell, the editor of *Paideuma*, at the University of Maine in
1985, and the Text and Image Conference directed by Frederick
Garber at SUNY-Binghamton in 1985. I received wonderful feedback
on the problem of collage from an audience at the University of Illi-
nois at Urbana in 1983, especially from Cary Nelson. And Robert von
Hallberg's Modernism Seminar, held at the University of Chicago in
the fall of 1985, provided precisely the help I needed with chapter 1.

Earlier versions of chapters 2 and 3 have appeared in the *New York
Literary Forum* and the *Chicago Review*, respectively. A small portion
of chapter 1 appeared in the *Yearbook of English Studies* for 1984. I
am grateful to the editors of these journals for permission to reprint
the material.

As always, I am indebted to my family for help and encouragement.
My husband, Joseph K. Perloff, has read the entire manuscript sev-
eral times and has called into question my more dubious generaliza-
tions or conclusions. His knowledge of art history and his uncanny
ability to "see" the function of a given detail in the visual field have
been especially helpful.

David Antin, to whom this book is dedicated, has played, perhaps
unwittingly, the largest role in helping me formulate the argument of
this book. It was David Antin's 1972 essay "Modernism and Post-
modernism: Approaching the Present in American Poetry" (*boundary
2*) that first sparked my interest in Blaise Cendrars, and it has been
the example of Antin's "talk poems"—part narrative, part poetry, part
conceptual art—that helped me understand the Futurist connec-

tion. Indeed, Antin's "Poetry and the Idea of an Idea," a philosophical lecture-poem on Marx, Brecht, and Wittgenstein, delivered at the Humanities Institute conference in Berkeley in the fall of 1984, must have convinced anyone who heard it that even our "cool" Futurism can be pretty hot when the occasion warrants.

And finally a word for those who prepared the manuscript. A book that deals with the Futurist cult of the machine should surely pay homage to our new "typists"—in my case, a Kaypro 4 word processor and a Hewlett Packard laser jet printer. Were Marinetti alive, he might have written an ode to these miracle workers, or at least have composed a manifesto on their behalf.

October 1985 Marjorie Perloff

PROFOND AUJOURD'HUI

We rang for room service and the year 1913 answered:
it gave Planet Earth a valiant new race of people, the heroic
Futurians.

—Velimir Khlebnikov

Can a man who always goes about in a cabriolet really
understand the experiences and impressions of one who
travels in an express or flies through the air?

—Kasimir Malevich

Every pine woods madly in love with the moon has a
Futurist road that crosses it from end to end.

—F. T. Marinetti

[*The Futurists*] *have grasped sharply and clearly that our
age, the age of big industry, of the large proletarian city and
of intense and tumultuous life, was in need of new forms
of art, philosophy, behaviour and language.* This sharply
revolutionary and absolutely *Marxist* idea came to them
when the Socialists were not even vaguely interested in such
a question, when the Socialists certainly did not have as
precise an idea in politics and economics. . . . In their
field, the field of culture, the Futurists are revolutionaries.
In this field it is likely to be a long time before the working
classes will manage to do anything more creative than the
Futurists have done.

—Antonio Gramsci [1]

I n the autumn of 1913, *Les Hommes nouveaux*, a radical journal and small press founded by Blaise Cendrars and his friend Emile Szytta, published a remarkable verbal-visual text called *La Prose du Transsibérien et de la petite Jehanne de France* (fig. 1.1 and pl. 1A–D). It bore the subtitle: "poèmes, couleurs simultanées de tirage atteignant la hauteur de la Tour Eiffel: 150 exemplaires numérotés et signés" ("poems, simultaneous colors, in an edition attaining the height of the Eiffel Tower: 150 copies numbered and signed").[2] *Le Premier livre simultané*, as the work was also called, was made up of a single sheet of paper, divided down the center, which unfolded like an accordion, through twenty-two panels to a length of almost seven feet. The height of the Eiffel Tower was to be attained by lining up the 150 copies of the text vertically.

On the left, a panel containing the title page initiates the passage of the eye downward, through a sequence of visual semiabstract forms in bright primary colors, to a final panel that contains a child's image of the Eiffel Tower, a curiously innocent giant red phallus penetrating an orange Great Wheel with a green center. On the right, meanwhile, the text of the poem is prefaced by a Michelin railway map of the Trans-Siberian journey from Moscow to the Sea of Japan; underneath this map, a wide strip of green introduces the poem's title in big block letters as if the *pochoir* were a poster signboard. The text then follows, arranged in succeeding blocks made up of different typefaces and broken by large irregularly shaped planes of predominantly pastel color. The coda, "Paris / Ville de la Tour unique du grand Gibet et de la Roue" ("Paris / City of the incomparable Tower of the Rack and the Wheel") corresponds to the visual image of tower and wheel on the bottom left.[3]

La Prose du Transsibérien was the collaboration of the poet Blaise Cendrars and the painter Sonia Delaunay. The particular version of modernity found in this text makes it an especially fitting emblem of what I call the Futurist moment. Cendrars's is not, of course, strictly speaking a "Futurist" (e.g., Italian Futurist or Russian Futurist) poem, but, perhaps precisely for that reason, it furnishes us with a

Fig. 1.1. *La Prose du Trans-*
sibérien et de la petite Jehanne de
France. Text by Blaise Cendrars;
pochoir illumination by Sonia
Delaunay. Editions des *Hommes*
nouveaux, Paris, 1913. *Pochoir*
gouache, 81¾″ × 13¾″. Biblio-
thèque Nationale, Paris.

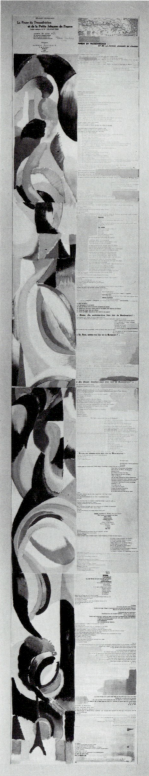

paradigm of Futurism in the larger sense, as the arena of agitation and projected revolution that characterizes the *avant guerre*. Certainly, *La Prose du Transsibérien* embodies Antonio Gramsci's understanding, voiced in *L'Ordine Nuovo* (the official organ of the newly formed Italian Communist party), that Futurism was the first movement to give artistic expression to the "intense and tumultuous life" of the newly industrialized urban landscape.

The very names Blaise Cendrars and Sonia Delaunay are emblematic of the anomalies that characterize the Futurist ethos. Mme Delaunay-Terk, as she is listed on the title page of the poem-painting, was born in the Ukraine to Jewish parents; as a small child she was adopted by her maternal uncle Henri Terk and grew up in Petersburg. In 1905 she went to Paris to study art; in 1909 she decided that the best way to assert her independence from her Russian relatives was to accept a marriage offer from a Parisian gallery owner, the German art collector William Uhde. A year later, the two were amicably divorced and Sonia Terk Uhde married her husband's painter friend Robert Delaunay.[4]

Sonia Delaunay's place in the French avant-garde of the 1910s (it is usual to speak of the "orphism" or "simultaneism" of "the Delaunays" as if Sonia's work were no more than a footnote to Robert's) is thus complicated by her Russian origins and German Expressionist connections. Blaise Cendrars's self-characterization as the only poet in the Paris of 1913 who could seriously rival Apollinaire is even more ironic.[5] Born in La Chaux-de-Fonds, Switzerland, Cendrars was christened Frédéric Louis Sauser. As a young man he called himself Freddy Sausey, and then, by the late fall of 1911, when he was living in New York, he was using the signature Blaise Cendrart, a name that, at the time of his arrival in Paris a few months later, had become Blaise Cendrars. Blaise, as the poet later explained it to a friend, came from *braise* (ember, cinder) by means of the simple "confusion of R- and L-sounds"; as for Cendrars, from *cendres* (again cinders, though more in the sense of ashes), in his autobiographical fragment *Une Nuit dans la forêt*, the poet explains:

> Or, on peut adorer le feu, mais non point respecter indéfiniment les cendres; c'est pourquoi j'attise ma vie et travaille mon coeur (et mon esprit et mes couilles) avec le tissonier. La flamme jaillit.

> Well, one may adore fire, but not indefinitely respect the ashes; that's why I rake up my life and exercise my heart (and my mind and my balls) with the poker. The flame shoots forth.[6]

The role-playing that transformed a Frédéric Sauser into Blaise Cendrars, a Sonia Terk into Madame Delaunay, points to the curious tension between nationalism and internationalism that is at the heart of *avant guerre* consciousness. Delaunay's abstractions have strong affinities to primitive Russian *lubki* (woodblocks) as well as to the collages of the Russian Cubo-Futurists who were her contemporaries; she also had contact with Wassily Kandinsky, then living in Munich. Yet although the Delaunays received artists and poets from all over Europe and the United States, she remained for the rest of her life ardently French, refusing, for example, so much as to visit America.[7]

Again, the Switzerland of Cendrars's birth represented the confluence of German and Latin currents, specifically the Milan (Italian Futurist)–Berlin (German Expressionist) axis. Freddy-Blaise was entirely bilingual (German-French); when he ran away from home at the age of seventeen and spent three years (1904–7) in St. Petersburg, he added Russian to his repertoire and then, in New York (1911–12), some English. Restlessly international by background and inclination, he had been in Paris a brief two years when the war broke out in August 1914. Nevertheless, despite his close ties with such German intellectuals and artists as Herwath Walden (the editor of *Der Sturm*) and Franz Marc, he could hardly wait to join the French Foreign Legion and to fight for what he, like his friend and fellow poet Apollinaire, who was also a foreigner with an adopted name, took to be the great cause. "This war," Cendrars wrote to a friend in September, on his way to the front, "is a painful delivery, needed to give birth to liberty. It fits me like a glove. Reaction or Revolution—man must become more human. I will return. There can be no doubt." And a little later, "The war has saved my life. This sounds like a paradox, but a hundred times I have told myself that if I had continued to live with those people [the bohemian radical artists of Montparnasse], I would have croaked." Within a year he had been wounded and lost his right arm: nevertheless on 2 November 1915 he wrote (painfully, with his left hand) to Apollinaire: "I had to have my arm amputated. I am as well as can be expected. My spirits are good."[8]

Seventy years and two world wars later, it is almost impossible to understand this particular mixture of radicalism and patriotism, of a worldly, international outlook and a violently nationalist faith. Yet we find this paradox everywhere in the arts of the *avant guerre*. Before we dismiss as a contemptible proto-Fascist the Marinetti who declared, in the first Futurist manifesto (1909), "We will glorify war—the world's only hygiene," we must look at the context in which such statements were made. The publication and exhibition history of *La Prose du Transsibérien* may provide us with some interesting leads.

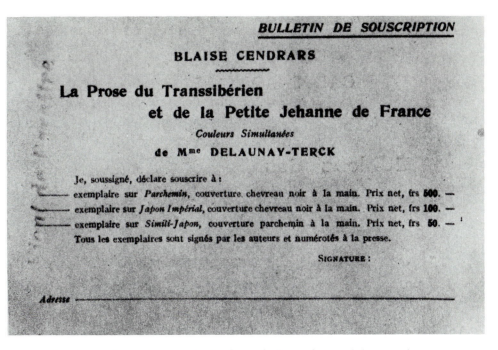

Fig. 1.2. Subscription form for *La Prose du Transsibérien*. Collection A. t'Serstevens, Paris, 1913.

I

Neither Blaise Cendrars nor Sonia Delaunay considered themselves Futurists: indeed, Cendrars repeatedly insisted that, as he put it in a letter to André Salmon (12 October 1913): "The inspiration of this poem [*La Prose du Transsibérien*] came to me naturally and . . . has nothing to do with the commercial agitation of M. Marinetti" (*IS* 362). But despite such disclaimers—disclaimers that, as we shall see, were largely prompted by the strong nationalist rivalries of the period—*La Prose du Transsibérien* can be taken as a kind of hub of the Futurist wheel that spun over Europe in the years of *avant guerre*.

Consider the publicity campaign launched by Cendrars on behalf of his poem. Its September 1913 publication was preceded by a flurry of leaflets, subscription forms, and prospectuses (see fig. 1.2) announcing the impending publication of "le Premier livre simultané," whose height would rival that of the Eiffel Tower. The word "*simultané*" predictably aroused the anger of the Italian Futurists, whose own manifestos had regularly advocated simultaneity: in the words of Boccioni's 1912 manifesto, "The simultaneousness of states of mind in the work of art: that is the intoxicating aim of our art."[9] By *simultaneity*, Boccioni and his fellow painters meant "the synthesis of *what one remembers* and of *what one sees*" (*FM* 47), the possibility of representing

successive stages of motion in linear sequence, as in Giacomo Balla's famous *Dynamism of a Dog in Motion* of 1912 (see fig. 1.3). The "Rayonism" of the Russian Futurist painters Mikhail Larionov and Natalya Goncharova was a similar call for the depiction of simultaneous motion, of dynamism and speed.[10]

Sonia Delaunay's term "*couleurs simultanés,*" on the other hand, refers, in the first place, to something quite specific: M. E. Chevreul's 1839 treatise *De la Loi du contraste simultané des couleurs* from which Robert Delaunay derived his doctrine of "simultaneism" as the dynamic counterpoint of otherwise dissonant colors when observed in complementarity.[11] Again, *La Prose du Transsibérien* is a "simultaneous" book in that the reader takes in, or is meant to take in, text and image simultaneously; the eye travels back and forth between Delaunay's colored forms and Cendrars's words. Third, *simultaneity* here refers to the spatial and temporal distortions that, as we shall see, characterize *La Prose du Transsibérien*, a poem that collapses present

Fig. 1.3. Giacomo Balla, *Dynamism of a Dog in Motion*, 1912. Oil on canvas, 35⅜″ × 43¼″. Bequest of A. Conger Goodyear to George F. Goodyear, life interest, and Albright-Knox Art Gallery, Buffalo, New York, 1964.

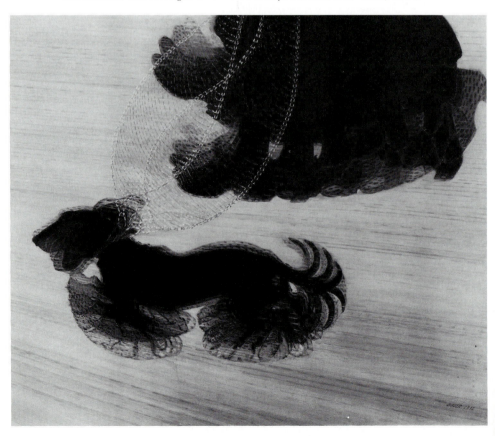

and past, the cities and steppes of the Russian orient and the City of the Tower, the Gibbet, and the Wheel, which is Paris.

Cendrars seems, in any case, to have relished the controversy generated by the circulars for *La Prose*. For one thing, it brought such poets as Apollinaire to his defense. In *Les Soirées de Paris* (15 June 1914), the latter reports:

> Blaise Cendrars and Mme Delaunay-Terk have carried out a unique experiment in simultaneity, written in contrasting colors in order to train the eye to read with one glance the whole of a poem, even as an orchestra conductor reads with one glance the notes placed up and down on the bar, even as one reads with a single glance the plastic elements printed on a poster.[12]

The poem-painting as a kind of advertising poster—here is the analogy at the heart of Marinetti's *parole in libertà*, the words-in-freedom arranged artfully on the page in different sizes, typefaces, and colors. But the transformation of the conventional page found in *La Prose*—a transformation I shall consider later—is specifically related by Cendrars himself to the layout of the "luminous" billboard. "The flower of contemporary life," as he playfully calls advertising, in a short piece called "Advertising = Poetry" (1927), "is the warmest sign of the vigor of today's men—indeed, one of the seven wonders of the world."

> Have you ever thought about the sadness that streets, squares, stations, subways, first class hotels, dance halls, movies, dining cars, highways, nature would all exhibit without the innumerable billboards, without show windows (those beautiful, brand new toys for thoughtful families), without luminous signboards, without the false blandishments of loudspeakers, and imagine the sadness and monotony of meals and wine without polychrome menus and fancy labels. (*OC* 6:87–88; *SW* 240–41)

Luminous signboards and polychrome menus—it is thus that "art" and "life" are destined to become one. To announce the publication of his own *La Prose du Transsibérien*, Cendrars published a manifesto in the September 1913 number of Herwath Walden's avant-garde Berlin periodical *Der Sturm:*

> Je ne suis pas poète. Je suis libertin. Je n'ai aucune methode de travail. J'ai un sexe. . . . Et si j'écris, c'est peut-être par besoin, par hygiene, comme on mange, comme on respire, comme on chante. . . .
> La littérature fait partie de la vie. Ce n'est pas quelque chose "à part." Je n'écris pas par métier. Vivre n'est pas un métier. . . . J'ai fait mes plus beaux poèmes dans les grandes villes, parmi cinq millions

d'hommes—ou à cinq mille lieues sous les mers en compagnie de
Jules Verne, pour ne pas oublier les plus beaux jeux de mon enfance.
Toute vie n'est qu'un poème, un mouvement. . . .

J'aime les légendes, les dialectes, les fautes de langage, les romans
policiers, la chair des filles, le soleil, la Tour Eiffel, les apaches, les
bons nègres, et ce rusé d'Européen qui jouit goguenard de la moder-
nité. Où je vais? Je n'en sais rien, puisque j'entre même dans les
musées. . . .

Voilà ce que je tenais à dire: j'ai la fièvre. Et c'est pourquoi j'aime la
peinture des Delaunay, pleine de soleils, de ruts, de violences. Mme
Delaunay a fait un si beau livre de couleurs, que mon poème est plus
trempé de lumière que ma vie. Voila ce qui me rend heureux. Puis
encore, que ce livre ait deux mètres de long!—Et encore, que l'édition
atteigne la hauteur de la Tour Eiffel! (*IS* 360–61)

I am not a poet. I am a libertine. I have no method of working. I
have a sex. . . . And if I write, it is perhaps out of need, for my health,
even as one eats, one breathes, one sings. . . .

Literature is a part of life. It is not something "special." I do not
write by vocation. Living is not a vocation. . . . I have written my most
beautiful poems in the great cities, among five million men—or, not
forgetting the most beautiful games of my childhood, five thousand
leagues under the sea in the company of Jules Verne. All of life is
nothing but a poem, a movement. . . .

I love legends, dialects, grammatical errors, detective novels, the
flesh of whores, the sun, the Eiffel Tower, Apaches, good negroes, and
that trickster of a European who makes fun of modernity. Where am I
going? I have no idea, since I even visit museums. . . .

Here is what I wanted to say. I have a fever. And this is why I love
the painting of the Delaunays, full of sun, of heat, of violence. Mme
Delaunay has made such a beautiful book of colors that my poem is
more saturated with light than is my life. That's what makes me happy.
Besides, think that this book should be two meters high! Moreover,
that the edition should reach the height of the Eiffel Tower!

Here, playing the enfant terrible, Cendrars grandly dissociates
himself from all poetic "schools" only to echo the Futurist doctrine
that life and art are inseparable, that poetry demands violence and
energy, that it is a kind of "fever" in which the life of the modern city
merges with the exotic Other, the fantasy world of Apaches and "les
bons nègres." Like Rimbaud, whose prose the *Sturm* essay recalls,
Cendrars is drawn to the offbeat, the erotic, the populist.[13] But the
urge to communicate directly with the masses, to play to the crowd—
the urge that makes Cendrars, like Apollinaire and like Marinetti, ex-

tol advertising—gives a kind of hard edge to Rimbaud's more vision-
ary mode. In a letter to Victor Smirnoff (December 1913), Cendrars
insists: "The role of the new poetry is to throw one's treasures out the
window, among the people, into the crowd, into life. I throw money
out of the window." And he quotes from his *poème élastique* "Con-
traste": "Les fénêtres de ma poésie sont grand'ouvertes sur les boule-
vards" ("The windows of my poetry are wide open to the boulevards"). [14]

Curiously enough, this was literally the case. During the fall of
1913, the Cendrars-Delaunay *Prose du Transsibérien* was exhibited in
Paris (the annual Salon d'Automne), Berlin (the Herbst Salon), Lon-
don, New York, Moscow, and St. Petersburg. It became not only a
poem but an event, a happening. In St. Petersburg, the poet-painter
Victor Smirnoff gave an accompanying lecture called "Simultaneous
Contrasts and Plastic Poetry." At the *Montjoie!* exposition in Paris on
24 February 1914, Mme Lucy Wilhelm stood on a chair so as to recite
the gigantic poem, which was hung on the wall. Beginning at ceiling
level, she gradually bent her knees and finally sat down on the chair
to read the conclusion. [15]

Performance art, we would now call it. But even more remarkable
is the way the "windows" of Cendrars's poetry "opened," so to speak,
onto the boulevards of Berlin. Herwath Walden's *Der Sturm*, which
began publication in 1910 with a weekly circulation of approximately
thirty thousand, published such writers as Karl Kraus, Heinrich
Mann, and August Strindberg, as well as the art work of the *Blaue
Reiter* group and the manifestos of the Italian Futurists. Wilhelm
Worringer's "On the Development of Modern Painting," Kandinsky's
"Language of Form and Color," Boccioni's *Futurist Painting: Technical
Manifesto*—all these appeared in the pages of *Der Sturm*. Cendrars
himself contributed a translation of Apollinaire's *Les Peintres cubistes*
and an essay on Henri Rousseau (both in 1913). [16]

Der Sturm also sponsored major exhibitions in which the German
Expressionists were shown side by side with Picasso and Delaunay,
with Vladimir and David Burliuk and Natalya Goncharova. In the
summer of 1913, Walden decided to organize a Herbst Salon, on the
model of the Paris Salon d'Automne. According to Peter Selz (p. 265),
Walden traveled with "meteoric speed" (the speed, we might say,
celebrated in Futurist art), through most European art centers from
Budapest to Paris and assembled 366 paintings and pieces of sculp-
ture by some ninety artists from fifteen countries. This was to be the
last of the significant international exhibitions of contemporary art
held in Germany before World War I. Accordingly, the list of painters
represented is significant:

FRANCE: Marc Chagall, Robert Delaunay, Sonia Delaunay, Albert Gleizes, Fernand Léger, Jean Metzinger, Francis Picabia.
ITALY: Giacomo Balla, Umberto Boccioni, Carlo Carrà, Luigi Russolo, Gino Severini, Ardengo Soffici.
RUSSIA: David Burliuk, Vladimir Burliuk, Natalya Goncharova, N. Kulbin, Mikhail Larionov.
AUSTRIA: Oskar Kokoschka.
HOLLAND: Five artists including Piet Mondrian.
SWITZERLAND: Members of the *Moderne Bund* including Paul Klee.
UNITED STATES: Lyonel Feininger, Marsden Hartley.
GERMANY: From *Der Blaue Reiter* group: Franz Marc, Wassily Kandinsky, Alfred Kubin, Alexej von Jawlensky, August Macke, Gabriele Münter. From the younger generation: Hans Arp, Max Ernst.

More specifically, the Herbst Salon included Balla's *Dog on Leash*, Boccioni's *Unique Forms of Continuity in Space*, Kandinsky's *Composition No. 6*, Delaunay's *Solar Discs*, Léger's *Woman in Blue*, and Marc's *Tower of Blue Horses*.[17]

It is in this international context that *La Prose du Transsibérien et de la Petite Jehanne de France* by Cendrars and Sonia Delaunay made its first appearance. Cendrars, for whom German was as native as French, had close personal ties with the Expressionist poets and painters who were his contemporaries. The correspondence between Cendrars and Walden, between the Delaunays and Franz Marc, flowed steadily throughout 1913. "People of different countries," wrote Delaunay to Marc on 11 January, "get to like one another by seeing. In Berlin, I felt out of place only in terms of the language spoken there."[18]

Yet within little over a year, the poets and painters of Delaunay's circle greeted the outbreak of war with Germany as both inevitable and desirable. Indeed, war, far from being extolled only by Marinetti's Italian Futurist circle, was, until 1916 or so, equated with revolution—the breaking of the vessels of oppression. Thus Kasimir Malevich could declare:

> The academy is a moldy vault in which art is being flagellated.
>
> Gigantic wars, great inventions, conquest of the air, speed of travel, telephones, telegraphs, dreadnoughts are the realm of electricity. . . .
>
> The new life of iron and the machine, the roar of motorcars, the brilliance of electric lights, the growling of propellers, have awakened the soul, which was suffocating in the catacombs of old reason and has emerged at the intersection of the paths of heaven and earth.
>
> If all artists were to see the crossroads of these heavenly paths, if they were to comprehend these monstrous runways and intersections of our bodies with the clouds in the heavens, then they would not paint chrysanthemums.[19]

It was a lesson Cendrars and Delaunay did not have to learn: the "roar of motorcars, the brilliance of electric lights, the growling of propellers" was precisely their subject, even as it was the subject of Malevich and Vladimir Tatlin. But the darker implications of this new technology, imperfectly understood by the artists of the *avant guerre* themselves, are expressed, however subliminally, in their poetry and painting, their collage works and artist's books. I turn now for a closer look at the text of Cendrars's poem.

II

The *Transsibérien* of Cendrars's title, the railway line linking western Russia to the Pacific Coast, was completed in 1905. Together with such other lines as the Trans-African and the Trans-Andine (Buenos Aires to Valparaiso—a great engineering feat, the tracks rising ten thousand feet over the Andes at the Argentine border), these new long-distance rail lines did much to shrink the world. By 1910 one could buy a combined railroad-steamship ticket that made it possible to go around the world, not in the eighty days of Jules Verne's Phileas Fogg, but in forty.[20]

Neither the seven-league boots and flying carpets of fairy tale, Pär Bergman comments wryly, nor the magical hats that abolish space and time, conjured up by Thomas Carlyle in his *Sartor Resartus*, nor, for that matter, the wings of Icarus, could match the real means of transportation that were now invented (Bergman, 9). Between 1909 and 1914, the world witnessed the first successful expeditions to both the North and the South poles (Robert Peary in 1909; Roald Amundsen in 1911), the first extended airplane run (124 kilometers by Wilbur Wright in 1909), the first flight across the English Channel (Louis Blériot in 1909)—an event celebrated in Robert Delaunay's *simultanéiste* painting *Homage to Blériot*, the first flight over the Alps (George Chavez in 1910), and—ominously—the first use of airplanes in the conduct of war (the Italian campaign in Tripoli in 1911).

"England," Blériot announced proudly, "is no longer an island"; indeed, with the increasing availability of the telegraph and telephone, the multiplication of automobiles (3,000 in 1900, over a 100,000 by 1913), and the new zero meridian for France, established at the Eiffel Tower and emitting hourly signals to 1/100 of a second, one had the sense of being everywhere at once. Indeed, as L. Brion-Guerry points out,[21] one could, in 1913, travel without a passport from the Urals to the Atlantic—a situation reflected everywhere in the arts. Thus Igor Stravinsky's *Rite of Spring* was first performed in Paris, but it was in Moscow that Gordon Craig mounted his experimental production of *Hamlet*. Marinetti's 1909 manifesto was first published in the Paris

Figaro, while Apollinaire wrote for *Lacerba* and *Der Sturm*. In November 1913, at the Stray Dog Cabaret in Petersburg, Tatlin heard his painter friend Georgiy Yakulov give a lecture on Robert Delaunay's *simultanéisme*.[22] James Joyce was living in Trieste, Kandinsky in Berlin, and Freddy Sauser, fresh from Petersburg, Basel, and New York, became the Frenchman, Blaise Cendrars.

In this context, it is not surprising that simultaneity became a central theme as well as a formal and structural principle. To be, figuratively speaking, in two places at once now became a possibility; indeed, the new cinema (by 1913 there were two hundred cinemas in Paris) could transport the viewer from Senegal to Sidney in a split second. Voyage, sometimes of epic, sometimes of comic proportions, was the dominant theme of early film: Charlie Chaplin, or Charlot as he was known in France, made his debut in a 1912 farce called *La Course d'auto*.[23] But unlike the great voyage poems and fictions of the nineteenth century, the voyage of the *avant guerre* is fragmented, dislocated, spliced. For the new shrinkage of distance, the ease of getting from A to B, gave rise to a wonder tinged with fear. The completion of the Trans-Siberian Railway, for example, caused Westerners like Henry Adams to tremble at the thought of the huge Russian Empire combining with China to constitute a "single mass which no amount of new force could henceforward deflect."[24]

Thus, if *La Prose du Transsibérien* is, first and foremost, a voyage poem in the great tradition of Baudelaire and Rimbaud (it was Jean Cocteau who remarked that Cendrars had created "a veritable drunken train after [Rimbaud's] *Bateau ivre*"),[25] Cendrars' discourse repeatedly breaks out of the voyage frame: its successive camera shots—of the Kremlin, "comme un immense gâteau tartare" ("like an immense Tartar cake"), of "L'homme aux lunettes bleues qui se promenait nerveusement dans le couloir" ("The man with the blue spectacles who paced nervously up and down the [train] corridor")—dislocate us in both space and time, even as the poet's storytelling explodes the mimetic recounting of the actual journey. It is this consistent slippage, this erasing of contours, whether on the level of narrative or imagery or syntax, that makes Cendrars's journey seem so curiously contemporary.

The very title of the poem subverts our normal expectations. In the letter to Victor Smirnoff cited earlier, Cendrars explains: "As for the word Prose: I have used it in the Transsiberian in the Vulgar Latin sense of 'prosa,' 'dictu.' Poem seems too pretentious, too closed. Prose is more open, popular" (*IS* 371). Here, as in the related poetic texts of the Italian and Russian Futurists, the lyric frame is seen as something

to be shattered. But the fact is that *La Prose du Transsibérien* is written in verse—a Whitmanian free verse, to be sure, but not quite yet the prose of the slightly later "Profond aujourd'hui" or "J'ai tué." Yet the reference to "la Prose" calls attention to the poem's simulation of actual speech rhythms, as in

> Pourtant, j'étais fort mauvais poète.
> Je ne savais pas aller jusqu'au bout.
> J'avais faim.
>
> *(OC* 1:17)
>
> Still, I was a very bad poet.
> I couldn't go to the end.
> I was hungry.
>
> *(SW* 69)

The poem thus hovers on the threshold between verse and prose, between Siberia and Paris, between "la petite Jehanne de France"— the little prostitute of Montmartre who is the modern counterpart of Jeanne d'Arc—and the Trans-Siberian train.[26]

Underneath the title of the poem, we read "dediée aux musiciens" ("dedicated to the musicians"). Whether this is a reference to Erik Satie, who was to become one of Cendrars's close collaborators, or to Stravinsky (Cendrars was in the audience on the opening night, 28 May 1913, of *Le Sacre du printemps* and, as he tells the story, defended the work so heatedly that a hostile neighbor pushed him through his orchestra seat, a seat he wore around his neck like a collar the rest of the night),[27] or whether it is a more general homage to composers and musicians (Cendrars had written a monograph called *Rimski-Korsakov et les maîtres de la musique russe* in 1912; see *IS* 322–51), or simply a reference to the rhythm of the train which Cendrars hopes to capture in his lines, the dedication is disorienting—it brings us up short. If the *avant guerre* is, as I shall argue, the period of artistic rupture—the rupture of established genres and verse forms as well as of the integrity of the medium, the very title and dedication of Cendrars's poem sets the stage for this process. For here, we are told, is a poem that is really "a prose," and further a verbal text that is dedicated to "the musicians," even as the verbal is absorbed into the visual by Sonia Delaunay's painting.

But the semantic ruptures are even more curious. Consider the presentation of self in the opening lines:

> En ce temps-là j'étais en mon adolescence
> J'avais à peine seize ans et je ne me souviens déjà plus de mon
> enfance

J'étais à 16,000 lieues du lieu de ma naissance
J'étais à Moscou, dans la ville des mille et trois clochers et des sept
 gares
Et je n'avais pas assez des sept gares et des milles et trois tours
Car mon adolescence était alors si ardente et si folle
Que mon coeur, tour à tour, brûlait comme le temple d'Éphèse ou
 comme la Place Rouge de Moscou
Quand le soleil se couche.
Et mes yeux éclairaient des voies anciennes.
Et j'étais déjà si mauvais poète
Que je ne savais pas aller jusqu'au bout.

<div align="right">(OC 1 : 16)</div>

It was in the time of my adolescence
I was scarcely sixteen and I had already forgotten my childhood
I was 16,000 leagues from the place of my birth
I was in Moscow, city of the one thousand and three bell towers and
 the seven stations
And I was not satisfied with the seven stations and the one thousand
 and three bell towers
Because my adolescence was so intense and so insane
That my heart, in turn, burned like the temple at Ephesus like the
 Red Square of Moscow
When the sun is setting.
And my eyes were lighting ancient paths.
And I was already such a bad poet
That I couldn't go to the end.

<div align="right">(SW 67)</div>

It sounds at first rather like Whitman: the long free verse line which the poet intoned, so Frank Budgen recalls, "in the manner of a psalm pointed as in the Anglican liturgy," the foregrounding of the lyrical "I," the cataloging of proper names and concrete images, the paratactic structure.[28] But the voice we hear is curiously unlike Whitman's oracular, rapturous "I"; Whitman would not, for instance, have his speaker say "Because my adolescence was so intense and so insane." Cendrars's voice moves restlessly between self-assertion and self-deflation; he regards himself with the curious detachment and distrust of the other. Thus the exuberance of the poet's extravagant hyperboles—"my heart . . . burned like the temple at Ephesus or like the Red Square of Moscow"; "my eyes were lighting ancient paths"— gives way abruptly to the refrain: "And I was already such a bad poet / That I couldn't go to the end."

The journey itself is poised on the threshold between documentary realism and fantasy. Time and space are carefully specified: the poet boards the Trans-Siberian in Moscow on a Friday morning in De-

cember; he is accompanying "the jewel merchant who was going to Harbin" in the heart of Manchuria. The train itself appears to be a microcosm of the international technology of the 1910s:

> L'un emportait cent caisses de réveils et de coucous de la Forêt-Noire
> Un autre, des boîtes à chapeaux, des cylindres et un assortiment de
> tire-bouchon de Sheffield
> Un autre, des cercueils de Malmoë remplis de boîtes de conserve et
> de sardines à l'huile
>
> $\qquad\qquad\qquad\qquad\qquad\qquad\qquad$ (*OC* 1:18)
>
> One took along a hundred boxes of alarm clocks and cuckoo clocks
> from the Black Forest
> Another, hatboxes, cylinders, and an assortment of Sheffield
> corkscrews
> Still another, coffins from Malmo filled with tin cans and cans of
> sardines in oil
>
> $\qquad\qquad\qquad\qquad\qquad\qquad\qquad$ (*SW* 71)

In the course of the journey, "l'Europe tout entière [est] aperçue au coupe-vent d'un express à toute vapeur" ("the whole of Europe [is] seen through the windcutter of an Express racing ahead at full speed"). The dizzying wheels churn, the train throbs, the poet invents comically grandiose aviation stories to entertain little Jehanne:

> Si tu veux nous irons en aéroplane et nous survolerons le pays des
> mille lacs,
> Les nuits y sont démesurément longues
> L'ancêtre préhistorique aura peur de mon moteur
> J'atterrirai
> Et je construirai un hangar pour mon avion avec les os fossiles de
> mammouth
> Le feu primitif réchauffera notre pauvre amour
> Samowar
> Et nous nous aimerons bien bourgeoisement près du pôle
> Oh viens!
>
> $\qquad\qquad\qquad\qquad\qquad\qquad\qquad$ (*OC* 1:26)
>
> If you like we'll go by plane and fly over the land of the thousand
> lakes
> The nights are fantastically long
> The prehistoric ancestor will be afraid of my motor
> I'll land
> And I'll build a hangar for my airplane out of fossilized mammoth
> bones
> The ancient fire will warm our meager love
> Samovar
> And we will make love like a good bourgeois couple near the pole
> Oh come!
>
> $\qquad\qquad\qquad\qquad\qquad\qquad\qquad$ (*SW* 87)

A kind of science-fiction fairy tale that alludes to the great discoveries of the avant guerre. And the reality is almost as strange and hallucinatory as the poet's fantasy. When Jehanne finally drops off to sleep, the poet thinks:

Et de toutes les heures du monde elle n'en a pas gobé une seule
Tous les visages entrevus dans les gares
Toutes les horloges
L'heure de Paris l'heure de Berlin l'heure de Saint-Pétersbourg et
 l'heure de toutes les gares . . .
Et l'avance perpétuelle du train
Tous les matins on met les montres à l'heure
Le train avance et le soleil retarde

 (OC 1:27)

And she hasn't gobbled up a single minute of all the hours in the
 world
All the faces glimpsed in stations
All the clocks
The time in Paris the time in Berlin the time in Saint Petersburg and
 the time in all the stations . . .
And the continuous rushing of the train
Every morning all the clocks are set
The train is set forward and the sun is set back

 (SW 89)

Or, as Malevich puts it in *From Cubism and Futurism to Suprematism,* "Since we run to our goal through the speed of futurism, our thought moves more swiftly, and whoever lives in futurism is nearer to this aim and further from the past" (*RA* 125).

But "the speed of futurism" is also problematic. Violence, energy, revolution—these all too readily find an outlet in war, not the "Gigantic Wars" or purification longed for by a Malevich or a Marinetti but a devastation still quite unimaginable to the poets of 1913. The voyage of *Le Transsibérien* takes us into this realm only gradually. At the opening of the poem, the poet's violent emotions are essentially those of youth:

J'avais faim
Et tous les jours et toutes les femmes dans les cafés et tous les verres
J'aurais voulu les boire et les casser
Et toutes les vitrines et toutes les rues
Et toutes les maisons et toutes les vies
Et toutes les roues des fiacres qui tournaient en tourbillon sur les
 mauvais pavés
J'aurais voulu les plonger dans une fournaise de glaives
Et j'aurais voulu broyer tous les os

Et arracher toutes les langues
Et liquéfier tous ces grands corps étranges et nus sous les vêtements
 qui m'affolent . . .
Je pressentais la venue du grand Christ rouge de la révolution russe
Et le soleil etait une mauvais plaie
Qui s'ouvrait comme un brasier.

<div align="right">(OC 1:17)</div>

I was hungry
And all the days and all the women in the cafés and all the glasses
I should have liked to drink them and break them
And all the shopwindows and all the streets
And all the houses and all those lives
And all the wheels of cabs turning like whirlwinds over broken
 pavements
I should have liked to plunge them into a furnace of swords
And I should have liked to grind up all the bones
And tear out all the tongues
And dissolve all those tall bodies, naked and strange under garments
 that enrage me . . .
I could sense the coming of the great red Christ of the Russian
 Revolution . . .
And the sun was a fierce wound
That burned like live coals.

<div align="right">(SW 69)</div>

Here sexual energy and appetite express themselves in images of warfare: the "furnace of swords," the desire to "grind up all the bones / And tear out all the tongues," the image of the sun as "fierce wound / burn[ing] like live coals." Cendrars, who may well have witnessed the October Revolution, since he was working in Petersburg when it occurred, curiously anticipates "the great red Christ of the Russian Revolution" which was to take place four years after the publication of *La Prose du Transsibérien*. But—what is even more uncanny—the poem's veiled allusions to the Russo-Japanese War of 1904–5 anticipate the Great War that was to come and specifically the poet's own "fierce wound" that led to the amputation of his right arm.

At first the war is still far away. In Moscow it is rumored that "En Sibérie tonnait le canon, c'était la guerre / La faim le froid la peste le choléra" ("In Siberia cannon were thundering, it was war / Hunger cold plague cholera"), but the "happy carefree" adolescent who boards the Trans-Siberian entertains himself with his "nickel-plated Browning," a gift from the merchant to whom he is apprenticed, and his mind conjures up images from Jules Verne and the Arabian Nights— violent stories of Mongol hordes and the Chinese Boxers that blend

with the boy's real fears of "Les rats d'hôtel / Et les spécialistes des express internationaux" ("Hotel thieves / And crooks operating on the International Express"). As the Trans-Siberian heads eastward, the poet's exotic fantasies of violent exploits increasingly merge with reality. In answer to little Jehanne's repeated question, "Dis, Blaise, sommes-nous bien loin de Montmartre?" he replies:

> Mais oui, tu m'énerves, tu le sais bien, nous sommes bien loin
> La folie surchauffée beugle dans la locomotive
> La peste le choléra se levent comme des braises ardentes sur notre
> route
> Nous disparaissons dans la guerre en plein dans un tunnel
>
> $\qquad\qquad\qquad\qquad\qquad\qquad\qquad\qquad$ (*OC* 1:23)
>
> Of course, you're driving me crazy, can't you see we're quite far
> Madness boiling-over bellows in the engine
> Plague cholera rise around us like burning coals along the route
> We are disappearing into war drawn into a tunnel
>
> $\qquad\qquad\qquad\qquad\qquad\qquad\qquad\qquad\qquad\qquad$ (*SW* 81)

From here on, the journey cuts back and forth from fantasy to reality, but even the poet's erotic escape fantasies have an undertone of menace:

> Au Fidji règne l'éternel printemps
> La paresse
> L'amour pâme les couples dans l'herbe haute et la chaude syphilis
> rôde sous les bananiers
>
> $\qquad\qquad\qquad\qquad\qquad\qquad\qquad\qquad$ (*OC* 1:25)
>
> On Fiji it's always spring
> Drowsiness
> Love makes the lovers swoon in the tall grass and syphilis in heat
> prowls under the banana trees
>
> $\qquad\qquad\qquad\qquad\qquad\qquad\qquad\qquad\qquad\qquad$ (*SW* 85)

Beyond Irkutsk, the train slows down, and the poet's self-deprecating lampoonery ("Je n'ai pas pris de notes en voyage"; "I didn't take any notes on my trip") gives way to sober reportage. The Rimbaldian echoes ("J'aurais voulu," "J'ai vu") now receive a strange twist:

> J'ai vu
> J'ai vu les trains silencieux les trains noirs qui revenaient de
> l'Extrême-Orient et qui passaient en fantômes
> Et mon oeil, comme le fanal d'arrière, court encore derrière ces
> trains
> A Talga 100,000 blessés agonisaient faute de soins
> J'ai visité les hôpitaux de Krasnoïarsk

Et à Khilok nous avons croisé un long convoi de soldats fous
J'ai vu dans les lazarets des plaies béantes des blessures qui
 saignaient à pleines orgues
Et les membres amputés dansaient autour ou s'envolaient dans l'air
 rauque
L'incendie était sur toutes les faces dans tous les coeurs
Des doigts idiots tambourinaient sur toutes les vitres
Et sous la pression de la peur les regards crevaient comme des abcès
Dans toutes les gares on brûlait tous les wagons
Et j'ai vu
J'ai vu des trains de 60 locomotives qui s'enfuyaient a toute vapeur
 pourchassées par les horizons en rut et des bandes de corbeaux
 qui s'envolaient désespérément après
Disparaître
Dans la direction de Port-Arthur.

<div align="right">(OC 1:29–30)</div>

I saw
I saw the silent trains the black trains returning from the Far East
 and passing like phantoms
And my eye, like a rear signal light, is still running along behind
 those trains
At Talga 100,000 wounded were dying for lack of care
I visited the hospitals at Krasnoyarsk
And at Khilok we encountered a long convoy of soldiers who had lost
 their minds
In the pesthouses I saw gaping wounds bleeding full blast
And amputated limbs danced about or took flight into the raucous air
Fire was on all the faces in all the hearts
Idiot fingers rapped on all the windowpanes
And in the press of fear glances burst open like abcesses
In all the stations where all the cars were burning
And I saw
I saw trains with 60 engines fleeing at top speed pursued by flaming
 horizons and by flocks of crows flying desperately after them
Disappearing
In the direction of Port Arthur.

<div align="right">(SW 93–95)</div>

This lyric sequence oddly blends the documentary (for example, the reference to Port Arthur, where the decisive battle of the Russo-Japanese War was fought in April 1905) with the visionary, the dream-like, the hallucinatory—unidentified fingers that rap on window panes, glances that burst open like abcesses. Prophetically, the image of the amputated limbs dancing about in the raucous air prefigures the poet's exclamation in *Au Coeur du monde* (1917), written not long after he had lost his arm, "Ma main coupée brille au ciel dans la con-

stellation d'Orion" ("My cut off hand shines in the sky in the constellation of Orion"; *OC* 1:241).

Ominous as these images are, *La Prose du Transsibérien* is by no means a pacifist poem. Violence, energy, the thrust into the future—these are essential to living. As the poet of *Au Coeur du monde* puts it, "Je suis l'homme qui n'a plus de passé" ("I am the man who no longer has a past"). And so, by the time the train stops at Chita for "quelques jours de répit" ("a few days' rest"), everything seems to have changed. For one thing, the poet's little traveling companion Jehanne has, without the slightest explanation, vanished. A new girl, the daughter of a Monsieur Iankelevitch, briefly takes her place, but soon we are on the train again, and now the poet, no longer under the spell of the magical journey, begins to see things as they really are. He has a bad toothache, he gets drunk "durant plus de 500 kilomètres," he longs for sleep. At Harbin, he abruptly decides that he will go no further, that this is "the last station," and he descends from the train just as the offices of the Red Cross are set on fire.

There is no transition between this scene set in the heart of Manchuria and the unanticipated and unexplained "O Paris" that introduces what we may call the poem's coda. As in film montage, the two shots are simply juxtaposed, the return to the left margin and the setting-off of the words "O Paris" in a separate line in heavy red type (in the standard printed version there is a break between the two paragraphs) providing the only signal. Indeed, by the time the poet announces his intention to go to the Lapin Agile and drink to the memory of little Jehanne, we realize that the Trans-Siberian voyage, geographically accurate as its depiction seems, cannot finally be charted; it might, for that matter, never have occurred.

Narrative, in other words, does not and cannot recount "what happened," for the past, as the Futurists repeatedly insist, does not exist. "The only freedom we demand," declares Velimir Khlebnikov in 1914, "is freedom from the dead, i.e., from all these gentlemen who have lived before us."[29] And in his 1916 memoir of Henri Gaudier-Brzeska, killed in the war at the age of twenty-three, Ezra Pound approvingly cites Apollinaire's aphorism, "On ne peut pas transporter partout avec soi le cadavre de son père."[30]

For Cendrars, whose own petit-bourgeois past was rejected along with the name Frédéric Sauser, narrative becomes a way of avoiding confrontation with the hidden self—hence the repeated use of hyperbole, the poet's longing for more than the "one thousand and three bell towers" of Moscow, his desire to drink "all the days and all the women in all the cafés and all the glasses," his need to make all the trains run

behind him, and so on. To be alive is to be part of this whirlpool, to nourish oneself with flames, to take flight with the pigeons in Red Square or over the Land of the Thousand Lakes. So *La Prose du Transsibérien* is presented as an elaborate montage of sensations, images, and narrative fragments by means of which the poet tries to keep his ego intact. He must, in the later words of Charles Olson, "Keep it moving!" Hence the immediacy that makes Cendrars's poem seem so "modern," the instant rapport with the reader established by the opening line, "En ce temps-là, j'étais en mon adolescence"; hence too the quick change of tenses (from past to present to future perfect to perfect) and of pronouns designating Jehanne, as if to say that, although the story cannot be told in a coherent manner, all of it is happening *now*, in an ongoing, continuous present. The constant use of proper names reenforces this sense of presence:

> Tchéliabinsk Kainsk Obi Taïchet Verkné Oudinsk Kourgane
> Samare Pensa-Toulouse

The exotic names roll off the speaker's tongue as if to say that if one can only name what one sees, the "words-in-freedom," as Marinetti was to call such catalogs of nouns, become one's own.

In such a context, what the poet most fears is arrest, the stopping of the train that will be final, the end of the journey. Again in Olson's words, "ONE PERCEPTION MUST IMMEDIATELY AND DIRECTLY LEAD TO A FURTHER PERCEPTION . . . get on with it, keep moving, keep in speed."[31] Accordingly, the free-verse line cannot exhibit metric recurrence or consistent rhyme, for that would stop us in our tracks, however temporarily. Again, when images of the past impinge upon the consciousness, as they inevitably do even as the Futurist poet tries to negate them, they become part of the seamless web of the present:

> Et voici mon berceau
> Mon berceau
> Il était toujours près du piano quand ma mère comme Madame
> Bovary jouait les sonates de Beethoven
> J'ai passé mon enfance dans les jardins suspendus de Babylone
> Et l'école buissonière, dans les gares devant les trains en partance
> (*OC* 1:21)
> And now here's my cradle
> My cradle
> It was always near the piano when my mother, like Madame Bovary,
> was playing Beethoven sonatas
> I spent my childhood in the hanging gardens of Babylon
> Playing hooky in stations before departing trains
> (*SW* 77–79)

Such privileged moments thicken the plot: the cradle has now become a railway compartment, the watcher of trains now rides in them, the Bovarisme of his piano-playing mother becomes his own: "Maintenant c'était moi qui avais pris place au piano" ("Now it was I who was at the piano"). But there is no consistent development from past to present, no explanation of the narrator's feelings toward his mother, only a voice persistently speaking, shifting from the jaunty optimism of "J'étais très heureux insouciant" ("I was very happy carefree") to the anxiety of "je ne sais pas aller jusqu'au bout / Et j'ai peur" ("I'm not capable of going to the end / And I'm afraid").

The poem thus becomes an arena for action, an elaborate performance work, a score for "les musiciens." What holds it all together is not only, as is often claimed, the rhythm of the train's violent and fitful motion, but a more subtle structural principle that we may call negation or inversion. *La Prose du Transsibérien* begins by making a series of assertions, assertions that are repeatedly called into question so that the experience of the "I" is fragmented and viewed from different perspectives, as in the Cubo-Futurist paintings of the period, especially those by Cendrars's friend Léger.[32]

"En ce temps-là," the poem begins, but of course the narrative soon breaks out of this particular time frame. "Je n'avais pas assez des sept gares et des milles et trois tours"—the adolescent poet wants even more than this, more than the seven stations and one thousand and one bell towers of Moscow. But more may also be less: Paris, which Cendrars addresses as "Grand foyer chaleureux avec les tisons entrecroisés de tes rues" ("Great smoldering hearth with the intersecting embers of your streets"), Paris, with its brightly colored posters and its speeding buses, whose engines "beuglent comme les taureaux d'or" ("bellow like golden bulls"), its hardware and paint stores, and its "Compagnie Internationale des Wagons-Lits et des Grands Express Européens," which Cendrars, true to the spirit of 1913, calls "la plus belle église du monde" ("the most beautiful church in the world"), Paris, the "Gare centrale" which is the center of the universe, the "débarcadère des volontés" ("last stop of desire") but also the "carrefour des inquiétudes" ("crossroads of unrest"), boasts not a thousand and three towers, but the one "tour unique"—the Eiffel Tower. Still, Cendrars's final apostrophe to Paris is equivocal:

> Ville de la Tour unique du grand Gibet et de la Roue

> City of the incomparable Tower of the Rack and the Wheel

The Wheel is literally the great ferris wheel erected next to the Eiffel Tower for the Paris Exposition of 1900: it appears with the Tower in a

Fig. 1.4. Robert Delaunay, *The Tower and the Wheel*, c. 1912–13. Ink on paper, 25½" × 19½". Collection, Museum of Modern Art, New York, Abby Aldrich Rockefeller Fund, 1935.

number of paintings by Robert Delaunay (fig. 1.4). But in the context of the "grand Gibet" or guillotine, the wheel is also the wheel of life. And that wheel turns, so to speak, between the two, between the brilliant promise of the new technology and the cutting edge of its instruments of power.

In one sense, *La Prose du Transsibérien* thus carries on the theme of Baudelaire's "Le Voyage": "Ah! que le monde est grand à la clarté des lampes! Aux yeux de souvenir que le monde est petit!"[33] But Baudelaire's elegant chiasmus gives way in Cendrars to a series of fragments, even as his distinction between past and present is replaced by a collage structure whose abrupt juxtapositions and dissolves challenge the reader to participate in the voyage. As Cendrars says toward the end of the poem:

> J'ai déchiffré tous les textes confus des roues et j'ai rassemblé les
> éléments épars d'une violente beauté
> Que je possède
> Et qui me force.
>
> (*OC* 1:31)

> I have deciphered all the confused texts of the wheels and I have
> assembled the scattered elements of a most violent beauty
> That I control
> And which compels me.
>
> (*SW* 97)

III

The "assembl[ing] of the scattered elements" of which Cendrars speaks involves, of course, the original typography and layout of the text as well as Sonia Delaunay's painted *pochoir* accompaniment. In recalling the train's approach to Mongolia, Cendrars declares:

> Si j'étais peintre je déverserais beaucoup de rouge, beaucoup de
> jaune sur la fin de ce voyage
> Car je crois bien que nous étions tous un peu fous
> Et qu'un délire immense ensanglantait les faces énervées de mes
> compagnons de voyage.
>
> (*OC* 1:29)

> If I were a painter I would spill great splashes of yellow and red over
> the end of this trip
> Because I am quite sure we were all a little mad
> And that a raging delirium was bloodying the lifeless faces of my
> travelling companions.
>
> (*SW* 93)

"Great splashes of yellow and red" do turn up in Delaunay's "illustration" for the poem, but her interpretation of the journey emphasizes its life, movement, energy, and color rather than its darker undertones: if Cendrars's sun is "a fierce wound," Delaunay's is a gorgeous golden ball. But even this contrast is not quite accurate for Delaunay's painting is, of course, essentially nonrepresentational; she and her

husband were among the first abstract artists of Europe. Her *Trans-sibérien* is a complex arrangement of concentric circles, ovals, triangles, and rectangles, whose brilliant opposition of colors is in itself the "subject" of the painting. A distinction Cendrars made in a 1914 article on Robert Delaunay applies equally well to Sonia:

> Our eyes reach up to the sun.
> A color is not a color in itself. It is a color only in contrast to another or to several other colors. A blue is only blue in contrast to a red, a green, an orange, a gray and all the other colors.
> Contrast is not a matter of black and white, an opposition, a nonresemblance. Contrast is a resemblance. One travels in order to know, to recognize men, things, animals. To live with. One faces things, one does not withdraw. It is what men have most in common that distinguishes them the most. The two sexes are in contrast. Contrast is love. (*OC* 6:48)

It is this system of differences that characterizes Delaunay's color field. But her painting is not wholly nonrepresentational either. Without illustrating Cendrars's narrative, it nevertheless compliments it. Thus we begin at the top with large blue and violet discs and a vertical white tower shape—a kind of abstract Moscow, the city of the one thousand and three bell towers and the "great almonds of the cathedrals all in white." Patches of red and yellow in the top quadrant suggest Red Square and the golden sun, or again the Kremlin "like an immense Tartar cake / Frosted in gold" and the "honeyed gold of the bells."

As the eye moves downward, it travels over a rainbow-colored world of whirling suns, clouds, and wheels—a vision, perhaps, of the Trans-Siberian journey as seen not from a moving train but from an airplane, a kind of unfolding aerial map. Paradoxically, as Pierre Caizergues remarks, the vertical axis is the privileged one, even though everything in the poem celebrates horizontality, the spatialization of time.[34] Indeed, the vertical-horizontal opposition is an example of what Cendrars calls simultaneous contrast. Delaunay's emphasis is on motion, circular form, color; her long sinuous ovals recall both machine parts and phalluses. These whirling forms descend, finally, on a little red toy version of the Eiffel Tower penetrating an equally childlike rendition of the Great Wheel.

At one point in the poem, Cendrars compares the rhythm of the speeding train to "Le ferlin d'or de mon avenir" ("The golden thread of my future"). This "golden thread" can be seen running from top to bottom of Delaunay's painting, curving in and out and finally materializing as the three-quarter halo that acts as the rim of the abstracted

wheel. Again, golden threads and red ones, as well as large planes of pastel colors—rose, light blue, light yellow, violet, pale green—are inserted between the verse paragraphs and lines of the poem so as to destroy the continuity of the whole as uniform text. The resultant blocks of print, surrounded by color forms, display their own internal contrasts: the lettering shifts from roman to italic, uppercase to lowercase, black to red, light to dark, and so on. (See the sample page from the first edition, fig. 1.5.)

There is not, of course, a one-to-one correspondence between typeface and a particular emotion or theme. But notice that what is prob-

Fig. 1.5. Blaise Cendrars, *Le Transsibérien*, p. 27. Editions Pierre Seghers, Paris, 1913 (1957). Editions Denoël SA, Paris.

ably the key turn in the poem—the abandonment of the journey and sudden "cut" to Paris—is printed in large black block letters and that the apostrophe to Paris that follows has a justified right rather than a justified left margin, heavy typeface being reserved for the references to color: "du rouge du vert," "du jaune," "Jaune." The second "O Paris" passage is juxtaposed to the first by the shift from a justified right to a justified left margin, the page thus opposing two rectangular forms that almost meet at midpoint, surrounded by equal amounts of white space.[35]

What is the effect of this visualisation of the page? It implies, I think, a *mise en question* of the text's lyric frame, its generic identity as lyric poem as well as its semantic coherence. For Delaunay's painting, far from matching the verbal text to be illustrated, undermines its meanings: her version is everywhere brighter, sunnier, more positive, more optimistic than is Cendrars's voyage into the world of war. Indeed, in Delaunay's painting, the war remains an absence; the technological world, the world of propellers and air balloons, of engines and steel towers, is bright and beautiful even as we will see that machine world represented by the early Léger or Tatlin. Delaunay's version of *La Prose* draws out, so to speak, the international side of Futurism, the productive energy and vitality that the verbal text, with its precise delineation of place, has already questioned. To put it another way: Paris, the brilliant and vibrant international center of the *avant guerre*, is juxtaposed to the Trans-Siberian journey that will finally destroy it.

IV

La Prose du Transsibérien et de la petite Jehanne de France is thus, as various critics have remarked, a poem of threshold, of passage from one world to another—from adolescence, if we will, to maturity, or from the promise of 1913 to the future of 1914 with its "fierce wounds" and "amputated limbs [that take] flight into the raucous air." Unlike the Dada texts that were soon to follow, Cendrars's poem remains committed to the possibility of articulating meanings; again, unlike, say, the poems of Tristan Tzara or Hugo Ball, *La Prose du Transsibérien* remains, at least overtly, committed to the value of technology, of machinery, of urbanization—indeed, of war itself.

From the perspective of the later twentieth century, such a problematic commitment is often dismissed as proto-Fascist or at best as a deviation from the true "progressive" path a socialist art might have taken. Thus, at the end of his classic essay "The Work of Art in an Age of Mechanical Reproduction" (1936), Walter Benjamin writes:

The growing proletarianization of modern man and the increasing formation of masses are two aspects of the same process. Fascism attempts to organize the newly created proletarian masses without affecting the property structure which the masses strive to eliminate. Fascism sees its salvation in giving these masses not their right, but instead a chance to express themselves. . . . The logical result of Fascism is the introduction of aesthetics into political life. . . . All efforts to render politics aesthetic culminate in one thing: war. War and war only can set a goal for mass movements on the largest scale while respecting the traditional property system.[36]

And Benjamin cites Marinetti's dictum that "War is beautiful because it initiates the dreamt-of metalization of the human body. War is beautiful because it enriches a flowering meadow with the fiery orchids of machine guns. . . . War is beautiful because it creates new architecture, like that of the big tanks, the geometrical formation flights, the smoke spirals from burning villages." Commenting on these egregious examples of Futurist phrasemaking (and we might compare Cendrars's 1916 "Souvenirs d'un amputé" with its references to "la nostalgie du feu" and to battle as "le grand bal aux orchestres bruyants"; *IS* 400), Benjamin writes: "The horrible features of imperialistic warfare are attributable to the discrepancy between the tremendous means of production and their inadequate utilization in the process of production." He concludes in a now famous passage:

"*Fiat ars—pereat mundus*," says Fascism, and as Marinetti admits, expects war to supply the artistic gratification of a sense perception that has been changed by technology. This is evidently the consummation of "*l'art pour l'art*." Mankind, which in Homer's time was an object of contemplation for the Olympian gods, now is one for itself. Its self-alienation has reached such a degree that it can experience its own destruction as an aesthetic pleasure of the first order. This is the situation of politics which Fascism is rendering aesthetic. Communism responds by politicizing art.[37]

Authoritative as this frequently cited distinction between fascism and communism appears to be, it also challenges us to ask certain questions. For while it is a truism that the Marinetti of the twenties and thirties had become a confirmed if unorthodox fascist, the Futurism of the *avant guerre* did not, as is often assumed, inevitably point in this direction. Here the example of Russian Futurism is especially instructive.

Like Marinetti and Cendrars, like the Apollinaire of "La Petite Auto" (August 1914), who declared, on his way to the front:

Je sentais en moi des êtres neufs pleins de dexterité
Batir et aussi agençer un univers nouveau.

I felt within me skillful new beings
Build and even arrange a new universe.[38]

the Russian poets and artists of the prewar years expressed a faith in war as the revolution that would bring about a Brave New World, as the necessary first step in bringing down the institutions of church, monarchy, and the class system.

Vladimir Mayakovsky, who joined the Bolshevik wing of the Russian Social Democratic Party as early as 1908 when he was fourteen and was soon arrested and jailed for printing and distributing illegal literature, recalls in his autobiography that he greeted the war in 1914 with great excitement. As his American biographer Edward J. Brown tells us:

> [Mayakovsky] was caught up in the mighty wave of patriotic and anti-German fever that infected all levels of Russian society in that year. . . . Patriotic jingles to accompany propaganda posters occupied the poet from August to October 1914, and he even produced a number of drawings, an enterprise in which he was joined by many artists of the Russian avant-garde: Malevich, Lentulov, Larionov, Burliuk. . . . The posters, called *lubki*, were primitive in content, and aimed at a wide and tasteless audience. The verses were on the same level: Austrians and Germans figure as repellent cartoon characters impaled on the bayonets or pitchforks of brave Russian soldiers, defending the Slavic lands.[39]

Again, in "Civilian Shrapnel," a series of articles for the liberal magazine *Virgin Soil*, Mayakovsky declares that war is "magnificent" because it threatens to dislodge the philistines who have dominated poetry and replace them with a poetic muse who "wants to ride the gun-carriage wearing a hat of fiery orange feathers" (Brown, *Mayakovsky*, p. 111). Yet, just as *La Prose du Transsibérien* conveys Cendrars's recoil from the horrors of war, so Mayakovsky's long poem of 1914, "War and the Universe," contains frightening glimpses of "Europe burning like a chandelier," of guns that "pounce on the cadaverous cities and villages," of waterpipes from which "the same red slime oozed out."[40] In Mayakovsky's later work, this ambivalence toward violence will be directed at the Revolution itself.

Again and again, in the Russian manifestos of the *avant guerre*, we come across the imagery of battle, destruction, annihilation. "We want," insists Khlebnikov in "Inventors and Acquisitors" (1913), "the

sword of pure iron of the young."[41] In *Why We Paint Ourselves: A Futurist Manifesto* (1913), Ilya Zdanevich and Mikhail Larionov declare:

> To the frenzied city of arc lamps, to the streets bespattered with bodies, to the houses huddled together, we have brought our painted faces. . . . The dawn's hymn to man, like a bugler before the battle, calls to victories over the earth, hiding itself beneath the wheels until the hour of vengeance; the slumbering weapons have awoken and spit on the enemy. (*RA* 80–81)

Or, as Larionov and Goncharova put it in *Rayonists and Futurists* (1913), "We leave the old art to die and leave the 'new' art to do battle with it; and incidentally, apart from a battle and a very easy one, the 'new' art cannot advance anything of its own" (*RA* 87).

"Apart from a battle and a very easy one"—here is the utopian innocence of 1913, the faith in an impending revolution that would fuse art, politics, and technology: "We exclaim: the whole brilliant style of modern times—our trousers, jackets, shoes, trolleys, cars, airplanes, railways, grandiose steamships—is fascinating, is a great epoch, one that has known no equal in the entire history of the world." On the other hand, the urge toward revolution took a darker turn when it was coupled with nationalism: "Long live nationality! . . . We are against the West, which is vulgarizing our forms and Eastern forms, and which is bringing down the level of everything" (*RA* 89–90).

In this arena of agitation, the October Revolution was greeted as the longed-for fulfillment of the Futurist dream. "The events of 1917 in the social field," wrote Tatlin, "were already brought about in our art in 1914 when 'material, volume and construction' were laid out as its 'basis.'"[42] And in 1919, Malevich declared: "Cubism and Futurism were revolutionary movements in art, anticipating the revolution in economic and political life of 1917."[43] Here, one might think, was fertile ground for what Benjamin calls "the politicizing of the aesthetic."

But of course it did not work out that way. Although the Russian Futurists identified from the start with the Revolution, they confused, so Marxist theorists from Leon Trotsky to the *Tel quel* critics have argued, the specifically political and the ideological level. They assumed, that is to say, that being avant-garde was preparation enough for the construction of the new proletarian state.[44] The classic analysis here is Trotsky's in *Literature and Revolution* (1922):

> Futurism carried the features of its social origin, bourgeois Bohemia, into the new stage of its development. In the advance guard of litera-

ture, Futurism is no less a product of the poetic past than any other literary school of the present day. To say that Futurism has freed art of its thousand-year-old bonds of bourgeoisdom is to estimate thousands of years very cheaply. The call of the Futurists to break with the past, to do away with Pushkin, to liquidate tradition, etc., has a meaning insofar as it is addressed to the old literary caste, to the closed-in circle of the literary caste, to the closed-in circle of the Intelligentsia. In other words, it has meaning only insofar as the Futurists are busy cutting the cord which binds them to the priests of bourgeois literary tradition. But the meaninglessness of this call becomes evident as soon as it is addressed to the proletariat. The working class does not have to, and cannot know the old literature, it still has to commune with it, it still has to master Pushkin, to absorb him, and so overcome him.[45]

Here Trotsky draws out the implications of a remark Lenin made as early as 1919, when he expressed contempt for the Futurists as no more than a "plethora of bourgeois intellectuals, who very often regarded the new type of workers' and peasants' educational institution as the most convenient field for testing their individual theories in philosophy and culture."[46]

In a recent reassessment of the critical reception of the avant-garde, Charles Russell essentially restates this doctrine, as filtered through a line of Marxist critics from Trotsky and György Lukács to the present.[47] The avant-garde, so the argument goes, naïvely thought that in reinventing the language (*zaum*) or in replacing stone sculpture with wall reliefs made from sheet iron, wood, and rope (Tatlin), it was bringing about social change. But in conferring primacy on the language and ignoring the new need for simultaneous collective reception, Futurist poets and painters, whether Russian or Italian, merely perpetuated the split between ideas and praxis and hence deprived the proletariat of an instrument for real revolution. As such, the Futurist ethos was no more than a poignant expression of the alienation of the modern artist from bourgeois society.

Even if this argument is correct (and this is not the place to take up its complexities and variants),[48] we must be careful not to misconstrue Walter Benjamin's opposition between a fascism that is the inevitable fruit of Futurism (aestheticizing the political) and a communism that would purportedly respond by politicizing the aesthetic. What Benjamin himself had in mind was, of course, the "communism" of a writer like Bertolt Brecht, but in practice, the politicization of art in the first communist country, the Soviet Union, led, as early as 1920, to such proclamations as the "Theses of the Art Section of Narkompros [The People's Commissariat for Enlightenment] and of the

Union of Art Workers." The former states: "We acknowledge the pro-
letariat's absolute right to make a careful reexamination of all those
elements of world art that it has inherited and to affirm the truism that
the new proletarian and socialist art can be built only on the founda-
tion of all our acquisitions from the past" (*RA* 184).

If at first the "proletariat's right" was judged to be no more than to
insist on the need for art to be productive, utilitarian, and based on
scientific laws—the foundation of the Constructivism of the twenties—
the stage was also set for the AKhR (Association of Artists of Revolu-
tionary Russia) Declaration of 1924 that "As artists of the Proletarian
Revolution, we have the duty of transforming the authentic revolu-
tionary reality into realistic forms comprehensible to the broad masses
of the workers and of participating actively in Socialist construction
by our socioartistic work" (*RA* 271). A few years before Benjamin
wrote "The Work of Art in an Age of Mechanical Reproduction," So-
cialist Realism was decreed law by the Stalin regime even as Nazi
Germany was preparing to outlaw Expressionist painting and to ex-
hibit it at the Degenerate Art Exhibition of 1937. The artistic parallel
between fascism and Russian communism was legitimized two years
later by the signing of the Hitler-Stalin nonaggression pact.

It will be countered that Stalinism, which a Marxist like Benjamin
actively decried, was a terrible deflection from the true communist
path and hence irrelevant to Benjamin's argument. But it is a nice
question whether the aestheticizing of politics which Benjamin rejects
as the "consummation of *l'art pour l'art*" is not itself endemic to a
utopian system like communism. As Robert Tucker puts it:

> Human self-realization means much more to Marx than the return of
> man to himself out of his alienated labor. . . . The ending of economic
> alienation will mean the end of the state, the family, law, morality, etc.,
> as subordinate spheres of alienation. . . . What will remain is the life
> of art and science in a special and vastly enlarged sense of these two
> terms. Marx's conception of ultimate communism is fundamentally
> aesthetic in character. . . . The alienated world will give way to the
> aesthetic world.[49]

Or, as Matei Calinescu argues: "In announcing the death of God and
in rejecting any transcendent justification of human suffering, the uto-
pian thinker postulates the possibility of 'paradise' here on earth and
in a not-too-distant future, and this paradise . . . can only be con-
ceived along aesthetic lines, as a final transformation of economics
and politics into aesthetics."[50]

Indeed, "aestheticizing the political" and "politicizing the aes-

thetic" may turn out to be two sides of the same coin. Perhaps the difficulty with all such definitive assessments of terms like Modernism or Avant-Garde or Futurism is that the actual historical realities continue to elude their totalizing power. Certainly, to trace the course of the so-called avant-garde movements of the first three decades of the century is to become increasingly aware of profound differences, not the least of which is the difference between the ethos of the *avant guerre* and the postwar period.

The evolution of Gramsci's response to the Futurists provides an interesting barometer to this change. In a youthful article for the *Corriere Universitario* (1913), Gramsci expresses his delight in the violence of the Futurist attack on the smug bourgeoisie and especially on the callow establishment press. Marinetti's *parole in libertà*, specifically the *Bombardment of Adrianopolis*, later performed in both London and Moscow, are compared to the paintings of Picasso. In both cases, writes Gramsci, one witnesses the decomposition of the image that is essential to the "new art."[51]

In subsequent articles Gramsci was to become highly critical of the Futurists' reactionary commitment to private property, but even after the war he spoke admiringly of their revolutionary role in the cultural sphere (see the epigraph at the beginning of this chapter), and, as he explained in an important letter to Trotsky of September 1922, the war was the watershed by which the Futurist movement "entirely lost its character and split up into different trends" (*SCW* 54). Boccioni, probably the greatest painter of the group, had been killed on the front in 1916. Gino Severini, living in Paris, broke with the movement after the war. Apollinaire, the group's "French" contact, was dead by 1918. By 1919 Blaise Cendrars was doing film work in London and Rome, and in 1924 he took up residence in Brazil.

What, then, of the world of the Trans-Siberian passage? Like such analogous texts as Kruchenykh's "Journey across the Whole World" or Apollinaire's "Zone," Cendrars's is a voyage poem in which time is spatialized, in which history gives way to geography. Yet paradoxically the sense of One World made possible by the new technology quickly gives way to a more elemental and fiercely competitive nationalism and to the insistence on *difference*. Thus Harold Monro, the editor of the avant-garde London periodical *Poetry and Drama*, which began publication in June 1913 and suspended it in December 1914 because of the war, writes approvingly of Italian Futurism:

> Now this is precisely the spirit which actuated men in the early days of the French Revolution between which and the Futurist revolt we do not hesitate to draw a fairly close analogy. Both represent the reaction of a

suppressed vitality against a tyrannous and antiquated power. . . .
The situation of England to the revolutionaries of 1789 is fairly paral-
leled by ours to those of today.

But then, fearing he has gone too far, Monro adds the disclaimer:
"The Latin temperament is not ours, and its present violent materi-
alism will fail to find permanent footing here." These comments ap-
pear in the December 1913 issue. By December 1914, in his regular
"Italian Chronicle," Arundel del Re writes, "We now have an oppor-
tunity of testing the Futurist dictum—'la guerre est la seule hygiène
du monde et la seule morale éducatrice.' It is not convincing. . . .
Marinetti, forgetting the real nature of war, has raised it to a romantic
ideal" (*Poetry and Drama* 2:403).

Monro's parallel between the early days of the French Revolu-
tion and the "Futurist revolt"—a parallel repeated, if negatively, in
Arundel del Re's reference to Marinetti's "romantic ideal"—is not, I
think, inaccurate. The "Futurist moment" was the brief utopian phase
of early Modernism when artists felt themselves to be on the verge of a
new age that would be more exciting, more promising, more inspiring
than any preceding one. Both the Italian and the Russian versions of
Futurism found their roots in economically backward countries that
were experiencing rapid industrialization—the faith in dynamism and
national expansion associated with capitalism in its early phase. In
the prewar years, political and aesthetic decisions seemed, for how-
ever brief a time, to be, so to speak, in synch—hence, no doubt, the
extraordinarily rich artistic production.

The equation of Italian Futurism and its cognates with a later fas-
cism is thus a simplification. Giovanni Lista and others have recently
traced the left-wing, anarcho-syndicalist origins of the Italian move-
ment, its anticlericalism, antimonarchism, its opposition to the lib-
eral bourgeoisie.[52] It is not coincidental that Marinetti's 1909 mani-
festo was first published in Italy in Ottavio Dinale's left-wing review
La Demolizione. Again, it is worth remarking that the young Boccioni,
whose career was aborted by the war, was a convinced Marxist; that
the artists Carla Carrà and Luigi Russolo were anarchists and Balla a
humanitarian socialist. In a series of political manifestos published
in *Lacerba*, whose readership was approximately four-fifths working
class, the Italian Futurists spelled out their anarchic, socialist, and
utopian demands: abolition of the monarchy, expulsion of the Papacy,
socialization of the land, of property, and of the church, of mineral
resources and water; heavy taxation of inherited wealth, an eight-hour
working day, equal pay for women, a free press and free legal aid,

protection of the consumer, easy divorce, and the progressive aboli-
tion of the state army.[53]

In a recent essay called "Futurism as Mass Avant-Garde," Germano
Celant sums it up this way:

> In the excitement over new possibilities for work and a better life,
> the doctrines of socialism spread in the city and countryside. Between
> 1904 and 1906, from one general strike to the next, a climate of great
> optimism was ushered in, since financial assets and social values
> seemed destined to reach new heights, creating a true faith in the
> "Future."
>
> On this extraordinary and feverish wave, which within the span of
> the next two years was to demonstrate its inconstancy and fragility, ex-
> posing the deficiencies of a crumbling bourgeoisie and an unprepared
> working class, Futurism made its appearance. . . . It was the first ar-
> tistic movement of a mass society . . . proposing an aesthetic connec-
> tion with the cabaret, politics, lust, architecture, cooking and dress.
> The structure of Futurism, despite its defects, was always "total." . . .
> the protagonist of culture could not be the abstract category of art or
> music, theater or film, but the concrete reality of the crowd, which, by
> its impromptu participation, its exchange of remarks and disputes, and
> its dominance over the actors, became the experimentation "uncon-
> trolled" by the tradition of the avant-garde.[54]

Blaise Cendrars, not himself a Futurist, his assumed French iden-
tity coupled with a fierce internationalism precluding rapprochement
with any national movement, was, paradoxically, the prototype of the
new "total" Futurist artist, as Germano Celant describes him. We
recall his insistence that "The role of the new poetry is to throw its
treasures out of the window, among the people, into the crowd, into
life," his remark that "As for the word Prose [in *La Prose du Trans-
sibérien*] . . . Poem seemed to me too pretentious, too closed. Prose is
more open, more popular" (*IS* 371). Or again, the plea in the *Sturm*
essay of 1913 that "Literature is part of life. It is not something
'special.'"

The equation of art and life, so ubiquitous in Futurist poetic, must,
of course, be understood as primarily an attack on the aestheticism of
the previous generation: "On ne peut pas transporter partout avec soi
le cadavre de son père." Cendrars, as we have seen in the case of *Le
Transsibérien*, knew very well that his own chaotic life was not to be
confused with "le premier livre simultané" or, for that matter, with
any of his other works. What the battle cry "Literature is a part of
life!" meant in practice was that (1) form should not call attention to

itself; (2) the "high" artwork should incorporate and come to terms with elements from "low" culture—the newspaper headline, the popular song, the advertising poster; and (3) the making of art could become a collective enterprise, designed for what was perceived to be a newly collective audience.

It is this straining of the artwork to assimilate and respond to that which is not art that characterizes the Futurist moment. It represents the brief phase when the avant-garde defined itself by its relation to the mass audience. As such, its extraordinary interest for us is as the climactic moment of rupture, the moment when the integrity of the medium, of genre, of categories such as "prose" and "verse," and, most important, of "art" and "life" were questioned. It is the moment when collage, the *mise en question* of painting as a representation of "reality," first makes its appearance, when the political manifesto is perceived aesthetically even as the aesthetic object—painting, poem, drama—is politicized. The media—verbal, visual, musical—are increasingly used in conjunction: Futurism is the time of performance art, of so-called sound poetry and of the artist's book. But behind this drive toward decomposition, toward a breaking of the vessels that will make it new, there is an extraordinary fragility and inconstancy. The specter of the future hovers over the Transsiberian journey, a future wholly unanticipated by the very artists who called themselves Futurists and who, in Gramsci's words, "destroyed, destroyed, destroyed, without worrying if the new creations produced were on the whole superior to those destroyed" (*SCW* 51).

Near the end of *La Prose du Transsibérien*, the poet makes this disclaimer:

> J'ai peur
> Je ne sais pas aller jusqu'au bout
> Comme mon ami Chagall je pourrais faire une série de tableaux
> déments
> Mais je n'ai pas pris de notes en voyage
> "Pardonnez-moi mon ignorance
> "Pardonnez-moi de ne plus connaître l'ancien jeu des vers"
> Comme dit Guillaume Apollinaire
> Tout ce qui concerne la guerre on peut le lire dans les "Mémoires"
> de Kouropatkine
> Ou dans les journaux japonais qui sont aussi cruellement illustrés
> A quoi bon me documenter.
>
> (*OC* 1:28–29)
>
> I'm afraid
> I'm not capable of going to the end

I could make a series of hallucinatory paintings like my friend
 Chagall
But I didn't take any notes on my trip
"Forgive me my ignorance
Forgive me for no longer knowing the old game of writing poetry"
As Guillaume Apollinaire says
Everything about war can be found in the *Memoirs* of Kropotkin
Or in the Japanese newspapers which are also cruelly illustrated
What's the use of documenting myself.

 (*SW* 91–93)

And then Cendrars turns around and documents precisely the realities
of modern warfare that he claims not to understand, realities that for
the generation of 1913 tended to be so much "literature"—some in-
teresting tales to be read in the *Memoirs* of a Kropotkin.

Of course it was all to change. By July 1916, a few days before
he was killed during a cavalry drill, Boccioni, who, less than a year
earlier, had written to his mistress that "War is a beautiful, mar-
velous, and terrible thing! In the mountains, it even seems like a
battle with the infinite. Grandiosity, immensity, life and death! I am
happy!" told his friend Vico Baer, "You cannot imagine what it means
to *play* the soldier at the age of 34 and in my circumstances and walk
of life. One needs courage but it is terrible. At moments I feel as if I
shall suffocate."[55]

V

By 1917 Cendrars, having been sent home from the front after the
amputation of his arm, was back in Paris, the "last stop of desire
crossroads of unrest." Alone in what was for him a deserted city
(Léger was at the front; Apollinaire in the south of France; the pub-
lishing houses and journals had closed down), he wrote the prose
poem "Profond aujourd'hui" ("Profound Today"), which may stand as
an elegy to the Futurist moment. It begins as a kind of ode to the new
technology (fig. 1.6):

> Je ne sais plus si je regarde un ciel étoilé à l'oeil nu ou une goutte
> d'eau au microscope. Depuis l'origine de son espèce, le cheval se
> meut souple et mathématique. Déjà les machines le rattrapent, le dé-
> passent. Les locomotives se cabrent et les paquebots hennissent sur
> l'eau. Jamais une machine a écrire n'aura fait une faute d'orthographe
> étymologique, alors que le savant bégaie, mâche ses mots, se casse les
> dents sur d'antiques consonnes. Quand je pense, tous me sens s'allu-
> ment et je voulais violer tous les êtres et quand je me laisse aller à mes
> instincts de destruction, je trouve le triangle d'une solution métaphysi-

Je ne sais plus si je regarde un
ciel étoilé à l'œil nu ou une goutte
d'eau au microscope. Depuis l'ori-
gine de son espèce le cheval se meut
souple et mathématique. Déjà les
machines le rattrapent, le dépassent.

Fig. 1.6. Blaise Cendrars, "Profond aujourd'hui." Belle Edition, Paris,
1917. Opening page with illustration by A. Zarraga. Courtesy of Arthur A.
Cohen, Ex libris, a division of T. J. Art, Inc., New York.

que. Houillères inépuisables! Les cosmogonies revivent dans les mar-
ques de fabrique. Affiches extravagantes sur la ville multicolore, avec
la bande, des trams qui grimpent l'avenue, singes hurleurs se tenant
par la queue, et les orchidées incendiaires des architectures qui
s'écroulent par-dessus et les tuent. Dans l'air, le crie vierge des trol-
leys! La matière est aussi bien dressée que l'étalon du chef indien.
Elle obéit au moindre signe. Pression du doigt. (*OC* 6:3)

I'm no longer certain whether I'm looking at a starry sky with the
naked eye or at a drop of water under a microscope. Since the origin of
his species, the horse has been moving, supple and mathematical. Ma-
chines are already catching up with him, passing him by. Locomotives
rear up and steamers whinny over the water. A typewriter may never
make an etymological spelling mistake, while the scholar stammers,

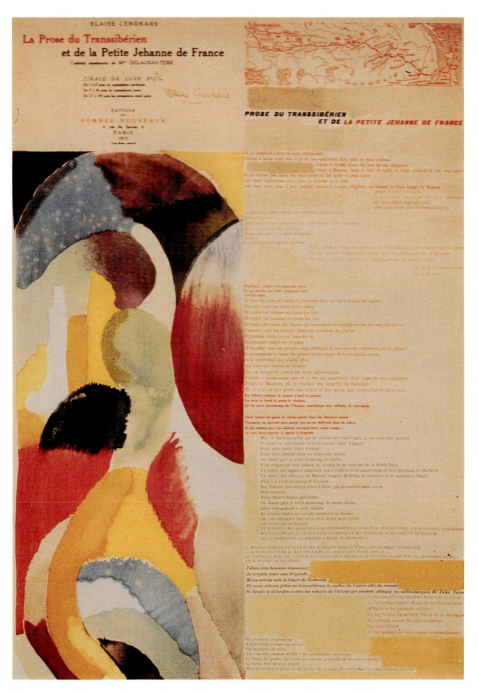

Pl. 1A. Detail of *La Prose du Transsibérien et de la petite Jehanne de France*
(see fig. 1.1) Bibliothèque Nationale, Paris.

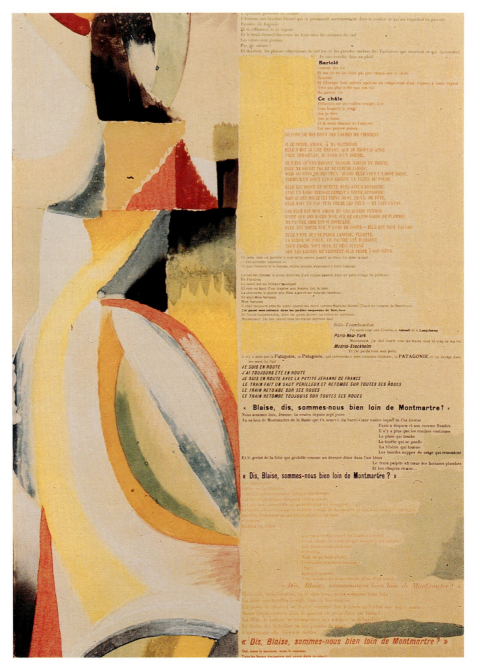

Pl. 1B. Detail of *La Prose du Transsibérien et de la petite Jehanne de France*

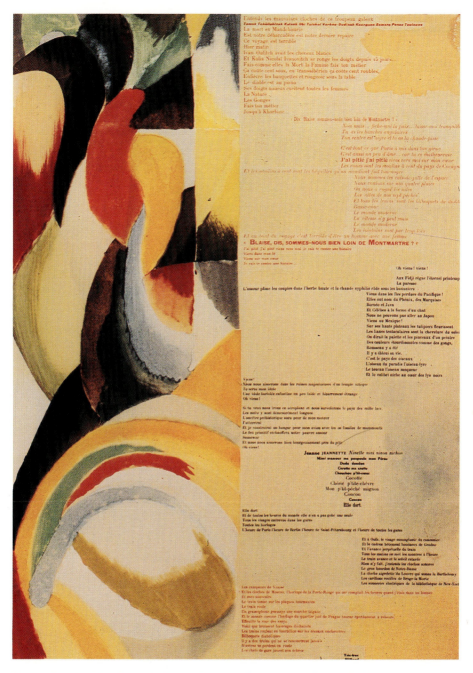

Pl. 1C. Detail of *La Prose du Transsibérien et de la petite Jehanne de France*

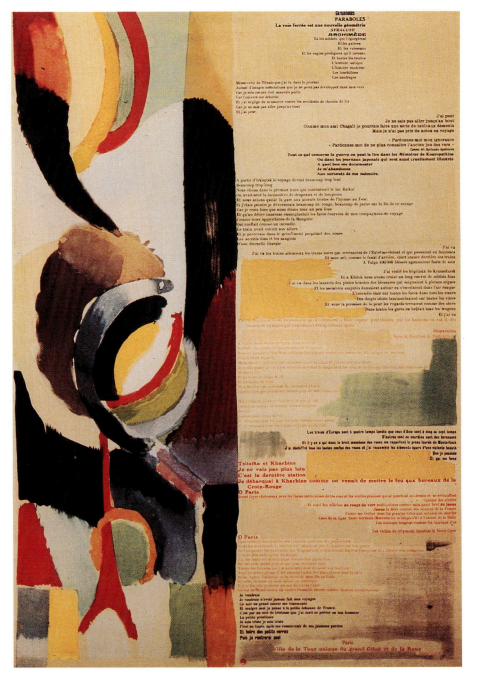

Pl. 1D. Detail of *La Prose du Transsibérien et de la petite Jehanne de France*

swallows his words, wears out his dentures on antique consonants. When I think, all my senses light up and I should like to violate everybody, and when I abandon myself to my destructive instincts, I find the triangle of a metaphysical solution. Inexhaustible coal mines! Cosmogonies revive in manufacturers' trademarks. Extravagant signboards over the multicolored city, with the ribbon of streetcars climbing the avenue, howling monkeys holding one another by the tail, and the incendiary orchid clusters of architectures that fall on top of them and kill them. In the air, the virgin cry of trolleys! Raw matter is as well trained as the Indian chieftain's stallion. It obeys the slightest signal. Pressure of a finger. (*SW* 228)

Here is the charged landscape of the *avant guerre*, which technology has created, a landscape that surpasses the poet's wildest fantasies. Everything is alive, in motion, transformation: the very touch of a finger spells creation, invention, mystery. Macrocosm (the starry sky) and microcosm (the water drop seen under the microscope) become one. If the poet "abandons himself to [his] destructive instincts," they nevertheless serve the cause of beauty and limitless possibility.

Very gradually, in the course of the prose poem, the emphasis begins to shift. Even as Cendrars celebrates "La roue qui tourne" ("The turning wheel") and "L'aile qui plane" ("The gliding wing"), even as he is electrified by the new internationalism—"Les produits des cinq parties du monde figurent dans le même plât, sur la même robe" ("Products from the five parts of the world show up in the same dish, on the same dress")—he becomes aware of the absence of the self in this new scheme of things. "Je" gives way to "Tu"—"Tu te perds dans le labyrinthe des magasins" ("You lose yourself in the labyrinth of stores")—and the poet admits that "Je ne me reconnais plus dans la glace" ("I can no longer recognize myself in the mirror").

The dispersal of what Marinetti called "the obsessive *I*" is both frightening and exhilarating. Emotion, no longer personalized, is projected onto the world of objects:

La tour Eiffel va et vient du sommet. Le soleil, un nuage, un rein suffit pour l'allonger, la raccourcir. Les ponts métalliques sont tout aussi mystérieux et sensibles. Les montres se mettent à l'heure. De tous les côtés les transatlantiques s'avancent vers leurs correspondances. Alors le sémaphore fait un signe. Un oeil bleu s'ouvre. Le rouge se ferme. Tout n'est bientôt que couleurs. Compénétration.

The Eiffel Tower comes and goes at the summit. The sun, a cloud, a mite is sufficient to lengthen it, to shorten it. Metallic bridges are just as mysterious and sensitive. Watches set themselves. From every side ocean liners advance toward their rendezvous. Then the semaphore

signals. A blue eye opens. The red closes. Soon there's nothing but color. Joint penetration.

Joint penetration, simultaneity, speed, color, constant motion. The scene becomes increasingly surreal: "On recoit un tramway dans le dos. Une trappe s'ouvre sous votre pied. On a un tunnel dans l'oeil. On monte au quinzième étage tiré par les cheveux." ("You get a streetcar in your back. A trap opens under your foot. You have a tunnel in your eye. You climb to the sixteenth floor drawn by your hair.") Animal turns to vegetable turns to mineral: "J'entends le moteur des eaux" ("I hear the water's motors"); "La peau . . . s'irradie comme de la chair d'anémone ("Skin . . . sends out spokes like anemone flesh"). Everything whirls, spins, undergoes metamorphosis. Yet— and here is where Cendrars differs from the Dadaists and Surrealists to come—the poet's hallucinatory vision remains rooted in the most ordinary reality:

Je suis homme. Tu es femme. Au revoir. Chacun réintègre sa chambre. Il y a des chaussures devant la porte. A ne pas confondre. Les miennes sont jaunes. Le garçon attend son pourboire. Je lui donne l'écu de mon blason. J'ai oublié de dormir. Ma glotte bouge. . . . Un declic. Soudain tout a grandi d'un cran. C'est aujourd'hui. . . . Crois-moi, tout est clair, ordonné, simple et naturel. Le minéral respire, le végétal mange, l'animal s'émeut, l'homme se cristallise. Prodigieux aujourd'hui. Sonde. Antenne. Port-visage tourbillon. Tu vis. Excentrique. Dans la solitude intégrale. Dans la communion anonyme. Avec tout ce qui est racine et cime, et qui palpite, jouit et s'extasie. Phénomènes de cette hallucination congénitale qu'est la vie dans toutes ses manifestations et l'activité continue de la conscience. Le moteur tourne en spirale. Le rhythme parle. Chimisme. Tu es.

I am a man. You are a woman. So long. Each one goes back to his room. There are shoes in front of the door. Don't mix them up. Mine are yellow. The bellhop waits for his tip. I give him the shield from my coat of arms. I have forgotten to sleep. My glottis moves. . . . A click. Suddenly everything has grown a notch. it is today. . . . Believe me, everything is clear, orderly, simple and natural. Mineral breathes, vegetable eats, animal feels, man crystallizes. Prodigious today. Sounding line. Antenna. Door—face—whirlwind. You live. Off center. In complete isolation. In anonymous communion. With all that is root and crown and which throbs, enjoys, and is moved to ecstasy. Phenomena of that congenital hallucination that is life in all its manifestations and the continuous activity of awareness. The motor turns in a spiral. Rhythm speaks. Body chemistry. You are.

Alone in his hotel room in the empty Paris of wartime, the poet observes his every movement as if "Je est un autre," as if his body belonged to someone or to something else. His pulse is, so to speak, at one with the pulse of the universe. Given the "Phenomena of that congenital hallucination that is life in all its manifestations and the continuous activity of awareness," who can remember to sleep? To live is to be "Off center. In complete isolation. In anonymous communion." But "the motor turns in a spiral"; the universe throbs, its mainspring tightens, its rhythm speaks. For Freddy Sauser, who had been born again by an act of will as Blaise Cendrars, this is the mordant ecstasy of "profond aujourd'hui."

2 THE INVENTION OF COLLAGE

On peut imaginer le temps où les peintres ne feront même
plus étaler par d'autres la couleur, ne dessineront même
plus. Le collage nous donne un avant-gôut de ce temps-là.
—Louis Aragon

The purpose of the *papier collé* was to give the idea that
different textures can enter into a composition to become the
reality in the painting that competes with the reality in na-
ture. We tried to get rid of "trompe l'oeil" to find a "trompe
l'esprit." . . . If a piece of newspaper can become a bottle,
that gives us something to think about in connection with
both newspapers and bottles, too. This displaced object has
entered a universe for which it was not made and where it
retains, in a measure, its strangeness. And this strangeness
was what we wanted to make people think about because we
were quite aware that our world was becoming very strange
and not exactly reassuring.
—Pablo Picasso[1]

O n ne peut pas," declared Apollinaire in *Les Peintres cubistes* (1913), "transporter partout avec soi le cadavre de son père." In what was perhaps a playful allusion to this aphorism, the painter Gino Severini assembled a series of visual images that metonymically referred to "le cadavre de son père" and re-presented these fragments in a collage called *Homage to My Father* (fig. 2.1). Exhibited, along with the Cendrars-Delaunay *Prose du Transsibérien* at Herwath Walden's *Der Sturm* gallery in Berlin, Severini's collage juxtaposes a page from a bulletin of judicial decrees (Severini père was, as the dedication in small script at the center bottom informs us, an "Usher for the Royal Prefecture of Pienza") with sheets of corrugated cardboard, playing cards, wallpaper, and semiabstract drawings of glasses and pitchers, both frontally and in profile, so as to give us a fond if faintly ironic image of bourgeois respectability.

Severini, the most Francophile of the Italian Futurists, made no bones about the derivation of this and the other collages that he constructed between 1913 and 1915. Some fifty years later, he explained to Raffaele Carrieri:

> As regards the so-called *papiers collés* I can tell you with precision that they were born in 1912 in the zone of Montmartre. As I remember it, Apollinaire suggested the idea to me after having spoken of it to Picasso, who immediately painted a small still-life onto which he applied a small piece of waxed paper (the type that was used for the tablecloths in the *bistros* of Paris). I tried to glue some *paillettes* and multicolored sequins onto forms of ballerinas in movement. I next saw a collage of Braque, perhaps the first, made of what seemed to be wood and large sheets of white paper on which he had sketched to a large extent with a black crayon. During my trip to Italy in August of 1912 I naturally spoke about the technique to Boccioni and he, in turn, to Carrà. During 1913 the first futurist experiments in this field saw the light of day. The reasons for which Apollinaire gave us these suggestions, as I remember them from conversations of a later date, were: in the first place, the need, at that time, to comprehend the sense of a more pro-

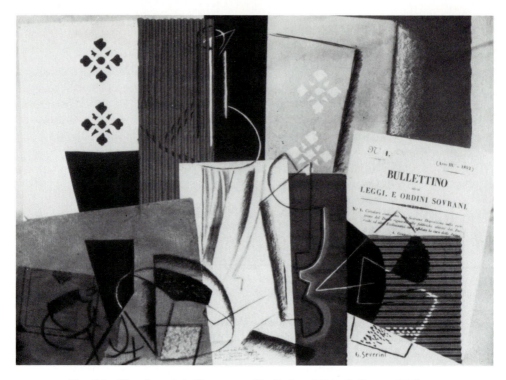

Fig. 2.1. Gino Severini, *Homage to My Father*, 1913. Collage, 19⅝″ × 27⅝″. Eric Estorick Gallery, London.

found and secret inner reality which would have been born from the *contrast* of materials employed directly as things placed in *juxtaposition* to lyrical elements.[2]

The rapid dissemination of what Gregory L. Ulmer has recently called "the single most revolutionary formal innovation in artistic representation to occur in our century" is in itself remarkable.[3] Strictly speaking—and here art historians seem to be in unusual agreement[4]—the first collages, Picasso's *Still Life with Chair Caning* and Braque's *Fruit Dish*, were both made in 1912, although collage composition is prefigured in Cubist painting at least as early as 1908 when illusionistically painted nails, guitar strings, letters, and numbers were introduced into the otherwise nonrepresentational picture surface with its oscillating and ambiguously defined planes. The Futurists, as Severini notes, were quick to adapt the Cubist model to their own purposes. Within a few years, collage and its cognates—montage, construction, assemblage[5]—were playing a central role in the verbal as well as the visual arts.

The word *collage* comes from the French verb *coller* and means literally "pasting, sticking, or gluing," as in the application of wall-

paper.[6] In this literal sense, collage has been practiced for centuries around the world. But when one examines early "collages"—for example, twelfth-century Japanese pasted papers, sprinkled over with flower patterns or tiny birds and stars made from gold and silver paper and then brushed with ink to simulate the contours of mountains, rivers, or clouds, and then covered with the calligraphy of appropriate poems—one finds little common ground with the structure of juxtapositions that characterizes a work like Severini's *Homage to My Father*.[7] Such assemblages as the feather mosaic pictures of Mexico, the Russian icons decorated with gems, pearls, and gold leaf, and especially the lace and paper valentines popular in western Europe and America from the eighteenth century to the present depend for their success on their ability to simulate particular objects. Thus postage stamps could be combined, as they were in the mid-nineteenth century, to create a picture of a classical vase bearing the portraits of American presidents (fig. 2.2). In this trompe l'oeil composition, each flower is a separate small collage made of stamps. The use of unexpected materials to create a recognizable image is, of course, an ingenious game, but a game circumscribed by the assumption that the pleasure of recognition (look, those are really stamps!) is a sufficient response to a given art work.

"Si ce sont les plumes qui font le plumage," Max Ernst said wittily, "ce n'est pas la colle qui fait le collage."[8] Collage composition, as it developed simultaneously in France, Italy, and Russia (and slightly later in Germany and Anglo-America) is distinguished from the "paste-ups" of the nineteenth century in that it always involves the transfer of materials from one context to another, even as the original context cannot be erased. As the authors of the recent Group *Mu* manifesto put it:

> Each cited element breaks the continuity or the linearity of the discourse and leads necessarily to a double reading: that of the fragment perceived in relation to its text of origin; that of the same fragment as incorporated into a new whole, a different totality. The trick of collage consists also of never entirely suppressing the alterity of these elements reunited in a temporary composition.[9]

Or, in Louis Aragon's words, "La notion de collage est l'introduction [dans la peinture] d'un objet, d'une matière, prise dans le monde réel et par quoi le tableau, c'est-à-dire le monde imité, se trouve tout entier remis en question" ("The principle of collage is the introduction [into the painting] of an object, a substance, taken from the real world and by means of which the painting, that is to say the world that is

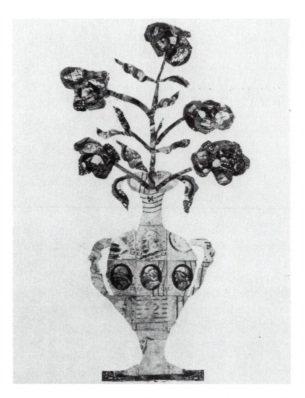

Fig. 2.2. *Vase with Flowers*. United States, nineteenth century. Postage-stamp collage, 10″ × 7⅞″. Menil Foundation Collection, Houston, Texas. (See Wescher, *Collage*, pl. 6.)

imitated, finds its whole self once again open to question").[10] How such *mise en question* actually works may be studied in a typical collage of the period, Picasso's *Still Life with Violin and Fruit*, which dates from the fall of 1913 (pl. 2).[11]

Here pasted papers are literally placed in front of and on top of one another on an opaque picture surface, thus challenging the fundamental principle of Western painting from the early Renaissance to the late nineteenth century that a picture is a window on reality, an imaginary transparency through which an illusion is discerned. Collage also subverts all conventional figure-ground relationships, for here nothing is either figure or ground; rather, the collage juxtaposes "real" items—pages torn from newspapers, color illustrations of apples and pears taken from a picture book, the letters "URNAL" (from JOURNAL) with half of the *U* cut off, and patches of wood-grained or

painted paper—so as to create a curiously enigmatic pictorial surface. For each element in the collage has a dual function: it refers to an external reality even as its compositional thrust is to undercut the very referentiality it seems to assert.

Take the function of the newspaper fragments in *Still Life with Violin and Fruit*. Within the framework of the whole composition, the large planes covered with tiny newsprint are seen as luminous planes; juxtaposed to the bolder black, white, gray, and blue rectangles on the canvas, they appear to be transparent. Yet the transparent tone hardens into opaque lines at the plane's edges, and the outline drawings of objects—a wine glass (which can also be a caricature of a man reading a newspaper), a violin top with two black tuning keys that also call to mind the trompe l'oeil nails Picasso regularly places on his Cubist surfaces—transforms what seems to be figure (newsprint on paper) into ground. But then ground reemerges as figure: the oval shape beneath the picture of fruit looks like the rim of the fruit bowl, the white plane perpendicular to it then serving as the stem of the bowl. Or, again, we perceive the sheet of newsprint (center bottom) as paper that is slightly charred at the top, perhaps because it has emerged, so to speak, from the painted rectangle to its left, which resembles a grate.

But the newsprint can also be read, so referentiality is reasserted even as it is called into question. The headline "arition" (*apparition*) in the upper right, for example, introduces a melodramatic account of a séance in which a Madame Harmelie finally succeeds in bringing to life the desired person ("C'est elle!"), even as the wind ominously blows the curtain away from the window. But we have only part of the story: the left margin is cut off, and within the outlined wine glass (or man reading newspaper) we find a fragment of a different story, something about a character called Chico who is given a fat purse by a Don Cesar and sent out on a picaresque journey. These romance elements are juxtaposed to what we might call scenes of Paris life: (1) a medical case history with references to the amount of morphine administered, the patient's muscle tone, and so on (top center behind and inside the violin); (2) classified ads for items like "Huile vitesse" for the automobile as well as racetrack news (upper left, below the fruit, with the page turned upside down); (3) a column called "LA VIE SPORTIVE" (center bottom, again upside down), which picks up the racetrack motif from above; it contains a calendar of events at Auteuil—races, football, rugby, "La Foire Automobile," "La Fête de ce Soir," and next to "LA VIE SPORTIVE" is the "CHRONIQUE FINA[NCIÈRE]" dated Paris, 5 December. Finally (4), two brief news items about a female mur-

derer and a female boxer (or are these two ladies one and the same?), the page tilted sideways beside the white vertical plane on the left. This particular newspaper fragment is comically juxtaposed to the gray buttock or breast shape next to it, a shape whose mirror image reappears slightly further to the right. These female curves may belong to the woman whose face is also the violin top (two eyes, nose, whiskers?, trunk top), and the sexual allusion (both shape and symbol) is picked up by the apple and pear pictures in the upper left.

If we take the trouble to read the newspaper fragments in Picasso's collage, we discover that their selection is hardly random, for the newspaper "circle" that acts as a kind of ground for the violin-woman shapes and abstract planes clustering together at the picture's center contains reference to most aspects of daily life in the Paris of 1912: sports, finance, sex, crime, religion (the séance), the new technology (*l'huile vitesse* to keep the new automobiles running), and the latest medical discoveries. Politics, the main subject of newspaper reporting, is the one missing field; its very absence challenges the viewer-reader to question the reality of the newsprint even as the cutting up and fragmenting of the newspapers forces us to see them as compositional rather than referential entities.

The position of writing in collage is thus equivocal; the words refer to people and events, yet the collage structure simultaneously contradicts that reference. We can, moreover, read captions and images literally or as witty allusions to other painters: the picture-book apples and pears to Cézanne, the Auteuil news to Monet or Renoir, and so on. Even the planes themselves, for that matter, provide us with contradictory clues. The wood-grained plane (center left) may belong to the table on which the newspaper is placed, yet it modulates into what seems to be a violin or female silhouette, a silhouette echoed by the grainy gray shape to its right as well as by the pear on the illustrated page. Again, the charcoal-blue square shape in the center is inscribed with an *f*, whose mirror image (minus the crossbar) faces it on the opposite side. Picasso regularly uses these *f*s to signify the sound holes of the violin, but here, as elsewhere in his work, they have neither the same shape nor the same size. Rosalind Krauss observes:

> With this simple, but very emphatic size difference, Picasso composes the sign, not of violin, but of foreshortening: of the differential size within a single surface due to its rotation in depth. And because the inscription of the *f*s takes place within the collage assembly and thus on the most rigidly flattened and frontalized of planes, "depth" is thus written on the very place from which it is—within the presence of the

collage—most absent. It is *this* experience of inscription that guaran-
tees these forms the status of signs.[12]

One might add that the mirror image of *f* recalls the arms of a woman,
the guitar strings and instrument forming the outline of her body—a
stick figure, as it were, to match the gentleman on her right. Again, this
inverted *f* provides us with the missing half of the *U* of JOURNAL, a *U*
turned into a *J* thus foreshortening the word, which is also a play on
URINAL. Or again, the two *f*s repeat the outline of the woman-violin's
head drawn on top of the newsprint.

In Picasso's collage, the relationship of forms is thus highly struc-
tured and yet curiously unstable. The structure of repetitions is re-
markable—head drawn in charcoal on newspaper becomes head
outline made of *f*s, both forming a network of relationships with
the rounded buttock-breast-violin shapes to the left as well as with the
pears and apples above them. The dismembered *U* of JOURNAL finds its
missing half in the reversed sound-hole image in the neighboring
plane. Yet this formal density is consistently called into question by
contradictory visual references. The grayish strip, widening and en-
tering the light at the upper right edge, for example, may be in front of
or behind the newspapers to which it is juxtaposed, just as the *U* of
URNAL is presented as being on top of the blue plane even as that
plane obliterates its left side. "It is this eradication of the original sur-
face," says Rosalind Krauss, "and the reconstitution of it through the
figure of its own absence that is the master term of the entire condition
of collage as a system of signifiers" (*OAA* 37). And here it may be
helpful to remember that *collage*, literally a pasting, is also a slang
expression for two people living (pasted) together—that is to say, an
illicit sexual union—and that the past participle *collé* means "faked"
or "pretended." The word *collage* thus becomes itself an emblem of
the "systematic play of difference," the *mise en question* of representa-
tion that is inherent in its verbal-visual structure.[13]

I

In *Les Peintres cubistes* (1913), Apollinaire observes:

> [Picasso] has not hesitated to entrust real objects to the light—a two-
> penny song, a real postage stamp, a piece of newspaper, a piece of
> oilcloth imprinted with chair caning. The art of the painter could not
> add any pictorial element to the truth of these objects. . . .
> It is impossible to foresee all the possibilities, all the tendencies of
> an art so profound and painstaking.

The object, either real or in *trompe-l'oeil*, will doubtless be called
upon to play an increasingly important role.[14]

This prediction proved true. In Cubist collage, as we have seen, the
introjected fragment—say, the newspaper page or the violin *f*—re-
tains its alterity even as that alterity is subordinated to the composi-
tional arrangement of the whole. In Picasso's *Violin and Fruit*, the pre-
formed messages and cut up materials are arranged to produce a new
coherent totality.[15] But when the object is called upon "to play an
increasingly important role," its difference is foregrounded. From
Cubist collage, it is, after all, a short step to the Dada ready-made.

The "first Futurist experiments" recalled so fondly by Severini pro-
vide the transition between these two poles. It is still customary to
regard Cubism and Futurism as oppositional movements. "The two
aesthetics," says Marianne W. Martin in her definitive study of Italian
Futurist art, "were fundamentally opposed, thus necessitating a choice
between the *l'art pour l'art* classicism of Cubism and the expres-
sionistic dynamism of Futurism."[16] True, Boccioni declared in 1912
that the Futurists were "absolutely opposed to [Cubist] art" for "They
[the Cubist painters] continue to paint objects motionless, frozen, and
all the static aspects of Nature; they worship the traditionalism of
Poussin, of Ingres, of Corot."[17] And Apollinaire, rising to the bait,
responded: "Futurism, in my opinion, is an Italian imitation of the
two schools of French painting that have succeeded each other over
the past few years: fauvism and cubism. . . . Neither Boccioni nor
Severini is devoid of talent. However, they have not fully understood
the cubists' painting, and their misunderstanding has led them to es-
tablish in Italy a kind of art of fragmentation, a popular flashy art."[18]

Such dismissive statements have less to do with the qualities of
Cubist or Futurist art than with the intense nationalistic rivalry that,
as I suggested in chapter 1, characterized the *avant guerre*. A state-
ment like Boccioni's must thus be carefully contextualized. No sooner
has he asserted his implacable opposition to Cubism than he lapses
into what we might call Cubist talk about "the dislocation and dis-
memberment of objects, the scattering and fusion of details, freed
from accepted logic, and independent from one another" (*FM* 47). In-
deed, in the *Technical Manifesto of Futurist Sculpture* (1912), Boc-
cioni advocates "a sculpture, whose basis will be architectural, not
only as a construction of masses, but in such a way that the sculptural
block itself will contain the architectural elements of the *sculptural
environment* in which the object exists." In such an environment, "the
cogs of a machine might as easily appear out of the armpits of a me-

chanic, or the lines of a table could cut a reader's head in two, or a book with its fanned-out pages could intersect the reader's stomach" (*FM* 62–63).

Here the urge toward decomposition is at least as intense as in Cubist aesthetic. But it is only fair to say that Boccioni's actual artworks of the period do not quite measure up to his manifesto statements. In sculptures like *Fusion of a Head and a Window* (fig. 2.3), he placed a sculptured head with a braided green chignon, made of real hair, under a real window frame complete with metal catch and triangles of glass. The diminutive house flanking the head is evidently meant to exemplify the Futurist principle of interpenetration: "Our bodies penetrate the sofas upon which we sit, and the sofas penetrate our bodies" (*FM* 28). The difficulty is that the individual items do not,

Fig. 2.3 Umberto Boccioni, *Fusion of a Head and a Window*, 1912. Wood, glass, plaster of paris, and wreath of hair. Destroyed. Photograph courtesy of the Museum of Modern Art, New York. (See Wescher, *Collage*, pl. 44.)

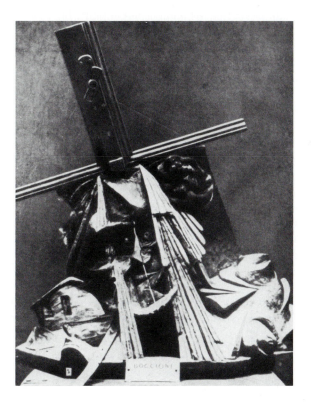

in fact, "interpenetrate" in any meaningful way. An uneasy alliance of abstraction and grotesque realism, this early Boccioni is character-ized by accretion rather than synthesis.

Nevertheless, it is interesting to note that Boccioni's insistence that the sculptor could use any material he likes "in order to achieve plas-tic movement," for example: "glass, wood, cardboard, iron, cement, hair, leather, cloth, mirrors, electric lights" (*FM* 65), echoes Ap-ollinaire's famous statement: "One can paint with whatever one likes, with pipes, postage stamps, postcards or playing cards, candelabras, pieces of oilcloth, starched collars."[19] Indeed, the use of different ma-terials initiated by the Cubists was quickly taken up by Futurists like Severini. A collage like *Still Life with Fruit Bowl* of 1913 (fig. 2.4) is composed of colored paper, printed matter, corrugated cardboard, and so on. But because of their peculiar (and non-Cubist) obsession with the machine, with speed, dynamism, and energy as the expres-sion of an intense nationalism, the Futurists tended to treat collage in their own way. Either they did not violate the medium directly, but submitted it to a conceptual analysis that transformed it—that is to say, they made works that are collages not literally but metaphorically; or, true to their insistence that the spectator must be placed at the center of the picture, they reconceived collage as propaganda art, an art that directly bombards the senses. The former may be exemplified by Boccioni's *Development of a Bottle in Space* of 1912 (fig. 2.5), the latter by Carrà's 1914 *Interventionist Manifesto*.

In his preface to the *Catalogue of the First Exhibition of Futurist Sculpture in Paris* (1913), Boccioni stresses the need for a "fusion of the environment with the object with the consequent *interpenetration of the planes*. I propose, in other words, to make the figure live in its environment, without making it a slave . . . to a supporting base."[20] So *Development of a Bottle in Space* is structured to be seen frontally, like a relief. The base bears a series of bottle-shaped shells, hollowed out and fitted inside each other. These shells rest on a concave shape with a simple, unbroken profile, as if to say that the sculpture does have a center—the bottom shell of the hypothetical bottle.

But although we can understand this concave form, resting on the base, from a single vantage point, frontally, the hollow shells them-selves create a perplexing uncertainty. In an interesting discussion of the work in *Passages in Modern Sculpture*, Rosalind Krauss observes:

> Boccioni has modelled the nested cutaway shells of the bottles so that they seem to have been rotated slightly in relationship to one another. The rotation tightens and becomes more extreme toward the top of the form, where the shells revolve, at different speeds, around the shaft of

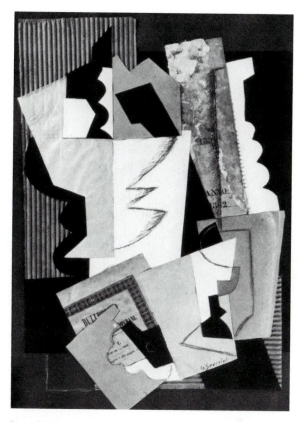

Fig. 2.4. Gino Severini, *Still Life with Fruit Bowl*, undated, c. 1913. Collage, 27″ × 19½″. Collection Eric Estorick, London. (See Wescher, *Collage*, color pl. 10.)

the bottle's neck. At times one can imagine that the shells would completely obscure the hollow center of the object, and at other moments, like the one caught and held by this particular configuration, the shells leave the center available to sight.[21]

The sculpture may thus be seen to dramatize a conflict "between the poverty of information contained in the single view of the object and the totality of vision that is basic to any serious claim to 'know it'" (p. 45). Accordingly, although *Bottle in Space* is made of one material—bronze—and is not strictly speaking collage at all, it exploits the collage principle of juxtaposition of disparate items without any explanation of their connection. To perceive the hollowed-out bottle shells in all their rotation, we have to assume the possibility of differ-

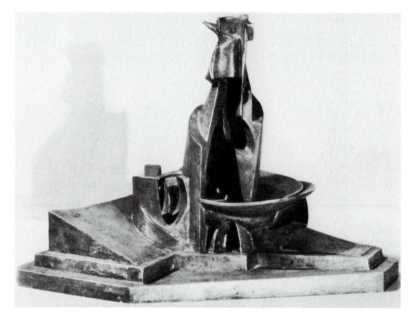

Fig. 2.5. Umberto Boccioni, *Development of a Bottle in Space*, 1912–13. Silvered bronze (cast 1931), 15″ × 12⅞″ × 23¾″. Collection, Museum of Modern Art, New York, Aristide Maillol Fund.

ent vantage points. Yet the frontal relief form and the concave center, signaling the origin of the bottle within its circle, make it impossible to perceive the shifting exterior from anything but a fixed perspective. The spectator is therefore puzzled, the question being how to "read" such a self-contradictory work. Does one participate in what Boccioni calls the "relative motion"—the contingent existence of objects in real space as the viewer changes position? Or does one subordinate such "relative motion" to the "absolute motion" of the bottle's inherent characteristics? Collage, in this sense, looks ahead to Conceptual art.

In the same year that Boccioni made *Bottle in Space*, Marinetti published *Technical Manifesto of Futurist Literature*. Together with the 1913 manifesto *Destruction of Syntax—Wireless Imagination—Words-in-Freedom*, this document, widely disseminated and translated,[22] provides an elaborate program of collage aesthetic with respect to literary discourse. Naïvely apocalyptic as it is, Marinetti's program stands behind or anticipates virtually every *ism* of the early war years, from Russian Cubo-Futurism and *zaum* to Anglo-American

Vorticism to Dada. Marinetti's manifestos are, for that matter, themselves collage works of a new kind.

Marinetti's argument is reductive enough to make for compelling propaganda. "The earth shrunk by speed," by new means of communication, transportation, and information, demands a wholly new verbal art, one that can express "the complete renewal of human sensibility brought about by the great discoveries of science":

> An ordinary man can in a day's time travel by train from a little dead town of empty squares, where the sun, the dust, and the wind amuse themselves in silence, to a great capital city bristling with lights, gestures, and street cries. By reading a newspaper the inhabitant of a mountain village can tremble each day with anxiety, following insurrection in China, the London and New York suffragettes, Doctor Carrel, and the heroic dog-sleds of the polar explorers. The timid, sedentary inhabitant of any provincial town can indulge in the intoxication of danger by going to the movies and watching a great hunt in the Congo. . . . Then back in his bourgeois bed, he can enjoy the distant, expensive voice of a Caruso or a Burzio. (*TIF* 57–58; *FM* 96)

How can traditional discourse with its complete sentences—the "prison of the Latin period"—convey this new language of telephones, phonographs, airplanes, the cinema, the great newspaper, which Marinetti calls "the synthesis of a day in the world's life"? The "old syntax" must be abolished: indeed, *l'immaginazione senza fili* (wireless imagination) becomes suspiciously like the language of the telegram. First of all, adjectives must go because they do not allow "the naked noun to preserve its essential color"; they provide too much of a pause. Second, "one must abolish the adverb, the old belt buckle that holds two words together. The adverb preserves the tedious unity of tone within a phrase." As for verbs, they should be used only in the infinitive form "because they adapt themselves elastically to nouns and don't subordinate them to the writer's *I* that observes or imagines. Alone the infinitive can provide a sense of the continuity of life and the elasticity of the intuition that preserves it" (*S* 84; *TIF* 41).

No adjectives, no adverbs, no finite verbs. And further, no punctuation—"the foolish pauses made by commas and periods" suppress "the continuity of a *living* style"—and no "free verse," which "fatally pushes the poet towards facile sound effects, banal double meanings, monotonous cadences, a foolish chiming, and an inevitable echo-play, internal and external" (*FM* 99; *TIF* 62). That leaves nouns, naked and freestanding, nouns not related by comparative adverbs such as *as* or *like* or by conjunctions, set side by side with their "doubles"—

which is to say, by analogous nouns. Marinetti gives this example of
such *parole in libertà:* "uomo-torpediniera, donna-golfo, folla-
risacca, piazza-imbuto, porta-rubinetto" ("man-torpedo-boat, woman-
gulf, crowd-surf, piazza-funnel, door-faucet") (*TIF* 41; *MSW* 85).

Poetry, accordingly, becomes "an uninterrupted sequence of new
images," a "*strict net of images or analogies,* to be cast into the myste-
rious sea of phenomena" (*S* 86). But not just any analogy:

> Up to now writers have been restricted to immediate analogies. For in-
> stance, they have compared an animal to a man or to another animal,
> which is almost the same as a kind of photography. They have com-
> pared, for example, a fox terrier to a very small thoroughbred. Others,
> more advanced, might compare the same trembling fox terrier to a
> little Morse Code machine. I, on the other hand, compare it to gurgling
> water. In this there is an *ever-vaster gradation of analogies,* there are
> ever-deeper and more solid affinities, however remote.
>
> Analogy is nothing more than the deep love that assembles distant,
> seemingly diverse and hostile things. (*S* 85)

Which is to say, although Marinetti never uses the word, *collage. Pa-
role in libertà,* disparate and related only by farfetched analogy, are to
be presented without overt connection or explanation, the ordering
signs that would specify the causal or temporal relations among pre-
sented elements being wholly suppressed.[23] As such, a set typo-
graphical format is no longer meaningful: "typographical harmony,"
says Marinetti, is "contrary to the flux and reflux, the leaps and bursts
of style that run through the page" (*FM* 104; *TIF* 67). An innovative,
expressive typography—the use of different colors of ink and of differ-
ent typefaces, the spacing and size of letters and words—as well as
an elaborate system of onomatopoeic devices, will replace the "ab-
stract cypher" of syntax.

Finally, words-in-freedom are to be presented without what Charles
Olson was to call, some forty years later, "the lyrical interference of
the ego":

> Destroy the *I* in literature: that is, all psychology. . . . To substitute for
> human psychology, now exhausted, the lyric obsession with matter.
>
> Be careful not to force human feelings onto matter. Instead, divine
> its different governing impulses, its forces of compression, dilation,
> cohesion, and disaggregation, its crowds of massed molecules and
> whirling electrons. . . . The warmth of a piece of iron or wood is on
> our opinion more impassioned than the smile or tears of a woman. (*S*
> 87; *TIF* 44)

And again:

My technical manifesto opposed the obsessive *I* that up to now the poets have described, sung, analysed, and vomited up. To rid ourselves of this obsessive *I*, we must abandon the habit of humanizing nature by attributing human passions and preoccupations to animals, plants, water, stone, and clouds. Instead we should express . . . the agitation of atoms . . . all the passionate hypotheses and all the domains explored by the high-powered microscope. (*FM* 100; *TIF* 64)

But what would a verbal composition, deprived of all syntagmatic relationships as well as of the possibility of articulating a particular sense of selfhood, look like? Consider Marinetti's own *Zang Tumb Tuuum* (1914), the account—if one can call it that—of the siege by the Bulgarians of Adrianopolis in the Balkan War, which Marinetti had witnessed as a war reporter in 1912.[24] As a performance, given in cities from London and Paris to Berlin, Moscow, and Petersburg in the course of 1913, *Zang Tumb Tuuum* had a great *succès de scandale;* Marinetti's extended sound poem exploits the performer's ability to use voice, gesture, and intonation so as to re-create the image of troops being mobilized, the departure for the front, the siege of the city, and finally the terrible fate of a trainload of injured soldiers left to die in the heat. On the page, however, Marinetti's *parole in libertà* are more problematic. Figure 2.6 illustrates a two-page sequence depicting the final train journey.

Strictly speaking, this passage exemplifies most of the features advocated in Marinetti's manifestos: no punctuation or verse form, no finite verbs, adjectives replaced by compound nouns ("montagne-ventre," "treni-anguille"), conjunctions replaced by mathematical symbols (+), heavy oversize black type used for emphasis ("**ZANG-TUMB-TUMB**"), phonetic spelling ("**uuuuuuuurlaaaare**" and "**crrr-rrrrepitare**"), onomatopoeia ("**tatatata**"), and so on. The presentation does, moreover, avoid what Marinetti calls "the obsessive *I*," indeed, the sequence of nouns and noun phrases is closer to newspaper or to film captioning than to lyric practice, the page neatly (and somewhat simplistically) juxtaposing the "Sogno di 1500 Ammalati" to the terrible image of existence inside the closed train.

It is all very vivid, and one can imagine Marinetti declaiming his "**uuuuuuuurlaaaare**" passage to an entranced audience. Yet *Zang Tumb Tuuum* curiously ignores Marinetti's own stated principle that "Analogy is . . . the deep love that assembles distant, seemingly diverse and hostile things." In sacrificing such syntactic relationships as entailment, subordination, and implication, Marinetti has substituted not a complex structure of disparate materials, but a fairly straightforward opposition between two sets of images: "ozio-eleganze-

sogno
di 1500
ammalati

ozio eleganze viaggi velocità
dei treni-bisturi montagne-ven-
tri slancio dei volumi dello
spazio agilità dei treni-anguille
reti di pioggia
spazzole del sole treni-aghi
cucire montagne di velluto
seta delle pianure
amoerri dei laghi
mobile stoffa dei viaggi ve-
locità praterie-teoremi mammelle
delle colline latte dell'alba nella
bocca freschezza
stazione letto len-
zuola fresche aranciata
 gelata
 rissa affastellamento
degli odori di tutte le malattie infornate

nel treno *fogliame vibrante dell'olfatto* odore
fecale della dissenteria + puzzo melato dei
sudori della peste + tanfo ammoniacale
dei colerosi + fetidità zuccherina delle gan-
grene polmonari + odore acidulo dei feb-
bricitanti + odori di cantina + piscio di
gatto + olio-rancido pane-caldo + aglio +
incenso + paglia-fradicia + stagni + frittura +
vinacce + odori di topo + tuberosa + ca-
volo-marcio **zang-tumb-tumb** tata-
tatatata **stop**
 uuuuuuuurlaaare degli
ammalati nel **crrrrrrrepitare** delle **palle**
fischi **schianto** di vetri rotttti sportelli-ber-
sagli Adrianopoli interamente accerchiata treno
abbandonato dai meccanici e dai soldati
rabbbbbia degli shrapnels bulgari
fame rapacità mordere mordere i minareti-

Fig. 2.6. F. T. Marinetti, from *Zang Tumb Tuuum* (1914), in *Opere di F. T. Marinetti*, vol. 2: *Teoria e invenzione futurista*, pp. 688–89. Mondadori, Rome, 1968. Edizioni Futuriste de "Poesia," 1914.

viaggi-velocità" (the dream) and "odori di tutte le malattie infornate nel treno" (the reality). The variety of typefaces, the use of plus (+) signs and phonetic spelling, the heavy alliteration and assonance cannot disguise the fact that Marinetti's *parole in libertà* are basically just lists: "odore acidulo dei febbricitanti," "Odori di cantina," "odori di topo," and so on. The structural principle operative, in other words, is less that of collage than of catalog. To put it another way, the elements paratactically related in the Marinetti text do not retain their "alterity," their "difference," and, accordingly, the sequence, far from operating, in David Antin's words, "in a middle space between representation on the one hand and . . . constructional game on the other" ("Questions about Modernism," p. 19) is merely what we might call a montage-string. Indeed, the elimination of the "exhausted" lyrical ego—one of Marinetti's main goals—is here achieved by rendering sensations at a level so generalized that anyone might feel them: witness the soldier's dream of clean sheets and orangeade.

All this is not to say that *Zang Tumb Tuuum* is not of great historical importance. Here and in related Marinetti poems and fictions, we

find in embryo the *parole in libertà* and *immaginazione senza fili* of Pound's *Cantos* or Schwitters's *Merzbau* constructions. In the Italy of *avant guerre*, Marinetti's concepts were quickly taken up in the "free-word paintings" of Francesco Cangiullo, Ardengo Soffici, Severini, and others,[25] the finest example of the genre probably being Carrà's small collage (Summer 1914) called *Interventionist Manifesto*, made, so Carrà says in a letter to Severini, as an experiment in getting rid of "all representation of the human figure," so as to concentrate on "a painterly abstraction of the uprising of the citizens."[26]

The resulting collage (fig. 2.7) looks at first glance like no more than an especially colorful and dynamic advertising poster, a billboard urging the painter's fellow citizens to join the war movement then sweeping Italy.[27] But different as this collage is from Cubist compositions, its strategies of fusing word and image are equally complex. We might begin with the following account by Max Kozloff:

> [The] basic motif is a vortex, reminiscent of the prop wash or wing insignia of a British or French airplane, that seems to unwind centrifugally to spew forth incessant printed militancies in several languages. Technically, the work is a collage whose tempera-painted passages and pasted papers are intercalated so intimately that it is impossible to sort them out or even to assign them differing status—as, no doubt, Carra intended. . . . Even the staccato, painterly touches and atomized bursts of pigment show that the tactile and sonic impact of the work are reflexes of each other.[28]

What Kozloff rightly calls Carrà's "vortex" is a whirling cone of opposites that demands reader participation. I say "reader" here advisedly because this is a work that must be read in order to be understood. The place of honor at the center of the vortex, for example, is reserved for a complex made up of the words "AUDACIA"—"ROM[A]"—"aviatore"—"Italia"—"battere il rècord" (break the record). This "patriotic" circle has behind it a darker one bearing the slogan "EEVVIIIVAAA IL REEE," "EVVIVAAA L'ESERCITO" (i.e., Looooong liiiive the Kiiiing! Looooong liiiive the Aaaarmy!); the words, spelled phonetically, are repeated, with slight variation, at least ten times and juxtaposed to the single German word "TOT" in large black block letters pasted on one of the diagonals that crosses the "great wheel" to the right. The war between Italy and Germany is thus, so to speak, announced a month or two before it actually broke out. But this is no simple propaganda poster, no straightforward call to arms. For the collage does not tell us, as spectators, which words or word groups to combine or in what sequence to read them. There is, in other words,

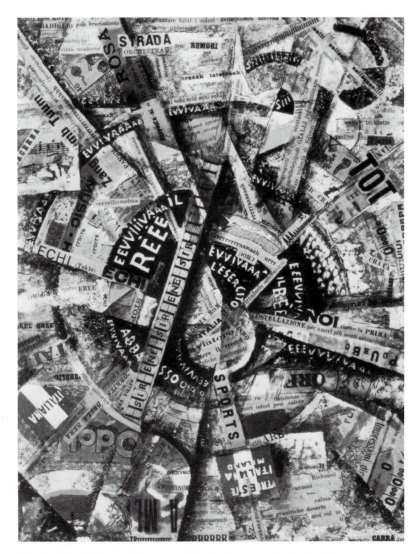

Fig. 2.7. Carlo Carrà, *Demonstration for Intervention in the War
(Interventionist Manifesto)*, 1914. Tempera collage on cardboard, 15″ ×
11¾″. Collection Gianni Mattioli, Milan. (See Wescher, *Collage*, pl. 51.)

no casual, temporal, or logical arrangement, the only principle—and it is an important one—being that no item is necessarily related to the adjacent one even as that item finds its proper analogues somewhere else in the painting. The effect of such scrambling is to impel the viewer to make his or her own connections.

Thus the central diagonal, bearing the inscription, "SIRENE," embedded in the larger letters "HU HU HU HU HU," is related metonymically to such phrases as "aria quotidiana di artiglieri," to "RUMORI," and to onomatopoeic sounds like "uiuiuiuiuiUiUi" and "BBBRRRRRPR." Or again, "PARIGI," almost hidden under the black band labeled "EVVIVAAA" that crosses it in the upper left, is drawn into the vortex with "TOKiO" (on the band inscribed "ECHI"), "MILANO" (in the red, white, and green Italian flag), and "ROMA," while "STRADA" (top center) is related to "PIAZZA," "citta moderne," "folle," "pedoni," "biciclette," "luce elletrica," and so on. The collage ironically juxtaposes the Futurists' radical newspaper *Lacerba* to the bourgeois *Corrière della Sera*; again, it brings together such Futurist works as *Zang Tumb Tuuum* and "La Rosa" (Apollinaire), as well as such pedestrian labels as "Cook and son," "Music H[ALL]," "STOP," and "SPORTS."

The effect of such splicing is compelling. The scream of the siren, coming over what looks like a ticker tape, is juxtaposed to the voice of tradition ("EEVVIIIVAAA IL REE") as well as to the everyday life of the Italian city with its bicycles, trains, electric lights, and "amiciparenti." The scorching sun ("sole bruccaticcio") is present only as a newsprint item, yet the vortex is itself a kind of scorching sun, whose rays are made up of "RUMORI," "SIRENE," and "ECHI." The collage thus challenges us to read the signs and decode the symbols, to take the scrambled clues and put them into a more orderly sequence. But so crowded is Carrà's canvas, so dizzying a spiral of inciting fragments, sounds, and colors, so shrill a torrent of spectacle and noise, that we can never perceive the picture as a coherent image.

Such verbal-visual overkill is surely intentional. In Cubist collage, the signifiers refer to a presence that is consistently absent, like the *f*s that seemingly designate the sound holes of the violin but are so different from one another that they finally call attention to their status as autonomous signs. Futurist collage is less teasing—we do know to what Carrà's *parole in libertà*, scattered across his colorful vortex, refer. In both cases, however, what is missing is an ordering system, a set of guidelines that might tell us to subordinate, say, "amiciparenti" (bottom center) to "NOI siami la PRIMA COSTELLAZIONE per nuovi più acuti astronomi" (right center), or to the Italian flag. In the absence of such an ordering system, the work acts as an intellectual challenge to

the viewer; it raises the issue of code and message in a striking way. And the painter seems to be enjoying it all: he has inscribed his name at the bottom left: "leggiero CARRÀ duraturo FUTUristA" (the light Carrà, a lasting Futurist), as if to say that his own selfhood is finally unimportant, given the larger culture, whose fragments are spread out before our eyes. It is those fragments, not any reasoned argument, that constitute the call to arms of the *Interventionist Manifesto*.

II

When Marinetti gave a reading from his *Zang Tumb Tuuum* in Petersburg in the winter of 1914, the audience, composed largely of Russian avant-garde poets and painters, was skeptical. In his very lively memoir of the period, *The One and a Half-Eyed Archer* (1933), Benedikt Livshits recalls that during the discussion after the reading, Marinetti was incensed to hear the Russians object that "destruction of syntax" and "words at liberty" were old hat compared to the *zaum* poetry of Khlebnikov, a poetry of which Marinetti had never heard. Livshits himself also objected to Marinetti's poetic doctrine on the grounds that the so-called destruction of syntax was violated by Marinetti's performance itself. He asked Marinetti:

> What is the point of piling up amorphous words, a conglomeration which you call "words at liberty"? To eliminate the intermediary role of reason by producing disorder, right? However, there's a large gulf between the typographical composition of your *Zang-Tum-Tumb* and your recitation. . . . is it worth destroying the traditional sentence, even the way you do, in order to reinstate it, to restore its logical predictate by suggestive gestures, mime, intonation and onomatopoeia? [29]

Forced to grant that there was some truth to this objection, Marinetti insisted that, nevertheless, his manifestos preached a wholly revolutionary doctrine and that Italian Futurist painters were doing something quite new. And indeed Livshits admits that "For all the abrupt difference between our ideology (not a group ideology—there wasn't one!—but everyone's individual one) and Marinetti's, we did agree with the Italians in some things: we postulated the same technical and formal tasks and we practiced a similar art" (*OHA* 186–87).

Similar, in that the central concern of the Russian, as of the Italian and French avant-garde of these years, was the crisis of representation. It is interesting to note that the one painter who came to Marinetti's defense when the latter's visit to Moscow was announced was not, say, the Westernized Mikhail Larionov (who, on the contrary, wrote diatribes against Marinetti in the newspapers),[30] but rather that

most uncompromising of abstractionists-to-be, Kasimir Malevich. Livshits tells us that "[Malevich] was the only one to assume the role of representative of Russian Futurism and to meet Marinetti at the station" (*OHA* 183). Perhaps this was a gesture meant to express Malevich's recognition of his affinity to such painters as Boccioni and Carrà, an affinity that stems from their common link to Cubism.[31]

Malevich's nonobjective works, beginning with the *Black Square* of 1915, have received so much attention that we tend to slight the proto-Cubist paintings and collages that preceded them and that, as various critics have recently argued,[32] laid the groundwork for the transition to abstraction. Let us look, for example, at the 1914 collage called *Woman at Poster Column* (pl. 3).

Donald Judd, writing from the perspective of Minimalism, with its firm commitment to abstraction, has made some shrewd observations about this work by his great precursor:

> In *Woman at Poster Column*, 1914, two rectangles, one medium-sized, vertical and pink, the other twice as large, horizontal and yellow, and not square on the right, are painted right over the small Cubist parts. The two areas connect locally to the rest of the painting only by a black line extending slightly into the pink and by a black area repeating at a greater angle the angled side of the yellow. A purple and a blue area are painted fairly flatly, though overlapped by the Cubist elements, and a pink strip, along the right edge is nearly free, only touching the recessed blue area. . . . In this painting, color is becoming independent, as are the two or three main flat shapes.[33]

Judd's emphasis on independent color zones is important because it points to the central difference between Malevich and the Picasso works that influenced him so strongly in this period.[34] From Malevich's point of view, Cubist art remained, despite its great innovations, rooted in the traditional faith in pictorial synthesis:

> There is nothing single in nature: everything consists of various elements and gives possibilities for comparison. Take a lamp—it consists of the most varied units, both painterly and formal. Technical formation has created the organism of the lamp from a mass of separate and different units; the result is a living organism which is not a copy. Similarly a Cubist construction is formed from the most varied units in a definite organization. . . .
>
> Just as nature decomposes a corpse into its elements, so Cubism pulverizes the old conclusions about painting and builds new ones according to its own system.[35]

This passage is taken from the 1919 essay "On New Systems in Art," in which Malevich defends Cubism against the charge of "bourgeois decadence" (*EA* 1:101). The "construction . . . from the most varied units in a definite organization," the "decompos[ition of the] corpse into its elements" and its reconstruction into a new "system"—these were the features of Cubist construction Malevich singles out for praise. Nevertheless, such "harmony of contradictions" produces stasis. Futurism, Malevich argues, solves this problem in that it renounces the "painterly" in favor of the "dynamic." The "sum of the moving urban energy . . . the *dynamics* of Moscow, Berlin or New York can be presented in the Futurist conception as a measure of real tension" (*EA* 1:115).

By "real tension," what Malevich seems to mean is that in Russian Futurist collage, the preformed messages or materials retain their separate identity. The letters *Y* and *B*, the number 25, the words and phrases, **AFRIKANSYAN** (African), **KVARTIRA** (apartment), *razoshelsya bez* (without gas heat), and **THEVENOT** (came apart without) can be viewed as partially glimpsed segments of advertisements and notices one would, in fact, find on a kiosk, but they are not subject to the punning or wordplay we find in Picasso. The *B*, in other words, could just as well be an *R*, the *Y* a *K*, the 25 a 26, without altering the basic structure of meanings in the collage. Again, the photograph of the man, half hidden behind the large pink rectangle (top center) and reemerging as a face on its other side, does not have the equivocal status we ascribed to the newsprint or the pictures of apples and pears in the Picasso collage. Here everything remains what it was to begin with: a photograph, a number, a letter, a word, a plane, a piece of lace. The title of the collage, for that matter, submits the process of signification to a more radical questioning than do the titles of Picasso or Braque: here the image of the woman is not decomposed or fragmented as it is in, say, Picasso's *Ma Jolie;* rather, "woman" becomes a kind of missing term, only dimly evoked by the bits of lace, the white egg shape on the left, the violet S-curve.[36] Ironically, the person "pictured" is not a woman at all but a man in black, painted quite realistically except that the face is severed from the profile of the body hidden behind the pink plane.

In Picasso's collage, the image is constantly being read as something else: the "URNAL" of "[J]OURNAL" suggests URINAL, the violin shape looks like a female torso, the wine glass embedded in the newsprint is also a man reading a newspaper. Transformation is central to the process. In Malevich's collage, on the other hand, the yellow plane is to be read as a yellow plane, a cylinder as a cylinder, and the

size of each object is whatever the painter wants it to be. Thus the letter *B* is about four times the size of the embroidered lace strip and equal in size to the man in the photograph.

In its refusal to synthesize disparate forms, Malevich's collage thus emphasizes the artist's dialogue with materiality. Indeed, it is this aspect of collage that Malevich was to single out in his discussion of Cubism in the *New Art* of 1928:

> a whole series of questions have arisen in connection with the appearance of *collage*. . . .
>
> Examining the surface of the painting from the painterly aspect, from the collage itself, we see how it grows into space like a tower. It stems from the surface plane of the canvas which is two-dimensional and tone-painted. The collage, however, does not function as a plane. Like the surface, it goes over to three-dimensionality, i.e. has volume, which grows towards us . . . in real space. . . . This illusion of volume unfolded before our eyes still on the plane of a two-dimensional canvas from the moment of collage, i.e. the growth of the surface towards us in real space; for our part we want to perceive it from all sides, since real volume is created and the picture grows perpendicularly. (*EA* 2:59–60)[37]

As such, Malevich's proto-Cubist collages of 1913–14—*Woman at Poster Column*, *Soldier of the First Division* (with its real thermometer and postage stamp affixed to the canvas), and *Partial Eclipse with Mona Lisa* (fig. 2.8), in which the Mona Lisa, with an X across her face and another across her breast, is playfully inserted into a semi-abstract, geometric structure of planes, thus anticipating, by more than five years, Duchamp's famous *L.H.O.O.Q.*[38]—look ahead both to Dada collage and, in terms of their treatment of color and plane, to the nonrepresentational Suprematist paintings that were to begin with the *Black Square* of 1915. More important, Malevich's emphasis on materiality, on the relation of collage work to external space, leads to a consideration of collage construction as the forerunner of the installations and environmental art of our own time. Here the decisive contribution was made by Malevich's great Russian rival, Tatlin.

Tatlin's visit to Picasso's studio on the Boulevard Raspail in the summer of 1913 is legendary. Here is Guy Davenport's fictionalized account in his *Tatlin!*:

> He was cutting paper and pasting it onto boards. Wallpaper, newspaper, construction paper. Here was a paper guitar with wrapping cord for strings.
>
> —He eats my studio with his eyes, Picasso said to Lipschitz.
>
> —Tell him, Tatlin said, that I understand what he is doing.

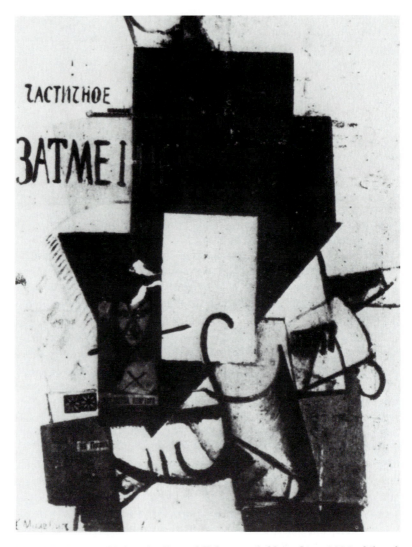

Fig. 2.8. Kasimir Malevich, *Partial Eclipse with Mona Lisa*, 1914. Oil and collage on canvas, 24″ × 19½″. Private collection, Leningrad.

Picasso shrugged his shoulders.

—This is what sculpture should be.

He was looking at a compote of ice cream complete with spoon modeled in plaster and painted with mauve and pink dots.

Picasso was jubilant. He shook Tatlin's hand. . . .

—Ask Picasso if I may become his pupil. Tell him that I am a sailor used to housework and will sweep his floors and clean his brushes.

—No, no, Picasso said. Waste not a minute. Go do what you want to, what you can. Get a lifetime of work into a week. Plan nothing: make.[39]

Tatlin, the story goes, received such a shock of inspiration from seeing Picasso's constructions that, upon his return to Russia, he began to make the wood and metal collages that led to the great "counterreliefs" of 1914–15. Yet, as Margit Rowell argues in an important essay in *October*,[40] the differences between the assemblages of the two artists are at least as great as their similarities. In a Picasso collage or construction, the intrinsic properties of the medium are, as I noted in the discussion of Malevich, less important than the oscillating role the collage-piece plays in the larger pictorial synthesis. As Picasso himself put it: "The sheet of newspaper was never used in order to make a newspaper. It was used to become a bottle or something like that. It was never used literally but always as an element displaced from its habitual meaning into another meaning."[41]

But for Tatlin, construction replaces composition. It is respect for the *faktura* (texture) of the material itself that makes the difference. Indeed, the material dictates the form. The formal possibilities of metal, for example, are quite different from those of wood. If the inherent form of wood is the geometric plane, flat on both sides and shaped with a saw so as to have clean edges, metal is manufactured in thin sheets, its purest form in the urban environment being the cylinder or cone, produced by cutting, bending, or folding. If wood has its own natural color, the polished surface of metal reflects light, thereby accentuating its shape. If wood, even when cut into small triangles or squares or perforated with a drill, is characterized by its solidity, metal has the flexibility and malleability to assume different shapes. A third medium used by Tatlin is glass, either in the form of rectangular panes or shaped into cylinders and cones. The main feature of glass exploited by the artist is, of course, its transparency, a transparency that, as Margit Rowell notes, "provides a transition between inner and outer space, the space of the work of art and the viewer's space.[42]

Tatlin's lexicon of materials thus corresponds to Marinetti's call for the destruction of syntax and words set free or, closer to home, to Khlebnikov's *zaum* language, in which words are fragmented and syllables and phonemes realigned so as to produce new meanings. Indeed, Khlebnikov is said to have dreamed of an alphabet in which the consonants would be of metal and the vowels of glass.[43]

When we look at a counterrelief (sometimes called "corner relief") by Tatlin (see fig. 2.9),[44] we are struck, first of all, by the fact that this is not a relief at all but an assemblage meant to be hung without a backing that would limit or define its physical extension in space. The implicit reference to painting, to something framed, is, in other words, no longer present. Whereas Boccioni segregates his *Bottle in Space* from real space by placing it on a pedestal base, Tatlin, as Rosalind Krauss notes, relates his corner reliefs to the actual wall planes that support the work physically:

> If the function of Boccioni's pedestal is to bracket the sculptural object from natural space, declaring that its true ambience is somehow different from the randomly organized world of tables, chairs, and windows, the function of Tatlin's corner is to insist that the relief it holds is

Fig. 2.9. Vladimir Tatlin, *Corner Relief*, 1915. Reconstructed from photographs by Martyn Chalk, 1979. Iron, zinc, aluminum, wood, paint. Annely Juda Fine Arts, London.

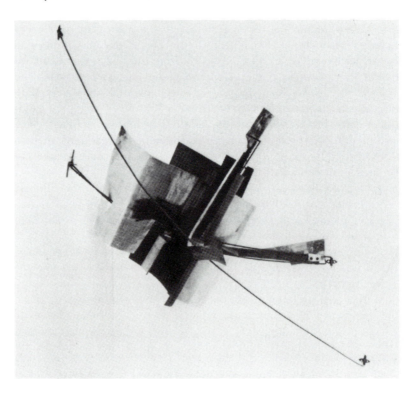

continuous with the space of the world and dependent upon it for its meaning.[45]

Here, once again, we meet the Futurist longing to make an art coterminous with life, the longing reflected in Marinetti's demand for an "imagination without strings" or in Cendrars's insistence in his *Sturm* manifesto that "Je n'écris pas par métier. Vivre n'est pas un métier." The Tatlin counterrelief is perceived by the viewer as a forward projection from the actual walls upon which it is anchored. The thin and airy sheets of metal are assembled so as to extend outward into space rather than coalescing around a central core. Indeed, there is no center here; the work confronts us as a weightless, seemingly moving object, floating, as it were, in an indeterminate space. Yet, although it is impossible to infer any part of this relief from the observable relationships of its other parts, the whole is carefully balanced by its tilted installation and its complex interaction of diagonals. "Tatlin," writes Charlotte Douglas, "brought his materials into such careful balance that we are not aware of their weight, but only of their texture and structural harmony. In doing away with obvious support—both of the back plane of a relief and the ground plane of traditional sculpture—Tatlin appears to do away with gravity itself."[46]

In this radical variant of collage, representational traces all but disappear. We can say, of course, that this particular counterrelief looks like a billowing sail or like the prow of a ship and relate it to its biographical sources in Tatlin's life as a sailor. Again, by its placement in the corner of a room, the relief can be seen as the Futurist counterpart of the Russian Orthodox family icon. But the construction is finally a new object existing in its own right, an assemblage made of juxtaposed fragments—wire, iron, aluminum, wood—materials whose nature is left intact even as their coordination gives them a new life. As Martyn Chalk, the artist who has been reconstructing Tatlin's lost reliefs, puts it:

> Tatlin uses materials and forms in ways which seem to extend the spatial and pictorial experiments of the Cubists with real shadows standing alongside illusions of shadow and with negative and positive shape working together. Like the Cubists he also includes fragments of the real world in some of the works, not perhaps as allusions to visual reality (the reliefs are non-objective, "bespredmetny," "subjectless" in the Russian), but as badges to confirm the existence of the reliefs as real objects in the real world.[47]

"Badges" of the "real" world such as bits of rope, damaged wood, or discarded sheet metal inevitably retain connotations of their former

use. The counterrelief thus occupies a middle space between representation on the one hand and formal construction on the other, depending on whether we choose to stress the nature of the materials and the contexts from which they are drawn, or their actual arrangement. Its structure, in Martyn Chalk's words, "is neither Art nor Engineering, but the result of some intuitive grasp of how the world might be put together."

III

An intuitive grasp of how the world might be put together—here is the mainspring of collage structure as the artists of the *avant guerre* envisioned it. Let me now try to draw some of the implications their work has for us.

Collage is, by definition, a visual or spatial concept, but it was soon absorbed into the verbal as well as into the musical realm.[48] From Marinetti's *Zang Tumb Tuuum*, it was just a short and perhaps inevitable step to Apollinaire's *Calligrammes*, William Carlos Williams's *Kora in Hell* or T. S. Eliot's *Waste Land*, a poem whose collage composition is at least partially the result of the cuts made by Ezra Pound, himself the great master in English of collage form.

But perhaps because verbal, as opposed to visual, collage must be understood metaphorically (words and phrases are not literally pasted and glued together), literary critics have tended to look at it disapprovingly as a mode that undermines coherence and unity, whether in lyric poetry or in the novel or drama. Yeats's famous declaration, in his preface to *The Oxford Book of Modern Verse* (1936), that "form must be full, sphere-like, single," and that, accordingly, Pound's poetry in the *Cantos* is a jumble of "exquisite or grotesque fragments," of "unbridged transitions [and] unexplained ejaculations,"[49] stands behind two decades of the New Criticism, which set itself the task of finding what Reuben Brower called the "key design," the "aura around a bright clear centre" (Eliot's phrase), the "Something central which permeated" (Woolf in *Mrs. Dalloway*), and so on.[50] If the poet's job is, as Yeats said, "to get all the wine into the bowl," the "play of difference" characteristic of collage can only be suspect.

Interestingly, the formalist critique of collage on the part of the New Critical Right is matched on the Left by a distrust of collage's semantic heterogeneity, its undermining of what Walter Benjamin called the aura or uniqueness of the work of art. Benjamin's account of "the decay of the aura" appears in "The Work of Art in an Age of Mechanical Reproduction," published in the same year as Yeats's preface to the *Oxford Book of Modern Verse*. "The technique of reproduction," writes

Benjamin, "detaches the reproduced object from the domain of tradition. By making many reproductions it substitutes a plurality of copies for a unique existence. And in permitting the reproduction to meet the beholder or listener in his own particular situation, it reactivates the object reproduced."[51]

Benjamin does not use the word *collage* here, but clearly the process he describes as the "detach[ment of] the object" and its "reactivat[ion]" elsewhere, is what the artists and poets of the *avant guerre* understood as the collage process. It is a process that is suspect in that the "artistic function" becomes one of many, and that, accordingly, as Benjamin says of photography, "exhibition value begins to displace cult value" (*Ill* 225; *GS* 485).

Such statements, neutral as they seem to be, convey a nagging nostalgia for what Eliot called "the aura around a bright clear centre." Thus Benjamin, echoing Stéphane Mallarmé's distinction between the newspaper and the book, writes:

> With the increasing extension of the press, which kept placing new political, religious, scientific, professional, and local organs before the readers, an increasing number of readers became writers—at first, occasional ones. It began with the daily press opening to its readers space for "letters to the editor." And today there is hardly a gainfully employed European who could not in principle, find an opportunity to publish somewhere or other comments on his work, grievances, documentary reports, or that sort of thing. Thus, the distinction between author and public is about to lose its basic character. . . . At any moment the reader is ready to turn into a writer. (*Ill* 232; *GS* 493)

And that, of course, is precisely what the Futurists wanted to happen. "The distinction between author and public" is the distinction they longed to break down. The declared populism of the *avant guerre* is a far cry from Benjamin's thinly veiled scorn for "that sort of thing" ("oder dergleichen").

A similarly elitist contempt for the world of public discourse, the print world of "Letters to the Editor," rears its head in the Marxist criticism of Fredric Jameson. After making a powerful case for the distinction between the novel, as practiced by Flaubert and Joyce—a literary form still marked by *la parole pleine*—and the "satire collage" of Wyndham Lewis, Fredric Jameson writes:

> The collage-composition practiced by Lewis thus draws heavily and centrally on the warehouse of cultural and mass cultural cliché, on the junk materials of industrial capitalism, with its degraded commodity art, its mechanical reproduceability, its serial alienation of lan-

guage. . . . In such a situation, the personal language, the private thought are themselves illusions, where conventionalized formulae dictate in advance the thought that had seemed to choose them for its own instruments.[52]

Jameson shares Benjamin's nostalgia—a nostalgia reminiscent not only of Mallarmé but also, ironically, of the "agrarian" New Critics— for a world not yet tainted by the machine. "The satire-collage," writes Jameson, "is the form taken by the artificial epic in the degraded world of commodity production and of the mass media" (p. 80). Here Jameson takes the degraded as a given, a conclusion that should give us some pause when we remember that the great Cubist and Futurist artists—Picasso, Braque, Gris, Boccioni, Severini, Carrà, Malevich, Tatlin—were quick to accept "the world of commodity production and of the mass media" as a challenge rather than a threat, a new source of imagery and of structuration. "Mechanical reproduceability," after all, was a way of reintroducing the public discourse into the poetic field, and it provided the artist with a chance to question the established ordering systems. As Gertrude Stein described World War I in her study of Picasso:

> Really the composition of this war was not the composition of all previous wars, the composition was not a composition in which there was one man at the centre surrounded by a lot of other men but a composition that had neither a beginning or an end, a composition in which one corner was as important as another corner, in fact the composition of cubism.[53]

In a recent essay on the aesthetic of Malevich and Kruchenykh, Charlotte Douglas argues persuasively that it is time to lay to rest our still pervasive clichés about the avant-garde as "the culture of negation," of "dehumanization" and "alienation," the belief that a "disordered illogical universe begets a disordered illogical art." On the contrary, Douglas suggests, artists like Malevich and Tatlin, and poets like Khlebnikov and Kruchenykh, all of whom had been trained as mathematicians or natural scientists, learned from Nikolai Lobachevsky's non-Euclidean geometry and P. D. Ouspensky's *Tertium Organum* of 1911 to regard the making of art not as an imitation of a sensible reality, but as a kind of model building:

> When, for example, Kruchenykh called the word "self-sufficient," it was not only because it had ceased to have any referents, but also that it included them all simultaneously; the word was "self-valuable" as the objectification of a flash of insight, the moment of resolution of the old dichotomies. . . . Far from finding uncertainty a destructive force

which undermines the meaning of life, the Futurists were charmed by accidental occurrences, by typographical errors, for example; they were the occasion for rejoicing, because they made manifest those all-pervasive natural laws which link man with nature.[54]

I think this is a very important point. What Fredric Jameson refers to as the "warehouse of cultural cliché" is perhaps more accurately viewed as "a giant laboratory of the poem,"[55] a laboratory in which art, in all its forms, worked to meet the challenge of the new science. This meant, of course, a radical questioning of existing modes of representation. "The extraordinary contribution of collage," writes Rosalind Krauss, "is that it is the first instance within the pictorial arts of anything like a systematic exploration of the conditions of representability entailed by the sign" (*OAG* 34). On the visual level, collage entails the loss of a coherent pictorial image; on the verbal, the loss of what David Antin calls "the stronger logical relations" between word groups in favor of those of similarity, equivalence, and identity ("Questions about Modernism," p. 21). In collage, hierarchy gives way to parataxis—"one corner is as important as another corner." Which is to say that there is no longer a central ordering system, that presence, as Rosalind Krauss puts it, is replaced by discourse, a "discourse founded on a buried origin" (*OAG* 38).

As such, the collage works of the *avant guerre* stand behind such contemporary works as Jacques Derrida's *Glas* (1974), John Cage's *Empty Words*, Robert Smithson's "Strata: A Geophotographic Fiction," or Laurie Anderson's *United States*. "Every sign," writes Derrida, "spoken or written in a small or large unit, can be *cited*, put between quotation marks; in so doing it can break with every given context, engendering an infinity of new contexts in a manner which is absolutely illimitable."[56] Such "citation"—a cutting free and regrafting—operates in Cage's various "writings through" the texts of others (e.g., "Writing Through Finnegans Wake," "Writing Through Howl"), and, as Gregory L. Ulmer points out in his challenging analysis of Derrida's grammatology as a collage mode,[57] Derrida himself has referred to his style as "a parody, a collage, a juxtaposition," carried out "as gaily and scientifically as possible."[58] In *Glas*, itself a print collage (see fig. 2.10), we read:

That the sign detaches itself, that signifies of course that one cuts it out of its place of emission or from its natural relations; but the separation is never perfect, the difference never consummated. The bleeding detachment is also—repetition—delegation, commission, delay, relay. Adherence. The detached [piece] remains stuck by the glue of difference.[59]

quoi du reste aujourd'hui, pour nous, ici, maintenant, d'un Hegel?

Pour nous, ici, maintenant : voilà ce qu'on n'aura pu désormais penser sans lui.

Pour nous, ici, maintenant : ces mots sont des citations, déjà, toujours, nous l'aurons appris de lui.

Qui, lui?

Son nom est si étrange. De l'aigle il tient la puissance impériale ou historique. Ceux qui le prononcent encore à la française, il y en a, ne sont ridicules que jusqu'à un certain point : la restitution, sémantiquement infaillible, pour qui l'a un peu lu, un peu seulement, de la froideur magistrale et du sérieux imperturbable, l'aigle pris dans la glace et le gel.

Soit ainsi figé le philosophe emblémi.

Qui, lui? L'aigle de plomb ou d'or, blanc ou noir, n'a pas signé le texte du savoir absolu. Encore moins l'aigle rouge. D'ailleurs on ne sait pas encore si *Sa* est un texte, a donné lieu à un texte, s'il a été écrit ou s'il a écrit, fait écrire, laissé écrire.

Sa sera désormais le sigle du savoir absolu. Et l'*IC*, notons-le déjà puisque les deux portées se représentent l'une l'autre, de l'Immaculée Conception. Tachygraphie proprement singulière : elle ne va pas d'abord à disloquer, comme on pourrait croire, un code c'est-à-dire ce sur quoi l'on table trop. Mais peut-être, beaucoup plus tard et lentement cette fois, à en exhiber les bords

On ne sait pas encore s'il s'est laissé enseigner, signer, ensigner. Peut-être y a-t-il une incompatibilité, plus qu'une contradiction dialectique, entre l'enseignement et la signature, un magister et un signataire. Se laisser penser et se laisser signer, peut-être ces deux opérations ne peuvent-elles en aucun cas se recouper.

Fig. 2.10. Jacques Derrida, *Glas*, p. 1. Editions Galilée, Paris, 1974.

As the mode of detachment and readherence, of graft and citation, collage inevitably undermines the authority of the individual self, the "signature" of the poet or painter. "Our renovated consciousness," declares Boccioni, "does not permit us to look upon man as the centre of universal life. The sufferings of a man is of the same interest to us as the suffering of an electric lamp" (*FM* 29). A foolishly extreme statement, of course, but it points to something important. The inclusion in a picture of "real" newspaper pages, or in a poem of the "real" words and phrases of another writer, calls into question what Charles Bernstein refers to as "the conduit theory of communication (me→you), [which] presupposes individuals to exist as separate entities outside

language and to be communicated *at* by language."[60] Carrà's *Interventionist Manifesto* is a good example of such "collective" discourse as are, from another angle, the "sculptural" assemblages of Tatlin—objects intentionally purged of "personality" that can rival the prow of a ship or the wing of an airplane so as to be of "use," so to speak, to the world at large.

Indeed, to collage elements from impersonal, external sources— the newspaper, magazines, television, billboards—is to understand, as it were, that, in a technological age, consciousness itself becomes a process of graft or citation, a process by means of which we make the public world our own. "L'art," says Louis Aragon in *La Peinture au défi* (1930), "a veritablement cessé d'être individuel, même quand l'artiste est un irréductible individualiste, du fait que nous pouvons suivre, en négligeant les individus, à travers des moments de leur pensée, un vaste raisonnement qui n'emprunte le truchement des hommes que d'une façon toute passagère" (Art has truly ceased to be individual, even when the artist is himself a confirmed individualist, for, even as we neglect individuals, we can trace across the moments of their separate thoughts, a vast argument that borrows from their conscious intervention only in passing (*Coll* 57).

But it does not follow that collage is essentially a "degraded" or "alienated" version of earlier (and presumably superior) genres. "On voit naître de ces negations," says Aragon, "une idée affirmative qui est ce qu'on a appelé *la personnalité du choix*" (There is born, from these negations, an affirmative idea that has been called *the personality of choice*) (*Coll* 53). *La personnalité du choix:* it is a nice phrase to keep in mind when we contemplate the evolution of collage from the first *papiers collés* of Picasso and Braque to, say, Kurt Schwitters's first *Merzbau* of 1933 (fig. 2.11).

This improvised "environment," built into an upstairs room of Schwitters's house in Hanover, obliterates the distinction between wall and collage or floor and sculpture. If its structural framework derives from the grid scaffoldings of Cubism, it is a Cubism transformed by the Futurist (and later Dada) drive to obliterate the distinction between the pictorial field and the "real" world outside the frame. Indeed, the piles of freestanding "rubbish" that constitute Schwitters's architectural assemblage were in constant flux as the artist added or subtracted items and created new configurations with the use of wood, cardboard, iron scraps, broken furniture, print media, railway tickets, playing cards, and so on. The resultant *Merzbau* is, paradoxically, the very opposite of the *Kommerz* that is the source of its materials as well as its title. A pure, unsaleable creation, it could not be transported or

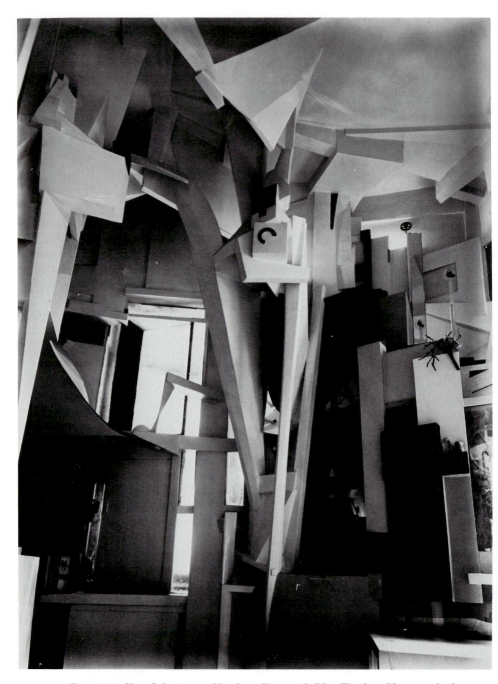

Fig. 2.11. Kurt Schwitters, *Merzbau: View with Blue Window*. Photographed
c. 1930. Landeshauptstadt Hannover, W. Germany. Cosmopress, Geneva.

even defined. Schwitters's fellow Dada artist Hans Richter describes
it this way:

> it was a living, daily-changing document on Schwitters and his
> friends. . . . the whole thing was an aggregate of hollow space, a
> structure of concave and convex forms which hollowed and inflated the
> whole sculpture. Each of these individual forms had a "meaning."
> There was a Mondrian hole, and there were Arp, Gabo, Doesburg,
> Lissitsky, Malevich, Mies van der Rohe and Richter holes. A hole for
> his son, one for his wife. Each hole contained highly personal details
> from the life of one of these people. . . . a piece of shoelace, a half
> smoked cigarette, a nailparing, a piece of tie (Doesburg), a broken
> pen. . . .
> When I visited him again three years later, the pillar was totally dif-
> ferent. All the little holes and concavities that we had formerly "oc-
> cupied" were no longer to be seen. . . . the column, in its overwhelm-
> ing and still continuing growth, had, as it were, burst the room apart at
> the seams.[61]

Longing for additional space, Schwitters made a hole in the ceiling
and extended his *Merzbau* into the floor above. And so the "ware-
house of cultural cliché" has literally gone through the roof. It is an
extension that has proved to be more than literal. Destroyed by bombs
in 1943, five years after Schwitters had escaped from Nazi Germany,
the *Merzbau*, as known in photographs and writings, stands behind
the next generation of collage-works, a model of how the world of
machine-made objects might be put together.

3 VIOLENCE AND PRECISION: THE MANIFESTO AS ART FORM

Space no longer exists: the street pavement, soaked by rain beneath a glare of electric lamps, becomes immensely deep and gapes to the very center of the earth. Thousands of miles divide us from the sun; yet the house in front of us fits into the solar disk.

—Umberto Boccioni

There is no reason why every activity must of necessity be confined to one or other of those ridiculous limitations which we call music, literature, painting, etc.

—Bruno Corradini and Emilio Settimelli

EVERYTHING OF ANY VALUE IS THEATRICAL.

—F. T. Marinetti[1]

I n the autumn of 1913, at the height of the manifesto fever that swept across Europe in the years preceding the First World War, Gino Severini, then living in Paris, sent the manuscript of a projected manifesto to F. T. Marinetti in Milan. Spurred on by the example of his fellow Futurist painters, Severini evidently wanted to participate in the new literary sport. His text did not, however, meet the standard of the movement's leader.[2] Here is Marinetti's reply:

> I have read with great attention your manuscript, which contains extremely interesting things. But I must tell you that there is nothing of the *manifesto* in it.
>
> First of all, the title absolutely won't do because it is too generic, too derivative of the titles of other manifestos. In the second place, you must take out the part in which you restate the *merde* and *rose* of Apollinaire, this being, in absolute contrast to our type of manifesto, a way of praising a single artist by repeating his own eulogies and insults. Moreover . . . you must not repeat what I have already said, in *Futurism* and elsewhere, about the futurist sensibility. The rest of the material is very good and very important, but to publish it as is would be to publish an article that is excellent but not yet a manifesto. I therefore advise you to take it back and reword it, removing all that I have already mentioned, and intensifying and tightening it, recasting the whole new part in the form of *Manifesto* [*in forma di Manifesto*] and not in that of the review article about futurist painting. . . .
>
> I think I shall persuade you by all that I know about *the art of making manifestos* [*dall' arte di far manifesti*], which I possess, and by my desire to place in *full* light, not in *half* light, your own remarkable genius as a futurist.[3]

To give one's text "the form of *Manifesto*"—a form Marinetti defined in an earlier letter to the Belgian painter Henry Maassen as requiring, above all, "de la violence et de la *précision*"[4]—this was to create what was essentially a new literary genre, a genre that might meet the needs of a mass audience even as, paradoxically, it insisted on the avant-garde, the esoteric, the antibourgeois. The Futurist manifesto marks

the transformation of what had traditionally been a vehicle for political statement into a literary, one might say, a quasi-poetic construct.

Consider the following definition of *manifesto* in the *OED:* "A public declaration or proclamation, usually issued with the sanction of a sovereign prince or state, or by an individual or body of individuals whose proceedings are of public importance, for the purpose of making known past actions and explaining the reasons or motives for actions as forthcoming." This definition dates from 1647. By 1848, when Marx and Engels published anonymously the most famous of all manifestos, *Der Manifest der Kommunistischen Partei,* "the sanction of a sovereign prince or state" had become at best irrelevant and at worst a mockery. In the wake of the French Revolution, the manifesto had become the mode of agonism, the voice of those who are *contra*—whether against king or pope or ruling class or simply against the existing state of affairs. It is this agonistic mode of discourse that set the stage for what Marinetti called *l'arte di far manifesti.* Indeed, it is the curiously mixed rhetoric of the *Communist Manifesto,* its preamble itself something of a prose poem,[5] that paved the way for the grafting of the poetic onto the political discourse that we find in Futurist, and later in Dada and Surrealist, manifesto. "Ein Gespenst geht über Europa—das Gespenst des Kommunismus" ("A specter is haunting Europe—the specter of Communism")—here is the paradigmatic opening shot—a kind of verbal *frisson*—that the Futurists would adapt to their own purposes.

The shrewd recipe that Marinetti sent to Henry Maassen—"l'accusation *précise,* l'insulte bien *définie*"—made its Marinettian debut in the *Fondation et manifeste du futurisme,* published in Paris on the front page of *Le Figaro* on 20 February 1909. The *Figaro* headnote reads:

> M. Marinetti, the young Italian and French poet, whose remarkable and fiery talent has been made known throughout the Latin countries by his notorious demonstrations and who has a galaxy of enthusiastic disciples, has just founded the school of "Futurism," whose theories surpass in daring all previous and contemporary schools. The *Figaro,* which has already provided a rostrum for a number of these schools, and by no means minor ones, today offers its readers the Manifesto of the "Futurists." Is it necessary to say that we assign to the author himself full responsibility for his singularly audacious ideas and his frequently unwarranted extravagance in the face of things that are eminently respectable and, happily, everywhere respected? But we thought it interesting to reserve for our readers the first publication of this manifesto, whatever their judgment of it will be.[6]

This bit of mythmaking sets the tone for the brilliant propaganda machine to come. I say mythmaking because the fact is that Marinetti became a public figure as a result of, not prior to, the publication of the first Futurist manifesto. Even more ironic, the Marinetti whose "theories" were ostensibly more "daring" than those of "all previous and contemporary schools" was writing, as late as 1909, decadent versions of Baudelairean lyric like the following:

> Mon bel ange sensuel, brûlant et trempé
> des voluptés du ciel et de l'enfer! . . .
> Je tends les bras éperdument vers toi
> dans la profonde solitude
> de cette nuit étincelante qui m'inonde
> d'un flot d'étoiles glacées!

> My beautiful, sensual angel, burning and bathed
> in the pleasures of heaven and hell! . . .
> Madly, I hold out my arms to you
> in the deep solitude
> of this glittering night that floods me
> with a cascade of frozen stars![7]

This is the first stanza of "Le Dompteur" ("The Vanquisher"), which appeared in *Akademos* just a month before the publication of Marinetti's first manifesto. It ends with the lines:

> Ta chair, ta chair et sa chaleur nue tout entière,
> et son arome qui embaume à jamais
> la terre en deuil où je vais
> creusant un sillon monotone,
> Ta chair, ta chair et sa saveur tout entière,
> je l'attends!

> Your flesh, your flesh and all its naked warmth
> and its scent that forever perfumes
> with mourning the earth where I wander
> cutting a monotonous path,
> your flesh and all its deliverance,
> I wait for it!

Within a year, in *Futurist Painting: Technical Manifesto*, Umberto Boccioni and his fellow artists were to launch their attack on "the nude in painting, as nauseous and as tedious as adultery in literature." "Artists," Boccioni declared, "obsessed with the desire to expose the bodies of their mistresses have transformed the Salons into arrays of

unwholesome flesh" (*FM* 30; *AF* 65–67). He might have been talking about Marinetti's "Ta chair, ta chair et sa saveur tout entière."

The 1909 manifesto thus reflects Marinetti's program for the future rather than his own poetic practice. As a lyric poet, he was a mediocre late Symbolist; as a thinker, he was almost wholly derivative, his extravagant statements being easily traceable to Nietzsche and Henri Bergson, to Alfred Jarry and Georges Sorel.[8] But as what we now call a conceptual artist, Marinetti was incomparable, the strategy of his manifestos, performances, recitations, and fictions being to transform politics into a kind of lyric theater. We can see this transformation if we compare the 1909 manifesto to such related documents of the decade as Saint-Georges de Bouhélier's *Manifeste naturiste* (*Le Figaro*, 1897), Jules Romains's manifesto *Les Sentiments unanimes et la poésie* (*Le Penseur*, 1905), and Ernst Ludwig Kirchner's *Program für die Brücke* (1906), which was the first manifesto written by a visual artist.

Each of these manifestos anticipates themes that turn up in Marinetti's writings. Saint-Georges de Bouhélier, for example, declares himself to be the enemy of *symbolisme* as it was codified by Jean Moréas in his famous manifesto of 1886. Against such notions as art for art's sake, elitism, transcendence ("des Idées primordiales"), and willed obscurity ("un style archetype et complexe . . . les mystérieuses ellipses"),[9] de Bouhélier contends that "les hommes nouveaux" must turn to populism, nationalism, energy, and violence: "The art of the future must be heroic. Moreover, we have invented a new conception of the world. For that military intoxication that not long ago so strongly moved our fathers, has been transformed by us into a sort of cult of strength from which no one will be able to escape. We will glorify the hero" (Mitchell, *Manifestes littéraires*, p. 59).

For de Bouhélier, the hero is specifically the farm laborer, the peasant who is at one with nature. But the populist notion was soon transferred to the urban worker: Jules Romains begins his Unanimist manifesto as follows:

> At the present time, the life of civilized man has assumed a new character. Essential changes have given a different meaning to our existence. . . . The actual tendency of the people to mass together in the cities; the uninterrupted development of social relationships; ties stronger and more binding established between men by their duties, their occupations, their common pleasures; an encroachment, even greater, of the public on the private, the collective on the individual: here are the facts that certain people deplore but that no one contests. (Mitchell, *Manifestes littéraires*, p. 81)

In the modern city, the street becomes a kind of theater—"alive, endowed with a global existence and unanimous feelings." Art is the natural expression of this *unanimisme:* "I strongly believe that the bonds of feeling between a man and his city, that the whole ethos, the large movements of consciousness, the colossal passions of human groups are capable of creating a profound lyricism or a superb epic cycle" (Mitchell, *Manifestes littéraires*, p. 83).

A new urban mass art (Romains), an art of heroic violence and nationalism (de Bouhélier), an art that breaks defiantly with tradition as Ludwig Kirchner argued in a proclamation for *Die Brücke*, hand printed on a woodcut and widely distributed:

> With faith in development and in a new generation of creators and appreciators we call together all youth. As youth, we carry the future and want to create for ourselves freedom of life and of movement against the long-established older forces. Everyone with directness and authenticity conveys that which drives him to creation, belongs to us. [10]

Such calls for freedom, for the necessity of inventing a new art, go hand in hand with the spread of literacy and the use of print media in the later nineteenth century. As early as 1850, the Pre-Raphaelite journal *The Germ* bore on its back cover the following statement:

> An attempt will be made, both intrinsically and by review, to claim for Poetry that place to which its present development in the literature of this country so emphatically entitles it. The endeavor held in view throughout the writings on art will be to encourage and enforce an entire adherence to the simplicity of nature; and also to direct attention, as an auxiliary medium, to the comparatively few works which Art has yet produced in this spirit. [11]

Notice *The Germ*'s emphasis on group aesthetic, its insistence that dramatic change must take place if the right kind of art is to flourish. But neither in *The Germ* nor in its successors—*The Yellow Book* and *The Savoy* in England; *Lutèce* and *La Plume* in France—do the manifestos and critical essays claim to be more than texts of mediation, designed to lead the audience to the proper view of a given artist or movement. The novelty of Italian Futurist manifestos, in this context, is their brash refusal to remain in the expository or critical corner, their understanding that the group pronouncement, sufficiently aestheticized, can, in the eyes of the mass audience, all but take the place of the promised art work. Indeed, when a few months after its *Figaro* publication, Marinetti, preceding the performance of his play *Les Poupées électriques*, declaimed the 1909 manifesto from the stage

of the Teatro Alfieri in Torino, the audience all but disregarded the play itself (a fable of husband and wife, plagued by the mechanical puppets made by the former—puppets that, as allegorical embodiments of bourgeois duty, money, and old age, turn out to be the couple's own alter egos)[12] and responded to the drama of the manifesto.

The typical manifestos of the period open with a particular assertion or generalization about the arts. For example:

> There are, in art, problems of circumstance and problems that are essential. The former change every fifteen years, every thirty years, and every half-century, according to whether the issue is one of fashion, of taste, or of custom. The more ephemeral they are, the more they absorb the attention.[13]

Or:

> Never has a time been more favorable to artistic disputes. The Athenian Republic of modern times takes a passionate interest in them, and judges and condemns five or six times a year, on the occasion of a Salon, a concert, or a play.[14]

Here, by contrast, is the opening of Marinetti's 1909 manifesto:

> We had stayed up all night, my friends and I, under hanging mosque lamps with domes of filigreed brass, domes starred like our spirits, shining like them with the prisoned radiance of electric hearts. For hours we had trampled our atavistic ennui into rich oriental rugs, arguing up to the last confines of logic and blackening many reams of paper with our frenzied scribbling. (S 39).[15]

Not exposition—the controversial statement, the daring generalization—but narrative: this invention was one of Marinetti's master strokes. For when the eleven "theses" that follow in the body of the manifesto are placed within the narrative frame, their "validity" has already, so to speak, been established. So Marinetti begins by telling us about a particular night in Milan when he and his poet-friends stayed up till dawn, planning for the glorious future that would include "stokers feeding the hellish fires of great ships," "black spectres who grope in the red-hot bellies of locomotives launched down their crazy courses," "drunkards reeling like wounded birds along the city walls" (S 39). As the night comes to an end, the friends are drawn outdoors, not by bird song or moonlight but by the "mighty noise of the huge double-decker trams that rumbled outside, ablaze with coloured lights, like villages on holiday suddenly struck and uprooted

by the flooding Po and dragged over falls and through gorges to the sea."

Violence and precision—here is Marinetti's formula put into action. The friends dash outside and take off in their three motor cars (called *fauves* in the French version),[16] traveling with breakneck speed so that "Here and there, sick lamplight through window glass taught us to distrust the deceitful mathematics of our perishing eyes." In this newly discovered fantastic landscape, everything is transformed. The "ideal Mistress" of Romantic and Symbolist poetry gives way to the poet's *macchina* (the Italian word for *automobile* is oddly appropriate, given the Futurist context), capable of "hurling watchdogs against doorsteps, curling them under our burning tires like collars under a flatiron" (*S* 40; *TIF* 8). Marinetti himself almost meets the same fate: just when the drive is at its most exhilarating, his car comes up against two cyclists, swerves, and turns over in a womblike ditch:

> Oh! Maternal ditch, almost full of muddy water! Fair factory drain! I gulped down your nourishing sludge; and I remembered the blessed black breast of my Sudanese nurse. . . . When I came up—torn, filthy, and stinking—from under the capsized car, I felt the white-hot iron of joy deliciously pass through my heart! (*S* 40–41; *TIF* 9; ellipses are Marinetti's)

Capsized, the automobile is reborn: "Up it came from the ditch, slowly, leaving in the bottom, like scales, its heavy framework of good sense and its soft upholstery of comfort." Accordingly, their "faces smeared with good factory muck," with "celestial soot," the group can put forward its program.

Marinetti's narrative contains a good deal of intentional buffoonery and declamation. Everything is presented in the most extreme terms possible: the automobile as beautiful shark, "running on its powerful fins," the steering wheel like "a guilliotine blade that threatened my stomach," and so on. The language, as Luciano de Maria has noted,[17] is still heavily Symbolist—the maternal ditch, the overturning of the car as rebirth metaphor, the "electric hearts" of the hanging mosque lamps. But these images do not point toward the self; they reflect neither inner struggle nor the contours of an individual consciousness. On the contrary, Marinetti's selfhood is subordinated to the communal "we" (the first word of the manifesto), addressing the "you" of the crowd, the mass audience whom he hopes to move as well as to delight. In its reliance on hyperbole and parody (the reference to the

"maternal ditch" immediately leads to the memory of "the black breast of my Sudanese nurse"), Marinetti's *symbolisme* takes on something of a hard edge; his landscape of capsized cars and factory drains has less in common with, say, Mallarmé's "transparent glacier" than with the animated surface of the Walt Disney cartoon.

In its celebration of what D. H. Lawrence, an early admirer of Marinetti, called "the inhuman will,"[18] the 1909 manifesto strikes an oddly impersonal note. It is lyrical (in the sense of choric), declamatory, and oracular without being in the least self-revelatory or intimate. Not that Marinetti did not possess, as did Lawrence, an enormous ego, decry ego as he might. But in his manifestos and other writings, questions of individual psychology and personal emotion are consistently subordinated to the discourse's pathetic argument, its appeal to the audience to join the movement. Marinetti thus uses question, exhortation, repetition, digression, tropes, and rhetorical figures to draw the audience into his radius of discourse. For example:

> Che ci si vada in pellegrinaggio, una volta all'anno, come si va al Camposanto nel giorno dei morti . . . ve lo concedo. Che una volta all'anno sia deposto un omaggio di fiori davanti alla *Gioconda*, ve lo concedo . . . Ma non ammetto che si conducano quotidianamente a passeggio per i musei le nostre tristezze, il nostro fragile coraggio, la nostra morbosa inquietudine. Perché volersi avvelenare? Perché volere imputridire? (*TIF* 11; ellipses are Marinetti's)

> That one should make an annual pilgrimage, just as one goes to the graveyard on All Souls' Day—that I grant. That once a year one should leave a floral tribute beneath the *Gioconda*, I grant you that. . . . But I don't admit that our sorrows, our fragile courage, our morbid restlessness should be given a daily conducted tour through the museums. Why poison ourselves? Why rot? (*S* 42)

A man on his feet talking, Charles Olson might have said of this. Or again, "ONE PERCEPTION MUST IMMEDIATELY AND DIRECTLY LEAD TO A FURTHER PERCEPTION. . . . get on with it, keep moving, keep in, speed, the nerves, their speed."[19]

> Ci opponete delle obiezioni? . . . Basta! Basta! Le conosciamo . . . Abbiamo capito! . . . La nostra bella e mendace intelligenza ci afferma che noi siamo il riassunto e il prolungamento degli avi nostri.—Forse! . . . Sia pure! . . . Ma che importa? Non vogliamo intendere! . . . Guai a chi ci ripeterà queste parole infami! . . . (*TIF* 13; ellipses are Marinetti's)

> You have objections?—Enough! Enough! We know them . . . we've
> understood! . . . Our fine deceitful intelligence tells us that we are the
> revival and extension of our ancestors—perhaps! . . . If only it were
> so!—But who cares? We don't want to understand! . . . Woe to anyone
> who says those infamous words to us again! (S 44)

I shall return to the question of the theatricality of Marinetti's mani-
festos below. But first, let us look at the theses he puts forward. Here
are the first four:

> 1. We intend to sing the love of danger, the habit of energy and
> fearlessness.
> 2. Courage, audacity, and revolt will be essential elements of our
> poetry.
> 3. Up to now literature has exalted a pensive immobility, ecstasy,
> and sleep. We intend to exalt aggressive action, a feverish insomnia,
> the racer's stride, the mortal leap, the punch and the slap.
> 4. We affirm that the world's magnificence has been enriched by a
> new beauty: the beauty of speed. A racing car whose hood is adorned
> with great pipes, like serpents of explosive breath—a roaring car that
> seems to ride on grapeshot is more beautiful than the *Victory of Samo-
> thrace* (S 41)

Marinetti's cult of energy, aggressiveness, violence, and heroism is
not unlike that of such manifesto writers as de Bouhélier and Ro-
mains. But here the theses are not enumerated until the narrative has
already presented them in action: we have witnessed the "feverish
insomnia" of the poet and his friends, the "racer's stride" and the
worship of the "roaring car that seems to ride on grapeshot." Accord-
ingly, when we come to the ninth thesis, "We will glorify war—the
world's only hygiene—militarism, patriotism, the destructive gesture
of freedom-bringers, beautiful ideas worth dying for, and scorn of
woman," we do not question it as closely as we might; indeed, war is
made to look like the necessary prelude to a new world composed of
"great crowds excited by work," of "polyphonic tides of revolution in
the modern capitals," of the "vibrant nightly fervor of arsenals and
shipyards blazing with violent electric moons" (S 42; TIF 10). Images
of sound, color, and kinetic motion are foregrounded, the rhetorical
strategy of the manifesto being to minimize the possibiities for rumi-
nation on the reader's part.

Marinetti claimed to have received more than ten thousand letters
and articles in response to the publication of his manifesto in *Le
Figaro,* and although much of this mail was negative, even angry and
jeering,[20] the response tells us a great deal about manifesto art. The

eleventh and final thesis, for example, is often cited as a description of what Boccioni, Balla, and Carrà were doing in their paintings, but, ironically, the painters had not yet produced a single "Futurist" painting at the time that Marinetti was writing his paean to "shipyards blazing with violent electric moons," to:

> greedy railway stations that devour smoke-plumed serpents; factories hung on clouds by the crooked lines of their smoke; bridges that stride the rivers like giant gymnasts, flashing in the sun with a glitter of knives; adventurous steamers that sniff the horizon; deep-chested locomotives whose wheels paw the tracks like the hooves of enormous steel horses bridled by tubing; and the sleek flight of planes whose propellers chatter in the wind like banners and seem to cheer like an enthusiastic crowd. (*S* 42; *TIF* 10–11)

Just as Gertrude Stein began to resemble her portrait by Picasso only years after he had painted it, so the Futurist paintings (for example, Boccioni's *The City Rises* of 1910–11 [fig. 3.1] or Carrà's *Funeral of the Anarchist Galli* of 1911–12 [fig. 3.2]) were painted only *after* the publication of the manifesto, as if Marinetti's Nietzschean prophecies ("In truth I tell you") had to be fulfilled.

But it is not enough to say of this and subsequent Futurist manifestos that theory preceded practice, that, say, Luigi Russolo's *The Art of Noises* (1913) outlined the new sounds of the "Futurist orchestra" before the machines made to produce these sounds had been invented. For the real point is that the theory, in Russolo's as in Marinetti's manifesto, *is* the practice in that the text foregrounds what Giovanni Lista calls "the problematic of the precedence of project to work, of metalanguages to creation" (*F* 103). To talk about art becomes equivalent to making it, and indeed most historians of Italian Futurism agree that the series of fifty-odd manifestos published between 1909 and Italy's entrance into the war in 1915 were the movement's literary form par excellence.[21] Not only are Marinetti's manifestos more interesting than his poems, novels, or even than such experimental collage-texts as the problematic *Zang Tumb Tuuum;* his *arte di far manifesti* became a way of questioning the status of tradi-

Fig. 3.1 (opposite, top). Umberto Boccioni, *The City Rises*, 1910–11. Oil on canvas, 6' 6½" × 9' 10½". Collection, Museum of Modern Art, New York, Mrs. Simon Guggenheim Fund.

Fig. 3.2 (opposite, bottom). Carlo Carrà, *Funeral of the Anarchist Galli*, 1911. Oil on canvas, 6' 6¼" × 8' 6". Collection, Museum of Modern Art, New York; acquired through the Lillie P. Bliss Bequest.

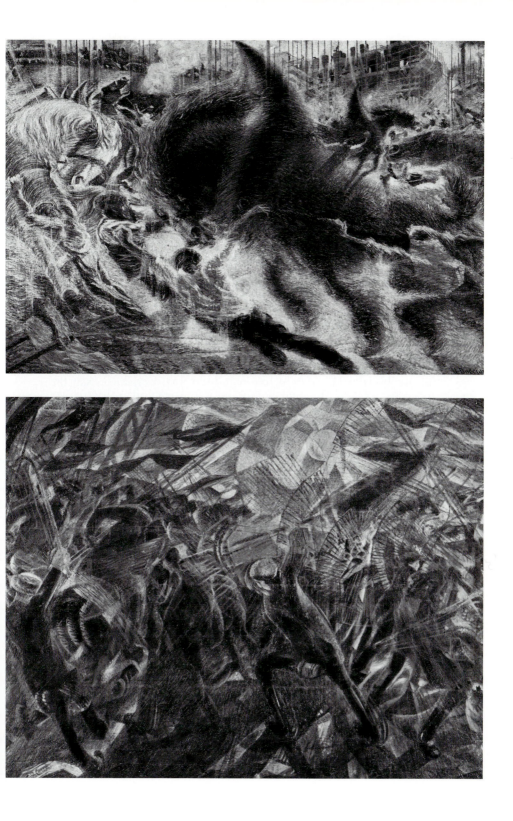

tional genres and media, of denying the separation between, say, lyric
poem and short story or even between poem and picture. The confla-
tion of music and noise, drama and theatrical gesture, narrative and
exposition, which has become so important in our own art, is gener-
ally understood as the manifestation of neo-Dada, but, as I shall argue
below, the Dada manifesto was itself, as in the case of Tristan Tzara's
1916 *Monsieur Antipyrine*, rooted in the Futurist model. I should like,
accordingly, to look more closely at that model, first as it evolved along
the Milan-Paris axis, and then, in the next chapter, as it evolved in
the work of the Russian avant-garde.

I

The *Futurist Painting: Technical Manifesto* was published as a leaf-
let in Marinetti's journal *Poésia* on 11 February 1910. It was com-
posed by Boccioni and Russolo (although the signatures of Carrà,
Balla, and Severini were also affixed to it) in a single day, Marinetti
joining the two artists in the evening to add the finishing touches.[22] A
few weeks later (18 March), the manifesto was declaimed from the
stage of the Teatro Chiarella in Torino to an audience of approximately
three thousand artists, students, and factory workers. Addressed "TO
THE YOUNG ARTISTS OF ITALY!" it adopted the violent rhetoric of con-
temporary political manifestos:

> Comrades, we tell you now that the triumphant progress of science
> makes profound changes in humanity inevitable, changes which are
> hacking an abyss between those docile slaves of past tradition and us
> free moderns, who are confident in the radiant splendour of our future.

And again:

> In the eyes of other countries, Italy is still a land of the dead, a vast
> Pompeii white with sepulchres. But Italy is being reborn. Its political
> resurgence will be followed by a cultural resurgence. In the land in-
> habited by the illiterate peasant, schools will be set up; in the land
> where doing nothing in the sun (*nel paese del dolce far niente*) was the
> only available profession, millions of machines are already roaring.
> (*FM* 24–25; *AF* 63)

The roaring machines are not only a prominent manifesto subject;
they also provide the manifesto writers with a new typographic format,
a format drawn from the world of advertising posters and newspapers,
which was soon to find its way into the literature of the period. In the
manifesto, the page supplants the stanza or the paragraph as the basic

print unit, a situation that, when applied to lyric poetry, was to call into question the integrity of the verse line itself.

This emphasis on the page is already notable in some of the German Expressionist periodicals of the period, especially Kandinsky and Marc's great almanac, *Der Blaue Reiter*, whose first edition appeared in May of 1912. The subscription prospectus written by Marc in mid-January of that year, begins:

> Today art is moving in a direction of which our fathers would never even have dreamed. We stand before the new pictures as in a dream and we hear the apocalyptic horsemen in the air. There is an artistic tension all over Europe. Everywhere new artists are greeting each other. . . . everywhere new forces are sprouting like a beautiful unexpected seed. . . .
>
> Out of the awareness of this secret connection of all new artistic production, we developed the idea of the *Blaue Reiter*. . . . The first volume herewith announced . . . includes the latest movements in French, German, and Russian painting. It reveals subtle connections with Gothic and primitive art, with Africa and the vast Orient, with the highly expressive, spontaneous folk and children's art, and especially with the most recent musical movements in Europe and the new ideas for the theater of our time.[23]

Thus Franz Marc's opening manifesto "Spiritual Treasures" ("Geistige Güter"), which makes the case for a new art of "*mystical inner construction*" ("die *mystisch-innerliche Konstruktion*"), contains six illustrations for what is a four-page text: (1) a German woodcut (1495) from the *Ritter vom Turn* series (fig. 3.3); (2) a Chinese painting of unknown origin, probably a nineteenth-century imitation; (3) a small etching of a horse by Marc and, on the facing page, (4) a Bavarian mirror painting of the death of a saint, painted after 1800; (5) Picasso's *Woman with Mandolin at the Piano* (1911), and (6) two children's drawings.[24] These juxtapositions are designed to illustrate the almanac's theme that art knows no geographical or historical boundaries, that, say, a folk painting from Bavaria may contain the same spiritual and artistic truths as a Picasso. As an illustrated book, *Der Blaue Reiter* is thus highly original; it forces the reader to make startling connections between the "primitive" and the "modern," between the medieval knight and the Benin warrior (see *BR* 128–29). The print format, on the other hand, is still quite conventional, captioned illustrations being carefully set apart from the type, which is arranged in blocks and serrated so that the eye travels in normal sequence from line to line.

Geistige Güter

von Franz Marc

Deutsch (15. Jahrh.)

s ist merkwürdig, wie geistige Güter von den Menschen so vollkommen anders gewertet werden als materielle.

Erobert z. B. jemand seinem Vaterlande eine neue Kolonie, so jubelt ihm das ganze Land entgegen. Man besinnt sich keinen Tag, die Kolonie in Besitz zu nehmen. Mit gleichem Jubel werden technische Errungenschaften begrüßt.

Kommt aber jemand auf den Gedanken, seinem Vaterlande ein neues reingeistiges Gut zu schenken, so weist man dieses fast jederzeit mit Zorn und Aufregung zurück, verdächtigt sein Geschenk und sucht es auf jede Weise aus der Welt zu schaffen; wäre es erlaubt, würde man den Geber noch heute für seine Gabe verbrennen.

Ist diese Tatsache nicht schauerlich?

Ein kleines, heute aktuelles Beispiel verleitet uns zu dieser Einleitung.

Meier-Graefe kam auf den Gedanken, seinen Landsleuten die wunderbare Ideenwelt eines ihnen ganz unbekannten, großen Meisters zu schenken – es handelt sich hier um Greco; die große Allgemeinheit, selbst der Künstler, blieb nicht nur gleichgültig,

Fig. 3.3. Wassily Kandinsky and Franz Marc, *Der Blaue Reiter*, p. 21. R. Piper, Munich, 1912; new critical edition, ed. Klaus Lankheit, R. Piper, 1979. The woodcut from *Ritter vom Turn, von den Exempeln der Gottesfurcht und Erbarkeit* is dated Basel, 1495.

It is this linearity that was called into question by the typography of the Italian Futurist manifesto. The use of boldface headings, capital letters, numbered series, and aphorisms set off from the text can, of course, be traced back to the various communist manifestos and pamphlets of Marx and Engels, but the more immediate source of Futurist page design was the language of advertising of the late nineteenth century. As Arthur A. Cohen observes:

> The placard, the sandwich man, the poster, the sign, the advertisement, the leaflet, the broadside, prospectus, *prier d'insérer*, ticket, handbill—all these methods of calling out, shouting, if you will, were

devices of circumventing traditional language, imitating the sound of speech, and hence restoring to a kind of primacy, the original spoken rhythm which had been for millenia abstracted by written language. . . . Since its [advertising's] intentions were thought to be vulgar, its means could be untraditional. Garishness of color, juxtapositions of bold wood typefaces, the use of illustrative cuts . . . the mix of fonts, the stridency of exclamation points and underscorings, all these could be employed by the commercial arm of the reigning bourgeoisie to advertise a product and to sell it. Typographic novelty began, so to speak, in the marketplace, catching the accelerated pace of an urban culture.[25]

L'arte di far manifesti was a way of infusing this commercial strain into the lyric fabric, the intent being to close the gap between "high" and "low" art.[26] Titles, for example, became very important. When Moréas published his manifesto of 1886, he called it quite simply *Le Symbolisme*; again, Jules Romains called his *unanimiste* manifesto *Les Sentiments unanimes de la poésie*. Here, by contrast, are some of Marinetti's titles, usually printed in big black block letters: *Uccidiamo il chiaro di luna!* (*Let's Murder the Moonshine*), *Contro Venezia passatista* (*Against Past-Loving Venice*), *Abbasso il tango e Parsifal!* (*Down with the Tango and Parsifal*), *Distruzione della syntassi—Immaginazione senza fili—Parole in libertà* (*Destruction of Syntax—Wireless Imagination—Words-in-Freedom*). To be memorable, Marinetti posited, a title must be concrete and provocative enough to catch the eye as well as the ear. Other Futurists followed suit: *Absolute Motion Plus Relative Motion Equals Dynamism* (Boccioni), *Futurist Reconstruction of the Universe* (Balla, Fortunato Depero), *Futurist Manifesto of Lust* (Valentine de Saint-Point), and so on.

Subtitles also play a big role. In *Destruction of Syntax—Wireless Imagination—Words-in-Freedom*, Marinetti introduces such subtitles as *The Semaphoric Adjective, Typographical Revolution, Death of Free Verse*, and *Multilinear Lyricism*. These subtitles are usually printed in italics or bold face, the model being the newspaper column. Under these headings, items are regularly numbered, again with boldface headings, as in *Futurist Painting: Technical Manifesto* where we read "WE DECLARE," followed by a list of nine items, and "WE FIGHT," followed by a list of four. Balilla Pratella's *Manifesto of Futurist Musicians* (1910) similarly lists eleven stated aims, all in the infinitive and in capital letters, beginning with the following:

1. TO CONVINCE YOUNG COMPOSERS TO DESERT SCHOOLS, CONSERVATORIES AND MUSICAL ACADEMIES, AND TO CONSIDER FREE STUDY AS THE ONLY MEANS OF REGENERATION. (*FM* 37)

Enumeration is, as the authors of political manifestos had long understood, a way of arresting the attention of the audience. The numbered principles or goals of the Futurists almost always shade into one another; they are all part of the same thrust. But numbering implies that the authors mean business, that the goals to be achieved are practical and specific. It also means that the individual units are short and immediately perceivable by the reader, as in the following list from *Wireless Imagination:*

1. Acceleration of life to today's swift pace. . . .
2. Dread of the old and the known. Love of the new, the unexpected.
3. Dread of quiet living, love of danger and an attitude of daily heroism.
4. Destruction of a sense of the Beyond and an increased value of the individual whose desire is *vivre sa vie*, in Bonnot's phrase.
5. The multiplication and unbridling of human desires and ambitions.
(*FM* 96; *TIF* 65)

Sometimes, as in Marinetti's *The Variety Theater*, first published in *Lacerba* in October 1913 and then in English in the *Daily Mail* that November,[27] different print faces, large type, numerical listing in boldface, and the use of plus and equal signs are combined with *parole in libertà*, that is, a string of nouns or noun phrases (usually concrete images) in apposition, with no connectives between them, as well as with onomatopoeic articles (see fig. 3.4).

Here Marinetti wants to present us with a graphic image of his thesis—that "The Variety Theater is absolutely practical, because it proposes to distract and amuse the public with comic effects, erotic stimulation, or imaginative astonishment" (*S* 116; *TIF* 70). Accordingly, the page contains advertising slogans in large bold type ("FUMEZ FUMEZ MANOLI FUMEZ MANOLI CIGARETTES"; "GIOCONDA ACQUA PURGATIVA"); the phonetic representation of screeching ambulance sirens ("**trrrr trrrr** sulla testa **trombeeebeeebeette** fiiiiiischi sirene d'autoambulanze + pompe elettriche"), and the burlesque cataloging of erotic measurements ("donna in camicia [50 m. + 120 altezza della casa = 170 m.]"). But, most important, the manifesto page substitutes white space or blanks for conventional punctuation so as to indicate an abrupt stop, a change of scene or image. The main effect is thus one of fragmentation. Once white space becomes an integral element of the composition, a kind of design feature, it is just one step to a manifesto like Apollinaire's *L'Antitradition futuriste* (fig. 3.5).[28]

Apollinaire's manifesto has an equivocal place in the canon. According to Carrà, the typographic arrangement was an afterthought,

exceutriques, capables de provoquer un boucan énorme par des pinçons aux femmes et autres bizar-
reries. Saupoudrer les fauteuils d'une poudre qui provoque le prurit ou l'éternûment.

4. Prostituer systématiquement tout l'art classique sur la scène, donnant, par ex., en une
seule soirée, toutes les tragédies grecques, françaises, italiennes, en abrégé. Vivifier les œuvres de
Beethoven, de Wagner, de Bach, de Bellini, de Chopin, en les coupant par des chansons napolitaines.
Mettre côte à côte sur la scène Mounet-Sully et Mayol, Sarah et Fregoli. Exécuter une symphonie
de Beethoven à rebours. Serrer tout Shakèspeare en un seul acte. En faire autant pour les auteurs
les plus vénérés. Faire jouer le *Cid* par un nègre. Faire jouer *Hernani* par des acteurs mi-enfermés
dans des sacs. Savonner soigneusement les planches de la scène pour provoquer des glissades
amusantes au moment le plus tragique.

5. Encourager de toute façon le genre des excentriques américains et des clowns, leurs
effets de grotesque mécanique, de dynamisme effrayant, leurs fantaisies grossières, leurs énormes
brutalités, leurs gilets à surprise et leurs pantalons profonds comme des cales, d'où sortira avec mille
cargaisons la grande hilarité futuriste qui doit rajeunir la face du monde. Car, ne l'oubliez pas,
nous sommes de **jeunes artilleurs en goguette,** comme nous l'avons proclamé dans
notre manifeste *Tuons le Clair de lune!*

Contre Clair de lune et vieux firmaments partir en guerre chaque soir
les grandes villes brandir affiches lumineuses immense visage de nègre (30 m.
de haut) fermer ouvrir un œil d'or (3 m. de haut) FUMEZ FUMEZ MANOLI
FUMEZ MANOLI CIGARETTES femme en chemise (50 m.) serrer
desserrer un corset mauve rose lilas bleu mousse de lampes électriques dans
une coupe de champagne (30 m.) pétiller s'évaporer dans une bouche d'ombre

affiches lumineuses se voiler mourir sous une main noire ténace renaître continuer
prolonger dans la nuit l'effort de la journée humaine courage **+** folie jamais mourir
ni s'arrêter ni s'endormir affiches lumineuses ⇋ formation et désagrégation de
minéraux et végétaux centre de la terre circulation sanguine dans les visages
de fer des maisons futuristes s'animer s'empourprer (joie colère) dès que les ténèbres
pessimistes négatrices sentimentales nostalgiques se rangent en bataille pour assiéger la
ville réveil fulgurant des rues qui canalisent durant le jour le grouillement
fumeux du travail 2 chevaux (30 m. de haut) faire rouler sous leurs sabots
boules d'or GIOCONDA ACQUA PURGATIVA ITALIANA
 entrecroisement de **trrrrr trrrrr** Elevated **trrrrr trrrrr** au-dessus
de la tête **teeeeee teeeeee** siiiiiifflets sirènes d'auto-ambulances **+** pompes
électriques transformation des rues en corridors splendides mener pousser
logique nécéssité la foule vers trépidation **+** hilarité **+** brouhaha du Music-hall
FOLIES-BERGÈRE EMPIRE CRÈME-ÉCLIPSE tubes de mercure rouges
rouges rouges bleus bleus bleus violets énormes lettres-anguilles d'or feu
pourpre diamant défi futuriste à la nuit pleurnicheuse défaite des étoiles
chaleur enthousiasme foi conviction volonté pénétration d'une affiche lumineuse dans la
maison d'en face **gifles jaunes** à ce podagreux en pantoufles bibliophiles qui sommeille
 3 miroirs le regardeeer l'affiche plonger dans les 3 abîmes mordorés
ouvrir fermer ouvrir fermer des profondeurs de 3 milliards de kilomètres
horreur sortir sortir ouste chapeau canne escalier auto tamponner
cris-de-cochon **keueu-keu** ça y est éblouissement du promenoir
solennité des panthères-cocottes parmi les tropiques de la musique légere
odeur ronde et chaude de la gaîté Music-Hall ⇋ ventilateur infatigable pour le cerveau
surchauffé du monde

MILAN, 29 Septembre 1913. **F. T. Marinetti.**

DIRECTION DU MOUVEMENT FUTURISTE: Corso Venezia, 61 – MILAN

Fig. 3.4. F. T. Marinetti, "The Music Hall." *Daily Mail*, November 1913.
Arnoldo Mondadori Editore. Reproduced in Giovanni Lista, *Marinetti et le
futurisme: Etudes, documents, iconographie*. L'Age d'Homme, Lausanne,
1977. Unpaginated photo section.

composed by Marinetti for the *Lacerba* edition (15 September 1913),
and it is true that the earlier French edition (*Gil-Blas*, 3 August 1913)
did not have this layout. Apollinaire scholars have gone even further,
arguing that, given Apollinaire's harsh criticism of the Futurists in
1912,[29] the manifesto must be a parody. Indeed, Apollinaire's poet-
friend André Salmon, who introduced the manifesto in *Gil-Blas*, wrote:

Futurism is dead! It is M. Guillaume Apollinaire, the poet of *Alcools*,
the novelist of *Hérésiarque et Cie*, who gave it its deathblow in signing
the manifesto you are about to read. It was necessary to do this: to be

more futurist than Marinetti! M. Guillaume Apollinaire has succeeded in it, to our joy. Here is the document, the originality of whose typography we regret not being able to follow entirely.

And Salmon refers to the manifesto as "the most colossal hoax of the century." [30]

Other critics have argued that the manifesto, though untypical of Apollinaire's response to Futurism, represents a brief flirtation with the Italian movement;[31] still others, like Giovanni Lista, suggest that, whatever Apollinaire may have said about Futurism in his essays and reviews, his own literary works—for example, "Les Fenêtres" and "Lettre-Océan," not to mention "Les Mamelles de Tirésias"—are in fact closely allied to Futurist poetic.[32]

For our purposes here, it matters less whether Apollinaire was or was not writing tongue-in-cheek, or whether Marinetti did or did not devise the typography of the manifesto after the fact, than that we have, in any case, a "simultaneous" text that functions very much like a poem. For here it is not just a matter of combining different typefaces, using boldface and italics, subheads and numbered lists,

Fig. 3.5. Guillaume Apollinaire, *L'Antitradition futuriste*, 1913, pp. 122 and 124. Reproduced in Giovanni Lista, *Futurisme*. L'Age d'Homme, Lausanne, 1973.

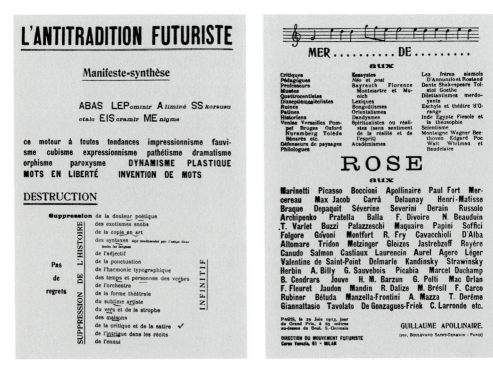

vertical printing, onomatopoeic devices, and white spaces. Rather, double entendre and word play begins with the very first phrase, an acrostic in which the capital letters spell out "À bas le passéisme," and the so-called nonsense words contain such buried words as "eliminé" and "énigme." Again, the manifesto does not just attack such "traditional" poetic features as syntax, the adjective, punctuation, the line and strophe, and so on; it demonstrates how writing looks when it is stripped of all these things. Not coincidentally, the last item to be suppressed is "l'ennui." Again, under the heading "CONSTRUCTION," Apollinaire beats Marinetti at his own game of *parole in libertà* by creating such comic combinations as "Nomadisme épique exploratorisme urbain **Art des voyages** et des promenades"—all these items presented nonhierarchically. Under subhead 2, *"Intuition vitesse ubiquité,"* we find complex punning: "**Analogies et calembours** tremplin lyrique et seule science des langues calicot Calcutta tafia Sophia le Sophi suffisant Uffizi officier officiel ô ficelles Aficionado Dona-Sol Donatello Donateur donne à tort torpilleur" (*F* 123). Here word play such as "uffizi officier officiel ô ficelles Aficionado" looks ahead to Dada, as does the musical parody of "MER. DE." which becomes "MERDE" and is wished on such disparate groups as "Quattrocentistes," "Défenseurs de paysages," and "Spiritualistes ou réalistes," the rhymes producing absurd conjunctions. A similar absurdity characterizes the catalog of contemporary artists to whom ROSE is given:

Severine Severini

Pratella Balla

Kandinsky Strawinsky

and so on. The typographic form of *L'Antitradition futuriste* looks ahead to the *calligramme* called "Lettre-Océan" (1914), with its juxtapositions such as:

 Correos
 Mexico
4 centavos

U.S. Postage
 2 cents 2

or its boldface nouns placed within the wheel figure such as "LES CHAUSSURES NEUVES DU POÈTE," "GRAMOPHONES," "AUTOBUS," and "SIRÈNES."[33] Once the manifesto had set the stage for such *parole in*

libertà, the transformation of the way literary texts were perceived on the page was inevitable.

There are two things especially worth noting about *L'Antitradition futuriste*. First, it takes materials from earlier manifestos and presents that material in highly condensed elliptical form, juxtaposition replacing any kind of logical or sequential statement. Second, the verbal-visual space created by the positioning of phrases, words, and letters, by the acrostics, puns, and catalogs in which discordant elements are introduced (as in the case of "les maisons," which is included in the list of grammatical features that are to undergo "DESTRUCTION"), a verbal-visual space that could not have existed prior to the invention of the typewriter, has strong affinities with collage composition, as defined in chapter 2. Within the next few years, the ideograms of Apollinaire and Marinetti gave way to actual pictogram, as in Balla's *Le Vêtement antineutraliste* of 1914 (see fig. 3.6) as well as in the free-word paintings of Marinetti, Severini, Soffici, and Carrà (see fig. 3.7).[34] In free-word painting, manifesto and collage come together,

Fig. 3.6. Giacomo Balla, *Le Vêtement antineutraliste*, 11 September 1914. Reproduced in *MF* 209.

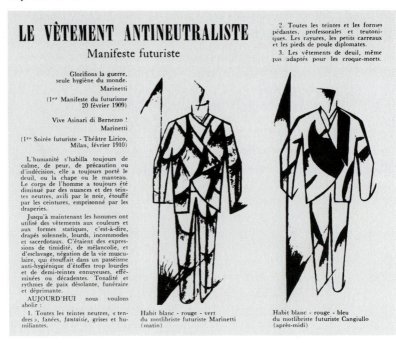

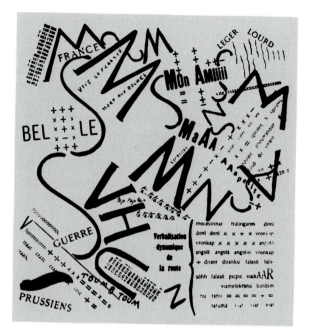

Fig. 3.7. F. T. Marinetti, *After the Marne, Joffre Visited the Front in an Automobile*, 1915. In *Les Mots en liberté futuristes*, 1919. Beinecke Rare Book and Manuscript Library, Yale University.

although not yet in ways as subtle as those used by the Russian Futurists.

II

In his manifesto *Futurist Painting and Sculpture* (1914), Boccioni declares:

> For us the picture is no longer an exterior scene, a stage for the depiction of a fact. A picture is not an irradiating architectural structure in which the artist, *rather than the object*, forms a central core. It is the emotive, architectural environment which creates sensation and completely involves the observer. . . . We therefore maintain, unlike Cézanne, that *the boundaries* of the object tend to retreat towards a periphery (the environment) *of which we are the centre*. (FM 177)

The "emotive architectural environment" that "involves the observer" is created, in Futurist manifesto, by a variety of theatrical strategies, the most important being the conception of the artist as *im-*

isatore, creating what Gerald L. Bruns has aptly called "a spe-
of unforeseen discourse":

> [Improvisation] is discourse whose beginning is what matters, because
> to improvise is to begin without second thought, and under the rules
> there is no turning back. . . . Improvisation is the performance of a
> composition at the moment of its composition. One preserves such a
> moment by refusing to revise its results. . . . it is discourse that pro-
> ceeds independently of reflection; it does not stop to check on itself. It
> is deliberate but undeliberated.[35]

"Deliberate" because the successful improvisation is designed, in
Bruns's words, "to outwit the reader . . . to disrupt readerly expecta-
tions and the consequent ability to recognize what is taking place"
(p. 148). Improvisation is, in other words, an art that depends not on
revision in the interests of making the parts cohere in a unified formal
structure, but on a prior readiness, a performative stance that leaves
room for accident and surprise. Or at least, in the case of the Futurist
manifesto, a stance that pretends to leave such room.

Thus Marinetti observes in *The Birth of Futurist Aesthetic* (1915):

> To a finished house we prefer the framework of a house in construction
> whose girders are the color of danger—landing platforms for air-
> planes—with its numberless arms that claw and comb out stars and
> comets, its aerial quarterdecks from which the eye embraces a vaster
> horizon. . . .
> The frame of a house in construction symbolizes our burning passion
> for the coming-into-being of things [*pel divenire delle cose*]. (*S* 81–82;
> *TIF* 271)

And in *The Futurist Synthetic Theatre*, written in collaboration with
Emilio Settimelli and Bruno Corra, Marinetti declares:

> We believe that a thing is valuable to the extent that it is improvised
> (hours, minutes, seconds), not extensively prepared (months, years,
> centuries). . . . THE GREATER NUMBER OF OUR WORKS HAVE BEEN
> WRITTEN IN THE THEATRE. . . . Our Futurist theatre jeers at Shake-
> speare but pays attention to the gossip of actors, is put to sleep by a
> line from Ibsen but is inspired by red or green reflections from the
> stalls. WE ACHIEVE AN ABSOLUTE DYNAMISM THROUGH THE INTER-
> PENETRATION OF DIFFERENT ATMOSPHERES AND TIMES. (*FM* 194–95;
> *TIF* 101–02)

"A thing is valuable to the extent that it is improvised"—this prefer-
ence for the unfinished, the tentative, the potential, for "girders that
are the color of danger," characterizes the form as well as the ideologi-

cal stance of Futurist manifesto. Consider the proclamation *Against Past-Loving Venice* (*Contro Venezia passatista*), printed on leaflets, eight hundred thousand of which were dropped from the top of the clock tower in Venice on 8 July 1910, just as the Sunday afternoon crowd was returning from its weekly excursion to the Lido:

> We renounce the old Venice, enfeebled and undone by worldly luxury, although we once loved and possessed it in a great nostalgic dream.
>
> We renounce the Venice of foreigners, market for counterfeiting antiquarians, magnet for snobbery and universal imbecility, bed unsprung by caravans of lovers, jeweled bathtub for cosmopolitan courtesans, *cloaca maxima* of passéism.
>
> We want to cure and heal this putrefying city, magnificent sore from the past. We want to cheer and ennoble the Venetian people, fallen from their ancient grandeur, drugged by a contemptible mean cowardice in the practice of their little one-eyed businesses.
>
> We want to prepare the birth of an industrial and military Venice that can dominate the Adriatic Sea, that great Italian lake.
>
> Let us hasten to fill in its little reeking canals with the shards of its leprous, crumbling palaces.
>
> Let us burn the gondolas, rocking chairs for cretins, and raise to the heavens the imposing geometry of metal bridges and howitzers plumed with smoke, to abolish the falling curves of the old architecture.
>
> Let the reign of holy Electric Light finally come, to liberate Venice from its venal moonshine of furnished rooms. (*S* 55; *TIF* 30)

The syntactic parallelism of this text is deceptive, for within the seemingly reasonable confines of its declarative statements ("Noi ripudiamo . . . ," "Noi vogliamo . . ."), Marinetti introduces a series of outrageous metaphors and hyperboles: Venice as market for "antiquari falsificatori," as "semicupio ingemmato [jeweled bathtub] per cortigiane cosmopolite," Venice as the city of "leprous crumbling palaces," its gondolas, "rocking chairs for cretins," and its contemptible and cowardly tradesmen practicing "their little one-eyed businesses." Venice is, in other words, the giant whore, as she is pictured in the caricatures of André Warnod that accompanied the text when it was printed in *Comoedia* in 1910 (see fig. 3.8).

Given this graphic emphasis on decayed splendor, a beauty destroyed by venereal disease, the designation of the Adriatic Sea as "that great Italian lake" is likely to strike a responsive chord in the reader. Who among the ordinary Venetian citizens of 1910, a people abjectly serving the tourist trade from the richer countries of northern Europe, did not yearn to make Venice once again the capital of the great Adriatic Empire? In this context, the "reign of Holy Electric

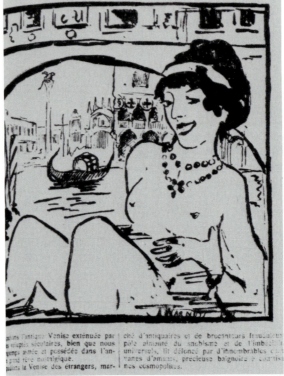

Fig. 3.8. André Warnod, cartoon illustration for "Venice futuriste," in *Comoedia*, 1910. Reproduced in *MF*, unpaginated photo section.

Light" surely promises a way out, an escape from the "venal moon-shine of furnished rooms."[36] So the cartoonist provided comic "be-fore" and "after" pictures (fig. 3.9). Before: the languid canal with swanlike gondolas; after: the regiment of gondoliers marching with their swords to the beat of the drum. Before: grotesque and flabby lovers smooching in the Piazza San Marco; after: a city of bridges, dirigibles, smoke stacks, and electric lamps, their rays replacing those of the sun. To the left of center, we see a replica of the Eiffel Tower, as if to say that Venice has now become Paris. And of course that is the point of *Contro Venezia passatista*.

The distribution of leaflets was followed by an improvised "Futurist Speech to the Venetians" ("Discorso futurista di Marinetti ai Veneziani") which provoked a terrible battle. According to R. W. Flint, "The Futurists were hissed, the passéists were knocked around. The Futurist painters Boccioni, Russolo, and Carrà punctuated this speech with resounding slaps. The fists of Armando Mazza, a Futurist poet who was also an athlete, left an unforgettable impression" (*S* 56). Marinetti's address, framed as a series of questions, exhortations, and apocalyptic lyric statements, is particularly interesting. In a manifesto scorning romantic love and the tyranny of "veiled women at every twilight turn," Venice itself is addressed as a woman so seductive that she is hard to resist:

Fig. 3.9. André Warnod, cartoon illustrations for "Venice futuriste," in *Comoedia*, 1910.

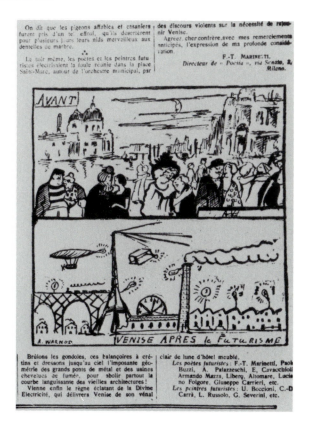

Enough! Enough! [*Basta! Basta!*] Stop whispering obscene invita-
tions to every mortal passerby, O Venice, old procuress, who, under
your heavy mosaic mantilla, still eagerly prepare exhausting romantic
nights, querulous serenades, and frightful ambushes!

Nevertheless, O Venice, I used to love the sumptious shade of your
Grand Canal, steeped in exotic lewdnesses [*impregnata di lussurie
rare*], the hectic pallor of your women who slip from their balconies
down ladders woven of lightning, slanting rain, and moonrays to the
tinkle of crossed swords.

But enough! . . . now we want electric lamps brutally to cut and
strip away with their thousand points of light your mysterious, sicken-
ing, alluring shadows! (*S* 56; *TIF* 31)

In presenting himself as torn between his former absorption in the
voluptuous, sensual life of the city and his new faith in its future as an
industrial capital, in which the former tour guides will have useful
employment, Marinetti is exploiting the ethical argument: he is the
man, he suffered, he was *there!* Yet we should note that, again, the
tone of the discourse is oddly impersonal. Nothing of the poet's private
life is revealed; on the contrary, his role is to speak for one and all,
the "we" and "you" brought into intimate collusion:

Oh! Don't defend yourselves. . . .

Oh! How we'll dance on that day! Oh! How we'll applaud the la-
goons, will egg them on to destruction! And what a splendid round
dance we'll have in the illustrious ruins! All of us will be insanely gay,
we, the last student rebels of this too wise world! (*S* 57; *TIF* 32–33)

Having taken the Venetians into his confidence, having treated them
as equals, he can now shrewdly take their innate opposition into ac-
count: "All right, shrug your shoulders and shout at me that I'm a bar-
barian, unable to enjoy the divine poetry that hovers over your en-
chanting isles!" He begs, wheedles, cajoles, but also scolds: "Shame
on you! Shame on you! And you throw yourselves one on top of an-
other like bags of sand to make an earthworks on the border, while we
prepare a great strong, industrial, commercial, and military Venice on
the Adriatic Sea, that great Italian lake!" (*S* 58; *TIF* 33).

Improvising as he goes along (and we must try to imagine what the
speech was like when accompanied by Russolo's noisemakers), Mari-
netti does not quite know what he will say next, nor does it really
matter. He can repeat, underscore, reposition himself, following the
paradigm of banter, question-and-answer, exhortation and exclama-
tion, hyperbole, personification, absurd metaphysical conceit, and

graphic image. The manifesto remains open-ended, its final reference to "a great strong industrial, commercial, and military Venice on the Adriatic Sea, that great Italian lake!" repeating, in formulaic style, a phrase from the original proclamation: "We want to prepare the birth of an industrial and military Venice that can dominate the Adriatic Sea, that great Italian lake."

Such variation of the formula can continue as long as the manifesto holds the attention of its audience. And it holds that attention by its continual provocation, its reference, for example, to the Aswan Dam as an "immense trap with electric folding doors in which the Futurist genius of England imprisons the fleeing sacred waters of the Nile!" If the waters of the Nile can be mastered, why not the Adriatic? Once set in motion, the pseudologic of the improvisation is implacable: "Have you forgotten that first of all you are Italians, and that in the language of history this word means: *builders of the future?*" By this time, the *improvvisatore* has the audience eating out of his hands.

When Marinetti told Henry Maassen that the formula for manifesto art was "violence and *precision*," he might have added a third quality that he and his fellow manifesto writers had in abundance—namely wit. We have already seen the effect of comic hyperbole in *Contro Venezia passatista,* in which the inertia of the modern Venetian is defined by comparing the gondoliers to "gravediggers trying in cadence to dig ditches in a flooded cemetery" (*S* 57; *TIF* 32). An even better example of Marinetti's proto-Dada sense of the absurd is found in the 1914 manifesto *Down with the Tango and Parsifal,* subtitled *Futurist letter circulated among cosmopolitan women friends who give tango-teas and Parsifalize themselves (Abbasso il tango e Parsifal!: Lettera futurista circolare ad alcune amiche cosmpolite che dànno dei thè-tango e si parsifalizzano).*

Here the coinage *parsifalizzano* comically implies that the cult of Wagner is no more than the latest fashion in social dance, in this case the tango. But the equation of tango and Parsifal is also quite serious, Marinetti implying that the revolutionary and nationalist spirit must embrace all areas of cultural life, its fashions in dance or food or clothing as well as in the "high" arts. In order to deflate the high-society cult of both these exotic imports—tango and Parsifal—the manifesto again resorts to catalogs of absurd metaphors, to gigantism:

> Monotony of romantic haunches, amid the flashing eyes and Spanish daggers of de Musset, Hugo, and Gautier. Industrialization of Baude-laire, *Fleurs du mal* weaving around the taverns of Jean Lorrain for impotent voyeurs *à la* Huysmans and inverts like Oscar Wilde. Last

crazy fling of a sentimental, decadent, paralytic romanticism toward
the Fatal Woman of cardboard [*la Donna Fatale di cartapesta*]. (*S* 69;
TIF 82)

The image is one of parody *fin de siècle*, of the final death throes of the
Romantic tradition of Victor Hugo and Alfred de Musset, culminat-
ing, via J. K. Huysmans and Oscar Wilde—and, one might add, via
the young Marinetti himself—in a mechanized ("Industrialization of
Baudelaire") cardboard version of *Les Fleurs du mal*. Such hyperbole
is punctuated, as so often in Futurist manifesto, by aphorism:

> To possess a woman is not to rub against her but to penetrate her.

And again the poet adopts the dialogic mode, responding to his own
cynical aphorism with the dismay of the outraged listener:

> "Barbarian!"
> "A knee between the thighs? Come! they want two!"
> "Barbarian!"
> Well, then, yes, we are barbarians!

Having declared his willingness to assume this adversary role, the
performance artist can now invent increasingly absurd fantasies about
the enraptured tango dancers:

> Is it amusing for you to look each other in the mouth and ecstatically
> examine each other's teeth, like two hallucinated dentists? To yank?
> . . . To lunge? . . . Is it so much fun to arch desperately over each
> other, trying to pop each other like two corked bottles, and never suc-
> ceeding? (*S* 69–70; *TIF* 82–83; ellipses are Marinetti's)

And then, having made us laugh, the poet shifts tone abruptly, casting
a cold eye on the concept of fashion in art, even as D. H. Lawrence
was to do in manifestos like "Surgery for the Novel—or a Bomb"
(1923). Here is Marinetti's indictment:

> Tristan and Isolde who withhold their climax to excite King Mark.
> Medicine dropper of love. Miniature of sexual anguish. Spun sugar of
> lust. Lechery out in the open. Delirium tremens. Cockeyed hands and
> feet. Pantomime coitus for the camera. Masturbated waltz. pouah!
> Down with the diplomatics of the skin! (*S* 70; *TIF* 83) [37]

Metaphor after metaphor, piled up in abrupt noun phrases, followed
by renewed exhortation: down with . . . up with! The speaker's atten-
tion then turns to Richard Wagner and the same strictures are applied
to *Parsifal*, with its "cloudbursts, puddles, and bogs of mystical
tears." Again the tone is comic—"Tears and false pearls of Mary

Magdalen in décolletage at Maxim's"—but the humor is savage, Marinetti making his case for an honest and open sexuality, for a rejection of romantic cant and coyness. His final rhetorical flourish—a sort of last twist of the knife—is to turn the significance of "tango" and "parsifalization" back on those who practice it by informing them that

> Furthermore, you forget *this final argument*, the only persuasive one *for you:* to love Wagner and *Parsifal* today, performed everywhere and especially in the provinces . . . to give tango-teas like all good bourgeois all over the world, come come, it's no longer CHIC! [NON È PIUUUÙ CHIC!] (*S* 71; *TIF* 84)

This is a good example of the power of improvisation to outwit the reader. For Marinetti has declared, in the opening paragraph of the manifesto, just two pages earlier, that "This epidermic oscillation [the tango] is spreading little by little through the whole world." How, then, can the fashion already be over? Because, so the text implies, it is the very nature of fashion to disappear before it has fully taken hold. And accordingly the artist's role is to expose it.

Most readers would grant that *Down with the Tango and Parsifal* has great rhetorical ingenuity, that it is a stunning performance. Still, by the norms of Modernist aesthetic, such theatricality, insofar as it has pretensions to being "art," is suspect. As Michael Fried has put it in his essay "Art and Objecthood" (1967), which is itself a kind of manifesto attacking, in the name of Op or color-field painting, the new minimal and conceptual art of the sixties, "*art degenerates as it approaches the conditions of theatre*"; indeed, "*The success, even the survival of the arts has increasingly to depend on their ability to defeat theatre.*"[38] An artwork "defeats" theater when it is a self-contained, coherent formal structure, adhering to its own medium and genre. When, on the other hand, the artwork has no existence apart from a given situation or environment, when "it depends on the beholder, is incomplete without him . . . has been waiting for him. . . . and refuses to stop confronting him, distancing him, isolating him" (*AO* 140), then it "degenerates" into "mere" theater. "There is a war," writes Fried, "going on between theatre and modernist painting, between the theatrical and the pictorial—a war that . . . is not basically a matter of program and ideology but of experience, conviction, sensibility" (*AO* 135).

Fried's argument is a direct response to the work of such Minimalist (or, as he calls them, "Literalist") artists as Robert Morris, Donald Judd, and Tony Smith, all of whom were, in the words of Howard N. Fox, "exploring the way in which environment, scale, placement, and

repetition could influence the manner in which the most simplified of
their 'minimal' or 'primary' structures—cubes, cylinders, and other
basic solids were perceived."[39] Like their Constructivist forebears—
and most notably Tatlin, whose "counterreliefs" I discussed in the
preceding chapter, the Minimalists of the sixties asserted that their
"sculptures" could exist only in relation to the environment and the
viewer, that they were affected by conditions external to their own ma-
teriality. It is such "latent or hidden naturalism"—the claim for ob-
jecthood in the real world—that Fried calls "theatricality." A related
claim, and one that Fried deplores, is the notion brought forward by
artists like John Cage that "the barriers between the arts are in the
process of crumbling. . . . Whereas in fact the individual arts have
never been more explicitly concerned with the conventions that con-
stitute their respective essences." And Fried concludes: "*The concepts
of quality and value—and to the extent that these are central to art,
the concept of art itself—are meaningful, or wholly meaningful, only
within the individual arts. What lies between the arts is theatre*" (*AO*
142).

Exactly why art "degenerates" as it approaches the condition of
theater, or exactly how quality and value inhere only within the indi-
vidual arts and their established divisions, is something Fried never
really explains. It is assumed that the art object is not to be confused
with the environment or its situation in the world and that its formal
structure should be governed by such values as coherence and unity.
The fact is, however, that, like it or not, most art and literature since
the midsixties has moved away from the coherency model of High
Modernism, and to dismiss such art wholesale as nonart or nonlitera-
ture is not particularly useful for criticism. Howard Fox observes:

> A broader notion of theatricality seems to be required here. The-
> atricality may be considered that propensity in the visual arts for a
> work to reveal itself within the mind of the beholder as something other
> than what it is known empirically to be. This is precisely antithetical to
> the Modern ideal of the wholly manifest, self-sufficient object; and the-
> atricality may be the single most pervasive property of post-Modern
> art. (*M* 16).

And, we might add, a pervasive property of Futurist art as well—an
art that anticipated our own predilection for the "space between the
traditional media" that Fried dismisses as theater.

Consider, in this connection, the status of the object in the collage
forms of the period. In Cubist and Futurist collage, as I suggested in
chapter 2, an object such as a railway ticket or newspaper page may

remain materially intact and yet be virtually transformed within its alien context (e.g., juxtaposed to the painted representation of a table-top or of the silhouette of a human body). In this sense, collage embodies what Howard Fox calls a situational aesthetic rather than a material one.

It is this situational aesthetic that governs what Marinetti calls *l'arte di far manifesti*. Situational in the literal sense, of course, in that the Futurist manifesto has a practical purpose: to move an audience to action, or at least to assent, in a particular situation in, say, the "passéist" Venice of 1910. Again, the manifesto is situational in that it operates in real time and real space; thus *Down with the Tango and Parsifal* is an attack on the cultural and sexual hypocrisy of the Italian upper classes and their bourgeois followers. But the Futurist manifesto is also theatrical in a deeper sense, occupying as it does a "space that lies between the arts" and conflating verbal strategies that do not conventionally cohere: the ethical and pathetic arguments of classical rhetoric, the rhythm, metaphor, and hyperbole of Romantic lyric poetry, the journalistic narrative of everyday discourse, and the dialogic mode of drama which acts to draw the reader (or viewer) into its verbal orbit. In its assemblage of such conflicting modes and techniques, *Down with the Tango* is an obvious precursor of the performance art of the sixties and seventies—the art that Michael Fried correctly diagnosed as threatening the "coherent" geometric paintings of Frank Stella and Kenneth Noland or the abstract sculptures. of Anthony Caro.

From *Down with the Tango and Parsifal* (1914) to Tristan Tzara's first Dada manifesto, the *Manifesto of Monsieur Antipyrine* (1916),[40] is a shorter step than the Dadaists would have liked us to think. Here and in subsequent manifestos, Tzara is eager to dissociate himself from the war-mongering Futurists, with their cult of violence and the machine, their obsession with the future at the expense of the past, their naïve belief that, as Tzara puts it in *Dada Manifesto 1918*, "to put out a manifesto you must want: ABC / to fulminate against 1, 2, 3," whereas his own stance is that "after all everyone dances to his own personal boomboom, and . . . the writer is entitled to his boomboom."[41]

Ironically, this overt rejection of Futurist principles is belied by Tzara's manifestos themselves, which exhibit the aggressive, polemical tone, the unusual typography (especially in the *Proclamation sans prétention* of 1918—see fig. 3.10), the extensive use of onomatopoeia, pun, and extravagant metaphor, and the "destruction of syntax" and *parole in libertà*, all of which are familiar to us from Futurist

Fig. 3.10. Tristan Tzara, *Manifesto of Monsieur Antipyrine*, 1916. Reproduced in Tzara, *Sept Manifestes Dada*, p. 9. Jean-Jacques Pauvert, Utrecht, 1963.

manifestos. Most important, Tzara adopts the performative stance and the improvisatory structures devised by Marinetti and his followers:

Dada est notre intensité: qui érige les baïonnettes sans conséquence la tête sumatrale du bébé allemand; Dada est la vie sans pantoufles ni parallèles; qui est contre et pour l'unité et décidément contre le futur; nous savons sagement que nos cerveaux deviendront des coussins dou-

illets, que notre antidogmatisme est aussi exclusiviste que le fonction-
naire et que nous sommes pas libres et crions liberté. (*SM* 9)

Dada is our intensity: it sets up inconsequential bayonets the Su-
matran head of the German baby; Dada is life without carpet-slippers or
parallels; it is for and against unity and definitely against the future;
we are wise enough to know that our brains will become downy pillows
that our anti-dogmatism is as exclusivist as a bureaucrat that we are
not free yet to shout freedom. (*DPP* 75)

Monsieur Antipyrine (aspirin) is a disillusionist pacifist who rejects
the strident nationalism of the Futurists. His indifference to conven-
tional values is suggested by his syntax: noun phrases in apposition
have no real connection; the bayonets are "sans conséquence," and
what should be the German enemy is only a German baby, and one
that has a Sumatran head at that. Again, Tzara declares with mock
alliteration and assonance that Dada rejects both the "pantoufles" of
the bourgeois household and the notion of "parallèles" (in the 1918
manifesto, he observes that "Painting is the art of making two lines
geometrically established as parallel meet on the canvas before our
eyes" [*DPP* 78]). Dada, moreover, is both for and against unity, "not
free" yet eager to "shout Freedom."

Such paradoxes seem ideologically remote from Marinetti's call for
"the racer's stride, the mortal leap, the punch and the slap." But the
difference is more seeming than real. Like Marinetti's, Monsieur
Antipyrine's program—or, more correctly, antiprogram—is gesture
rather than substance; his announcement that Dada is "shit after all
but from now on we mean to shit in assorted colors and bedeck the
artistic zoo with the flags of every consulate" is an appeal at least as
strong as Marinetti's to an audience ready to applaud that poet or art-
ist who can *épater le bourgeois*, and, beyond the bourgeois, who can
épater the artist of the ruling culture:

nous ne voulons pas compter les fenêtres de l'élite merveilleuse, car
DADA n'existe pour personne et nous voulons que tout le monde com-
prenne cela. Là est le balcon de Dada, je vous assure. D'où l'on peut
entendre les marches militaires et descendre en tranchant l'air comme
un séraphin dans un bain populaire pour pisser et comprendre la para-
bole. (*SM* 10–11)

we do not want to count the windows of the marvelous elite, for Dada
exists for no one and we want everybody to understand this because it
is the balcony of Dada, I assure you. From which you can hear the

military marches and descend slicing the air like a seraph in a public bath to piss and comprehend the parable. (*DPP* 75)

An antimilitaristic gesture as comically aggressive as any of Marinetti's military ones. Dada exists for "no one," provided that "you"— Tzara's audience—agree who "no one" is. Which is to say that, like the Futurists, the Dadaists must explode bourgeois morality and bourgeois meters:

> L'art était un jeu noisette, les enfants assemblaient les mots qui ont une sonnerie à la fin, puis ils pleuraient et criaient la strophe, et lui mettaient les bottines des poupées et la strophe devint reine pour mourir un peu et la reine devint baleine, les enfants couraient à perdre haleine. (*SM* 11)

> Art was a game of trinkets children collected words with a tinkling on the end then they went and shouted stanzas and they put little doll's shoes on the stanza and the stanza turned into a queen to die a little and the queen turned into a wolverine, and the children ran till they all turned green. (*DPP* 75)

Here the tone is more intimate, more equivocal than anything we find in Marinetti. The fairy-tale diction and syntax as well as the tinkling rhymes ("reine"—"haleine"—"baleine") create an aura of childlike playfulness that makes Tzara's strictures on conventional meters ("les bottines des poupées") rather different from Marinetti's outcry, in *Destruction of Syntax*, against "facile sound effects, banal double meanings, monotonous cadences, a foolish chiming" (*FM* 99).

Indeed, the supposition that the manifesto is designed less to move the masses to action than to charm and give pleasure to one's coterie, to those who are like-minded, governs the form of Tzara's own later manifestos as well as of Dada manifesto in general. The relationship between the "we" and the "you" begins to shift. "We" becomes, as it does here for Tzara, subordinated to "I" ("If in exhibiting crime we learnedly say ventilator, it is to give you pleasure kind reader I love you so I swear I adore you" (*DPP* 76), and "you" is no longer the "you" of the Sunday crowd in the Piazza San Marco but *you* who are my intimate friends, who are, in Tzara's words, "sympathiques."

Given this intimacy, the Tzara manifesto is often indistinguishable from a prose poem; its coterie address, its complex network of concrete but ambivalent images, and its elaborate word play and structuring look ahead to André Breton's first Surrealist manifesto of 1924 and, beyond Breton, to many of our own exemplars of conceptual

art—texts no longer claiming to be manifestos and to move society to action, but occupying a similar space between lyric and narrative, or lyric and theater, or lyric and political statement. Manifesto art thus paves the way for the gradual erosion of the distinction between "literary" and "theoretical" texts that has become a central problematic in our own critical discourse.

Such generic rupture, like the cutting and intercalation of collage, is symptomatic of what we might call the new technopoetics of the twentieth century. It is a commonplace that the avant-garde movements of the 1910s and 1920s were by definition *anti*, that their informing spirit was one of rupture and reversal, of negation in defiance of the art of the dominant culture. But there can hardly be rupture without a compensatory addition: to cut out X inevitably means to make room for Y. In the case of Futurist experiment—whether with words-in-freedom or collage or performance—the urge is to include extraliterary (or extrapainterly) material that might situate the work in its actual context. "Les fenêtres de ma poésie," said Cendrars, "sont grand'ouvertes sur les boulevards."[42]

One way to achieve such an opening is to make language visible or, conversely, to make the visual what Roland Barthes has called *scriptible*. Writers such as Marinetti, artists such as Carrà and Severini, present us with important theorizing about the opening of the verbal-visual field, but for the most interesting examples of collaborative ventures in this particular area, I turn next to Marinetti's Russian counterparts.

4 THE WORD SET FREE: TEXT AND IMAGE IN THE RUSSIAN FUTURIST BOOK

I have destroyed the ring of the horizon and got out of the circle of objects.

—Kasimir Malevich

W̶e read these apocalyptic words on the first page of a small (thirty-one-page) book titled *From Cubism and Futurism to Suprematism: The New Painterly Realism*, published by Kasimir Malevich in 1915 in conjunction with the famous exhibition 0.10 (Last Futurist Exhibition of Pictures 0.10), held in Petrograd in the second year of the Great War.[1] It was 0.10 that witnessed the debut of Malevich's *Black Square on a White Background*, along with some thirty-five related Malevich abstractions as well as the first group of Tatlin's counterreliefs and such works as Olga Rozanova's collage *The Workbox* and Ivan Kliun's construction *Cubist at Her Dressing Table*. The public and the journalists, milling about in the ornate winter palace that housed the show, thought it all a hoax, if not a scandal. The famous painter-critic Aleksandr Benois declared: "It is no longer futurism that we have before us but the new icon of the square. Everything that we held holy and sacred, everything that we loved and which gave us a reason to live has disappeared."[2] Others who scoffed at the Malevich squares and circles took a more optimistic line. Perhaps, they held, the show was called the Last Futurist Exhibition because the Futurists could obviously go no further in their experimentation: surely, then, the end of "modern art" must be in sight, and a healthy return to traditional figurative painting might be expected.[3]

The return to figuration was, of course, to come with the advent of Socialist Realism in the midtwenties, but by this time the lessons of the Russian avant-garde had already been absorbed into the fabric of Western art. Indeed, it is in the nonobjectivism (*bespredmetnost'*) of Malevich and his circle that we find what is perhaps the most radical version of the *avant guerre* rupture of the mimetic pact between artist and audience, a rupture that manifested itself, paradoxically, in a new synthesis of the verbal and the visual.

Malevich's manifesto, written in the wake of some fifty artist's books—miscellanies in which verse, prose, and visual image come together in startling new combinations—is itself an interesting ex-

117

emplar of the manifesto as poem, a text remarkable less for its power
of argumentation than for its rhetoric. Its basic thesis, that art must
cease to hold the mirror up to nature, that it must, on the contrary,
celebrate the "new beauty of our modern life" (*CFS* 120), the beauty
of the machine, of speed—"Gigantic wars, great inventions, conquest
of the air, speed of travel, telephones, telegraphs, dreadnoughts . . .
the realm of electricity" (*CFS* 125)—that in order to do so, "Form
must be given life and the right to individual existence" (*CFS* 123), is
familiar enough to us from the Italian Futurist manifestos. Familiar
too is the contempt for the individual ego—"Only dull and impotent
artists veil their work with *sincerity*. Art requires *truth*, not *sincerity*"
(*CFS* 119)—and the insistence that the past must not only be forgot-
ten but actively destroyed. Indeed, Malevich's contempt for the paint-
ing of "Madonnas and Venuses . . . with fat, flirtatious cupids" and
his assertion that "any hewn pentagon or hexagon would have been a
greater work of sculpture than the Venus de Milo or David" (*CFS* 123)
recall Boccioni's *Technical Manifesto of Futurist Sculpture* (1912),
with its assertion that "To construct and try to create, now, with ele-
ments which have been stolen from the Egyptians, the Greeks, or
Michelangelo is like trying to draw water from a dry well with a bot-
tomless bucket."[4]

Still, nothing in Italian Futurism quite prepares us for the mystical,
oracular fervor, the gnomic aphoristic utterance of *From Cubism and
Futurism to Suprematism*. The prophetic voice that speaks to us in
metaphors and riddles, that exhorts us, daring us to move into a fu-
ture that it already sees and knows, is an elaborate fictional construc-
tion of a sort one does not expect to meet in a painter's defense of his
art. From the very first declaration:

> I have transformed myself *in the zero of form* and have fished myself
> out of the *rubbishy slough of academic art.*

> I have destroyed the ring of the horizon and got out of the circle of
> objects, the horizon ring that has imprisoned the artist and the forms
> of nature.

> This accursed ring, by continually revealing novelty after novelty,
> leads the artist away from the *aim of destruction.* (*CFS* 118)

to the last page:

> I have overcome the impossible and made gulfs with my breath.
> You are caught in the nets of the horizon, like fish! (*CFS* 135)

Malevich's manifesto enacts the process of destruction and re-creation which is its subject. More lyric than expository, a kind of "Song of the Man Who Has Come Through!" the text can be described as an extended prose poem in which statements of willed equivalence (*A* must be *B*) alternate with narrative (I have done *X*, I have done *Y*), as if to say, I have done so, and therefore it *is* so, and therefore you must "Hurry up and shed the hardened skin of centuries, so that you can catch up with us more easily" (*CFS* 135). In Walt Whitman's words, "What I assume, you shall assume."

For Malevich, the destruction of the old includes not only the rejection of all representation in painting but, more enigmatically, of the "cohesiveness of things," of "wholeness," and "the purely aesthetic basis of niceness of arrangement":

> however much we arrange furniture about rooms, we will not extend or create a new form for them. . . .
>
> For art is the ability to create a construction that derives not from the interrelation of form and color and not on the basis of aesthetic taste in a construction's compositional beauty, *but on the basis of weight, speed, and direction of movement.* (*CFS* 122–23)

Not, in other words, a centered composition in which each part contributes to the articulation of the whole; nor again a linear structure with beginning, middle, and end. Rather, "We must see everything in nature, not as real objects and forms, but as *material*, as masses from which forms must be made that have nothing in common with nature" (*CFS* 123). The distinction Malevich is making here is between art as the "repeating or tracing the forms of nature" (*CFS* 122) and what John Cage was to call art as "the imitation of nature in her manner of operation."[5]

Accordingly, the composition of the manifesto cannot be linear; it cannot, for example, be a list of the sort we find in Marinetti's *Destruction of Syntax* (1913), where the requirements for the "New Art" are numbered 1, 2, 3, and so on. Rather, the text is full of repetitions; it circles back so as to move forward. Thus the phrase "little nooks of nature" is repeated again and again, each time with increasing scorn and contempt. Or again, the sentence *"Objects have vanished like smoke,"* which appears on the first page, returns on the penultimate page, after Malevich has taken up the question of Cubism and Futurism as steps in the evolution of the new Suprematist art. Futurism, he suggests, was right to celebrate the dynamics of the new technology

and the freedom of color. "But in failing to destroy objectivism (*pred-metnost'*), they [the Futurists] achieve only the dynamics of things":

> The galloping of a horse can be transmitted with a single tone of pencil. But it is impossible to transmit the movement of red, green, or blue masses with a single pencil. (*CFS* 130)

As for Cubism, its central discovery was "the energy of dissonance . . . obtained from the confrontation of two contrasting forms":

> In achieving this new beauty, or simply energy, we have freed ourselves from the impression of the object's wholeness.
> The millstone around the neck of painting is beginning to crack. (*CFS* 131)

Notice the use of "we" and the present tense here. Malevich is presenting us with his own evolution from Cubism and Futurism (as in his canvases and collages of 1913–14) to abstraction. We must therefore witness the process whereby he himself comes to see that Cubism is found wanting because it refuses to take the final step, to get rid of the object completely. The strategy of the manifesto is to convince us that *"Forms move and are born, and we are forever making new discoveries"* (*CFS* 120). Hence the aphoristic, fragmentary, parabolic discourse:

> The art of painting, the word, sculpture, was a kind of camel, loaded with all the trash of odalisques, Salomés, princes, and princesses. (*CFS* 124)

> If all artists were to see the crossroads of these heavenly paths, if they were to comprehend these monstrous runways and intersections of our bodies with the clouds in the heavens, then they would not paint chrysanthemums. (*CFS* 126)

Hence too the imagery of violent rupture—"I have broken out of the inquisition torture chamber, academism"—and of escape: "I have released all the birds from the eternal cage and flung open the gates to the animals in the zoological gardens" (*CFS* 135). At the end of the manifesto, Malevich urges his readers to "Hurry up and shed the hardened skin of centuries, so that you can catch up with us more easily. . . . Hurry! For tomorrow you will not recognize us."

The implication is that Suprematism, as he now calls it, is not just another *ism*, the latest in a series of explosive movements—Ego-Futurism, Cubo-Futurism, Rayonism—but the manifestation of a higher reality.[6] The Cubists, that is to say, had succeeded only in violating the integrity of form; the represented object, however fragmented and distorted, still exists. Malevich's own thrust is to elimi-

nate the object completely so as to attain what he called, following Ouspensky and other mathematical philosophers of the period, the fourth dimension.[7] In its urgency of questioning, its exclamatory lyricism, and its exhortation, the manifesto cannot help but suspend our disbelief, for it promises to place us at the cutting edge, the threshold of the new, the about-to-be-realized. Indeed, Malevich's oracular lyric prose repeatedly refers to the Black Square in anthropomorphic terms, for instance:

> Each form is a world.
> Any painterly surface is more alive than any face from which a pair of eyes and a smile protrude.
> A face painted in a picture gives a pitiful parody of life, and this allusion is merely a reminder of the living.
> But a surface lives; it has been born. (*CFS* 134)

I

"A surface lives": Malevich's words take us back to the manifestos (or fragments of manifestos) of 1913 written by the two poets Velimir Khlebnikov and Alexei Kruchenykh under the titles *The Word as Such* (*Slovo kak takovoe*) and *The Letter as Such* (*Bukva kak takovya*).[8] The best known of these was published in book form with a semiabstract lithograph by Malevich on the cover.[9] The title *Slovo kak takovoe* refers to what Kruchenykh called his *zaum* (transrational) language— that is to say, language that undermines or ignores the conventional meanings of a given word, thus allowing its sound to generate its own range of significations, or, in its more extreme form, the invention of new words based purely on sound.[10] Thus Kruchenykh declares in a series of intentionally misnumbered paragraphs:

> 4. Thought and speech cannot catch up with the emotional experience of someone inspired; therefore the artist is free to express himself not only in a common language (concepts), but also in a private one (a creator is individual), as well as in a language that does not have a definite meaning (is not frozen), that is *transrational*. A common language is binding; a free one allows more complete expression. . . .

> 5. Words die, the world stays young forever. An artist has seen the world in a new way, and, like Adam, he gives his own names to everything. A lily is beautiful but the word "lily" is soiled with fingers and raped. For this reason I call a lily "euy" [pronounced in Russian approximately "ehooee"], and the original purity is reestablished. . . .

> 3. It is better to substitute for a word one similar in sound, rather than one similar in idea. . . .

1. New verbal form creates a new content, and not vice-versa.

6. Introducing new words, I bring a new content, where everything begins to slide (shift). . . .

7. In art there can be unresolved dissonances—"something unpleasant for the ear"—because there is a dissonance in our soul.[11]

Fig. 4.1. Alexei Kruchenykh, "Dyr bul shchyl" (poem) and Mikhail Larionov, drawing, in *Pomada*. Moscow, 1913. Leaf 2. Courtesy of the British Library, London.

Out of this aggressive program for a new poetic language come poems like the famous "Dyr bul shchyl," which first appeared in the Kruchenykh-Larionov book *Pomada* of 1913 (fig. 4.1) and was reprinted in, among other places, *Slovo kak takovoe:*[12]

<div align="center">

dyr bul shchyl

ubeshshchur

skum

vy so bu

r l èz

</div>

Vladimir Markov comments: "The poem begins with energetic monosyllables, some of which slightly resemble Russian or Ukrainian words, followed by a three-syllable word of shaggy appearance. The next word looks like a fragment of some word, and the two final lines are occupied with syllables and just plain letters, respectively, the poem ending on a queer, non-Russian sounding syllable" (*RF* 44).

Read as an independent poem, Kruchenykh's little *zaum* text may well strike us as negligible, a proto-Dada joke that depends for its effect on its sheer defiance of reader expectation. Yet its placement on the page in the original *Pomada* version deserves attention. The poem appears in the center between Kruchenykh's program note—"3 poems / written in / my own language / different from others: / its words do not have / a definite meaning"[13]—and Larionov's Rayonist drawing, a grid of diagonal lines and curves. The three units look alike: the note "written in / my own language" is set in five short lines as is "Dyr bul shchyl," and the nonreferentiality of the poem is matched by the nonrepresentational grid of Larionov's drawing. The shapes of Kruchenykh's letters, especially the Лs (*l*s) and рs (*r*s), correspond to the forms in the drawing. Thus the page announces that poetry is to be read in a new way, that its visual representation is itself a significant part of its *écriture*. Indeed, as the *Slovo kak takovoe* manifestos make clear, there is much more at stake here than the invention of nonsense words, phonemic puzzles, or onomatopoeia. Rather the "word as such" is a serious experiment in intertextuality, the poets' aim being to respond to the elegant Symbolist poetry still dominant in 1912 by creating a new discourse appropriate to the new world of science and technology. Accordingly, *The Word as Such* begins with the following proclamation:

1. As if it were written and read in the twinkling of an eye! (singing, splash, dance, throwing down of clumsy structures, forgetting, unlearning).

2. As if it were written with difficulty and read with difficulty, more uncomfortable than blacked boots or a truck in a drawing room. (*RF* 129; *MPF* 53)

The first is called the method of Khlebnikov, Kruchenykh, and Elena Guro; the second, that of David and Vladimir Burliuk, of Benedikt Livshits and Mayakovsky. "Both methods," Markov observes, "are considered equally valuable" (*RF* 130). We might press this point further and note that, in fact, the two principles are simply opposite sides of the same coin. "What is more valuable," the poets ask, "wind or stone?" And the reply is, "Both are priceless." To make the reader see something as if for the first time, to defamiliarize, in Shklovskian vocabulary, the object, "to transfer the usual perception of an object into the sphere of a new perception,"[14] the poet either "speeds up" or "slows down" the familiar poetic process, either produces a text that appears to be spontaneous and improvisatory ("singing, splash, dance"), thus allowing us to forget, to unlearn what we had taken a "poem" to be, or, by foregrounding artifice, difficult locution, and highly contrived sound patterning, the poet makes us feel "more uncomfortable than blacked boots or a truck in a drawing room." In either case, our reaction will be one of puzzlement. For, as the Formalist critic Juri Tynyanov put it, "The very existence of a fact as *literary* depends on its differential quality. . . . We tacitly consider metrical prose to be prose and nonmetrical free verse to be poetry, without considering the fact that in another literary system we would thus be placed in a difficult position."[15]

The poetry of the past, like the painting of the past for Malevich, must, in any case, be scrapped. The drive toward renewal, toward the recognition of the "differential" of poetry, inevitably involves outrageous statement. A "sono-visual assemblage" like "Dyr bul shchyl," Kruchenykh declares in a grand Marinettian gesture, has "more Russian nationalistic spirit than all the poetry of Pushkin."[16] Or again, "before us, the following things were demanded of language: clarity, purity, propriety, sonority, pleasure (sweetness for the ear), forceful expression (rounded, picturesque, tasty)." All these prescriptions, the poets insist, are more applicable to woman than to language:

as a matter of fact: fair, pure (oh of course!) virtuous (hm! hm!), pleasant sounding, tender (exactly!), finally—tasty, picturesque, round . . . (who's there? come in!)

it is true that these days one is forced to metamorphose Woman into the Eternal Feminine, into the elegant lady, and so the skirt is *mystical* (this shouldn't shock the uninitiated—so much the better! . . .) As for us, we believe that language should first of all be *language*, and if it is to remind us of anything, let it remind us of a saw or the poisoned arrow of a savage.[17]

So the call for the self-sufficient word is less a call for *zaum* as pure sound poetry than a call for a poetry that will avoid what Khlebnikov and Kruchenykh considered to be the clichés of Symbolist love poetry—the labored expression of inner feeling and of the "Soul," for the Soul has been "sullied by our predecessors." What the new language might look like is made clearer in *The Letter as Such*.

In this manifesto, Kruchenykh and Khlebnikov coin the word *rechar'* (Gary Kern translates it as "speechist"; Paul Schmidt as "writewright"; Gerald Janecek as "worder") for the one who is expert in questions of poetic language: "just ask any speechist, and he'll tell you that a word written by one hand or set in one typeface is completely unlike the same word in a different inscription. After all, you wouldn't dress all your pretty women in the same regulation peasant coats, would you?"[18]

Such foregrounding of the visual element in poetic discourse, the emphasis on the actual disposition of the words on the page, inevitably erodes the nineteenth-century concept of the poem as something that has already been written and that will be read the same way no matter where it may appear in print:

> the question of signs which are written, visible or simply palpable, as by the hand of a blind man, must be posed. Of course, it is not obligatory that the speechist also print the book in his own hand. Indeed, it would be better if this were entrusted to an artist. But there haven't been any books like this before. The first ones to make them were the futurists [*budetlyanine*]. . . .
>
> Strange, neither Balmont nor Blok, seemingly the most modern people, ever got the idea to entrust their child not to the typesetter, but to the artist.
>
> A piece may be reprinted by the creator himself or by somebody else, but if he does not relive the writing, it will lose all the charms which its script receives at the moment of "the awesome snowstorm of inspiration." (*ST* 199–200)

To entrust the child "not to the typesetter, but to the artist"—this is the new view of the poetic text embodied in the dozens of artist's books printed in the explosive years before the war. It is important to remember that nearly all the early Russian Futurists came to poetry

from painting or worked in both media. Nearly all had spent some time at art school and many, like David Burliuk, the young Kruchenykh, Elena Guro, and her husband, the poet and composer Mikhail Matyushin, exhibited regularly with such artists as Malevich and Tatlin. At the Grand Exhibition of Painting, 1915, in Moscow, for example, Mayakovsky's Cubist painting *Roulette*, as well as a collage he had made of a top hat cut in two with two gloves nailed next to it, were hung side by side with works by Larionov, Goncharova, Kandinsky, and Chagall.[19] Indeed, the close connection between the verbal and visual artists of the period can be seen in the tendency of Futurist poets to use the terminology of painting—*sdvig* (dislocation), *faktura* (texture), *bespredmetnost'* (nonobjectivism), *postroeniya* (constructions)—in their discussions of their own work.

A second important point about the Russian avant-garde: almost all the poets and painters (Goncharova was a notable exception) came from the lower middle class or lower-class provincial families, unlike their predecessors, the Symbolists, who tended to belong to the aristocracy or upper middle class of Moscow and Petersburg.[20] Accordingly, the Futurists regarded the city to which they came as a citadel to be stormed: the ivory tower of the Symbolists gave way to the rooftops of the modern city, with its crowded streets, theaters, and cafés. Thus Zdanevich and Larionov, in a manifesto called *Why We Paint Ourselves* (1913), declared: "To the frenzied city of arc lamps, to the streets bespattered with bodies, to the houses huddled together, we have brought our painted faces; we're off and the track awaits the runners." And again, "We have joined art to life. Art is not only a monarch but a newsman and a decorator. We value both print and news . . . that's why we paint ourselves."[21] And a few months earlier, the famous manifesto *A Slap in the Face of Public Taste*, signed by Kruchenykh, Khlebnikov, David Burliuk, and Mayakovsky, declared:

> Throw Pushkin, Dostoevsky, Tolstoy et al. overboard from the ship of modernity.
>
> He who does not forget his *first* love will not recognize his last.
>
> But who is so gullible as to direct his last love toward the perfumed lechery of a Balmont? Does it reflect the virile soul today? (*RF* 46; *MPF* 50)

As in the case of Cendrars or Marinetti, the insistence that art can be "joined" to life must be understood as primarily a class rebellion against the aestheticism of both the previous generation and the contemporary "genteel" culture. But unlike the Italian Futurists, many of whom similarly came from the lower classes and similarly de-

spised "the perfumed lechery of a Balmont," the Russian artists had a mathematical-mystical bent that gave their poetry and painting, their stage designs and sculpture a different slant. And here a word must be said about the special place held in Futurist poetic by Ouspensky's *Tertium Organum* (1911).

Unlike the Cubists, whose theories of the fourth dimension had a logical mathematical basis in non-Euclidean geometry, especially in Jules Poincaré's theory of the "hypercube"[22]—a theory interpreted freely by the painters as a license to renounce perspective and create a "motor space" in which objects are depicted in fragmented or partial form, as they would appear from multiple points of view—the Russian avant-garde regarded the ability to visualize the object from all sides at once as only the first step toward the desired "higher consciousness" that Ouspensky associated with the fourth dimension. Thus Matyushin declared in the preface to the collaborative book *Troe* (*The Three*) of 1913: "perhaps the day is not far off when the vanquished phantoms of three-dimensional space, of seemingly drop-like time, of melancholy causality . . . will prove to be for all of us exactly what they are: the annoying bars of a cage in which the human spirit is imprisoned."[23] And in *Novye puti slova* (*The New Ways of the Word*), which also appears in *Troe*, Kruchenykh points out that *zaum* is now possible because, in addition to "sensation, motion, and concept," the fourth unit, "highest intuition," is being formed (*RF* 127; *MPF* 65).

The fourth dimension, as Ouspensky and his followers used the term, had nothing to do with Einstein's theory of relativity, which had no currency in Russia before the Revolution.[24] The central argument of the *Tertium Organum*, as outlined in chapter 2, is easy enough to summarize:

> [1.] Taken as an object, i.e. visualized as outside our consciousness, space is for us the *form of the universe*. . . . we can measure it in three independent directions only: length, breadth, height. . . . Moreover . . . we cannot *visualize* more than three perpendiculars.

> [2.] But we say that space is infinite. Therefore, since the first condition of infinity is infinity in all directions and in all possible respects, we must assume that space has an infinite number of dimensions.

> [3. Therefore,] the idea of the *fourth dimension* arose from the assumption that, in addition to the three dimensions known to our geometry, there exists a fourth, for some reason inaccessible and unknown to us, i.e. that in addition to the three perpendiculars known to us a mysterious fourth perpendicular is possible.[25]

To buttress this supposition, Ouspensky gives various geometric "proofs." Although we cannot visualize a four-dimensional body, we can, he posits, deduct its existence from certain kinds of evidence. For example:

> If we imagine a horizontal plane, intersecting the top of a tree in a direction parallel to the earth, then on this plane the sections of the branches will appear separate and quite unconnected with one another. And yet in our space, from our point of view, these are sections of the branches of *one tree* together forming one top, fed by one common root and casting one shadow. (*TO* 23)

Or again, an example that appealed to the poets and painters:

> If we touch the surface of a table with our five fingertips of one hand, there will then be on the surface of the table only five circles, and on *this surface* it is impossible to have any idea either of the hand or of the man to whom the hand belongs. There will be five separate circles. . . . Our relation to the four-dimensional world may be exactly the same as the relationship between that consciousness which sees the five circles on the table and *the man*. (*TO* 24)

By the same token, Ouspensky suggests, our traditional concepts of time and space must be adjusted. Usually we consider the past as no longer existing and the future as not yet. The present is then "*the moment of the transition of a phenomenon from one non-existence into another*. . . . But in actual fact this brief moment is a fiction. It has no dimension. . . . We can never catch it. That which we catch is *always already past!*" (*TO* 26).

But suppose we think of time in less restricted terms. "In reality, our relation to the past and the future is much more complex than it appears. In the past, in what is behind us, lies not only what was, but also *what could have been*. In the same way, in the future lies not only what will be *but also all that may be*." If we think of the past and future as equally undetermined, as existing in all their possibilities, then we can see them as existing "simultaneously with the present": "By time we mean the *distance* separating events in the order of their sequence and binding them into different wholes. This distance lies in a direction not contained in *three-dimensional* space. If we think of this direction as lying in space, it will be a *new extension of space*." "This new extension," says Ouspensky, "fulfills all the requirements we may demand of the *fourth dimension*." Since "extension in time" is extension into an unknown space, time is the *fourth dimension of space*" (*TO* 33).

We must, in other words, transcend the limits of our ordinary observation:

> If a man climbs a mountain or goes up in a balloon he sees *simultaneously* and *at once* a great many things that it is impossible to see simultaneously and at once when on earth—the movement of two trains toward one another which must result in a head-on collision; the approach of an enemy detachment to a sleeping camp; two towns separated by a mountain ridge and so on. (*TO* 33–34)

In this way, time becomes space, and space is perceived as surface. Ouspensky quotes Charles Hinton: "A surface is nothing more nor less than the relation between two things. Two bodies touch each other. The surface is the relationship of one to the other" (*TO* 35).

The reception of Ouspensky's mystical geometry by the Russian avant-garde has been scrupulously documented by Linda Dalrymple Henderson.[26] What is important, for our purposes here, is that what we might call the "Ouspensky strain" manifests itself as an insistence, on the part of the artists, on noncausality, nonlogical relationships, the simultaneous existence on a surface plane of seemingly unrelated verbal and visual events. Thus one of the first lithographs that Malevich made for Kruchenykh was called *Simultaneous Death of a Man in an Aeroplane and at the Railway* (fig. 4.2), and Kruchenykh

Fig. 4.2. Kasimir Malevich, *Simultaneous Death of a Man in an Aeroplane and at the Railway. Vzorval' (Explodity)* by Alexei Kruchenykh and others. St. Petersburg, 1913. Leaf 17. Courtesy of the British Library, London.

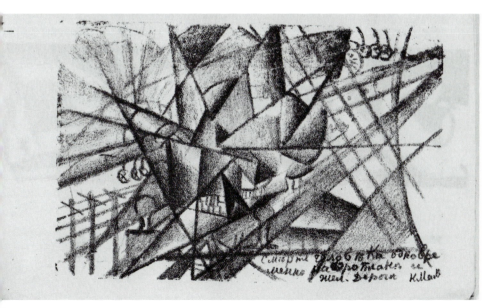

himself began to experiment with the visual relationships of letters, words, and images as ways of generating meaning. In the artist's books that resulted from such collaboration, the collage aesthetic that first becomes prominent in Cubism takes an important new turn.

II

The art magazines produced in Russia in the first decade of the twentieth century—*Mir isskustva* (*The World of Art*), *Vesy* (*The Scales*), *Zolotoe runo* (*The Golden Fleece*)—were lavish productions in which the new literature appeared side by side with expensive color reproductions of art works as well as essays about them. Even Nikolai Kulbin's *Impressionists' Studio* of 1910, which introduced Khlebnikov's "Zaklyatie smekhom" ("Incantation by Laughter") to the public,[27] followed the *World of Art* format with exotic Art Nouveau illustrations on pages facing the text, which was conventionally printed (figs. 4.3 and 4.4). *Sadok sudei* (*A Trap for Judges*), also of 1910, went a step further: the 130-page book was printed entirely on the reverse side of patterned wallpaper, with the title label glued to the wallpaper cover. *A Trap for Judges* is notable as the first major collection of Futurist poetry: it includes Khlebnikov's "Zverinets" ("Zoo") and "Zhuravl'" ("The Crane"), as well as more than a dozen poems by each of the Burliuk brothers and as many again by Elena Guro. But the principle of the separation of media is not yet violated.

Against this background, the publication in October 1912 of *Starinnaya lyubov* (*Old-Time Love*) can be seen to usher in a new aesthetic. The little book, printed in an edition of three hundred, has only fourteen leaves, each postcard size, with the folded pages printed on one side and stapled together—an obvious attack on the luxury editions of *World of Art* or *Golden Fleece*. The seven poems by Kruchenykh are written by hand with deliberate misprints, jumbled letters (for example, a capital letter inside a word), omission of commas and periods, and erratic spacing. According to Susan Compton, the process used in making the book was called "autolithography." The artist who originated the image or the handwriting rarely worked on the lithographic stone, but provided the drawing or writing on paper; the printing was then done by a professional (*WB* 70–71).

The inextricability of "drawing" and "writing" can be seen in the cover design of *Starinnaya lyubov* (fig. 4.5). Larionov's design is based on a series of interlocking triangles and diamond shapes, a geometric abstraction of a human body with arms outstretched, upright trunk, and legs bent at the knees—perhaps the figure of a dancer.[28]

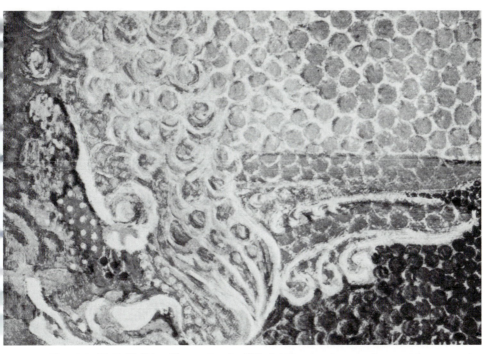

Fig. 4.3. N. I. Kulbin, illustration for Nikolai Evreinov's monodrama, *The Performance of Love*, in *Studiya impressionistov (Impressionists' Studio)*. Moscow, 1910. Courtesy of the British Library, London.

Fig. 4.4. L. F. Shmit-Ryzhova, illustration for *The Performance of Love*, in *Studiya impressionistov (Impressionists' Studio)*. Moscow, 1910. Courtesy of the British Library, London.

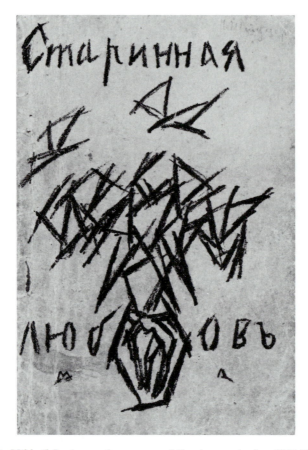

Fig. 4.5. Mikhail Larionov, front cover of *Starinnaya lyubov (Old-Time Love)* by A. Kruchenykh. Moscow, 1912. Courtesy of the British Library, London.

The word *lyubov* (Любовь, written in alternating lower- and upper-case letters) is playfully divided in half after the *b* (б) by the open legs—surely an erotic suggestion; the handwritten letters of the title correspond in a dozen ways to the triangle forms: the letter *S* (С) of *Starinnaya* (Старинная), for example, is drawn as an almost perfect diamond shape, and the final two letters (ая) and first letter of *lyubov* correspond to the inverted triangles above the "figure" as well as to the "arms" and "trunk." At the same time, the *O* (О) and *V* (В)— rounded forms—stand out as a contrast to the angular grid. It is, accordingly, difficult to say whether the title is illustrated by Larionov's

design or whether the design is reenforced by the title. *The Letter as Such:* it is impossible to separate its existence—say, ю—from the visual image.

Word and image, letter and brushstroke are thus played off against one another throughout the book. Sometimes text and image appear on the same page, sometimes separately, but the conceptual identity remains remarkable. Here, for example, is one of Krucheykh's characteristic parody love poems (fig. 4.6):

Fig. 4.6. A. Kruchenykh, *Starinnaya lyubov (Old-Time Love)*. Moscow, 1912. Leaf 5. Courtesy of the British Library, London.

Всего милый ты в шляпке старой
Измятые бока,
Сама ты кажешься не старой,
И трепетны́й руки,
Тогда уже не модная картинка
И не богиня ты,
Простая славная ты Зинка,
Светлый черты..

С такой тобой иду я рядом,
Люблю гулять,
Не можешь ты тиранить взглядом,
Иль дерзко оскорблять.

Твой взор родной глядит с заботой:
Мы старые друзья,
И лгать скрываться не охота:
Была давно моя.

5

You are dearest of all in an old hat
Crumpled at the sides
You yourself appear not old
And your hand more trembling.
And then you are no longer a fashion-plate
And not my goddess,
You are simple-hearted good old Zinka,
Your features are lighter.
I walk side by side with such a you,
I like to walk,
You cannot tyrannize me with a look
Or brazenly insult me:
Your dear familiar face gazes with tender care
And there is no wish to lie, to dissimulate:
Long ago you were mine [29]

Here the comical rhymes ("boka / ruka"; "kartinka / Zinka"), repetition ("staroy, staroy"), everyday vocabulary, and pointless parentheses ("lyublyu gulyat'"; "I like to walk") lead up to the punchline: "Byla davno moya"; "Long ago you were mine." The satiric treatment of love is echoed by Larionov's "Rayonist" lithograph (fig. 4.7), in which the geometric grid of diagonals all but obscures what is still a representational image: the figure of a woman holding an umbrella (left foreground), a man, drawn to smaller scale, who walks in the opposite direction, and a giant lamppost emitting rays of light, rays that become part of the formal abstract design. Instead of, say, a pair of lovers seated in the moonlight, we have here a woman and a man (half her size) at cross-purposes, the light rays illuminating not their paths but what seems to be the opposite side of the picture. Moreover, viewed as a whole, Larionov's composition looks rather like an Abstract Expressionist drawing in the vein of Franz Kline.

In his manifesto *Rayonist Painting*, written for the catalog of the Donkey's Tail exhibition (July 1913), Larionov declares: "painting is self-sufficient; it has its own forms, color, and timbre. Rayonism is concerned with spatial forms that can arise from the intersection of the reflected rays of different objects, forms chosen by the artist's will." [30] And he quotes Walt Whitman:

I hear it was charged against me that I sought to destroy institutions,
But really, I am neither for nor against institutions,
(What indeed have I in common with them? or what with the
 destruction of them?).

(*Calamus*, in *RA* 94)

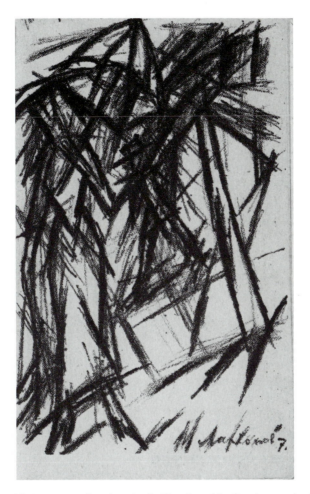

Fig. 4.7. M. Larionov, drawing, in A. Kruchenykh, *Starinnaya lyubov*
(Old-Time Love). Moscow, 1912. Leaf 7. Courtesy of the British Library,
London.

The "self-sufficient" painting, in Larionov's terms, is not yet fully
an abstraction; the object remains but it is seen in special Rayonist
terms—a cross between Impressionist notions of light, Cubist geo-
metric fragmentation, and Italian Futurist force lines, conveying the
dynamism of the urban world:

> We do not sense the object with our eye, as it is depicted conven-
> tionally in pictures and as a result of following this or that device; in

fact, we do not sense the object as such. We perceive a sum of rays proceeding from a source of light; these are reflected from the object and enter our field of vision.

Consequently, if we wish to paint literally what we see, then we must paint the sum of rays reflected from the object. (*RA* 98)

And Larionov goes on to elaborate what happens when the sum of rays from object A intersects that from object B ("In the space between them a certain form appears"), concluding: "The picture appears to be slippery; it imparts a sensation of the extratemporal, of the spatial. In it arises the sensation of what could be called the fourth dimension, because its length, breadth, and density of the layer of paint are the only signs of the outside world" (*RA* 99). And, just as Malevich was to do a few years later, Larionov ends on an apocalyptic note: "Hence the natural downfall of all existing styles and forms in all the art of the past. . . . With this begins the true liberation of painting."

Larionov's paintings do not, on the whole, live up to this revolutionary claim: indeed, they owe more than they cared to acknowledge to such Impressionist studies of light rays as Monet's *Gare St. Lazare*, not to mention the work of such Italian Futurists as Boccioni.[31] It is as a collaborator with the avant-garde poets, whose work, like his, is poised between "self-sufficiency" and representation, that Larionov finds his métier. *Mirskontsa* (*Worldbackwards*), published shortly after *Starinnaya lyubov*, is a good example of a Larionov collaboration, this time with both Khlebnikov and Kruchenykh. The little book (forty-one leaves) also features artwork by Goncharova and a rare drawing by Tatlin.[32]

In the case of an artist's book like *Mirskontsa*, we can—indeed must—judge the book by its cover (pl. 4).[33] Here the cutout flower shape, made of shiny black paper and glued onto a gold background, reflects Goncharova's particular fusion of the primitivism of the *lubok* or peasant woodcut on the one hand and the movement toward nonobjective (*bespredmetnoe*) art on the other. On one level, the design is purely abstract, the torn oval on the left emphasizing its handmade, provisional character. But the form brings to mind not only a flower on a stem between two leaves but also a primitive figure in silhouette, the two ovals being either arms or breasts.

The lettering below the figure is equally equivocal. The word MIR-SKONTSA (the title signifies not only "worldbackwards" but also "the end of the world" or "world from the end"—which is to say, its beginning)[34] and the signatures "А. Крученыхъ" and "В. Хлебниковъ"are made partly of handwritten letters (both large and small) and partly of printed ones: for example, the OH in the title and the EH of

Kruchenykh. The letters are purposely misaligned (note the C in the title, which is elevated), and their sizes vary. On the other hand, the initials A and B are neatly lined up as are the K and X and the final hard consonant sign ъ. Each letter is thus "self-sufficient": indeed the letter shapes resemble miniature versions of the "flower" design by Goncharova.

In keeping with this cover, the texts that follow are either written by hand and then mimeographed or printed as if by hand in stamped letters of unequal size: they intentionally contain misprints, errors, deletions, and corrections. The space between two letters is sometimes larger than that between two words, and letters are sometimes printed in mirror image or upside down—"worldbackwards." Often a page looks as if it had been made with a child's printing outfit, using a rough stencil or potato cut, colored letters being tipped in after the design is complete.[35] The text thus hesitates, as it were, between writing as signification and writing as the affirmation of play.

The opening page of *Mirskontsa* contains a two-stanza poem rhyming *abab* by Kruchenykh in the upper half and a Rayonist composition by Larionov in the lower (fig. 4.8). The Larionov abstraction again presents the "intersection of the reflected rays of different objects" so as to create a dense web of diagonals and vortices, suggestive of a cityscape—rooftops, windows, chimneys—on a flat surface. Just as this nonobjective "city" inverts the possibilities of picturing a landscape, so Kruchenykh's poem again parodies the conventional love song or complaint:

Kak trudno mertvykh voskreshat'
Trudnei voskresnut' samomu!
Vokrug mogily brodish' tat'
Prizyvy shepchesh' odnomu

No bespolezny vse slova,
I net tvoriashei very v chudo,
Ukorom shepchut les trava
I ty molchish' . . . zabudu . . .

How difficult to resurrect the dead
More difficult to resurrect oneself!
Around the grave you wander like a thief
You whisper appeals to one . . .

But useless are all words,
And there's no creative belief in a miracle,

Fig. 4.8. M. Larionov, drawing, and A. Kruchenykh, "Kak trudno
mertrykh voskreshat'" (poem), *Mirskontsa*, 1912. Leaf 1. Courtesy of the
British Library, London.

> In reproach whisper the forest the grass
> And you are silent . . . I forget . . .[36]

The deflationary note of "zabudu" ("I forget") chiming uneasily with
"chudo" ("miracle") corresponds to Larionov's little rectangles and
stick figures playing hide and seek behind the diagonal fan-shaped
rays. The drawing is, of course, an analogue rather than an illustra-
tion of the poem, the repetition of *m*, *t*, and *sh* sounds (the three look
alike in the handwritten Cyrillic alphabet), playing the same role as

the clusters or fans of rays repeated throughout Larionov's drawing. In both cases, the emphasis is on "making strange"—transforming the rhyming ballad stanza or the presentation of a cityscape into something unexpected. The whole is brought together by the signature, bottom right, of "M. Larionov" and the credit line, bottom left, "litografiya V. Tityaeva, Moskva" ("lithograph by V. Titaev—Moscow), both of which draw the eye back up to the same letters in the poem. These signatures remind us that for the Russian avant-garde, writing and drawing—the making of words and the making of images—are part of the same process.[37] Indeed, one ray on the upper right of the drawing is heading right for the *du* of "zabudu."

A slightly different relationship between Larionov image and Kruchenykh text is set up, a few pages later, by the *Portrait of Akhmet* and accompanying poem by Kruchenykh (figs. 4.9 and 4.10). It is difficult to say which of these works has prior status. The primitivist, stylized portrait with prominent nose and ears is identified by the lettering on the left, but the word is split in half and the *T* omitted or replaced by the outlined harp in the upper right. The *T*, absent in the drawing, becomes the primary feature of the poem, which is a play on verb suffixes in *-et*, rhyming with noun endings so as to create comic effects:

AKHMET		
chashu	dErzhet	
VOeNnyi	PoRtret	
	GENeRaL	
CHEREZ	5 LeT	
	UMet	
ANGEL	Let'	
BUDEt	Poet	
DRAMU	PIshet	

AKHMET		
hOlds	a	cup
Soldier		PoRtrait
GENeRaL		
IN FIVE	YEARS	
he	CAn	
An ANGEL	FLies	
WILL Be	a	Poet
is WRITING	a PLAY[38]	

In this parodic portrait, the absurd parallels ("angel let' / budet poet") are reconciled by the intricate rhyming of *-et*, which plays off nouns, whether singular ("portret," "poet") or plural ("let"), against verbs ("derzhet," "umet," "let'," "pishet").[39] Furthermore, the poem is visualized even as the painting contains letters: the presence of black writing marks—giant *X, B,* and *Л*—within the crooked green rubber-stamped letters, transforms text into image. We see the poem as a visual configuration before we try to determine what it says. And since its meanings do not cohere in any sort of consistent framework, syn-

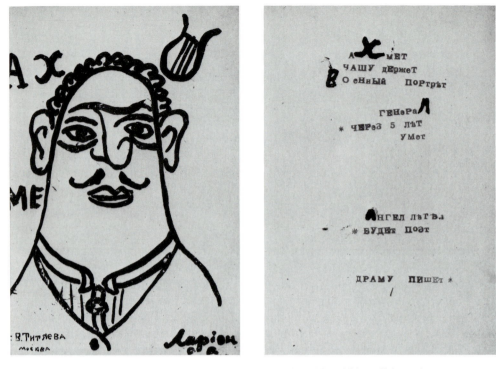

Fig. 4.9. M. Larionov, drawing, for A. Krucheynkh, "Akhmet" (poem), *Mirskontsa*, 1912. Leaf 5. Courtesy of the British Library, London.

Fig. 4.10. A. Kruchenykh, "Akmet" (poem), *Mirskontsa*, 1912. Leaf 6. Courtesy of the British Library, London.

tactic parallelism not being matched by semantic equivalence, its words are, so to speak, set free: "AKHMET" becomes a verbal entity in its own right; the name is detached from the soldier to whom it ostensibly refers.

At the center of *Mirskontsa*, we find a longer text called "Journey across the Whole World" ("Puteshestivie po vesmu svetu"), written by Kruchenykh and "illustrated" by Goncharova. This curious prose poem is an anomaly, a work closer to later Dada and Surrealist texts than to the great Symbolist voyage poems. For one thing, it is, strictly speaking, neither in prose nor in verse, its unpunctuated sentences often breaking off, blending and overlapping. For another, the "journey" progresses neither through space nor through time: geographic locales—India, Persia, the imaginary realm of "lapinandririya"—fade in and out, and the tense shifts from present to past and back again without indication of which incident is prior or subsequent in time to any other. What begins quite normally—"I journeyed for a long time and was in ten countries"—soon gives way to the fantastic:

I travelled away to a magic grove pretended to be Buddha let down my moustache and a flower a handkerchief but there's no room for me someone keeps calling in on me and whispering don't forget to pull out your teeth and I was stupefied only that. . . . and the road fell on to the sky and the trees foregather the spirit of the box is entwined with Innocents and the doors creak and the contradictions between the word and the gesture the young cliff became hateful.

Indeed, Kruchenykh's journey is primarily linguistic; it revolves around neologisms ("charodubie" for "magic grove"), nongrammatical constructions ("I alone am listening goblet vat magician tickle my shoulder"), repetition ("many times many went shook sticks went nodded I wept others went first came came here where they went"), and non sequitur coupled with ellipsis: "they went away toward the north collected (glass) wanted to build trees but another land was very good love stood out on it like sweat excluded roots the rhubarb died."

Goncharova's fanciful, childlike drawings parallel this antinarrative, recounted in wobbly, childish handwriting. The final page (fig. 4.11) places an abstract drawing between the words "save scissors cut nieces cast furtive glances sick man not to crawl out they shoot themselves well only once" and the final ВЕСЕЛИР ВЕСЕЛИЕ (*Veselir Veselie*), where *Veselir* is a play on *Velimir* (i.e., Khlebnikov) as well as *veselie* (merriment), so that a *veselir* would be one who creates merriment, one who animates the atmosphere. Goncharova's collage is the visual counterpart of this word play. The cutout shapes ("cut nieces") suggest the use of scissors; the white spaces further bring to mind Kruchenykh's "furtive glances" or something alternately appearing and disappearing ("crawling"?) behind something else. The little black bullet shapes might refer to the shooting in the text. And yet nothing here is fully referential—the design is, on one level, a study in black and white, curve and line.

Neither short story nor lyric poem, "Journey across the Whole World" typifies the Futurist drive to liberate the word, to abolish the traditional boundaries between genres as well as between verse and prose. Further, if we take the whole book as representative of the new generic model, we find that *Mirskontsa* is a collage text in which verse, whether metrical ("Kak trudno") or free ("Akhmet") is played off against "free prose" ("Journey across the Whole World"); lyric (Khlebnikov's "Archer") against folk epic (Khlebnikov's "Vila and the Wood Goblin"); and primitivist *lubok*-drawing (Goncharova and Tatlin) against portrait (Larionov) on the one hand and abstraction (Larionov, Goncharova) on the other. The collage leaf on the cover thus emblematizes what is to come inside the book: it announces a new concep-

Fig. 4.11. N. Goncharova, drawing for A. Kruchenykh, *Mirskontsa*, 1912. Leaf 27. Courtesy of the British Library, London.

tion of the page-as-such, the page as "field of action" or, in Russian Futurist terms, as simultaneity, as the fourth dimension beyond space and time.

A more elaborate example of the interaction of modes, genres, and media within the covers of a single Futurist book is found in *Troe* (*The Three*), completed in the spring of 1913.[40] Published by Matyushin after the death of his wife Elena Guro ("the three" are Khlebnikov, Kruchenykh, and Guro), *Troe* brings together at least six generic forms characteristic of this period. There is, notably, not a single short lyric in the volume. Rather, we find (1) manifesto (Matyushin's preface,

Kruchenykh's *Novye puti slova* [*New Ways of the Word*]); (2) topo-graphical poem (Khlebnikov's "Khadzi-Tarkhan"); (3) prose poem (Guro's "The Secret" or "Picasso's Violin"); (4) digressive short story or what we might call "the short story written as a poem" (Khleb-nikov's "Hunter Usa-Gali" and "Nikolai"); (5) free prose improvisa-tion (Kruchenykh's "From Sahara to America"); and (6) satiric portrait (Kruchenykh's "Of Contemporaries"). These texts are further comple-mented by four semiabstract drawings by Malevich and a reproduc-tion of the opening bars of Matyushin's *Victory over the Sun* with the text by Kruchenykh. Although the text of *Troe* is printed conven-tionally rather than handwritten and rubber-stamped as is *Mirskontsa*, its correlation of word and image is complex.

Malevich's cover (fig. 4.12) provides a visual analogue to Kruche-nykh's manifesto *Novye puti slova*. In the center of the page is placed a clean-edged, chunky black figure, as seen from the rear, a mannikin whose parts are constructed out of simple geometric forms—triangle,

Fig. 4.12. Kasimir Malevich, cover for *Troe (The Three)*, by A. Kruchenykh, V. Khlebnikov, and E. Guro. Moscow, 1913. Courtesy of the British Library, London.

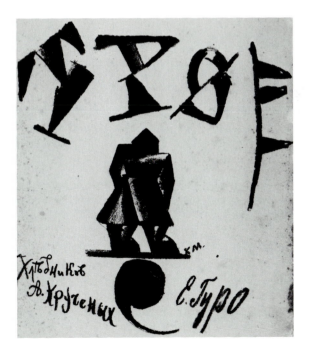

circle, cylinder—as one would construct a machine. Malevich neither celebrates this dehumanized figure (a more extreme version of his costume designs for *Victory over the Sun*),[41] as does Boccioni in comparable drawings, nor does he satirize the machine as the Dadaists were to do just a few years later. Rather, his mechanical robot-man merely *is*—immobile, anonymous, poised for action. He stands on a narrow ledge (a heavy straight line, actually) below which is the mirror image of a giant comma, almost the same size as the human silhouette, as if to say that in the New World, man has become the occasion for the creation of form itself, for the word as such. Indeed, the four giant letters of *Troe*, placed above the figure, are disjointed and reassembled to correspond to Malevich's mechanical man: the *T* is given a similar torso and two arms; the *P* and *O* repeat the triangle forms, now slightly rounded, and the elongated snaky *E* draws the beholder's eye down to the signature Е. Гуро (bottom right) and then in turn to the comma and the signatures of Khlebnikov and Kruchenykh in the bottom left.

The comma, this time hurling through cosmic space, reappears in the Malevich drawing *Pilot* (fig. 4.13). Here the outlined figure of the aviator becomes no more than an object among other objects—letters, numbers, giant commas and periods, aeroplane parts seen as geometric solids. Malevich presents us with the disintegration of three-dimensional space and its rebirth as something mysterious, something other—the fourth dimension of Ouspensky. As the Elocutionist puts it in act 2 of *Victory over the Sun:* "liberated from the weight of earth's gravitation, we whimsically arrange our belongings as if a rich kingdom were moving."[42]

The disintegration and remaking of space in Malevich's drawing is paralleled by the repeated call, on the part of the poets, for a language that will eschew logic, causality, temporality, syntax—referentiality itself. In the preface to *Troe*, Matyushin declares:

> perhaps the day is not far off when the vanquished phantoms of three-dimensional space, of seemingly droplike time, of melancholy causality and many other things will prove to be for all of us exactly what they are: the annoying bars of a cage in which the human spirit is imprisoned—and that's all. (*Troe*, 2; *WB* 102)

This rejection of "seemingly droplike time" and "melancholy causality" (the same motif appears in Kruchenykh's *Novye puti slova*) is exemplified by Khlebnikov's tale "Nikolai." Just as Malevich decomposes his "pilot" and gives us an "airplane" that is everywhere and nowhere, so Khlebnikov's story of a hunter, at home only in the natu-

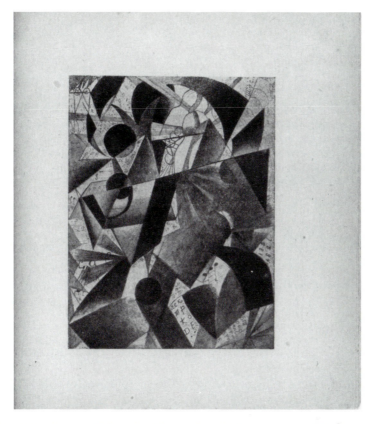

Fig. 4.13. Kasimir Malevich, *Pilot*, in *Troe*, 1913, opposite p. 82. Courtesy of the British Library, London.

ral world but paradoxically nature's victim, can be read as an experiment in the transfer of digressive, alogical, lyric structure, as that structure was conceived by such poets of the period as Apollinaire or Cendrars or Khlebnikov himself, into the realm of prose. Indeed, one of Khlebnikov's American translators, Gary Kern, points out (*ST* 254) that one passage in the story derives from Nikolai Nekrasov's poem "Knight for an Hour" ("Rytsar' na chas") of 1862:

I sank into an unclear mire
Of petty pursuits, petty passions.
From the rejoicing ones, idly chattering,
Take me away to the camp of the perishing ones
For the great deed of love!

He, whose life has uselessly broken apart,
May by his death still prove
That an untimid heart beat in him,
That he knew how to love.

In "Nikolai," this becomes:

> by way of a hunter's life this soul had to travel from the world of the
> "perishing ones" to the world replacing it, casting a farewell eye at the
> snowstorms of ducks, the desolation, the world where the red geese's
> blood poured over the sea, travel to the land of white stone piles driven
> into the river bed, delicate laces of iron bridges, city anthills—the
> strong but uncongenial, somber world. (*ST* 153)

Interestingly, Khlebnikov inverts Nekrasov's imagery: the reddening
blood is now associated not with the society of the idly chattering but
with the geese, which epitomize the natural world to which Nikolai
belongs. Khlebnikov thus "poeticizes" his prose account at the same
time that he gives it a parodic edge, for the allusion to Nekrasov de-
flates the pathos of the hunter's journey.

"Nikolai" begins as follows:

> Strange is the nature of an event, it leads you unconcerned past that
> which claims the name of something terrible, and you, on the contrary,
> seek profundities and mysteries in a negligible event. I walked along
> the street and stopped at the sight of a crowd gathering around a dray.
> "What's going on?" I asked a chance passerby. "As you see," he an-
> swered with a laugh. Indeed, in the midst of sepulchral silence an old
> black horse struck its hoof monotonously on the pavement. The other
> horses attended, lowering their heads, silent, unmoving. In the clop of
> the hoof were heard a thought, a destiny perused and a command, and
> the remaining horses, drooping, paid heed. The crowd grew rapidly
> until the drayman came out from somewhere, jerked the horse by the
> reins and rode away. (*ST* 150)

This curious anecdote raises expectations it never satisfies. For the
event recounted not only seems negligible but is so. The hoof clap of
the poor old dray horse, which would in, say, a Chekhov story fore-
shadow a particular turn of events or relate thematically to particular
images and psychological traits, is a portent here only insofar as the
narrator is looking for a sign. Indeed, what looks like a carefully or-
chestrated opening functions as a false lead: the fate of the old dray
horse is only marginally related to the "adversities of the wandering
life," which Khlebnikov now declares to be his true subject.

The poet's meeting with Nikolai is called "a magical event." But
again the "magic" is undercut by the actual description of the "indif-

ferent and diffident hunter," a man of "tawny brow and chin" whose
"eyes, much too honestly express nothing." Nikolai, the narrator tells
us, has a "lonely will," like "manors which stand off from the road,
with a fence turned to the crossways." He seems "quiet and simple,
wary and unsociable," but "When tipsy he became crude and inso-
lent" (*ST* 150–51).

This "characterization" borders on cliché (the Strong Silent Type),
as if to say that the subject eludes the narrator's attempts to define
him. But in the next breath, that very attempt is burlesqued:

> But who will read the soul of a companionless gray hunter, a stern
> pursuer of boars and wild geese? Here I am reminded of the stern sen-
> tence pronounced on all of life by a certain deceased Tatar, who left a
> note at his death with the curt but noteworthy inscription: "I spit on the
> whole world." (*ST* 151)

This digression is intentionally misleading, for the fact is that Nikolai
is not at all like the Tatar: he withdraws from the world rather than
spitting at it. And now something curious happens. Having used vari-
ous narrative strategies to displace his subject, Khlebnikov, in the
words of Gertrude Stein, begins over and over again:

> In a certain old album now many years old, among faded and bent-
> over old men with a star on their chests, among prim elderly women
> with a gold chain on their wrist, who are forever reading an open book,
> you might come upon the modest yellow portrait of a man with unre-
> markable features, a straight beard and a double-barreled gun across
> his knees. A simple part divides his hair.
> Should you ask who this paled photograph is, you will receive the
> brief answer that it is Nikolai. . . .
> I knew this hunter. (*ST* 151–52)

Another possible beginning for a story whose narrative thread seems
to be stuck, so to speak, on its spool. Instead of unraveling, it stub-
bornly reiterates what we already know:

> He was hidden and silent, most often uncommunicative, and only
> those whom he had shown the tip of his soul could guess that he con-
> demned life and knew the "contempt of the savage" for the human fate
> in its entirety. . . .

> He was simple, direct, even stern in a crude way. He was a good
> man to sit at bedside and care for sick comrades. For his tenderness
> toward the weak and his readiness to be their shield, he might have
> been envied by a medieval knight in armor, helmet and panache. . . .

He had people whom he could call friends, but the more his soul emerged from its "shell," the more masterfully did he destroy the equality between the two to his own advantage. He became haughty, and the friendship resembled a temporary truce between quarrelers. . . .

But to many it was clear that this man did not really belong to the human race. With his thoughtful eyes, his silent mouth, he had already served for two or three decades as the priest in the temple of Slaughter and Death. (*ST* 153–54)

Why these multiple readings of what is essentially the same situation? The device of retardation acts to produce mystery: we know Nikolai is simple and quiet, wary and unsociable, a kind of god ("Bird Perun"), "cruel but loyal to his subjects," "cold and foreign," "not really of the human race." Accordingly, the account of Nikolai's death in his overturned boat comes as a shock: "close by, with gun in hand, lay a man pecked clean by the birds, his flesh remaining only in his boots. A cloud of birds circled above him. A second dog lay half-dead at his feet." Nature, it seems, has deceived the heart that loved her. The God is only an ordinary man. His "friends"—did he have any?—place a modest cross at the head of his grave. "Thus died the wolfslayer."

In its rejection of "melancholy causality," Khlebnikov's narrative becomes self-conscious. For "Nikolai" is not so much "about" the terrible death—the flesh remaining only in the boots—of the strange hunter as it is about the nature of narrative, the way of recounting what seem to be clear-cut events. The story is "legendary" because we cannot know the connecting links between an *A* and a *B*. We see, in Ouspenskian terms, only the fingerprints, not the fingers that made them.

A similar self-reflexiveness, but in much more radical form, characterizes Kruchenykh's astonishing text called "From Sahara to America" ("Iz Sakhary v Ameriku"). Here is the opening:

Who wants to count us as five? Five sharpnosedneighboring black-handed clearly visible in each five students hung from above by our ears we listen big bristles by mistake we whisper
 When we strode through the skyscrapers
 We fluttered easier from first to last
 who believes won't grudge his silver
 throw it away and we the altar
 we all deepened behind the machines
 curls were flying out
 with a little axe I hit

> the further sea blows
> valuable cups are thrown at it
> shaving cups
> and who knows them . . . right?[43]

Here, a decade before the publication of Williams's *Spring and All*
or Pound's *A Draft of XVI Cantos*, is a poem that shifts readily from
prose to verse, from sentence to line, a poem in which free verse gives
way to what Marinetti calls "free words." As in the case of "Journey
across the Whole World," the title is absurd for the poem does not
recount a journey from Sahara to America, or indeed from any X to
any Y. Rather, it presents a montage of disparate elements and story
lines: some sort of hunting scene with howling curs and bullets, a
mock quest romance involving the Ceremonious One, who may or may
not be identical to the Princess. It all takes place in a landscape con-
taining skyscrapers and machines as well as trees, pastures, logs,
hawks, and herons. Sometimes the "I" seems to be alone, sometimes
one of "five students hung from above by our ears." Scraps of every-
day conversation are spliced with what seem to be fragments of fairy-
tale narrative:

> the pancakes don't settle
> nimble
> no one knows
> as if to be deceived when people have identical handwriting
> and I spit into the vessel of abomination and she reared and
> gushed and I a damper mushroom stood before her with my head
> bowed and it appeared to my ears the smoky air boldly drew something
> and herring hung on her shoulders and in the middle of her forehead
> uttered a young old woman (*Troe*, p. 8)

This fairy-tale collage gives way, in turn, to the image of "us five sit-
[ting] on the stone and fix[ing] our eyes between the planets that are
visible between bygone leaves we see the abyss." Stone, leaves, trees,
herring, snake, curs—the same images recur again and again, and
the dizzying sequence of "events" in Kruchenykh's nonjourney culmi-
nates in a moment of mock prophecy:

> I will begin to chase rabbits
> a beard won't be a baby's pacifiers
> and I will be refreshed with salt
> cured in smoke and tar
> but heaped upon by dust
> I won't taste again. . . .
>
> (*Troe*, p. 15; ellipses Kruchenykh's)

Event, memory, prophecy—all are subsumed by the glittering verbal surface where everything shifts, merges, evaporates, returns. Kruchenykh's rhetoric is bent on "laying bare the device": for example, the running together of words ("five sharpnosed neighboringmaned blackhanded clearly visible in each five students"); paradox ("all her wealth is ours / we didn't become richer"); transferred epithet ("the curs are crueling between trees"); indeterminate pronouns ("the curs yawn at us quietly we aren't hung they aren't hanging"); colloquial diction ("and who knows them . . . right?"); agrammatical construction ("when the curs leave remains their claw is thin wool on the floor trembles); mock exposition ("the brain of a snake is medicinal"); onomatopoeia (э э зеи; "e e zey"); and repeated neologisms and double entendres. "From Sahara to America" turns out to be the poet's journey into a language field in which word choice and phrasing *is* the theme. Malevich's "zero of form," the "destruction of the ring of the horizon," is also his.

Between the second and third page of Kruchenykh's Sahara poem, we find the first of Malevich's Cubo-Futurist drawings (fig. 4.14). Just as Kruchenykh's verbal structure is characterized by alogicality, by the repeated undercutting of conventional schemes of signification, so Malevich's geometric landscape presents us with familiar objects— a light bulb, a wheel, a piece of pipe, a leg—decomposed and fragmented in what is an intricate network of interlocking and overlapping planes, of light versus dark, circle versus rectangle. Both Kruchenykh's verbal and Malevich's visual images are characterized by what Roman Jakobson calls, with reference to Khlebnikov's "Khadzi-Tarkhan" (*Troe*, p. 35–36), *nanizyvanie*, "the conjoining of motifs which do not proceed on the basis of logical necessity but are combined according to the principle of formal necessity, similarity or contrast."[44] *Nanizyvanie*, as Jakobson characterizes it in "Khadzi-Tarkhan," has the effect of dispelling the autonomy of the lyrical "I" in favor of a more communal "one" or "we." The collective voice is even more marked in "Nikolai" or in Kruchenykh's "From Sahara to America," with its subordination of ego to the invention of *novye puti slova*. Like Malevich, Khlebnikov and Kruchenykh would have insisted that "Art requires *truth* not *sincerity*."

III

Malevich's "aim of destruction" is met again in a work that would at first seem to be its very opposite, a work that is sometimes taken to be the height of egocentric lyricism—namely, Mayakovsky's *Vladimir Mayakovsky: A Tragedy*, first performed alternately with *Victory over*

Fig. 4.14. Kasimir Malevich, untitled drawing, *Troe*, 1913, opposite p. 9.
Courtesy of the British Library, London.

the Sun on 2 and 4 December 1913 at the Luna Park Theatre in
Petersburg and then published, some four months later, in an edition
of five hundred copies, with complex typographical devices and illus-
trations by David and Vladimir Burliuk.[45]

In the Luna Park production, Mayakovsky as hero evidently ap-
peared at center stage, dressed in the Futurist yellow blouse that was
his trademark, whereas the actors surrounding him had costumes
painted by Pavel Filonov on canvas stretched on figure frames, which
they pushed in front of them. They thus took on the air of cardboard
puppets, each exemplifying a single trait: the Man with a Stretched
Face, the Man without an Ear, the Old Man with Cats, and so on.
Indeed, the stage design was in keeping with the spirit of the play,
which is less drama, let alone "tragedy," than it is what we now call

performance art—a verbal-visual improvisation that assaults the spectator's senses, drawing him or her into the poet's orbit.

Mayakovsky not only produced, directed, and starred in his play; he also insisted that the other roles—the Man with One Ear, the Man with One Eye, and so forth—be played by university students rather than professional actors so that he could coach them and bring their puppet figures into close conjunction with his own role. The performances were sponsored by the avant-garde painters' organization, the Union of Youth, and two artists, Pavel Filonov and I. Shkolnik, provided the stage settings and the sandwich-board costumes. The backdrop, depicting a spider's web of streets, was painted by Mayakovsky himself. Alternately hissed and widely applauded by the Luna Park audience, Mayakovsky turned his "tragedy" into a Futurist event, a happening. As he remarked the following year in *The First Journal of Russian Futurists* (March 1914), theater should fuse the ingredients of ballet and *zaum* language: the intonation of a speech that has no special meaning and the invented but rhythmically free movement of the human body work together. Both sound and movement are, in turn, closely coordinated with the visual image of the stage.[46]

Vladimir Mayakovsky: A Tragedy was originally called *The Revolt of Objects*,[47] and indeed the play presents us with a world in which the distinction between subject and object, self and world is curiously obliterated. The sky "weeps uncontrollably," the sun "has swollen fingers sprouting reddish hairs," the "side streets roll up their sleeves for a fight," and the "smokestacks dance on the rooftops / and their knees made a shape like 44."[48] Into this Futurist city the poet's soul is "carried on a platter / to be dined on by future years"; he is brought food in the form of "the iron herring from a street sign; a huge golden twisted loaf of bread; swatches of yellow velvet." The various "characters" who confront him on this "beggars' holiday" have no individuality; they are fragments of Mayakovsky's own self. "The poet," says Viktor Shklovsky, "dissects himself on stage, holding himself between his fingers as a gambler holds his cards."[49]

The ritual performed by poet and "puppets" is one of exorcism: the destruction of all that exists for the sake of revolution. "Ladies and Gentlemen," pleads the poet, "Patch up my soul so the emptiness can't leak out! . . . Seek out the fat ones in their shell-like dwellings, / and beat out revels on the drum of the belly!" These revels are marked by a ferocious energy, often cruel but sometimes comic, as in the suggestion, made by the Old Man with the Scrawny Black Cats, that the stroking of cat fur will produce the electricity necessary to run the city's tramways:

Only in cats
whose fur is shot through with blackness
will you catch flashes of electric eyes.
The entire catch of those flashes
(a big catch!)
we'll pour into wires—
those muscles of traction:
streetcars will start off in a rush;
the flame of wicks
will glow in the light like triumphant banners.
The world, in gay greasepaint, will stir into action;
the flowers in the windows will strut, peacock bright;
people will travel on rails—
always trailed
by cats, more cats, lots of black cats!
We'll pin the sun on the gowns of our sweethearts;
we'll adorn them with glittering brooches of stars.

<div align="right">(VM 24–25)</div>

Here and in related images of explosive movement, the natural, the human, and the intimate are fused so as to bombard the audience with the possibility of a new Futurist city. "I've wiped out the differences / between faces like mine and those of strangers," declares the poet, and indeed the projected world is impersonal and faceless. In such a world, the beloved can function only as an absence: the silent Enormous Woman who is unveiled in the course of act 1, only to be dropped on the floor by a careless crowd and forgotten, is a parody version of the divine lady of courtly love:

She came out
in a blue dressing gown,
and said:
"Sit down.
I've been waiting a long time for you.
Wouldn't you like a glass of tea?"

<div align="right">(VM 27)</div>

Only the Conventional Young Man, whose wife will "soon give birth to a son or a daughter" (VM 28), can respond to such a banal question; the rest of the crowd rushes out into the street and, having dropped the Enormous Woman, engages in a mock Walpurgisnacht in which man-made objects rebel against their makers and create their own life:

Suddenly,
all things went rushing off, ripping

their voices, and casting off tatters of outworn names.
Wineshop windows, all on their own,
splashed in the bottoms of bottles,
as though stirred by the finger of Satan.
From the shop of a tailor who'd fainted
trousers escaped
and went walking along—
alone,
without human buttocks!
Out of a bedroom,
a drunken commode—
its black maw agape—
came stumbling.
Corsets wept, afraid of tumbling
down from signs reading "ROBES ET MODES."
Every galosh was stern and straitlaced.
Stockings, like sluts,
winked flirty eyes.

<div align="right">(VM 30–31)</div>

The stage direction for the first act is "Jolly" ("Veselo"), for the second, "Depressing" ("Skuchno"). Indeed, act 2, written almost five years before the Bolshevik Revolution occurred, presents us with what is surely an uncanny prophecy of the fate of that revolution. The poet now wears a toga and laurel wreath; suppliants come to bring him gifts—tears of various sizes and kisses that turn "huge, / fat / tall- / first laughing, / then in a rage," like the bodies of ugly women (*VM* 35). In a sequence that looks ahead to the Nighttown sequence of *Ulysses*, Child Kisses, "manufactured by the millions . . . with the meaty levers of lips that smack," enter "playfully" and announce:

They've turned out the lot of us!
Take these!
Any minute the others will come.
So far, there's just eight.
I'm
Mitya.
Please!

And each puts down a tear which the poet, now playing the buffoon, rejects: "Gentlemen! / Listen! / I can't stand it! / It's alright for you. / But what about me, with my pain?" Gathering the tears in his suitcase, he sets off on his mock journey to Golgotha:

I'll go out through the city,
leaving

shred after shred of my tattered soul
on the spears of houses,
And the moon will go with me
to where
the dome of the sky is ripped out.
She'll come up beside me,
and briefly try on my derby hat.
I,
with my heavy load,
will walk on;
I'll stumble and fall.

<div align="right">(VM 36–37)</div>

Part Calvary, part circus, the *Tragedy* ends on a note of camp as in the epilogue Mayakovsky emerges, mocking his audience: "I wrote all this / about you— / poor drudges! / It's too bad I had no bosom: I'd have fed / all of you like a sweet old nanny." Dramatic illusion is, in any case, a myth:

Sometimes it seems to me
that I'm a Dutch rooster,
or else
A Pskovian king,
But at other times, what pleases me
more than anything
is my own name:
Vladimir Mayakovsky.

<div align="right">(VM 38)</div>

The apparent self-centeredness of this conclusion has often been misunderstood. "The Greeks," observed Trotsky in his essay on Mayakovsky, "were anthropomorphists, naively likening the forces of nature to themselves; our poet is a Mayakomorphist, and he populates the squares, the streets, and the fields of the Revolution only with himself."[50] True enough, but there is also a self-parodying dimension of the Mayakovskian gesture. In an essay called "Theatre, Cinema, and Futurism" (27 July 1913), Mayakovsky wrote:

contemporary theater appears only as an oppressor of the word and the poet. . . . the special art of the actor [will be one] where the intonation of a word . . . does not even have a specific meaning, and where movements of the human body . . . are invented but free in their rhythms [so as to] express the greatest inner feelings.[51]

The name as such may thus be one way of avoiding the "oppression" of a dominant poetic (in this case, "contemporary theater") that de-

mands words to contain a core of hidden meanings. In the printed text
of *Vladimir Mayakovsky: A Tragedy*, with its typographic innova-
tion and verbal-visual play, this emphasis on the relation of word to
literal image is even more emphatic. Of David Burliuk, who, with his
brother Vladimir did the art work for the book, and who was Maya-
kovsky's first real artist friend and patron, Mayakovsky wrote in his
autobiography (1928): "David had the anger of a master who had out-
passed his contemporaries and I had the fervor of a socialist who was
aware of the terrible destruction of the old. Russian Futurism was
born."[52] In *Vladimir Mayakovsky*, the text is set in a variety of type-
faces, large and small, Roman and italic, light and heavy. The page
thus becomes a visual unit, and the lineation itself, so central to
free verse, is obscured. On page 14 (fig. 4.15), for example, certain
words are set in heavy type: О бросьте ("Oh abandon"), сухих
("scrawny"), Мечется ("rushes around"). Further, when the word
гладьте ("stroke") is repeated, it is given larger letters for emphasis.
More important: certain letters—the final A of *pravda* ("truth"), the
Ф (phi) of *flygerov* (weather vanes)—are, as it were, removed from
their fixed stations inside a word and allowed to live a life of their
own. Thus the giant A (three times the size of the standard typeface)

Fig. 4.15. D. Burliuk, illustration for V. Mayakovsky, *Vladimir Mayakovsky: A Tragedy*, pp. 14–15. Moscow, 1914. Courtesy of the British Library, London.

becomes an alpha to the omega of *O bros'te.* The characters in the
play, on the other hand, are designated by miniature italic type, as in
Chelovek bez ikha (the Man Missing an Ear)—as if to subordinate the
voice that speaks to the words spoken. Indeed, the page functions as
musical score rather than replica of the speech; it can come fully to
life only when it is enunciated by the actor.

Burliuk's accompanying drawing is part sophisticated abstraction,
part child art. Solid and outlined geometric forms, suggestive of roof-
tops, weather vanes, buildings, and streets, are silhouetted against a
white backdrop. The stick figure of a man is depicted sideways, so
from the front, torso and legs look like another pointed roof. An eye-
lid, a mouth, a set of curves (woman? cavern? gobs of spit?) can
be detected, but these outlined forms are absorbed into the abstract
geometric composition of the whole. The A on the left-hand page
matches the various white and black shapes in the Burliuk drawing;
the Φ, by contrast, is, within this design, sui generis; it stands out
near the center of the page as a promised circle, an alternative to the
angular forms to its right.

Thus the doctrine of the "letter as such"—"ask any speechist, and
he'll tell you that a word written by one hand or set in one type is
completely unlike the same word in a different inscription"—is put
into action. Throughout the Mayakovsky-Burliuk book, individual
words and letters used to create visual images that correspond to
the lines, circles, trapezoids, the chimneys, wheels, rooftops, and
moon slivers in Burliuk's pictures. "The word," as Khlebnikov ob-
serves in his "Conversation between Oleg and Kazimir,"[53] is "like a
face with a hat pulled low over the eyes." The placement of words on
the page fulfills Mayakovsky's own credo that "the word, its outline
and its phonic aspect determine the flourishing of poetry."[54] So the
printed text of *Vladimir Mayakovsky: A Tragedy* tries to capture the
elasticity of the performance, the split-second shifts between vision
and ironic withdrawal, between the savagery of the prophet and the
horseplay of the clown. Geometric abstraction coexists, in Burliuk's
illustration, side by side with a little black cat straight out of a chil-
dren's book (fig. 4.16).

In *The New Russian Poetry* (1921), Roman Jakobson notes that the
difficulty and defamiliarization characteristic of Russian Futurist
texts obliges the reader to participate in the process of their realiza-
tion (*realizatsya*).[55] This formula, and the concept of "making diffi-
cult" (*zatridnenie*) that underpins it, anticipates, as G. M. Hyde has
noted,[56] Roland Barthes's now famous distinction between the *lisible*

Fig. 4.16. D. Burliuk, illustration for Mayakovsky, *Vladimir Mayakovsky: A Tragedy*, pp. 8–9. Moscow, 1914. Courtesy of the British Library, London.

(readerly) and *scriptible* (writerly) text. Indeed, Barthes's definition of the *scriptible*—"this text is a galaxy of signifiers, not a structure of signifieds; it has no beginning; it is reversible; we gain access to it by several entrances, none of which can be authoritatively declared to be the main one"[57]—carries out the implications of the doctrine of *The Word as Such*, as it is expounded in manifesto after manifesto of the Futurists, and it brings us full circle to the text with which I began, Malevich's *From Cubism and Futurism to Suprematism*, with its call for the "breakup and violation of cohesion" so as to lay bare "the latent meaning that has been concealed by the naturalistic purpose" (*CFS* 127), its apocalyptic declaration that

> I have released all the birds from the eternal cage and flung open the gates to the animals in the zoological gardens. (*CFS* 135)

For that matter, *Le Degré zéro de l'écriture* (the title of Barthes's first major book) surely takes us back to Malevich's "zero of form,"[58] and, as I shall argue in my final chapter, Barthes and other poststructuralist writers often seem to be teasing out implications already present in Futurist poetic, masked though such implications sometimes are by the poets' naïve infatuation with the future and its accompanying dismissal of the traditions that have shaped their work.[59] In

discussing the "verblessness" (*bezglagolnost'*), the nonlinear time continuum made by the juxtaposition or collaging of words, letters, and visual images in the Futurist book, Jakobson talks of "words in search of a meaning."[60] So, in *Vzorval'* (*Explodity*), a Futurist book assembled by Kruchenykh, Rozanova, Kulbin, Malevich, and Goncharova, we find, *avant la lettre*, texts like that found in figure 4.17.

Here a single *zaum* word, бепяматокияй (*belyamatokiyai*)—is spread diagonally across a page littered with letters—нs, пs, тs—

Fig. 4.17. A. Kruchenykh, *zaum* text, *Vzorval'* (*Explodity*), 1913. Leaf 3. Courtesy of the British Library, London.

and punctuation marks that seem to live a life of their own, to turn into pictograms—quotation mark as bird wing, Π (*P*) as stick figure, and so on. One wants to move these letters around, as in a board game, and, in search of possible meanings, put them inside the *zaum* word or substitute them for other letters. At the same time, the spectator perceives the page as visual design, as a structure of linear and oval shapes on a neutral background. The drive toward nonobjectivism (*bespredmetnost'*) here approaches its "zero" limit. In Malevich's words, "A surface lives. It has been born."

5 EZRA POUND AND "THE PROSE TRADITION IN VERSE"

Toute page est un spectacle. . . .toute mise en page represente et pratique une conception du langage à decouvrir.

—Henri Meschonnic

No good poetry is ever written in a manner twenty years old.

—Ezra Pound[1]

The London counterpart of such Russian Futurist assemblages as *Dokhlaya luna* (*The Crooked Moon*), *Vzorval'* (*Explodity*), and *Troe* (*The Three*) was a large (nearly a foot high) folio, whose shocking-pink cover bore, in three-inch block letters arranged diagonally from top to bottom, the title *BLAST*. Its first issue appeared, after much advance publicity, in June 1914.[2] Like the Russian Futurist books of the same period, *BLAST* was a collaborative venture: its opening manifesto, although written primarily by Wyndham Lewis with some help from Ezra Pound, bore eleven signatures.[3] In its aggressive tone, this "BLAST/BLESS" manifesto recalls Kruchenykh's *Novye puti slova* (*The New Ways of the Word*); in both cases, moreover, an opening manifesto is followed by short stories (Khlebnikov's "Hunter Usa-Gali" and "Nikolai"; Ford Madox Ford's "The Saddest Story," which was the germ of *The Good Soldier*); by essays on questions of aesthetic (Kruchenykh's "Of Contemporaries," a study of Cubist metaphysic; Edward Wadsworth's translation of Kandinsky's *Über das Geistige in der Kunst*); and by reproductions of abstract or semiabstract art works (Malevich in the former; Lewis, Gaudier-Brzeska, and other Vorticists in the latter).

Pound's contribution to *BLAST* was the manifesto "Vortex. Pound," reprinted in *Gaudier-Brzeska* (1916), and a set of short satiric poems and epigrams, some of which found their way into *Lustra* (1916).[4] No one would argue that the *BLAST* poems have a central place in the Pound canon; inevitably, they have been eclipsed by *Cathay* (1915), Pound's first indisputably great lyric collection. Nevertheless, *BLAST* and *Gaudier-Brzeska* represent a turning point for Pound, the working out of an aesthetic that was to transform the formal, strophic free verse he and his fellow Imagists were writing in the early 1910s—a free verse based on the *vers libre* of the French Symbolists—into the assemblage of "verse" and "prose" that we find in the *Cantos*. If there is nothing in *BLAST* that quite matches the free verse/free prose mix of Kruchenykh's "From Sahara to America" in *Troe*, its typographical

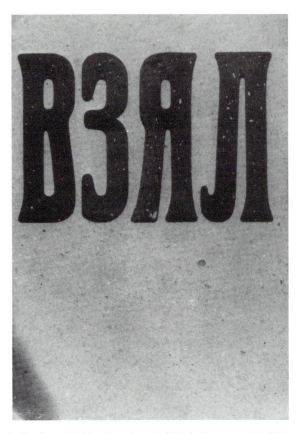

Fig. 5.1. D. Burliuk, V. Mayakovsky, V. Khlebnikov, and V. Shklovsky, cover design for *VZYAL: Baraban futuristov (TOOK: A Futurists' Drum)*. Moscow, 1915. Courtesy of the British Library, London.

and syntactic innovations were nevertheless startling; the cover design of *BLAST*, for that matter, became the model for David Burliuk and Mayakovsky's 1915 journal *VZYAL: Baraban futuristov (TOOK: A Futurists' Drum)* (see pl. 5 and fig. 5.1).[5]

It is a commonplace that Pound's prosodic experiments were designed to explode traditional English metrics: "To break the pentameter, that was the first heave." But the breaking of the pentameter was only one step in a much more radical development of the *avant guerre*, namely, the breaking down of the binary opposition between verse and prose, as those two terms were understood at the turn of the

century. We have already looked at Kruchenykh's invention of a mixed or "third" rhythm, a prose-verse collage that has its counterpart in France in the conversation poems and visual lyrics assembled in Apollinaire's *Calligrammes.*[6] In Anglo-America, however, even such reputedly "advanced" magazines as *The Egoist, Poetry,* and *The Little Review* were publishing, in 1913–14, poems only nominally departing from Edwardian meters and stanza forms, so Pound, like D. H. Lawrence a few years later, had to assume an adversary role, not just vis-à-vis the cultural establishment, as was the case with Apollinaire or Marinetti or Mayakovsky, but against what claimed, ironically enough, to be the "new poetry."[7] In this context, *BLAST*'s "CURSE [on] the flabby sky that can manufacture no snow, but can only drop the sea on us in a drizzle like a poem by Mr. Robert Bridges"[8] helped to clear the stage for a new prosodic order.

I

The new order was not simply synonymous with *vers libre* as that term was construed in the London of 1914. The Imagist manifesto of 1912 had laid down as its third principle, "As regarding rhythm: to compose in the sequence of the musical phrase, not in sequence of a metronome" (*LE* 3). This was not a particularly radical precept: Pound and his fellow Imagists derived it from the French Symbolists, especially from Gustave Kahn, who had codified the "rules" for *vers libre* by the midnineties.[9] In the *Poetry Review* for August 1912, F. S. Flint published a long essay called "Contemporary French Poetry," which defined Symbolist *vers libre* as "a living flow of speech," whose element was "the strophe, of no conventional form, composed of verses that were free from exterior law." But this *vers libre*, Flint insisted, was "by no means free; it must follow rigorously the interior law of the poet's emotion, and the idea which has given it birth." And, as an example of this, "the most difficult [verse] form of all," Flint cited Henri de Régnier's "Odelette IV," which begins:

Si j'ai parlé
De mon amour, c'est à l'eau lente
Qui m'écoute quand je me penche
Sur elle; si j'ai parlé
De mon amour, c'est au vent
Qui rit et chuchote entre les branches;
Si j'ai parlé de mon amour, c'est à l'oiseau
Qui passe et chante
Avec le vent;

Si j'ai parlé
C'est à l'echo.

Praising the delicate assonance (e.g., "lente"/"penche") and phrasal
repetition ("Si j'ai parlé") of this strophe, Flint declared that "The
music of [the Symbolists'] language had been so enriched that it was
like the revelation of the chromatic scale to a nation that had only
known the diatonic."[10]

Or, in Pound's words, "Compose in the sequence of the musical
phrase, not in sequence of a metronome." Pound's own interest in this
side of Symbolist poetry was sparked by his reading, in early 1912, of
Rémy de Gourmont's prose poems.[11] In the second of a series of ar-
ticles called "The Approach to Paris" for A. R. Orage's *The New Age*
(11 September 1913), Pound declared that "The history of English po-
etic glory is a history of successful steals from the French," and he
proceeded to praise Gourmont as the poet who "knows more about
verse-rhythm than any other man now living; at least he has made
a most valuable contribution to the development of the strophe"
(Pondrom, *Road from Paris*, p. 175). And he cites Gourmont's "Li-
tanies de la rose":

> Rose au visage peint comme une fille d'amour, rose au coeur pros-
> titué, rose au visage peint, fais semblant d'être pitoyable, fleur hypo-
> crite, fleur du silence.

> Rose à la joue puerile, ô vierge des futures trahisons, rose à la joue
> puerile, innocente et rouge, ouvre les rets de tes yeux clairs, fleur
> hypocrite, fleur du silence.

> Rose aux yeux noirs, miroir de ton néant, rose au yeux noirs, fais-
> nous croire au mystère, fleur hypocrite, fleur du silence. (Pondrom,
> *Road from Paris*, pp. 175–76)

What delights Pound here is the "ever more sweeping cadence with
ever more delicate accords," the subtle phrasal and clausal repeti-
tions, "the wave-length of the rhythm," reminiscent of "Greek verse-
art" (p. 176). Not that "rhythm-units," Pound admits, need always
be "homogeneous" and "symmetrical" as are the units of "Litanies de
la rose." But, if "asymmetrical," they must nevertheless observe the
laws of "musical construction" so as to produce Beauty and Harmony.[12]

Pound's own poems of 1913 swerve oddly back and forth between
symmetrical "rhythm-units" in the vein of Gourmont:

I hâve nót foúnd theê in the ténts,
In the bróken dárkness.

I hâve nót foúnd theê at the wéll-heâd
Amóng the wómen with pítchers.[13]

and a more abrupt, disjunctive speech rhythm found in poems like
"The Condolence":

Ó my féllow súfferers, ‖ sóngs of my yóuth,
A lót of ásses práise yôu becáuse you are "vírile,"
Wé, ‖ yóu, ‖ Í! ‖ Wê are "Réd Blôods"!
Imágine ît, ‖ my féllow súfferers—
Our máleness lífts ûs oút of the rúck,
 Whó'd have fôreseén it?

<div align="right">(P 82)</div>

It is this latter rhythm that comes to the fore in *BLAST* and that was
promptly castigated by other poets and reviewers. In the *Little Review*
for March 1914, Eunice Tietjens published an essay called "The
Spiritual Dangers of Writing Vers Libre," in which Pound is cited as
"the most perfect example" of the corruption of a form that, so Tiet-
jens maintains, all too easily leads to "mental laziness" and "cru-
dity."[14] Pound's earlier work, says Tietjens, "was clean-cut, sensitive
poetry, some of it very beautiful." And she quotes a poem from the
1909 *Personae* called "Piccadilly":

Beautiful, tragical faces,
Ye that were whole, and are so sunken;
And, O ye vile, ye that might have been loved,
That are so sodden and drunken,
 Who hath forgotten you?

O wistful, fragile faces, few out of many!
The gross, the coarse, the brazen,
God knows I cannot pity them, perhaps, as I should do,
But, oh, ye delicate, wistful faces,
 Who hath forgotten you?

<div align="right">(CEP 98)</div>

Tietjens contrasts this poem (which Pound did not reprint in the 1926
Personae) to "Salutation the Third," which begins:

Let us deride the smugness of "The Times":
GUFFAW!
 So much for the gagged reviewers,
It will pay them when the worms are wriggling in their vitals;
These were they who objected to newness,
Here are their TOMB-STONES.

They supported the gag and the ring:
A little black BOX contains them.
 so shall you be also,
You slut-bellied obstructionist,
 You sworn foe to free speech and good letters,
You fungus, you continuous gangrene.[15]

"So flagrant a spiritual and cerebral degeneration," declares Tietjens, cannot be blamed on *vers libre* as such: "Fortunately . . . we are not all Ezra Pounds and there are still poets balanced enough to appreciate these dangers and to make of free verse the wonderful vehicle it can be in the hands of a genius" (p. 29).

From our vantage point in the eighties, neither "Piccadilly" nor "Salutation the Third" seems especially memorable; indeed, in both cases the poet's emotion (lament in the former, contempt and outrage in the latter) may well strike us as insufficiently grounded in a particular situation and hence somewhat trivialized. But Tietjens no doubt prefers "Piccadilly" because she is offended by the "crude" and vulgar language of "Salutation the Third": "slut-bellied obstructionist," "fungus," "continuous gangrene," and so on. Poetic language, she implies, should be "elevated," removed from ordinary speech. If the poet must refer to, say, the drunks that hang around Piccadilly, aesthetic distance should be maintained, a distance that allows the "Ye that were whole, and are so sunken" to be regarded as "tragical." But "Salutation the Third" refuses to distinguish between "poetic" and "ordinary" language: the "I" who speaks, defying the formalities, wishes worms and gangrene to descend upon the "fungus" growth of "gaggling reviewers from 'The Times.'"

What does all this have to do with free verse? Could not the same "ugly" language crop up in, say, octosyllabic couplets? Here a comparison between the two poems is instructive. For the "free verse" of "Piccadilly" is not, in fact, free at all: its two stanzas are closely related by syntactic parallelism, phrasal repetition, and refrain and are placed on either side of the "keystone" line, "O wistful fragile, faces, few out of many!" which provides us with a variant of the refrain even as its alliterative *f*s point back toward "forgotten." If, as Eliot was to declare in "Reflections on Vers Libre" (1917), "the ghost of some simple metre should lurk behind the arras in even the 'freest' verse; to advance menacingly as we doze, and withdraw as we rouse,"[16] then "Piccadilly" is a model free-verse poem, its ninth line (a variant of the refrain) providing the pentameter norm:

Bút, | óh, ye délicate, wístful fáces.

By contrast, the rhythm of "Salutation the Third" has a puzzlingly "rough" quality: there seems to be no "ghost of a simple metre . . . lurk[ing] behind the arras" of such lines as

HERE are their TOMBSTONES.
 They suppórted the gág and the ríng:
A líttle blâck BÓX contáins them.
 só shâll yoú bê álsô,
Yoû slútbêllied obstrúctionist.

By the time of the *Cantos*, we find that the harmonious strophic cadences of "Piccadilly," cadences characteristic of the Francophile *vers libre* of the 1910s in England, tend to be reserved for the set pieces or "magic moments" in the poem[17]—the medievalizing "high" style of "Compleynt, compleynt I hearde upon a day" (Canto XXX), the Usura Canto (XLV), and "Pull down thy vanity" (LXXXI), or for such lyric apostrophes as the invocation to the Goddess in XC:

 Sybílla,
from únder the rúbble héap
 m'elevásti
from the dúlled édge beyond paín,
 m'elevásti
óut of Érebus, | the déep-lýing
 from the wínd únder the eárth,
 m'elevásti

 (XC, 606)

Much more common in the *Cantos* are the "prose" rhythms found not only in the cited documents (e.g., the Adams-Jefferson correspondence), but also in the poet's own ruminations on history, economics, and his own past:

"Jólly wóman" | sáid the respléndent hêad waíter
 2̇0 yéars áfter ‖ í.é. áfter ôld Káit'
 had púffed în, | stéwing with ráge
 concérning the lándlâdy's *dóings*
 with a lódger unnámed
 az wâz near Ĝt Tíchfield Śt. nêxt dóor to the púb
"márried wúmman, ‖ you coúldn't fôol *hér*"

 (LXXX, 502)

Indeed, the "m'elevasti" litany of Canto XC is framed by passages like the following, which marks the end of the preceding canto:

And whén "EXPÚNGED", ‖ Á. J. sênt báck the búllet,
 which ís, ‖ I sûppóse, ‖ párt of párliaméntary hístory
dúll or nót, ‖ as you chóose to regárd it.
 I wânt Frémont loóking at moúntains
 ór, ‖ if you líke, ‖ Réck, at Lâke Bíwa.

 (LXXXIX, 604)[18]

What we might call, with respect to rhythm, the Pound signature—
the seemingly casual talk, broken by the insertion of Chinese ideo-
grams, of Greek and Latin meters, or of found objects (documents,
letters, quotations), all these welded into a tight web of trochees,
spondees, and amphibrachs, culminating either in a heavy stress
("with rage," "to the pub" in LXXX) or, more characteristically, in a
dying fall ("búllet," "hístory," "moúntains," "Bíwa," in LXXXIX)—
has little to do with the "contrast between fixity and flux" that Eliot,
no doubt thinking of his own poetry, attributes to successful free
verse. Eunice Tietjens's dismay is surely animated by a similar con-
ception of verse, a dismay hardly surprising when we consider the
hostility that regularly greeted, and still sometimes greets, Pound's
Canto structure. As late as 1940, Randall Jarrell, reviewing *The Fifth
Decad of Cantos* (XLII–LI) for *The New Republic*, declared: "The ver-
sification of these cantos is interesting: there is none. The prose is an
extremely eccentric, slangy, illogical sentence-fragment, note-taking
sort of prose but prose; the constant quotations from letters or docu-
ments or diaries are no different from the verse that frames them."[19]

In thus dismissing Pound's "versification" as nonexistent, Jarrell
evades what should have been the obvious question: why would a poet
who had displayed such obvious mastery of esoteric meters, whether
Greek or Provençal or Italian or Old English, a poet who clearly had
control over both English and Continental stanza forms as well as the
new *vers libre*, be inclined to write an "extremely eccentric, slangy,
illogical sentence-fragment, note-taking sort of prose"? What was it
that turned the Imagist Pound of 1912, the author of "Doria" and "Ap-
paruit," into the enfant terrible of the 1914 *BLAST?* To pose the ques-
tion more broadly, what was the attraction that "prose" offered the
poets of the *avant guerre,* an attraction reflected in, say, the title of
Blaise Cendrars's poem, *La Prose du Transsibérien et de la petite
Jehanne de France?*

II

In an essay called "The Prose Tradition in Verse" (*Poetry*, 1914),
Pound compliments his friend Ford Madox Ford for teaching poets that

"prose is as precious and as much to be sought after as verse, even its shreds and patches" (*LE* 372). The story of Ford's influence on Pound is a familiar one: we know that it was Ford who introduced Pound to the novels of Stendhal and Flaubert, and that the example of these two novelists as well as that of Joyce profoundly influenced the writing of *The Cantos*.[20] In the essays of 1913–14, Pound regularly admonishes his reader to "Go in fear of abstractions. Do not retell in mediocre verse what has already been done in good prose. Don't think any intelligent person is going to be deceived when you try to shirk all the difficulties of the unspeakably difficult art of good prose by chopping your composition into line lengths" (*LE* 5); or again, "Don't imagine that a thing will 'go' in verse just because it's too dull to go in prose" (*LE* 6); and "I believe no man can now write really good verse unless he knows Stendhal and Flaubert" (*LE* 32).

I have discussed elsewhere the impact that the "matter of prose fiction" as opposed to the "matter of lyric" had on the *Cantos;* as Michael A. Bernstein puts it, "It was Pound who "show[ed], for the first time in over a century, that poetry can actually *incorporate* prose, that the modern verse epic is a form sufficiently strong to absorb large chunks of factual data into its own texture . . . without ceasing to be poetry."[21] But it is not simply a matter of poetry plus prose—of *A* + *B*. For the characteristic rhythms of the *Cantos* are not, strictly speaking, prose either, and the visualisation of the page, which, needless to say, plays no role in the novels of Stendhal and Flaubert, is one of the striking features of the *Cantos* even as it is of *BLAST*. Indeed Poundspeech, with its jagged lines, abrupt collage cuts and startling juxtapositions, is closely related to a source more immediate than Flaubert's or even Joyce's prose: namely the *parole in libertà* of the various Futurist performances that were the talk of London in 1913–14.

The relation of Vorticism to Italian Futurism is still imperfectly understood, largely because Anglo-American critics, even such fine ones as William C. Wees, Richard Cork, and Timothy Materer, have tended to take at face value the hostile statements Lewis and Pound made about Marinetti and the Futurists, statements that have less to do with actual Futurist aesthetic than with the aggressive nationalism of the *avant guerre*, a nationalism that also colors Pound's response to Apollinaire or Lewis's response to Picasso.[22] To study *BLAST* and related books and journals of 1914 is to see that, whatever the protests lodged by Lewis, Pound, and their artist friends, Vorticism would not have come into being without the Futurist model.

In an important essay called "Futurism and the English Avant-

Garde: The Early Pound between Imagism and Vorticism" (1981),
Giovanni Cianci reminds us how pervasive the Futurist presence was
in London from 1910, when Marinetti read his famous founding mani-
festo at the Lyceum Club, to 1915 when the war brought travel to a
standstill.[23] A short chronology may be helpful:

April 1910: Marinetti reads the first Futurist manifesto (1909)
 at the Lyceum Club in London.

August 1910: Douglas Goldring's review *The Tramp* publishes
 parts of Marinetti's 1909 manifesto and *Contro Ve-*
 nezia passatista (*Against Past-Loving Venice*). The
 same issue contains Wyndham Lewis's second
 short story, "A Breton Innkeeper."

March 1912 Exhibition of Futurist painters (Boccioni, Carrà,
 Russolo, Severini, Balla) at Sackville Gallery.
 Catalog contains, aside from notes by the artists,
 three important documents of Futurist theory: the
 1909 manifesto, the *Futurist Painting: Technical*
 Manifesto (1910), and an introduction by the ex-
 hibiting painters. In conjunction with the exhibit,
 Marinetti gives conference at Bechstein Hall.
 Boccioni joins suffragist demonstrations.

April 1913 Severini one-man exhibition at the Marlborough
 Gallery. Horace B. Samuel publishes essay called
 "The Future of Futurism" in *The Fortnightly Review.*

September 1913 Harold Monro devotes issue of *Poetry and Drama*
 to Futurism: among other works, Marinetti's "Fore-
 word to the Book of Anrep" and his manifesto,
 Destruction of Syntax—Wireless Imagination—
 Words-in-Freedom, translated by Arundel del Re,
 as well as a "French Chronicle" on Marinetti by
 F. S. Flint.

November 1913 Marinetti's manifesto *The Variety Theater* pub-
 lished in the *Daily Mail*. Marinetti gives "Futurist
 evenings" at the Cabaret Club, the Poet's Club, the
 Poetry Bookshop, and the Doré Galleries. Lewis,
 C. R. Nevinson, Richard Aldington, and Harold
 Monro give accounts to friends in their correspon-
 dence and memoirs. At a dinner organized for

Marinetti by the painters Etchells, Hamilton, Wadsworth, Nevinson, and Lewis at the Florence Restaurant (18 November), Marinetti recites the *Siege of Adrianople.*

April–June 1914 Exhibition of Italian painters and sculptors, Doré Galleries. Seventy-three paintings by Balla, Boccioni, Carrà, Russolo, Severini, Soffici; four sculptures by Boccioni, self-portrait by Marinetti, and a *tavola polimatericà* by Marinetti and Cangiullo. Related Futurist *manifestazioni,* including twelve "intonarumori" concerts at Coliseum and Albert Hall. The April 1 and 15 issues of *The Egoist* carry an ad for *BLAST.* The ad, composed by Pound, promises, among other things, "Discussion of Cubism, Futurism, Imagisme and all Vital Forms of Modern Art," and declares "Putrefaction of Guffaws Slain by Appearance of *BLAST*," "No Pornography," "No Old Pulp," "END OF THE CHRISTIAN ERA."

May–July 1914 *The New Age* publishes Marinetti's manifesto "Lo Splendore geometrico e meccanico e la sensibilità numerica" ("Geometric and Mechanical Splendour in Words at Liberty").

June 1914 Publication of *BLAST.*

Pound was right at the center of what we might call the Futurist vortex. However irritating he may have found Marinetti's posturing, as well as his obsession with "automobilism" and the new technology and the Futurists' simplistic rejection of tradition, Pound nevertheless absorbed the more specifically aesthetic doctrines of Futurism. The first axiom in the 1909 manifesto is, "We intend to sing the love of danger, the habit of energy and fearlessness."[24] "Vortex. Pound" begins with the sentence, "The vortex is the point of maximum energy," a point made even more emphatically in "The Serious Artist" (1913): "We might come to believe that the thing that matters in art is a sort of energy, something more or less like electricity or radioactivity, a force transfusing, welding, and unifying" (*LE* 49). Again, Boccioni's declaration, in the *Technical Manifesto* of 1910, that "The gesture which we would reproduce on canvas shall no longer be a fixed *moment* in universal dynamism. It shall simply be the *dynamic sensation* itself," and

that, further, "all things move, all things run, all things are rapidly changing" (*FM* 27) is matched by Pound's "All experience rushes into this vortex" (*B* 153).

Energy, force, dynamism—these were to be key terms in Poundian poetic. Another was simultaneity, which is to say, the juxtaposition, within the same construct, whether visual or verbal, of different time frames. In their Sackville Gallery catalog (1912), Boccioni and his fellow painters wrote: "The simultaneousness of states of mind in the work of art: that is the intoxicating aim of our art." Such "simultaneousness" was to be achieved by means of "the dislocation and dismemberment of objects, the scattering and fusion of details, freed from accepted logic" (*FM* 47). This law of "decomposition" where "every object influences its neighbor . . . by a real competition of lines and by real conflicts of planes" (*FM* 48) was carried over into the verbal realm by Marinetti in the *Wireless Imagination* manifesto published in *Poetry and Drama*. Here, for the first time, was a defense, not of *vers libre* vis-à-vis the traditional meters, as in the manifestos of the Imagists, but a section called, of all things, "The Death of Free Verse":

> Free verse once had countless reasons for existing but now is destined to be replaced by *words-in-freedom*.
> The evolution of poetry and human sensibility has shown us the two incurable defects of free verse.
> 1. Free verse fatally pushes the poet towards facile sound effects, banal double meanings, monotonous cadences, a foolish chiming, and an inevitable echo-play, internal and external.
> 2. Free verse artificially channels the flow of lyric emotion between the high walls of syntax and the weirs of grammar. The free intuitive inspiration that addresses itself directly to the intuition of the ideal reader finds itself imprisoned and distributed like purified water for the nourishment of all fussy, restless intelligences. (*FM* 99)

"Words-in-freedom" as opposed to "free verse" would mean, so Marinetti argued, the avoidance of "rhetoric and banalities telegraphically expressed" in favor of "TELEGRAPHIC IMAGES . . . COMPRESSED ANALOGIES . . . MOVEMENTS IN TWO, THREE, FOUR, FIVE DIFFERENT RHYTHMS" (*FM* 100). To achieve such rhythms, the "qualifying adjective" must be suppressed, for adjectives suppose "an arrest in intuition, too minute a definition of the noun" (*FM* 103). Or, in Pound's words, "Use no superfluous word, no adjective which does not reveal something" (*LE* 4).

In the last section of the manifesto, Marinetti calls for a "typographical revolution," aimed at exploding the "harmony of the page, which is

contrary to the flux and reflux, the leaps and bursts of style that run through the page." To convey these leaps and bursts, three or four colors of ink could be used as well as a variety of typefaces. "I oppose," writes Marinetti, "the decorative, precious aesthetic of Mallarmé and his search for the rare word, the one indispensable, elegant, suggestive, exquisite adjective." Indeed, Mallarmé's "static ideal" must be replaced by what Marinetti calls "multilinear lyricism" (*FM* 104–5), a lyricism that would involve, as he puts it in the 1914 manifesto "Geometric and Mechanical Splendour" (*The New Age*), the systematic destruction of the "literary 'I' in order to scatter it into the universal vibration" (*FM* 155).

In the pages of *The Fortnightly*, *The Egoist*, and *Poetry and Drama*, these radical notions of poetic form were greeted with enthusiasm, even though, ironically, the same journals were publishing the sort of poem Marinetti was condemning. In "The Future of Futurism," Horace B. Samuel notes that "M. Marinetti carries the metrical revolution considerably further [than the *vers librists* or Whitman]," and that in the case of Marinetti's own *parole in libertà*, the reader is "quite oblivious of the immaterial question of whether he is perusing verse or prose" (*Fortnightly* 93 [April 1913]: 733). And in his "French Chronicle" for *Poetry and Drama*, F. S. Flint concludes, "The *vers libre* was a reform in *length;* the simultaneous poem will be a reform in *depth*" (1 [September 1913]: 360).

None of this can have been lost on Pound. If the term *vortex* had, as Timothy Materer and others have shown, many sources, both esoteric and theosophical,[25] Cianci is probably right when he suggests that, "between 1913–1914 . . . in line with [Pound's] decision to join the battle in support of the new art, the concept of *vortex* shed its overtones of mysticism and metaphysics to become more concrete and actual, embracing, as in the Futurist ideology, both urban culture and society" ("Futurism and English Avant-Garde," p. 15). Certainly the "vortex" of *BLAST* and *Gaudier-Brzeska* can be related to Carrà's 1913 manifesto "The Painting of Sounds, Noises, and Smells," which contains the sentence, "This kind of bubbling over [of forms and light in painting] requires a great emotive effort, even delirium, on the part of the artist, who in order to achieve a *vortex*, must be a *vortex of sensation* himself, a pictorial force and not a cold multiple intellect" (*FM* 115). And in 1913–14, Balla, whom Lewis called in *BLAST* "the best painter" of the Futurists,[26] was exhibiting a series of charcoal drawings called *Vortice* (fig. 5.2), abstract studies of forms in motion that closely conformed to Pound's thesis that "The image is not an idea. It is a radiant node or cluster . . . a VORTEX, from which,

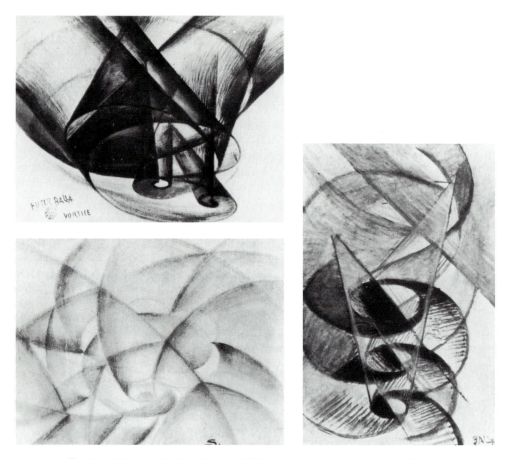

Fig. 5.2. Giacomo Balla, *Vortice*, 1913–14. Tempera on paper. Galleria d'Arte Fonte d'Abisso, Modena, Italy.

and through which, and into which, ideas are constantly rushing" (*GB* 92).

In practice, what these formulations meant is that Pound began to question the sufficiency of what was, in his "Imagist" poems, an essentially static, decorative, and calligraphic verse form. For although Pound, under the tutelage of Ford Madox Ford, talked a great deal about the necessity of "prose training," such training was not put into practice in the British poetry of the early teens, certainly not in Ford's own. In a review of Ford's book of poems, *High Germany* (1912), Pound admitted that "Mr. Hueffer [Ford] is so obsessed with the idea that the language of poetry should not be a dead language, that he forgets it must be the speech of to-day, dignified, more intense, more dynamic, than to-day's speech as spoken."[27] And, indeed, Ford's *Collected Poems*, which Pound reviewed somewhat evasively for *Poetry* in

June 1914, was written entirely in traditional verse forms—heroic couplet, tetrameter ballad stanza, blank verse, and so on.[28]

In this context, the Futurist concept of words-in-freedom and of *vortice* as energy introduced the possibility not just of modeling poetry on the "limpidity" of prose, but of interjecting actual prose rhythms into the lyric fabric in the interest of a new dynamism. In the *ABC of Reading*, Pound puts it this way:

> The defect of earlier imagist propaganda was not in misstatement but in incomplete statement. The diluters took the handiest and easiest meaning, and thought only of the STATIONARY image. If you can't think of imagism or phanopoeia as including the moving image, you will have to make a really needless division of fixed image and praxis or action. (*ABC* 52)

Here Pound makes the distinction in terms of Image.[29] But it can also be made in terms of rhythm, lineation, and typography. It is this area to which I now turn.

III

Ironically, Pound's equivalent of *parole in libertà* makes its first appearance not in the lyric poems, but in the poet's prose writings. This is not really surprising when one considers that, in England and America, even the so-called avant-garde journals of the prewar period were publishing poems like Percy Mackaye's "In the Bohemian Redwoods," which begins:

Silent above, with seraph eyes
　　That peer amid the fronded spars,
More intimate, more friendly wise,
　　More tender glow the eternal stars.

Lyric beneath, with echoing blast
　　Of fellowship Arcadian,
More cosmic-strange, more pagan-vast,
　　More stellar glow the hearts of Man.[30]

"In the Bohemian Redwoods" appeared in the special American number of Monro's *Poetry Review* (later *Poetry and Drama*) in October 1912. The issue also included a selection from William Carlos Williams's *The Tempers*, introduced by none other than Ezra Pound. In a headnote to the poetry section, Monro prides himself on the "catholicity" of his taste—"we require only that work be genuine and new"—and praises Mackaye's "skill in the manipulation of unusual words, and their combination into phrases which, if but rightly understood,

produce, on the combined senses, rather than on the hearing alone, a most remarkable, indeed, almost startling effect" (p. 479). A "startling effect," we might add, that must have impressed Pound as no more than the tum-ti-tum of the metronome.

The poet's prose, on the other hand, was free to pursue its own trajectory: no one, after all, was likely to submit the prose of *Patria Mia* or *Gaudier-Brzeska* to the sort of scrutiny reserved for "works of art." A similar dichotomy can be observed in the writings of Lawrence: the prose of, say, "Twilight in Italy," written during 1912–13, is much closer to the Futurists' "multilinear lyricism" than are such poems of the same period as "The Excursion," written in rhyming stanzas.[31]

In Pound's first prose book, *The Spirit of Romance*, published only four years before *BLAST*, the iconoclastic impulse soon to manifest itself is still held firmly in check. Here is a sample passage, found at the opening of chapter 2, "Il Miglior Fabbro":

> The Twelfth Century, or, more exactly, that century whose center is the year 1200, has left us two perfect gifts: the church of San Zeno in Verona, and the canzoni of Arnaut Daniel; by which I would implicate all that is most excellent in the Italian-Romanesque architecture and in Provencal minstrelsy.
>
> While the "minds" of the age were legislating for orderly angles, and reconstructing the laws of God with an extreme precision, the architects were applying the laws of proportion to buildings "meet for the new religion," (or they were simply continuing the use of Byzantine stone forms, lacking the money to incrust the interior with mosaic) and the Troubadours were melting the common tongue and fashioning it into new harmonies depending not upon the alternation of quantities but upon rhyme and accent.[32]

This is discourse that does not call attention to itself: the topic to be discussed is put forward logically and succinctly in the first paragraph and developed in the second paragraph, which consists of one long complex sentence. The voice that conveys information to the reader and makes value judgments about that information is sensible, authoritative, and clear-headed. Indeed, the passage might have been written by any young scholar, fresh from his studies in the Romance languages and enamored of Romanesque art as well as Troubadour poetry, were it not for the quotation marks around the word "minds" and the parenthetical phrase "(or they were simply continuing the use of Byzantine stone forms, lacking the money to incrust the interior with mosaic)." Here there is just a shade of the ironic, quizzical voice that was to become a Pound signature: the self-interruption that calls into question what is being said.

Within three years, Pound was writing an entirely different sort of "prose." Here is a passage from *Patria Mia* (1913). The subject is the quality of American life, as seen by the expatriate poet, returning to his native land after five years abroad:

> Nevertheless, America is the only place where contemporary architecture may be held to be of any great interest. That art at least is alive.
>
> And New York is the most beautiful city in the world?
>
> It is not far from it. No urban nights are like the nights there. I have looked down across the city from high windows. It is then that the great buildings lose reality and take on their magical powers. They are immaterial; that is to say one sees but the lighted windows.
>
> Squares after squares of flame, set and cut into the ether. Here is our poetry, for we have pulled down the stars to our will.
>
> As for the harbour, and the city from the harbour. A huge Irishman stood beside me the last time I went back there and he tried vainly to express himself by repeating:—
>
> 'It uccedes Lundun'.
>
> 'It uccedes Lundun'.
>
> I have seen Cadiz from the water. The thin, white lotus beyond a dazzle of blue. I know somewhat of cities. The Irishman thought of size alone. I thought of the beauty, and beside it Venice seems like a tawdry scene in a play-house. New York is out of doors.
>
> And as for Venice; when Mr. Marinetti and his friends shall have succeeded in destroying that ancient city, we will rebuild Venice on the Jersey mud flats and use the same for a tea-shop. (*SP* 107)

Satiric as is the allusion to Marinetti (specifically to *Contro Venezia passatista*), the text itself establishes a continuity between Marinetti's style and Pound's own. For here the expository "normal" prose of *The Spirit of Romance* gives way to a series of abrupt statements, questions, exclamations, sentence fragments, and phonetic spellings. The dominant rhythm is the discontinuous, repetitive, heavily accented rhythm of speech, whose unit is not the prose sentence but the short phrase or exclamatory utterance, as in "That art at least is alive" or "No urban nights are like the nights there."

A man on his feet, talking, as Charles Olson was to put it. But— and here Pound's discourse differs from Marinetti's—the passage is also highly "poetic," its rhythms and phrasing often anticipating poems Pound would write within the next few years. Such locutions as

I have loôked dówn acróss the cíty from hígh wíndows.

or

I have seén Cadíz from the wáter.

could be trial runs for "Provincia Deserta" (1915), which is structured
around the repetition of comparable "I" clauses with feminine endings:

> I have crépt óver óld ráfters,
> péering dówn
> I have wálked
> into Périgôrd
> I have séen the tórch-flâmes, | hîgh-léaping
> I have lóoked báck óver the stréam
> and séen the hîgh buílding
> I have lóoked sóuth from Háutefôrt
> I have séen the ruíned "Doráta"

<div align="right">(P 121–22)</div>

Again, if we lineate the noun phrases embedded in the *Patria Mia*
passage, we find ourselves in the linguistic field of the early *Cantos*.
The stress pattern of a phrase like:

> Squáres after squáres of fláme,
> sét and cút into the éther

is echoed in lines like:

> Tórches mélt in the gláre
> sét fláme of the córner cóok-stâll

<div align="right">(IV, 15)</div>

and the cadence of the phrase:

> The thín, whíte lótus beyónd a dázzle of blúe

turns up in such lines as:

> And the whíte fórest of márble, ‖ bént boúgh ôver boúgh

<div align="right">(XVII, 79)</div>

Are we to construe locutions like "I have seen Cadiz from the
water" and "Squares after squares of flame" as poetry or as prose? The
commonsense view is that discourse written in sentences rather than
in lines is prose. But the very thrust of Pound's writing was to break
down such simple binary oppositions. As he says in "The Serious Art-
ist" (1913): "I do not know that there is much use in composing an
answer to the often asked question: What is the difference between
poetry and prose? I believe that poetry is the more highly energized.
But these things are relative" (*LE* 50). In Pound's case, they were in-

deed "relative": the description of New York in *Patria Mia* with its
ecstatic account of the "lighted windows," "squares after squares of
flame," comically undercut by the Irishman's inarticulate appraisal,
"It uccedes Lundun," is surely more arresting, more genuinely imagi-
native than the poem of the same period called "N.Y.," which dis-
misses the actual life of the city with a vague gesture—"For here are a
million people surly with traffic"—and makes New York the occasion
of a self-conscious litany:

My City, my beloved,
Thou art a maid with no breasts,
Thou art slender as a silver reed.
Listen to me, attend me!
And I will breathe into thee a soul,
And thou shalt live for ever.

(P 62)

In *Patria Mia*, Pound suggests that in America, prose may well be
superior to poetry because prose can be related to the American in-
stinct for "action and profit." In particular, he cites "the composition
of advertisements" as a "symptomatic prose" in which "there is some
attention paid to a living and effective style" (*SP* 109). The next step
was to carry such "symptomatic prose," the language of advertise-
ments, over into the realm of art. The Futurists had already provided
such a model, and in *BLAST*, which Pound originally described in a
letter to Joyce as "a new Futurist, Cubist, Imagiste Quarterly . . .
mostly a painters magazine with me to do some poems" (*PJ* 26), the
lessons of Marinetti's *Destruction of Syntax*, and, more immediately,
of Apollinaire's manifesto, *L'Antitradition futuriste* were applied.[33]

"While *BLAST* was filled with scornful allusions to the Futurists'
gush over machines," writes William Wees, "its illustrations and text
showed that it was committed to exploring the potentialities of the
'forms of machinery.'"[34] More specifically, it was a matter of rethink-
ing the function of the printed page, and, beyond the page, the Idea of
the Book. Thus the opening manifesto, sophomoric as are many of its
specific "BLASTS" and "BLESSES," presents us with a visual format that
recalls the advertising poster or billboard rather than the page to be
consecutively read from top to bottom and from left to right. This new
page, which, incidentally, defies numbering since it does not neces-
sarily follow the page that precedes it, is made up of rhythm units that
are hardly sentences, if we take the sentence to be "a literary model of
wholeness and completeness."[35] Consider the format of the opening
page (fig. 5.3):

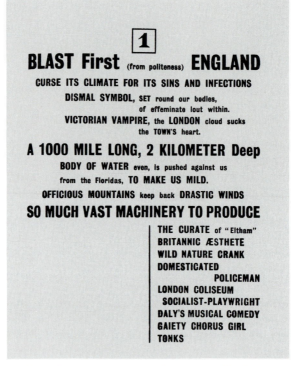

Fig. 5.3. Wyndham Lewis, *BLAST* 1 (1914), p. 11. Black Sparrow Press, 1981.

BLÁST FÍRST (from políteness) ÉNGLAND
 CÚRSE ITS CLÍMATE FOR ITS SÍNS AND INFÉCTIONS
 DÍSMAL SÝMBOL, | SÉT roûnd our bódies

These heavily stressed end-stopped lines are not categorically differ-
ent from Pound's "poems" in the same issue:

Cóme my cântilátions,
Lét us dúmp our hátreds into óne búnch and be dóne with thêm,
Hót sún, ‖ cléar wáter, ‖ frésh wínd
Lét me be frée of pávements,
Lét me be frée of prínters.

("Come My Cantilations," *B* 46)

Again, the cataloging of personality types to be "BLASTED" that ap-
pears in the bottom right-hand column is prosodically related to such
catalogs in the *Cantos* as the following:

And with the Émperor cáme the archbíshops:
The Ârchbíshop of Mórea Lówer
And the Ârchbíshop of Sárdis
And the Bíshops of Lácedaémon and of Mýtelêne,
Of Rhôdos, | of Módon Brándos,
And the Ârchbíshops of Áthens, | Córinth, | and of Trébizônd.

<div align="right">(XXVI, 123)</div>

"The Archbishop of Morea Lower," "The Curate of 'Eltham'"—these lines could easily appear in the same text, as could the lineated program notes on the character of Argol in Lewis's "The Enemy of the Stars" (B 61) or the cryptic pronouncements of the "Vortex. Gaudier Brzeska":

THE SPHERE SWAYED.
THE VORTEX WAS ABSOLUTE.
The Shang and Chow dynasties produced the convex bronze vases.

<div align="right">(B 157)</div>

As for "Vortex. Pound," its "energized" discourse seems to have rejected most of the polite conventions of formal prose. "One can see in ordinary speech," writes Northrop Frye, "a unit of rhythm peculiar to it, a short phrase that contains the central word or idea aimed at, but is largely innocent of syntax. It is much more repetitive than prose, as it is in the process of working out an idea, and the repetitions are largely rhythmical filler."[36] It is just this "associative rhythm" that we find in "Vortex. Pound" and in *Gaudier-Brzeska*—short aphoristic sentences or sentence fragments that repeat, in slightly altered contexts, the same words—"energy," "efficiency," "emotion," "experience," and of course "vortex." These terse breath units are arranged in paragraphs that have no more than three lines; bundles of these "paragraphs" are captioned in heavy black print so as to facilitate reading. As Pound was to put it in a letter of February 1939, with reference to the idiosyncracies of his own letters: "ALL typographic disposition, placings of words *on* the page, is intended to facilitate the reader's intonation." Abbreviations, for example, "save *eye* effort"; they show "various colourings and degrees of importance or emphasis attributed by the protagonist of the moment."[37]

A further point. Despite Pound's insistence, in "The Chinese Written Character as a Medium for Poetry," that "The verb must be the primary fact of nature" and that the ideal sentence is transitive ("Farmer pounds rice"), despite his declaration that "The moment we use the copula . . . poetry evaporates," that "We should avoid 'is' and bring in a

wealth of neglected English verbs," that "The dominance of the verb
and its power to obliterate all other parts of speech gives us the model
of terse fine style,"[38] his own rhythmic units, whether in his "prose" or
in the "verse" of *The Cantos*, tend to be suspended noun phrases,
and, when there is predication, the copula is much more frequent
than the transitive "action" verb. Thus:

> All experience rushes into this vortex. All the energized past, all the
> past that is living and worthy to live. All MOMENTUM, which is the past
> bearing upon us, RACE, RACE-MEMORY, instinct charging the PLACID,
> NON-ENERGIZED FUTURE.
> The DESIGN of the future in the grip of the human vortex. All the
> past that is vital, all the past that is capable of living into the future, is
> pregnant in the vortex, NOW. (*B* 153)

Here the first sentence follows the subject-verb-object model, but it is
followed by a series of sentence fragments in the form of open-ended
noun phrases, and finally by a statement of predication ("The DESIGN
of the future . . . is pregnant"). The syntax is, in other words, that of
parole in libertà—nouns and noun phrases in repetitive, oracular
sequences:

> All experience rushes into this vortex.
> All the energized past
> All the past that is living and worthy to live
> All MOMENTUM, which is the past bearing upon us
> All the past that is vital
> All the past that is capable of living into the future

The key words—"all," "past," "future," "vortex"—are repeated so as
to be "charged with meaning." As Marinetti prescribed, the "qualify-
ing adjective" is used as little as possible. Again, in keeping with
Futurist doctrine, the "typographical harmony of the page" (*FM* 104)
is destroyed. And, most important, the "obsessive *I*" (*FM* 100) is dis-
persed and fragmented in the interest of what the Futurists called
"multilinear lyricism."

"Vortex. Pound" is thus a recognizable offspring of such *parole in
libertà* as Marinetti's "Foreword to the Book of Anrep," reprinted in
the Futurism number of *Poetry and Drama* (fig. 5.4). In his lyric
poems, however, Pound found it more difficult to strike the right note.
Without the props of sentence structure and strophic cadence, the
tendency was to resort to the merely smart epigram:

> WOMEN BEFORE A SHOP
> The gew-gaws of false amber and false turquoise attract them
> "Like to like nature." These agglutinous yellows!

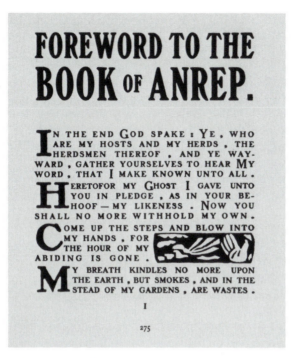

FOREWORD TO THE BOOK OF ANREP.

IN THE END GOD SPAKE : YE , WHO ARE MY HOSTS AND MY HERDS , THE HERDSMEN THEREOF , AND YE WAY-WARD , GATHER YOURSELVES TO HEAR MY WORD , THAT I MAKE KNOWN UNTO ALL .

HERETOFOR MY GHOST I GAVE UNTO YOU IN PLEDGE , AS IN YOUR BE-HOOF — MY LIKENESS . NOW YOU SHALL NO MORE WITHHOLD MY OWN .

COME UP THE STEPS AND BLOW INTO MY HANDS , FOR THE HOUR OF MY ABIDING IS GONE .

MY BREATH KINDLES NO MORE UPON THE EARTH , BUT SMOKES , AND IN THE STEAD OF MY GARDENS , ARE WASTES .

I

275

Fig. 5.4. F. T. Marinetti, "Foreword to the Book of Anrep," in *Poetry and Drama*, p. 275. September 1913. Reproduced by permission of the Huntington Library, San Marino, California.

or

L'ART
Green arsenic smeared on an egg-white cloth,
Crushed strawberries! Come let us feast our eyes.

(B 49)

And the urge to get rid of the "obsessive I" too often meant the adoption of the public persona, the hectoring bully of "Salutation the Third" and "Come My Cantilations." *Lustra* (1916) thus remains a problematic volume, a relative failure next to *Cathay* with its concise presentation of sharply focused ideograms, its unifying themes, and its "break[ing] of the pentameter" in a series of brilliantly varied linear units.

The line from *Cathay* to the *Cantos*, however, is not necessarily more continuous than that from *BLAST* and *Lustra*. In studying the genesis of the *Cantos* from their Imagist beginnings in 1912, Ronald Bush convincingly demonstrates that "between *Three Cantos* (1915)

and the publication in 1919 of the very different Canto IV, Pound grew disenchanted with Robert Browning's rhetorical mannerisms and sought more subtle methods to dramatize a different kind of speaking voice."[39] Bush's discussion of the impact of various strains—Vorticism, the Chinese ideogram, the fiction of Joyce—on the organization of the *Cantos* is masterful, but I would argue that the Browning model ultimately failed Pound, not only because the structural and tonal properties of the Browning dramatic monologue got in the way of the poet's urge to juxtapose disparate elements in a more dynamic and "simultaneous" poetic structure, but also because he felt constricted by the progressive and linear form inherent in the use of blank verse. Consider the following lines from the original Canto I (1915):

> I wálk the aíry stréet,
> Sée the smáll cóbbles fláre with the póppy spóil.
> 'Tis yóur "grêat dáy," the Córpus Dóminí,
> And áll my chósen añd penínsular víllage
> Has máde ône glórious bláze of áll its lánes.[40]

Lines 3 and 5 are regular iambic pentameter; the others, whether longer or shorter, retain the iambic rhythm; their syntax is, moreover, that of normal literary prose, continuous sentences being draped over the individual lines. It is hard to believe that the poet of *BLAST* and of poems like "The Coming of War: Actaeon" and "Provincia Deserta" would take, at this juncture, what now strikes us as a step backward.

Convention, however, is very powerful, and Pound's original aim in the *Cantos* was to write a verse epic in the tradition of Homer and Dante, but utilizing the style of Browning. Accordingly, the poet willing to experiment with the ideogram in *Cathay* and with *parole in libertà* in his "Vorticist" prose writings was, in current parlance, "blocked" when it came to the Long Poem. The solution, already present in embryo in the prose writings and in *BLAST*, came slowly, first in the form of translation or "imitation" in the "Homage to Sextus Propertius" (1917), and then, in 1919, with the opening lines of Canto IV:

> Pálace in smóky líght,
> Tróy but a héap of smoúldering boúndary stónes,
> ANÁXIFÓRMINGÉS! ‖ AURÚNCULÉIA!
> Héar mê. ‖ Cádmus of Gólden Próws!

> (IV, 13)

Line 2, as Christine Froula shows in her excellent textual study of Canto IV, was intact in the first typescript draft of 1918, whereas the rest came only in the final version.[41] "Troy but a heap of smouldering boundary stones"—the iambic pentameter line with an initial trochaic substitution is preceded and followed by lines neither metrical nor strophic as in French *vers libre*. Rather, the canto opens with a series of abrupt noun phrases, of explosive fragments, the prosodic form being the short, repetitive rhythmic cluster of apostrophe ("AURÚNCULÉIA!" or heightened speech ("Héar mê"). The rhythmic disjunctiveness can be seen even more clearly in the last section of the Canto:

Pêre Hénri Jácques would spéak with the Sénnin, on Rókku
Moúnt Rókku betweén the róck and the cédars,
Pólhonac,
As Gýges on Thrácian plátter sét the féast,
Cábestan, ǀ Téreus,
 It is Cábestan's héart in the dísh,
Vidál, or Écbatán, ǀ upón the gílded tówer in Écbatán
Lây the gód's bríde, ǀ láy éver, ǀ waíting the gólden ráin.
By Garónne. ‖ "Saáve!"
The Garónne is thíck like páint,
Procéssion,—‖—"Et sa'áve, ǀ sa'áve, ǀ sa'áve Regína!"—
Móves like a wórm, in the crówd.
Adíge, ‖ thín fílm of ímages,
Acróss the Adíge, ‖ by Stéfano, ‖ Madónna in hórtulo,
As Cávalcánti had séen her.
 The Céntaur's héel plánts in the éarth lóam.
And wé sît hére . . .
 thére ǀ ín the aréna . . .

 (IV, 16)

"Père Henri Jacques would speak with the Sennin, on Rokku"—Randall Jarrell would undoubtedly dismiss this line as mere prose, and indeed it intentionally fulfills Pound's dictum that poetry should be as well written as prose. The next line, a noun phrase, picks up the word "Rokku" and permutes it to "rock"; the third line contains the single word "Polhonac." Such composition is no longer a matter of breaking the pentameter because there is here no pentameter to break. Rather, the passage juxtaposes a formal five-stress line ("The Centaur's heel plants in the earth loam"), ordinary conversation ("And

we sit here . . . / there in the arena . . ."), quotation ("Et sa'ave, sa'ave, sa'ave Regina!"), and strings of proper names ("Cabestan, Tereus") so as to create a rhythm that is, strictly speaking, neither verse nor prose. We can call it verse if by verse we mean simply "line," but the fact remains that the lines are largely disparate, whereas the rhythms of recurrence often ignore the lineation, as in

> *Adige, thin film* of *images,*
> Across the *Adige,* by Stef*ano,* Mad*onna* in hort*ulo*

where everything depends upon the repetition of short *a* and *i* vowels and soft *gs*—*Adige, images, Adige*—as well as the related endings of "Stef*ano*," "Mad*onna*," and "hort*ulo*." The repetition of *a* sounds is, moreover, the leitmotif of the verse paragraph: "J*a*cques," "Pol-hon*ac*," "Pl*a*tter," "C*a*best*a*n," "he*a*rt," "Ecb*a*t*a*n," "G*a*ronne," "S*a*ave," "*A*dige," "*A*cross," "M*a*donna," "*As* C*a*v*a*lc*a*nti," "pl*a*nts," "*A*nd," "*a*rena." "Ch*a*nt" "Et s*a*'*a*ve, s*a*'*a*ve, s*a*'*a*ve Regin*a!*"

However we wish to describe the rhythm of this passage—and of course in the later cantos, the units will become more fragmentary, the juxtapositions more startling and abrupt, and the "documentary" element heightened—this is clearly not the "free verse" of Eliot and the Symbolists—that is to say, verse in which "the ghost of some meter is always lurking behind the arras." Nor is it like the bulk of what passes for free verse today, which is all too often a fairly ordinary discursive prose, cut up into line lengths. To define its nature, let me conclude by raising some larger theoretical issues.

IV

In his monumental *Critique du rythme* (1982), Henri Meschonnic argues that verse and prose are never fixed entities or stable categories, that, on the contrary, the opposition between the two is inseparable from the specific historical, cultural, and linguistic situation in which it occurs: "Historically, poetically, linguistically, the difference between prose and verse is one of degree, not of kind."[42]

Consider the problems raised by the equation of poetry and verse, an equation that leads to the negative definition of prose as non-rhythmic language. In ninth-century Europe, Meschonnic points out, the word *prose* was used to designate a cadenced liturgical sequence based on the assonance of *a* so as to prolong the sonority of the *Al-lelulia*. Is such an assonantal sequence poetry or prose? The issue was further complicated by the introduction of a "song freely de-

claimed" or recitatif into the singing of the psalm so that the key op-
position became that between song/speech rather than between po-
etry/prose. Or again, the oratorical prose of the seventeenth century
was so highly structured, so "rhythmical," that a twentieth-century
poet like Paul Claudel could claim that he had learned his verse craft
from the sermons of Bossuet (p. 459). Boris Eikhenbaum, studying
the composition of Nikolai Gogol's "The Overcoat," found that, with
respect to the proportion of accented to unaccented syllables, Gogol's
prose was indistinguishable from the poetry of Mayakovsky (p. 461).
And, closer to home, the prose poems of Baudelaire, Mallarmé, Rim-
baud, and their successors have made it all but impossible to equate
poetry with verse.

But even those theorists who now grant that poetry cannot be
equated with verse, indirectly continue to make the identification
by equating the words *verse* and *line*. As Charles O. Hartman puts
this equation, "*Verse is language in lines.* This distinguishes it from
prose. . . . This is not really a satisfying distinction, as it stands, but
it is the only one that works absolutely. The fact that we can tell verse
from prose on sight . . . indicates that the basic perceptual difference
must be very simple. Only lineation fits the requirements."[43]

Common sense tells us that this definition is foolproof. Or is it?
Meschonnic points out that to make lineation the sine qua non of
verse (and hence, indirectly, of the free-verse poem, which is the
dominant form of twentieth-century poetry) leads to the negative defi-
nition that to lineate any discourse whatever is to turn it into a poem,
for that is how it will be perceived.[44] But this is to make typography
the sole differentium of the poem, regardless of rhythm, sound pat-
terning, and syntax. And, as Meschonnic puts it, such single-minded
attention to typography makes of a given text the reader's poem, but
not necessarily the author's (*Critique du rythme*, p. 304). Further, and
this is a point theorists of free verse like Hartman tend to ignore, as
more and more printed texts—newspaper advertising, greeting cards,
billboards, television commercials—are lineated, the reader will no
longer equate the line with poetry. The conventions readers bring to
texts, in other words, are always historically conditioned.

A third false equation is contained in the tautological statement
made by the "maître de philosophie" when poor Monsieur Jourdain
asks what it is he is speaking:

—Et comme l'on parle, qu'est-ce que c'est donc que cela?
—De la prose.

(*Le Bourgeois Gentilhomme*, ii, 4)

Like Northrop Frye, whose *The Well-Tempered Critic* concerns itself with this question, Meschonnic argues that it is Monsieur Jourdain who is right. "Spoken discourse is of another order (phonological, morphological, syntactic) from the conventions of writing."[45] Or, as Frye puts it:

> The irregular rhythm of ordinary speech may be conventionalized in two ways. One way is to impose a pattern of recurrence on it; the other is to impose the logical and semantic pattern of the sentence. We have verse when the arrangement of words is dominated by recurrent rhythm and sound, prose when it is dominated by the syntactical relation of subject to predicate.[46]

This "associative" or "third" rhythm, as Frye calls it, can be found in the literature of many periods and cultures, but in the free verse and what Frye calls the "free prose" of the twentieth century it has become so prominent that we set up the binary opposition verse/prose at our peril. "Prose," says Meschonnic, "is as far from spoken discourse as is verse, in another direction. . . . Prose is a rhetorical and literary idea. It interferes, but is not, precisely speaking, to be confused with, the linguistic notions of code and register, and with the anthropological opposition of writing and speech."[47]

Once we understand that prose is, like verse, a way of conventionalizing speech, we can begin to sort out the complexities of the Futurist "Liberation of the Word." For just as Cubist and Futurist collage constituted a break with "mimesis," a putting into question of the illusions of representation, so the "new poetry," whether Kruchenykh's vowel poems, or Apollinaire's *calligrammes*, or Pound's injection of the ideogram or the found text into the verse structure of the *Cantos* was a way of calling into question the lingering faith in the logocentric subject, the unifying Poetic Theme. *Parole in libertà, slovo kak takovoe*, wireless imagination—what all this sloganizing really meant was that the visual and oral dimensions of poetry, thrust into the background by the Victorian longing to turn poetry into the embodiment of a Higher Truth, were given renewed importance.

"Modern poetry," says Meschonnic, "has not only destabilized the opposition between verse and prose, it has also destroyed the poem-object."[48] Perhaps this is the case because the "poem-object," the poem as isolated artifact, could not finally contain the vortex created by the scientific and technological revolution of the *avant guerre*, the energy, speed, dynamism, and simultaneity associated with the invention of the airplane, automobile, print media, radio, and cinema.

Product gave way to process: collage and montage acted to undercut the reproduction of the "real" and to foreground the constructive impulse itself—the making of a work rather than the work itself.

In this context, neither *vers libre* nor the prose poem were sufficiently "radical," if we remember that works are radical not in some absolute sense, but only intertextually. Free verse, as Eliot defined it, and as he practiced it in the poems written prior to *The Waste Land,* remained an essentially continuous and coherent form: neither "Prufrock" nor "Gerontion" violates syntactic norms or introduces the sort of alien material we find in the poetry of Kruchenykh or in the *Cantos.* Again, the prose poem on the nineteenth-century French model was conceived primarily as a variant on the dense Symbolist lyric, a text, in Michael Beaujour's words, "where the verse density approaches that of regular metrical forms, while eschewing the anaphoric servitudes of prosody."[49]

Given this matrix, the Futurists' foregrounding of the isolated word or even sound on the one hand (as in Khlebnikov's "Zaklyatie smekhom") and the insertion of "ordinary" prose, in the form of letters, charts, archives, and so forth, on the other, can be seen as a way of calling attention to the materiality of the signifier so as to reduce the transparency of language. The same is true for the incorporation of visual devices—the abandonment of the left margin, the typographical play, the use of ideograms—into the text. To visualize the poem is to insist that language does not simply point outside itself to some metaphysical reality but that it oscillates between representational reference and compositional game. Again, visual prosody calls into question the centrality of the foot, the line, the stanza, even the whole poem, and substitutes for the framed poetic text the basic unit of the poetic page.

But perhaps the most important oscillation, at least in Pound's case, is that between verse, prose, and the associative rhythm, an oscillation that makes it impossible to follow any given path to its conclusion. For instead of isolating verse from prose in a text called a poem, as had his predecessors, Pound's *collagiste* prosody became a way of recreating the vortex as "radiant node or cluster . . . from which, and through which, and into which, ideas are constantly rushing." In *BLAST,* this technique is still tentative, a somewhat defensive vacillation between the anaphoric trimeter of "Come My Cantilations":

Let come the graceful speakers
Let come the ready of wit,
Let come the gay of manner.

(*B* 46)

the disjunctive speech rhythms of

> PERHAPS I will die at thirty,
> Perhaps you will have the pleasure of defiling my pauper's grave,
> I wish you JOY, I proffer you ALL my assistance
>
> (B 45)

and the prose of "Vortex. Pound." But the "prose," as I argued above, is already "contaminated": under the title "ANCESTRY," for example, Pound compiles a catalog of quotations from Walter Pater, James Whistler, and himself, an assemblage that looks ahead to the *Cantos* in its use of the words of others as exhibits and documents—as *objets trouvés* that relate only equivocally to the discourse in which they are embedded.

By the fifties, Pound was beginning to be hailed as the master of poetic rhythm. "I scarcely know," wrote John Berryman, "what to say of Pound's ear. Fifteen years of listening has not taught me that it is inferior to the ear of *Twelfth Night*.[50] Or, in Allen Ginsberg's eulogy of 1972, "[Pound is] the one poet who heard speech as spoken from the actual body and began to measure it to lines that could be chanted rhythmically without violating human common sense, without going into hysterical fantasy or robotic metronomic repeat."[51] But at the time of *BLAST*, the experiment struck the typical English or American critic as merely puzzling. In a review of *Lustra* called "Ezra Pound—Proseur" (1918), Louis Untermeyer calls it "incredible" that the poet of *Provenca* (1911) should now be writing this "carefully enshrined series of trivialities, translations, annotated excerpts, snobbery, and bad temper." Indeed, *Lustra* is "not so much a collection of poems as a catch-all for Pound's slightest gibes and gesticulations."[52]

In an ironic sense, Untermeyer was right. Much of the poetry of the *avant guerre*, whether Pound's or Khlebnikov's or Cendrars's, was "not so much a collection of poems" as the creation of a new poetic field or energy discharge. As Apollinaire summed it up in "L'Esprit nouveau et les poètes," written in the last year of the Great War, which was also the last year of his life:

> jusqu'à maintenant, le domaine littéraire était circonscrit dans d'é-troites limites. On écrivait en prose ou l'on écrivait en vers. En ce qui concerne la prose, des règles grammaticales en fixaient la forme. . . .
>
> Le vers libre donna un libre essor au lyrisme; mais il n'était qu'une étape des explorations qu'on pouvait faire dans le domaine de la forme. . . .
>
> L'esprit nouveau admet donc les expériences littéraires même hasardeuses, et ces expériences sont parfois peu lyriques. C'est pourquoi le

lyrisme n'est qu'un domaine de l'esprit nouveau dans la poésie d'au-
jourd'hui, qui se contente souvent de recherches, d'investigations,
sans se préoccuper de leur donner de signification lyrique.

> Up to now the literary field has been kept within narrow limits. One
> wrote in prose or one wrote in verse. In prose, rules of grammar estab-
> lished the form. . . .
> Free verse gave wings to lyrics; but it was only one stage of the ex-
> ploration that can be made in the domain of form. . . .
> The new spirit . . . admits even hazardous literary experience, and
> those experiences are at times anything but lyric. This is why lyricism
> is only one domain of the new spirit in today's poetry, which often con-
> tents itself with experiments and investigations without concerning it-
> self over giving them lyric significance.[53]

The admission of "even hazardous literary experience," of rhythms
that may be "anything but lyric"—it was this rupture and the conse-
quent reassembling of the poetic field that enabled the "Futurist mo-
ment" to cast such a long shadow.

6 DEUS EX MACHINA: SOME FUTURIST LEGACIES

Le fer donne en effet à la circulation humaine une image nouvelle, celle du *jet;* comme fondu d'un seul trait (même si, en fait, il est minutieusement assemblé), l'ouvrage métallique semble *jeté* par-dessus l'obstacle, d'un mouvement rapide, suggérant ainsi que le temps lui-même est vaincu, raccourci d'un tour preste et préfigurant une fois de plus le jet de l'avion par-dessus les continents et les océans.

Indeed, iron provides human communication with a new image, that of the *thrust* [*jet*]. The work of metal, as if cast at a single stroke (even though, in fact, it is minutely assembled), seems to be hurled [*jeté*] above obstacles, thus suggesting that time itself is conquered, curtailed by a sharp turn and prefiguring once more the thrust [*jet*] of the plane above continents and oceans.

—Roland Barthes[1]

This lyrical account of the building of the Eiffel Tower, an homage to the technology that discovered the power of upward thrust, the shooting of the iron tower or the airplane into the heavens in what seems to be the conquest of time, was written not by Marinetti or Mayakovsky or Apollinaire but, a half-century after the publication of the first Futurist manifesto, by Roland Barthes. It testifies, as do the score of Futurist art exhibitions and the increasing role played by "performance art," visual poetry, and intermedia works, in a renewal of interest, after decades in which artists and poets decried technology as the brutalization of the landscape and the machine as the enemy of the human spirit, in what we might call the "science-fiction" world of the early century, which contains so many of the seeds of our own mythologies.

But of course revival always means repetition with a difference. When we compare Barthes's meditation on the ways we interpret the Eiffel Tower to Blaise Cendrars's "Futurist" essay "La Tour Eiffel,"[2] we find that even as Barthes echoes Cendrars's themes, he ironizes and problematizes them. If, in other words, the ethos of *avant guerre* has its counterpart in the contemporary dissolution of the boundaries between art and science, between literature and theory, between the separate genres and media, ours is what we might call a disillusioned or cool Futurism.

Cool, in that postmodernism has little of the enthusiasm and exuberance that characterizes the "Futurist moment." Consider Cendrars's "poème élastique" called "Tour," written in August 1913 as an homage to Robert Delaunay, the great painter of the Tower (fig. 6.1). The young poet playfully addresses the Eiffel Tower as "sonde céleste" ("divine sounding line"), a beacon shining "avec toute la magnificence de l'aurore boréale de ta telegraphie sans fil" ("with all the splendor of the aurora borealis of your wireless telegraph"):

> Gong tam-tam zanzibar bête de la jungle rayons-X express bistouri
> symphonie

Tu es tout
Tour
Dieu antique
Bête moderne
Spectre solaire
Sujet de mon poème
Tour
Tour du monde
Tour en mouvement

Gong tam-tam zanzibar jungle beast X-rays express scalpel symphony
You are everything
Tower
Ancient god
Modern beast
Solar spectrum
Subject of my poem
Tower
Globe-circling tower
Tower in motion.[3]

Cendrars's alliterative and punning "Tu es tout" (to which Barthes will reply "la Tour n'est *rien*") is matched by Apollinaire's poem, also called "Tour," written on a postcard to commemorate the 1913 Delaunay exhibition in Berlin:

Au Nord au Sud
Zénith Nadir
Et les grands cris de l'Est
L'Océan se gonfle a l'Ouest
La Tour à la Roue
S'adresse

To the North to the South
Zenith Nadir
And the great cries of the East
The Ocean swells to the West
The Tower to the Ferris Wheel
Appeals[4]

Again, in Apollinaire's *calligramme* "Lettre-Océan," the Eiffel Tower, designated first by its location ("Sur la rive gauche devant le pont d'Iéna") and then by its height ("Haute de 300 mètres"), becomes the center of the circle from which radiate lines of words like radio waves departing in all directions from the transmitters in the Tower (see fig. 6.2).[5] And in his collage-novel *Le Poète assassiné*, written in the same

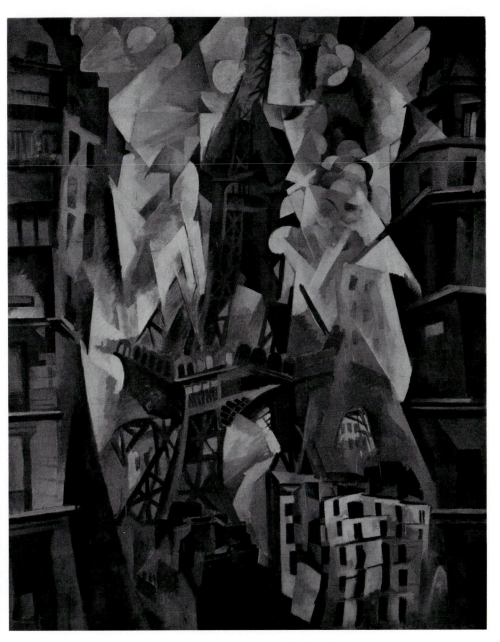

Fig. 6.1. Robert Delaunay, *Champs de Mars (The Red Tower)*, 1911. Oil on canvas, 64″ × 51½″. Art Institute of Chicago, Joseph Winterbotham Collection.

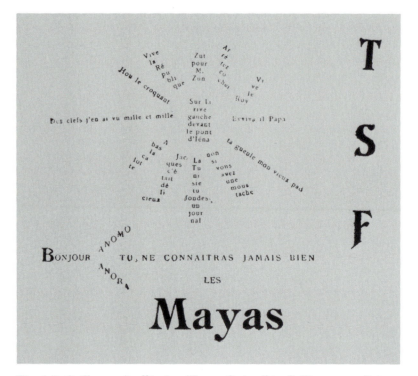

Fig. 6.2. Guillaume Apollinaire, "Lettre-Océan," in *Calligrammes: Poèmes de la paix et de la guerre*. Mercure de France, Paris, 1918.

year, Apollinaire relates the birth of his autobiographical hero to the "birth" of the virile Tower:

> C'était l'année de l'Exposition Universelle, et la tour Eiffel, qui venait de naître, saluait d'une belle érection la naissance héroïque de Croniamantal.

> It was the year of the Universal Exposition and the Eiffel Tower, which had just been born, saluted the heroic birth of Croniamantal with a handsome erection.[6]

Jim Dine, illustrating *The Poet Assassinated* in 1968, responded to this passage with a photomontage (fig. 6.3) in which a street map from an English guidebook is cut up and collaged so as to make it unusable; this city plan, whose segments, drawn to different scale, refuse to cohere, is placed above a photograph of the Eiffel Tower seen

sideways, as if to say that, from one point of view, the "belle erection" has collapsed under the weight of the city.[7] This is another way of reminding us that, as Barthes points out, the Tower is peculiarly weightless for there is nothing inside it. In this sense, it is "une sorte de degré zero du monument" (*TE* 33).

But then what is a monument for Barthes or for the artists of our own time? In a remarkable photomontage-essay called "A Tour of the Monuments of Passaic, New Jersey" (1967), the "site sculptor"/ conceptual artist Robert Smithson observes that our contemporary "zero panorama seem[s] to contain *ruins in reverse*, that is—all the new constructions that would eventually be built. This is the opposite of the 'romantic ruin' because the buildings don't *fall* into ruin *after* they are built but rather *rise* into ruin before they are built." But this "anti-romantic *mise-en-scène*" has its own "pleasures of the text." "Along the Passaic River banks," writes Smithson, "were many minor

Fig. 6.3. Jim Dine, illustration for Apollinaire, *The Poet Assassinated*, trans. Ron Padgett, p. 47. Holt, Rinehart, and Winston, New York, 1968.

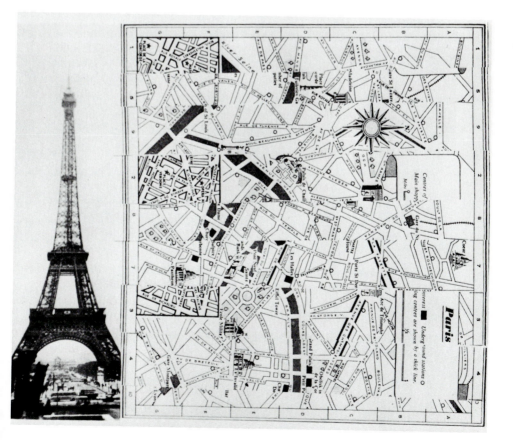

monuments such as concrete abutments that supported the shoulders of a new highway in the process of being built," and he wonders:

> Has Passaic replaced Rome as The Eternal City? If certain cities of the world were placed end to end in a straight line according to size, starting with Rome, where would Passaic be in that impossible progression? Each city would be a three-dimensional mirror that would reflect the next city into existence. The limits of eternity seem to contain such nefarious ideas.[8]

Here is a variation on Blaise Cendrars's boast that if all 150 copies of his and Sonia Delaunay's two-meter-high *livre pochoir, La Prose du Transsibérien,* were laid end to end, the poem would attain the height of the three-hundred-meter-high Eiffel Tower.[9] Smithson's urban fantasy may be read as an ironized version of the Futurist dream. Rome as a three-dimensional mirror, "reflecting" Passaic, New Jersey, into existence: it is a notion that the Marinetti of "Contra Venezia passatista" would have relished.

I. A Tower of Two Tales

The Eiffel Tower was, so to speak, born twice: first as a monument to industry, the centerpiece of the international Paris Exposition of 1889 and, only some twenty years later, as the emblem of the new Futurist aesthetic. The great Victorian engineer Gustave Eiffel, who easily won the design competition to build his cast-iron monument, declared that his purpose was "to raise to the glory of modern science, and to the greater honor of French industry, an arch of triumph as striking as those that preceding generations had raised to conquerors."[10] And Alfred Picard, the official historian of the 1889 Exposition wrote:

> This colossal work was to constitute a brilliant manifestation of the industrial strength of our country, attest to the immense progress realized in the art of metal structures, celebrate the unprecedented progress of civil engineering during the course of this century, attract multitudes of visitors and contribute largely to the success of the great peaceful commemoration of the centenary of 1789. (*TT* 20)

The art world of the late eighties saw it differently. A *Protestation des artistes,* bearing such famous signatures as those of Guy de Maupassant, Leconte de Lisle, and Dumas *fils;* of Charles Gounod, the composer of *Faust,* and Charles Garnier, the architect of the Paris Opera, was sent to the Minister of Public Works in 1887; the *Protestation* denounced the projected monument as follows:

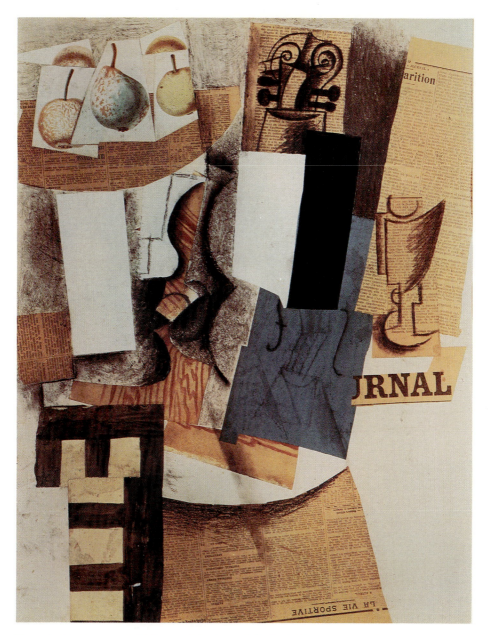

Pl. 2. Pablo Picasso, *Still Life with Violin and Fruit*, 1913. Collage and charcoal on paper, 25⅜″ × 19½″. Philadelphia Museum of Art, A. E. Gallatin Collection.

Pl. 3. Kasimir Malevich, *Woman at Poster Column*, 1914. Oil and collage, 28″ × 25¼″. Collection Stedelijk Museum, Amsterdam.

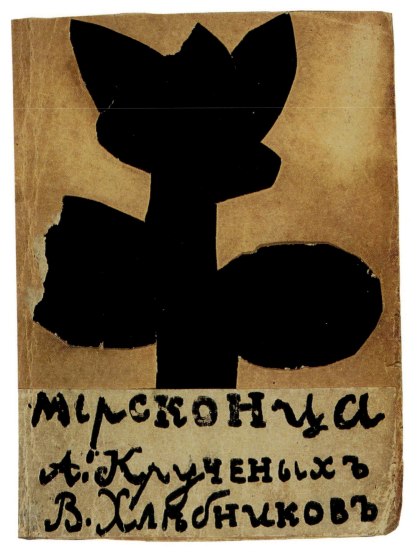

Pl. 4. Natalya Goncharova, cover design for *Mirskontsa (Worldbackwards)*, by A. Kruchenykh and V. Khlebnikov. Moscow, 1912. Courtesy of the British Library, London.

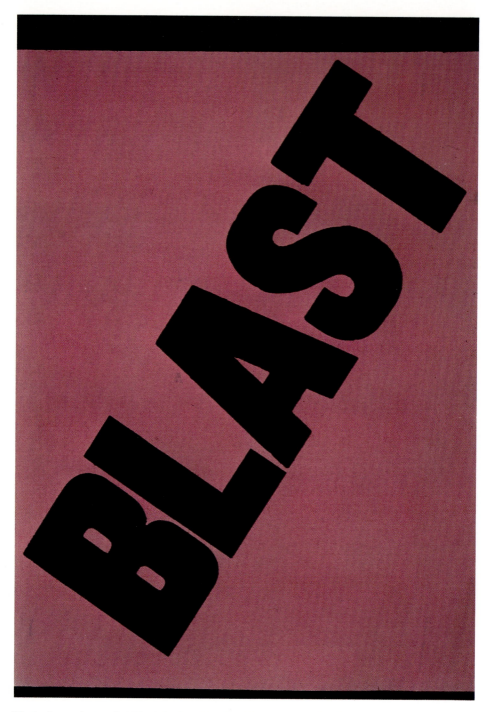

Pl. 5. Cover design for *BLAST*, edited by Wyndham Lewis. London, 1914.
Black Sparrow Press, 1981.

Writers, painters, sculptors, architects, passionate lovers of the heretofore intact beauty of Paris, we come to protest with all our strength, with all our indignation, in the name of betrayed French taste, in the name of threatened French art and history, against the erection in the heart of our capital of the *useless and monstrous* Eiffel Tower, which the public has scornfully and rightly dubbed the Tower of Babel. . . .

When foreigners visit our Exposition . . . they will be right to mock us, for the Paris of sublime gothic, the Paris of Jean Goujon, of Germain Pilon, of Puget, of Rude, of Barye, etc., will have become the Paris of Monsieur Eiffel.[11]

Ironically, the petitioners turned out to be quite right: it was of course "the Paris of Monsieur Eiffel" that was to be celebrated by the poets and artists of the new century. But according to *fin de siècle* norms of purity, the "monstrous" Tower was decried as "a black and gigantic factory chimney," "crush[ing] beneath its barbarous mass Notre Dame, the Sainte Chapelle, the Tour Saint Jacques, the Louvre, the dome of the Invalides, the Arch of Triumph, all our humiliated monuments, all our raped architecture disappearing in this stupefying dream" (*TT* 21). The *Protestation* urged Parisians to protest against this "odious column of bolted metal," whose shadow would cover the great city "like a spot of ink." Or rather, since the iron frame was covered by a coat of reddish brown paint named Barbados Bronze, progressively lightened to pale yellow at the top so as to accent the visual impression of height (*TT* 100), the Tower was derided, in the words of the great aesthete Joris-Karl Huysmans, as the folly of an "ironmonger" who behaved as if he were dipping his work in congealed meat juices. Indeed, Huysmans pronounced, the color of the iron frame was exactly that of "le veau en Bellevue," served by the restaurants of the boulevards: "c'est la gelée sous laquelle apparait, ainsi qu'au premier étage de la tour, la dégoutante teinte de la graisse jaune" (it is the jellied meat under which appears, as on the first story of the tower, the disgusting tinge of yellow grease).[12]

The aesthete's longing to protect art from the encroachments of industry, an industry synonymous with the vulgar and the popular, has dogged the artistic production of our century from the time of the Eiffel Tower to our own. It is the distinction of the *avant guerre* to have created the first artistic movement that tried to solve this problem, to break down the barriers between "high" and "low," between, so to speak, the Ivory and the Eiffel towers. The short-lived internationalism of the period, a period where one could still cross the real borders between nations without a passport, supported this faith in communal

experiment. Whether one thinks of Khlebnikov's elaborate mathe-
matical calculations determining the dating of future events, of Boc-
cioni's *Unique Forms in Space*, or of Pound's aphorisms in *Gaudier-
Brzeska*, we find an intense concentration (later carried further by
Dada) on the artistic potential of scientific and technological discovery.

Art, in this view, is less the creation of beauty than it is, in the
original sense of the word, a making, a mode of invention. From
Huysmans's point of view, Gustave Eiffel was just a vulgar engineer
who understood nothing about aesthetic form, composition, and color.
For a poet like Cendrars, on the other hand, the charm of Eiffel's crea-
tion was precisely the incongruity of its role, the quality that Apol-
linaire extolled as the "surprise" essential to "l'esprit nouveau."[13] In
his "La Tour Eiffel," Cendrars recounts a visit he paid to M. Eiffel in
1914, on the occasion of Eiffel's seventy-fifth birthday and the Tower's
twenty-fifth:

> On m'introduisit dans un petit hôtel d'Auteuil, encombré d'un tohu-
> bohu d'oeuvres d'art hetéroclites et toutes affreusement laides et in-
> utiles. Au mur du cabinet de travail de ce fameux ingénieur étaient
> accrochées les photographies de quelque-unes de ses plus belles créa-
> tions, des ponts, des tracés de voie ferrées, des gares. Et comme je
> faisais allusion à tout cet immense travail et à *l'esthétique qui se dé-
> gageait de ses oeuvres*, et comme je lui rendais surtout hommage pour
> la Tour, je vis les yeux de ce vieillard s'ouvrir démesurément et j'eus
> l'impression très nette, qu'il croyait que je me moquais de lui! Eiffel
> lui-même était une victime de Viollet-le-Duc et s'excusait presque
> d'avoir déshonoré Paris avec la Tour. ("TE" 57–58; my italics).

> I was ushered into a little villa in Auteuil, cluttered with a *tohu-bohu*
> of eclectic art works, all terribly ugly and useless. On the wall of this
> famous engineer's study were hung photographs of some of his most
> beautiful works: bridges, designs of railways, stations. And as I made
> allusion to all this immense work and to *the aesthetic that emerged from
> it*, and was especially complimenting him on the Tower, I saw the eyes of
> the old man open wide and I had the distinct impression that he thought
> I was making fun of him! Eiffel himself was a victim of Viollet-le-Duc
> and almost apologized for having dishonored Paris with the Tower.

For Cendrars, it is a delicious irony that the stolid Victorian engi-
neer fails to understand the aesthetic superiority of his construction to
the neo-Gothic gingerbread of Viollet-le-Duc. Indeed, the special ap-
peal of the Eiffel Tower is that it made no claim to being a "work of
art" in the traditional sense, that it was, on the contrary, popular.
Eiffel's own preoccupation, after all, had been with the engineering

problems of the Tower, the major one being how to build out of a heavy material like iron a thousand-foot tower that could resist the wind. Accordingly, he planned the "montage" of his tower with the aid of complex logarithmic calculations down to the last millimeter. But critics agree that his most brilliant stroke, inadvertently as artistic as it was practical, was to reduce the supporting elements of the openwork structure until, in Joseph Harris's words, "the wind has virtually nothing to seize. Otherwise stated, the real strength of the Eiffel Tower is in its voids as much as in its iron" (*TT* 63; see fig. 6.4).

It is a case of what later architects would call form following function. Or is it? For if the original function was to anchor a stable thousand-foot tower on four piers in the less-than-secure bedrock of the Champs de Mars near the Seine, and to build an iron lacework structure whose every part cohered, thus showing the world at the Paris Exposition the triumph of modern French engineering, what was the Tower ultimately to *be?*

Eiffel, whose original concentration was on the system of caissons, cylindrical shoes, and trussing that would make construction both possible and pleasing, realized, even before the opening ceremonies took place in March of 1889, that he now had to provide a raison d'être for the Tower's continued presence. As Barthes puts it (*TE* 28): "il n'était pas dans l'esprit d'une époque communément devouée a la rationalité et à l'empirisme des grandes entreprises bourgeoises, de supporter l'idée d'un objet inutile (à moins qu'il ne fut declarative-ment un objet d'art, ce qu'on ne pouvait non plus penser de la Tour)" (it was not in the spirit of a period commonly dedicated to rationality and to the empiricism of great bourgeois enterprises to endure the notion of a useless object [unless it was declaratively an *objet d'art*, which was also unthinkable in relation to the Tower]).

Accordingly, Eiffel conscientiously drew up a blueprint of the Tower's future uses:

> Strategic operations—In case of war or siege it would be possible to watch the movements of an enemy within a radius of 45 miles. . . . If we had possessed the tower during the siege of Paris in 1870, with its brilliant electric lights, who knows whether the issue of that conflict would not have been entirely changed?
>
> Meteorological observations—It will be a wonderful observatory in which may be studied the direction and force of atmospheric currents, the electrical state and chemical composition of the atmosphere, its hygrometry, etc.
>
> Astronomical observations—The purity of the air at such a height, the absence of mists, which often cover the lower horizons in Paris,

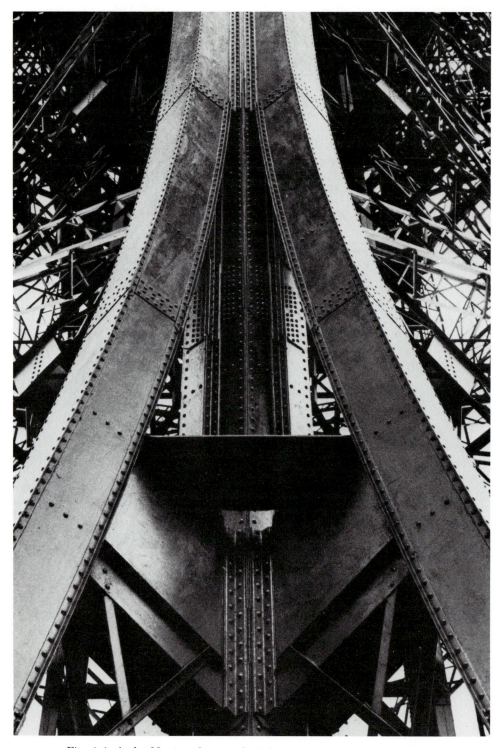

Fig. 6.4. André Martin, photograph of the interior structure of the Eiffel Tower; decorative arches and crossbeam of a pillar, seen from the ground, in *La Tour Eiffel*, p. 42. Delphire, Lausanne, 1964.

will allow many physical and astronomical observations to be made
which would be impossible in our region.

Scientific experiments may be made, including the study of the fall
of bodies in the air, resistance of the air according to speed, certain
laws of elasticity, compression of gas and vapors, and, using a large-
scale pendulum, the rotation of the earth. It will be an observatory and
a laboratory such has never before been placed at the disposal of sci-
entists. (*TT* 102)

What Eiffel perhaps could not anticipate in 1889 is that the same
technology that had made the Tower possible would soon make it ob-
solete. True, some meteorological and aerodynamic experiments were
conducted from its heights, and in 1904 radio signals began to be sent
from a single antenna installed at the top. On 1 July 1913 the Eiffel
Tower sent the first time signal transmitted around the world, thus es-
tablishing a global electronic network that seemed to promise what
the poets and painters were to call "simultaneity." It is also true that
in August 1914, the Tower's receiver captured a radio message from
the German army advancing on Paris, and that other enemy messages
were intercepted. After World War II, the Tower housed the first civil
radio station and, in 1953, the first television station.[14]

Still, the Tower's function as giant laboratory was soon eclipsed by
its symbolic role as the emblem of Paris. By the time the Great War
erupted, Eiffel's plans for "strategic operations" were sadly obsolete.
The international radio network no longer depended on its presence,
and trench warfare and bombing made the capacity of "watch[ing] the
movements of an enemy within a radius of 45 miles" rather beside the
point. The intrinsic uselessness of the thousand-foot iron structure
was already apparent to the poets and painters of the *avant guerre*.
Indeed, it was its very emptiness as a signifier that challenged the
Futurist imagination to invent extravagant metaphors for it, even as
that emptiness was to delight a postmodern writer like Barthes. "In-
utile," writes the latter, "la Tour était donc une sorte de forme an-
thologique résumant tous ces ouvrages de grande circulation, la prise
du siècle sur l'espace et le temps à l'aide du fer" (In its uselessness,
the Tower thus became a kind of anthology, summing up all those
great modes of transportation, the century's conquest, with the help of
iron, of space and time) (*TE* 63).

We thus have a double paradox. The first major monument de-
signed by an engineer rather than an architect, the Tower consecrates,
in Barthes's words, "le pouvoir de la technique pure sur des objets
(les édifices) jusque-là soumis (du moins partiéllement) à l'art" (the
power of pure technology over objects [buildings] heretofore governed

[at least in part] by aesthetic norms") (*TE* 64). At the same time, its reception as a work of art depends upon its ultimate uselessness, its emptiness as a signifier that challenges "le déchiffrement" (decipherment). The Eiffel Tower is, for Barthes, as for Cendrars and Delaunay, the emblem of an illusory presence; it is the *jet* that is always there, the charged object inside the window frame or picture frame, and yet it has no being of its own. Cendrars recalls that he first "met" the Eiffel Tower when, as a result of an automobile accident, he spent twenty-eight days in a Saint-Cloud hotel, with his leg in traction:

> tous les matins, quand le garçon m'apportait mon petit déjeuner, et qu'il écartait les volets et qu'il ouvrait la fenêtre toute grande, j'avais l'impression qu'il m'apportait Paris sur son plateau. Je voyais par la fenêtre la Tour Eiffel comme un carafe d'eau claire, les dômes des Invalides et du Pantheon comme une théière et un sucrier, et le Sacré-Coeur, blanc et rose, comme une confiserie. Delaunay venait presque tous les jours me tenir compagnie. Il était toujours hanté par la Tour et la vue que l'on avait de ma fenêtre l'attirait beaucoup. Souvent il faisait des croquis ou apportait sa boîte de couleurs. ("TE" 52–53)

> every morning, when the boy brought me my breakfast, threw open the shutters, and opened the window wide, I had the impression that he was bringing me Paris on his tray. I could see, through the window, the Eiffel Tower like a carafe of clear water, the domes of the Invalides and the Pantheon like a teapot and a sugar bowl, and Sacré-Coeur, white and pink, like a candy. Delaunay came almost every day to keep me company. He was always haunted by the Tower and the view from my window attracted him strongly. He would often sketch or bring his paintbox.

Barthes's text begins with the same acknowledgement of the Tower's presence, although here the inability to escape that presence is seen as something of a nuisance:

> Maupassant déjeunait souvent au restaurant de la Tour, que pourtant il n'aimait pas: *c'est*, disait-il, *le seul endroit de Paris où je ne la vois pas*. Il faut, en effet, à Paris prendre des précautions infinies, pour ne pas voir la Tour; quelle que soit la saison, à travers les brumes, les demi-jours, les nuages, la pluie, dans le soleil, en quelque point que vous soyez, quel que soit le paysage de toits, de coupoles, ou de frondaisons qui vous sépare d'elle, *la Tour est là. . . .* Il n'est à peu près aucun regard parisien qu'elle ne *touche* à un certain moment de la journée; à l'heure où, écrivant ces lignes, je commence à parler d'elle, elle est là, devant moi, découpée par ma fenêtre; et au moment même ou la nuit de janvier l'estompe, semble vouloir la rendre invisible et démentir sa présence, voici que deux petites lueurs s'allument et cli-

gnotent doucement en tournant à son sommet: toute cette nuit aussi elle sera là, me liant par-dessus Paris à tous ceux de mes amis dont je sais qu'ils la voient: nous formons tous avec elle une figure mouvante dont elle est le centre stable: la Tour est amicale. (*TE* 27)

Maupassant often lunched at the restaurant in the tower, though he didn't care much for the food: *It's the only place in Paris,* he used to say, *where I don't have to see it.* And it's true that you must take endless precautions, in Paris, not to see the Eiffel Tower; whatever the season, through mist and cloud, on overcast days or in sunshine in rain— wherever you are, whatever the landscape of roofs, domes, or branches separating you from it, *the Tower is there.* . . . There is virtually no Parisian glance it fails to *touch* at some time of day; at the moment I begin writing these lines about it, the Tower is there in front of me, framed by my window; and at the very moment the January night blurs it, apparently trying to make it invisible, to deny its presence, two little lights come on, winking gently as they revolve at its very tip: all this night, too, it will be there, connecting me above Paris to each of my friends that I know are seeing it: with it we all comprise a shifting figure of which it is the steady center: the Tower is friendly.

"La Tour est là"—a presence that cannot be denied, a steady center. For Cendrars, the tower is a synecdoche for the "prodigieux centres d'activité industrielle, épars sur toute la surface de la terre" ("prodigious centers of industrial activity spread out over the whole surface of the earth"). It functions as a magnet for lovers and for young men from distant countries, but its special role is to serve as the hub of the new wheel of spacecraft:

Les premiers avions tournaient autour d'elle et lui disaient bonjour, Santos-Dumont l'avait déjà prise pour but lors de son mémorable vol en dirigeable, comme les Allemands devaient la prendre pour objectif durant la guerre, objectif symbolique et non stratégique, et je vous assure qu'ils ne l'auraient pas eue, car les Parisiens se seraient fait tuer pour elle et Galliéni était décidé à la faire sauter, notre Tour! ("TE" 57)

The first airplanes circled around it and said hello, Santos-Dumont had already taken it as his destination for his memorable dirigible flight, even as the Germans were to take it as their target during the war, a symbolic and not a strategic target, and I assure you that they wouldn't have had it because the Parisians would have killed themselves for it and Gallieni had decided to blow it up, our Tower![15]

Here is the tension between nationalism and internationalism so characteristic of the *avant guerre*. The emblem of the new "universal" industry, the magnetic beacon around which airplanes revolve, turns,

in what seems to be a parallel clause of analogy ("comme . . ."), into a war target for the Germans. And so hotly nationalistic are the French declared to be that Cendrars is convinced they would have killed themselves for the Tower or been prepared to blow up what is in fact a perfectly useless technological monument.

Perhaps it is for this reason that Barthes writes "la Tour surgit comme un acte de rupture" (the Tower shoots up like an act of rupture) (*TE* 73). It is a "symbole de subversion," not only because its "nonesthetic" form and new materials aggressively challenge the "paysage parisien" of domes, steeples, and arches, but because "elle a été le geste moderne par lequel le present dit non au passé" (it was the gesture of modernity by means of which the present said no to the past). And to say no to the past, in this context, is to opt for a world as dangerous as it is dazzling. No sooner are the planes lifted into the air so as to make beautiful circles around the Tower than the Tower itself becomes a military target. What Cendrars happily refers to as "the latest scientific theories in electrochemistry, biology, experimental psychology, and applied physics," theories that had great impact on Cubist and abstract painting, become, in Barthes's meditation, "le mythe de la Science" (*TE* 28).

From Science to the Myth of Science: here is one central difference between the Futurist sense of "rupture" and our own. But even this is a simplification. Delighted as he is by the image of airplanes making circles round the Tower, Cendrars is not really interested in its military potential. When, in "Contrastes" (October 1913), he declares, "Je conseille à M. Cochon de loger ses protégés à la Tour Eiffel" ("I advise Mr. Pig to quarter his protégés in the Eiffel Tower"; *SW* 146), he is poking fun, just as does Barthes, at the fact that there is nothing inside the lacy framework of the iron structure, that it is an empty monument and hence can house any number of undesirable people. The poet, for that matter, has no desire to participate in the meteorological or mathematical experiments being carried on at the Tower. It is its aesthetic potential—"Les arcencielesques dissonances de la Tour dans sa télégraphie sans fil" ("The rainbow dissonances of the Tower in its wireless telegraphy") [16]—that is his focus.

Indeed, the Tower is seen as a challenge to the artist's will to power. Like Marinetti's manifestos, Cendrars's text has a Nietzschean cast. Thus Delaunay's struggle to "represent" the Eiffel Tower is described as "un drame inoubliable: la lutte d'un artiste avec un sujet tellement nouveau qu'il ne savait comment l'empoigner, le mater" ("an unforgettable drama: the struggle of an artist with a subject so new that he didn't know how to capture it, to subdue it"). But although De-

launay is pronounced the "vainqueur" ("victor"), Cendrars empha-
sizes the intractability of matter, the impossibility of "representing"
what is outside the picture frame, of producing a coherent visual im-
age. The conditions of representability entailed by the sign are now
called into question:

> Aucune formule d'art, connue jusqu'à ce jour, ne pouvait avoir la
> prétention de résoudre plastiquement le cas de la Tour Eiffel. Le real-
> isme le rapetissait; les vieilles lois de la perspective italienne l'amin-
> cissaient. La Tour se dressait au-dessus de Paris, fine comme une
> épingle à chapeau. Quand nous nous éloignions d'elle, elle dominait
> Paris, roide et perpendiculaire; quand nous nous en approchions, elle
> s'inclinait et se penchait au-dessus de nous. Vue de la première plate-
> forme, elle se tirebouchonnait et vue du sommet, elle s'affaissait sur
> elle-même, les jambes ecartées, le cou rentré. Delaunay voulait égale-
> ment rendre Paris tout autour d'elle, la situer. Nous avons essayé tous
> les point de vues, nous l'avons regardée sous tous ses angles, sous
> toutes ses faces, et son profil le plus aigu est celui que l'on découvre
> du haut de la passerelle de Passy. Et ces milliers de tonnes de fer, ces
> trente-cinq millions de boulons, ces trois cents mètres de hauteur de
> poutres et de poutrelles enchevêtrées, ces quatre arcs de cent mètres
> d'envergure, toute cette masse vertigineuse, faisait la coquette avec
> nous. ("TE" 56)

> No formula of art, known at that time, could make the pretense of
> resolving plastically the problem of the Eiffel Tower. Realism made it
> smaller; the old laws of Italian perspective, made it look thinner. The
> Tower rose above Paris, as slender as a hat pin. When we distanced
> ourselves, it dominated Paris, stiff and perpendicular; when we ap-
> proached it, it bowed and bent over us. Seen from the first platform, it
> twisted itself like a corkscrew and seen from the top, it collapsed
> under its own weight, its legs spread, its neck tucked in. Delaunay
> also wanted to depict the Paris around it, to situate it. We tried all
> points of view, we looked at it from all angles, from all sides, and its
> sharpest profile is the one you discover from the top of the Passy foot-
> bridge. And those thousands of tons of iron, those thirty-five million
> bolts, those three-hundred meters high of interlaced girders and beams,
> those four arcs with a spread of a hundred meters, all that vertiginous
> mass flirted with us. (SW 238–39)

This passage is less an accurate description of Delaunay's *Tower*
paintings of 1910–11, which are, in fact, still essentially realistic in
their conception of the two-dimensional picture plane as a window,
however distorted, on "reality,"[17] than it alludes to the new Cubist and
Cubo-Futurist aesthetic, the need "de remettre tout en question, de

reviser toutes les valeurs ésthétiques . . . de supprimer le sujet" ("to put everything in question, to revise all aesthetic values . . . to suppress the subject"; "TE" 53; *SW* 236). For it is, of course, not the Tower that changes, depending upon the angle of vision, but the artist's perception of what it means to "represent" a subject.

Like Cendrars, Barthes regards the primary "open" form of the Eiffel Tower as conferring upon it the vocation of "infinite cipher." Again, like Cendrars, he construes the Tower as an emblem of sexual duality. What looks from a distance like a giant phallus (painters from Seurat and Signac to the postcard artists of the present have thus represented the Eiffel Tower) becomes, when one is inside its open lacework structure, a repertoire of female sexual forms:

> La Tour est une silhouette humaine; sans tête, sinon une fine aiguille, et sans bras . . . c'est tout de même un long buste posé sur deux jambes écartées. . . . Mais ici encore, l'approche photographique découvre une nouvelle verité de la Tour, celle d'un objet sexué; dans le grand lâcher des symboles, le phallus est sans doute sa figure la plus simple; mais à travers le regard de la photographie, c'est tout l'intérieur de la Tour, projeté sur le ciel, qui apparait sillonné des formes pures du sexe. (*TE* 82)

> The Tower is a human silhouette; with no head, if not a fine needle, and without arms . . . it is nevertheless a long torso placed on top of two legs spread apart. . . . But here again the camera eye discovers a new truth of the Tower, that of an object that has a sex. In the great unleashing of symbols, the phallus is no doubt its simplest figuration; but through the perspective of the photograph, it is the whole interior of the Tower, projected against the sky, that appears streaked by the pure forms of sex.

Similar as Barthes's metaphor is to Cendrars's, his "déchiffrement" of the text has a rather different emphasis. If Cendrars's concern is typically *avant guerre* in its foregrounding of the aesthetic properties of the New Technology, Barthes, just as typically for his time, regards the aesthetic as part of the larger realm of semiotic and hermeneutics. Not only, for example, is the Tower an ambiguous visual image of sexuality, it is also "un objet complet, qui a, si l'on peut dire, les deux sexes du regard" (a complete object which has, if one may say so, both sexes of sight)—both sexes of sight in the sense that the Tower is the vantage point of seeing (and hence the masculine "ce qui *voit*") as well as the object that is seen (the Tower as "elle").

Barthes thus begins with Cendrarian premises, but, interested as he is in the larger process of signification, he patiently and re-

lentlessly teases out the conceptual implications latent in Cendrars's images:

> tour à tour et selon les appels de notre imagination, symbole de Paris, de la modernité, de la communication, de la science ou du XIXe siè-cle, fusée, tige, derrick, phallus, paratonnerre ou insecte, face aux grands itinéraires du rêve, elle est le signe inévitable; de même qu'il n'est pas un regard parisien qui ne soit obligé de la recontrer, il n'est pas un fantasme qui n'en vienne tôt ou tard à retrouver sa forme et à s'en nourrir; prenez un crayon et laissez aller votre main, c'est-à-dire votre pensée, et c'est souvent la Tour qui naîtra, reduite à cette ligne simple dont la seule fonction mythique est de joindre, selon l'expres-sion du poète, *la base et le sommet*, ou encore *la terre et le ciel*. (*TE* 27)

> in turn and according to the appeals of our imagination, the symbol of Paris, of modernity, of communication, of science or of the nineteenth century, rocket, stem, derrick, phallus, lightning rod or insect, con-fronting the great itineraries of our dreams, it is the inevitable sign; just as there is no Parisian glance which is not compelled to encounter it, there is no fantasy which fails, sooner or later, to acknowledge its form and to be nourished by it; pick up a pencil and let your hand, in other words your thoughts, wander, and it is often the Tower which will appear, reduced to that simple line whose sole mythic function is to join, as the poet says, *base and summit*, or again, *earth and heaven*. (P. 4)

We should note here that Barthes's prose, theoretical as are its con-cerns, is not necessarily less "poetic" than Cendrars's. Indeed, in the passage just cited, it is a prose that enacts the very modes of significa-tion it discusses. For, just as the Tower is at once phallus and derrick, pencil line and lightning rod, so, the text implies, a neat line can-not be drawn between "expository" and "poetic" modes of discourse. Barthes's "critical essay" adopts such conventions of the prose poem as the foregrounding of sound recurrence ("science"—"siècle"—"signe"), phrasal repetition ("de la . . ."), and elaborate image clus-ters or puns ("tour à tour").

It is, in any case, important to see that Barthes's concept of the ineluctability of the "pure—virtually empty sign" ("signe pur—vide, presque"), empty *"because it means everything"* (*"parce qu'il veut tout dire"*), subscribes to the Cendrarian myth of power (Delaunay battling with the Tower and emerging the "victor") even as it problematizes it. For Barthes, as for Cendrars, the Tower is the scene of conquest.

> Monter sur la Tour pour y contempler Paris, c'est l'équivalent de ce premier voyage, par lequel le provincial "montait" vers Paris, pour en

faire la conquête. A douze ans, le jeune Eiffel lui-même prit la dili-
gence de Dijon avec sa mere et découvrit la "féerie" de Paris. (*TE* 47)

To climb the Tower so as to contemplate Paris is the equivalent of that
first journey in which the young provincial "went up" to Paris, in order
to conquer it. The young Eiffel himself, at the age of twelve, took the
stagecoach from Dijon with his mother and discovered the "enchant-
ment" of Paris.

For Cendrars, Eiffel is a real person, whom one might visit in his Au-
teuil villa, the irony being that this old man, who surrounds himself
with ugly and pretentious Victorian bric-a-brac, is also the architect
of the great Tower. For Barthes, writing half a century after Eiffel's
death, it is the other way around. A fictionalized Eiffel takes his place
with those legendary young men from the provinces whose dream is to
conquer Paris—Balzac's Rastignac and Stendhal's Julien Sorel.

Power, possession, conquest—there may be nothing behind these
words, but they continue to fuel our illusions. For Barthes, there are
three power myths especially identified with the Eiffel Tower. First,
the Balzacian or Faustian myth of Iron, the image of Vulcan at his
forge creating a new material, at once light and heavy, that symbolizes
"l'ideé d'une domination âpre, triumphante, des hommes sur la na-
ture" (the idea of a ruthless, triumphant domination of men over na-
ture). Second, the myth of flight, "le theme aérien." The Tower is "le
symbole de l'ascension, de toute ascension"; no other monument,
says Barthes, is at once so tall and so slender. And third, the myth of
openness associated with the Tower's *ajouré* (its iron fretwork), which
makes it "une dentelle de fer" (a piece of iron lace). The *ajouré* en-
ables us to perceive the empty spaces inside and beyond the Tower; it
erases the margin between inside and outside; it transforms the seem-
ingly heavy tower into a plant peacefully swaying on its stem, into an
arabesque of petals, and finally into a bird, whose flight would be
even higher, into the clouds, had its wings not been clipped. Or, as
Apollinaire put it, "Soleil cou coupé."

All these power fantasies are part of the same dream, "un rêve de
transgression de la matière vers des états inconnus, sans cependant
jamais les réjoindre tout à fait" ("a dream of the transgression of
matter toward the unknown, without, however, ever quite reaching
it"). On the last page of "La Tour Eiffel" we come back full circle to
the Futurist fantasy of what Cendrars calls "la grande transformation
de monde moderne." Barthes concludes:

Regard, objet, symbole, la Tour est tout ce que l'homme met en elle,
et ce tout est infini. Spectacle regardé et regardant, édifice inutile et

irremplaçable, monde familier et symbole héroïque, témoin d'un siè-
cle et monument toujours neuf, objet inimitable et sans cesse re-
produit, elle est le signe pur, ouvert à tous les temps, a toutes les im-
ages et à tous les sens, la métaphore sans frein; à travers la Tour, les
hommes exercent cette grande fonction de l'imaginaire, qui est leur
liberté, puisque aucune histoire, si sombre soit-elle, n'a jamais pu la
leur enlever. (*TE* 82)

A look, an object, a symbol, the Tower is all that man puts into it,
and that all is infinite. A spectacle looked at and looking, a useless
and irreplaceable edifice, a familiar world and a heroic symbol, witness
to a century and monument ever new, inimitable object yet ceaselessly
reproduced, it is the pure sign, open to all seasons, to all images, and
to all senses, the unbridled metaphor. Through the Tower, men exer-
cise the great function of the imaginary, which is their freedom, since
no history, however dark, could ever deprive them of it.

The abrupt reminder, in the final sentence, that ours is a somber
history injects an elegiac note into Barthes's otherwise genial con-
clusion. No longer is the Tower Apollinaire's emblem of progress and
revolution; no longer is it, as it was for Cendrars, an object to be
struggled with and mastered by the heroic artist. For Barthes such
mastery is no longer at issue. But the Tower can still function as un-
bridled metaphor, as pure sign—as the inimitable object that is end-
lessly reproduced—and, as such, it brings us back, in an ironic loop,
to the performance arena of 1914, to Vladimir Burliuk's *A Slap in the
Face of Public Taste* and to Pound's definition of the vortex as "a radi-
ant node or cluster . . . from which, and through which, and into
which, ideas are constantly rushing." Indeed, when, in 1965, Robert
Smithson made his own "useless and irreplaceable edifice" in the
form of a stainless steel cube pierced with an intersecting mirrored
pyramid, he called his "monument" *Four-Sided Vortex* (fig. 6.5).[18]

This abstract "crystal" (Smithson's term for "a solid bounded by
symmetrically grouped surfaces, which have relationships to a set of
imaginary lines called axes") would seem to be the most elementary of
geometric forms: Smithson, for that matter, had his "sculpture" fab-
ricated locally by Arco Steel and Milgo Industrial Corporation. But
the insertion of the "negative" mirrored pyramid immediately trans-
forms the stainless steel solid into what Smithson calls punningly
"solid-state hilarity." It is "a well of triangular mirrors," designed to
take the viewer through Lewis Carroll's looking glass into the "fourth
dimension."[19]

Fig. 6.5. Robert Smithson, *Four-Sided Vortex*, 1965. Stainless steel, mirrors, 35″ × 28″ × 28″. Courtesy of the Estate of Robert Smithson, John Weber Gallery, New York.

II. From the Empty Monument to the Antimonument

"A l'heure actuelle . . . ," Barthes tells an interviewer in 1975, "la 'littérature,' le texte, ne peuvent plus coïncider avec [la] fonction de *mathésis*" ("At present . . . 'literature,' the text, can no longer coincide with [the] function of *mathesis*").[20] *Mathesis* is Barthes's term for "un champ complet du savoir" ("a complete field of knowledge"), a "field" that is unattainable today, so Barthes argues, for three reasons:

1. Le monde est planétaire, aujourd'hui. C'est un monde profus, ce que l'on sait du monde, on le sait tout de suite, mais on est bombardé d'informations parcellaires, dirigées. La connaisance du monde n'étant plus filtrée, ce monde aurait beaucoup de mal à entrer dans une *mathésis littéraire*.
2. Le monde est trop surprenant, son pouvoir de surprise est si excessif qu'il échappe aux codes du savoir populaire. . . . L'excès, la surprise rendent impossible l'expression littéraire. La littérature, comme *mathésis*, était la clôture d'un savoir homogène.
3. Il est banal de dire que le savoir a un rapport avec la science, mais aujourd'hui, la science est plurielle: il n'y a pas une science mais des sciences et le vieux rêve du XIXe s'est effondré. En effet, les frontières entre les sciences sont impossibles à maintenir. (*GV* 225)

1. Today our world is a global village. It's a profuse world, and what we learn about it is made known immediately, but we are bombarded by fragmentary, controlled bits of information. Since knowledge of the world is no longer filtered, this world would not fit easily into a *literary mathesis*.
2. The world is too surprising, its unexpectedness is so excessive that it goes beyond the codes of popular wisdom. . . . Literature, as *mathesis*, was the closure of a homogeneous body of knowledge.
3. It's banal to say that knowledge has a relation to science, but science is plural today: there is not one science but many sciences, the old dream of the nineteenth century has collapsed. In fact, it is impossible to maintain frontiers between sciences. (*Int* 237–38)

How, then, does literature (or art) function today? "Les textes," says Barthes, "essaient alors de constituer une *semiosis*, c'est-à-dire une mise en scène de *signifiance*. Le texte d'avant-garde . . . met en scène le savoir de signes" ("Texts seek instead to constitute a *semiosis*, a *mise en scène* of *signifiance*. The avant-garde text . . . brings into play a knowledge of signs." No longer a *mathesis* or a *mimesis* "with its correlative metalanguage: reflection," the text becomes a *semiosis*, a *mise en scène* "non pas du contenu, mais des détours, des retours, bref des jouissances du symbolique" ("not of content, but of the detours, twists, in short the bliss of the symbolic") (*GV* 225; *Int* 238).

Such *mise en scène* characterizes contemporary texts as otherwise diverse as Michel Serres's *Le Parasite*, Joseph Kosuth's *Art Investigations*, Laurie Anderson's performance pieces, and John Cage's conversations with Daniel Charles collected in *For the Birds*.[21] Robert Smithson, whose *Writings*, assembled by his widow Nancy Holt in 1979, are modestly subtitled *Essays with Illustrations*, explains his choice of a site for the projected *Spiral Jetty* (fig. 6.6) as follows:

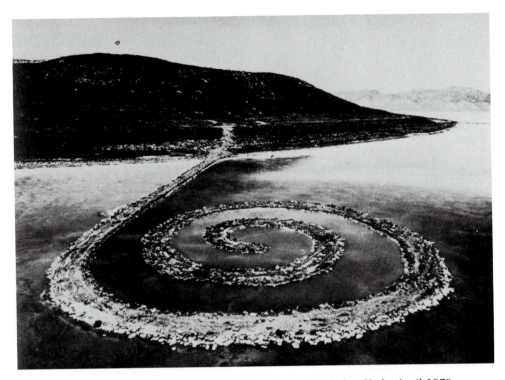

Fig. 6.6. Robert Smithson, *Spiral Jetty*, Great Salt Lake, Utah, April 1970. Courtesy of the Estate of Robert Smithson, John Weber Gallery, New York.

It is one of few places on the [Great Salt] lake where the water comes right up to the mainland. Under shallow pinkish water is a network of mud cracks supporting the jig-saw puzzle that composes the salt flats. As I looked at the site, it reverberated out to the horizons only to suggest an immobile cyclone while flickering light made the entire landscape appear to quake. A dormant earthquake spread into the fluttering stillness, into a spinning sensation without movement. This site was a rotary that enclosed itself in an immense roundness. From that gyrating space emerged the possibility of the Spiral Jetty. *No ideas, no concepts, no systems, no structures, no abstractions could hold themselves together in the actuality of that evidence.* (*RS* 111; my italics)

Or, as Barthes put it, "Since knowledge of the world is no longer filtered, this world would not fit easily into a *literary mathesis*." For Smithson, writing, in a "profuse world" takes the form of assemblage—the layering (but not blending or filtering) of photographic image, illustration, blueprint, graph, chart, commentary, narrative, and citation (the latter ranging from Flaubert and Barthes to P. A. Shumkii's *Principles of Structural Glaciology*)—so as to bring into play "le savoir des signes."

Smithson's counterpart to Cendrars's and Barthes's lyric essays on the Eiffel Tower is a text called "A Tour of the Monuments of Passaic, New Jersey," first published in *Artforum* in 1967. At once "travel narrative" and collage, critical essay and poetic fiction, "The Monuments of Passaic" is reminiscent of Russian Futurist manifestos, especially Malevich's *From Cubism and Futurism to Suprematism*, which Smithson frequently cites. But, just as Barthes gives us an ironized version of Cendrars's paean to the Eiffel Tower, so Smithson's discovery of "monuments" in the waste spaces of New Jersey carries to its logical—and absurdist—conclusion Malevich's demand for "forms that have nothing to do with nature," his longing for the "breakup and violation of cohesion." [22]

The Eiffel Tower, so both Cendrars and Barthes tell us, is the monument no Parisian can escape, the monument one must enter in order not to see it. By contrast, Smithson's are "monuments" that one must, so to speak, "see" in order to "enter," for they are monuments only because the artist chooses to recognize them as such. Indeed, the narrator's "journey" from the Port Authority Bus Terminal in New York to Passaic is described as if it were a science-fiction voyage to another planet. It is no coincidence that the book Smithson purchases at the station is Brian W. Aldiss's *Earthworks*, a science-fiction fantasy set in the twenty-second century, in which the earth has become an uninhabitable desert tilled by former criminals called "landsmen" who must wear protective suits. [23] But Smithson himself is no "landsman"; like the novel's hero, an entrepreneur, punningly named Knowle Noland, who ships sand around the world, the Smithson of "The Monuments of Passaic" wants to find a use for materials such as sand and quartz grain that others dismiss as mere rubble.

Passaic has special significance for Smithson because it is both his birthplace and the locale made famous by William Carlos Williams, who happened to be Smithson's pediatrician and whose poetry and prose (especially *Life along the Passaic River*) Smithson knew well and admired. In a 1972 interview with Bruce Kurtz, Smithson describes a visit he paid to Williams in 1959, and, after recalling the poet's conversation about Ezra Pound and Hart Crane, Marcel Duchamp and Charles Demuth, he remarks:

> I guess the Paterson area is where I had a lot of contact with quarries and I think that is somewhat embedded in my psyche. As a kid I used to go and prowl around all those quarries. And of course, they figured strongly in *Paterson*. When I read the poems I was interested in that, especially this one part of *Paterson* where it showed all the strata levels under Paterson. Sort of proto-conceptual art, you might say. (*RS* 148)

Indeed, Smithson regards his own meditation on the Passaic "monuments" as "a kind of appendix" to *Paterson*. Both works, he remarks, "come out of that New Jersey ambience where everything is chewed up. New Jersey like a . . . derelict California" (*RS* 187).

But Smithson is not an ecologist, decrying the destruction of nature by the machine. On the contrary, he is as fascinated by the pumping derricks, bridges, and pipe works that dot New Jersey as is Cendrars by the technology of the Eiffel Tower. "Somehow," he tells Gianni Pettena "to have something physical that generates ideas is more interesting to me than just an idea that might generate something physical" (*RS* 187).

His own "proto-conceptual" art work, in any case, sets the stage for the "physical" domain of the New Jersey landscape by recording, with seeming neutrality, the "art news" in the *Times*, scanned by the artist as he rides the number 30 bus to Passaic:

> I sat down and opened the *Times*. I glanced over the art section: a "Collectors', Critics', Curators' Choice" at A. M. Sachs Gallery (a letter I got in the mail that morning invited me to "play the game before the show closes October 4th"), Walter Schatzki was selling "Prints, Drawings, Watercolors" at "33 1/3% off," Elinor Jenkins, the "Romantic Realist," was showing at Barzansky Galleries, XVIII–XIX Century English Furniture on sale at Parke-Bernet, "New Directions in German Graphics" at Goethe House, and on page 29 was John Canaday's column. He was writing on *Themes and the Usual Variations*. I looked at a blurry reproduction of Samuel F. B. Morse's *Allegorical Landscape* at the top of Canaday's column; the sky was a subtle newsprint grey, and the clouds resembled sensitive stains of sweat reminiscent of a famous Yugoslav water-colorist whose name I have forgotten. A little statue with right arm held high faced a pond (or was it the sea?). "Gothic" buildings in the allegory had a faded look, while an unnecessary tree (or was it a cloud of smoke?) seemed to puff up on the left side of the landscape. Canaday referred to the picture as "standing confidently along with other allegorical representatives of the arts, sciences, and high ideals that universities foster." (*RS* 52)

So much for the New York gallery scene, with its pretentious and meaningless gestures (the painting of "Gothic" buildings flanked by "unnecessary" trees against a sky whose color recalls nothing so much as "newsprint grey") and its commercial exploitation of anything "old world," whether English furniture or German graphics or the "Romantic Realism" of an Elinor Jenkins. The marked-down prices ("33 1/3% off") are especially absurd since most of the commodities in question are not worth anything in the first place. To value the nostalgic landscape of a Samuel F. B. Morse (fig. 6.7) is, so

A Tour of the Monuments of Passaic, New Jersey

He laughed softly. I know. There's no way out. Not through the Barrier. Maybe that isn't what I want, after all. But this—this—' He stared at the Monument. 'It seems all wrong sometimes. I just can't explain it. It's the whole city. It makes me feel haywire. Then I get these flashes—'
—Henry Kuttner, *Jesting Pilot*

. . . today our unsophisticated cameras record in their own way our hastily assembled and painted world.
—Vladimir Nabokov, *Invitation to a Beheading*

On Saturday, September 30, 1967, I went to the Port Authority Building on 41st Street and 8th Avenue. I bought a copy of the *New York Times* and a Signet paperback called *Earthworks* by Brain W. Aldiss. Next I went to ticket booth 21 and purchased a one-way ticket to Passaic. After that I went up to the upper bus level (platform 173) and boarded the number 30 bus of the Inter-City Transportation Co.

I sat down and opened the *Times*. I glanced over the art section: a "Collectors', Critics', Curators' Choice" at A.M. Sachs Gallery (a letter I got in the mail that morning invited me "to play the game before the show closes October 4th"), Walter Schatzki was selling "Prints, Drawings, Watercolors" at "33⅓% off," Elinor Jenkins, the

Art: *Themes and the Usual Variations*

"Allegorical Landscape" by Samuel F. B. Morse, displayed at Marlborough-Gerson Gallery

"Romantic Realist," was showing at Barzansky Galleries, XVIII—XIX Century English Furniture on sale at Parke-Bernet, "New Directions in German Graphics" at Goethe House, and on page 29 was John Canaday's column. He was writing on *Themes and the Usual Variations.* I looked at a blurry reproduction of Samuel F. B. Morse's *Allegorical Landscape* at the top of Canaday's column; the sky was a subtle newsprint grey, and the clouds resembled sensitive stains of sweat reminiscent of a famous Yugoslav watercolorist whose name I have forgotten. A little statue with right arm held high faced a pond (or was it the sea?). "Gothic" buildings in the allegory had a faded look, while an unnecessary tree (or was it a cloud of smoke?) seemed to puff up on the left side of the landscape. Canaday referred to the picture as "standing confidently along with other allegorical representatives of the arts, sciences, and high ideals that universities foster." My eyes stumbled over the newsprint, over such headlines as "Seasonal Upswing," "A Shuffle Service," and "Moving a 1,000 Pound Sculpture Can Be a Fine Work of Art, Too." Other gems of Canaday's dazzled my mind as I passed through Secaucus. "Realistic waxworks of raw meat beset by vermin," (Paul Thek), "Mr. Bush and his colleagues are wasting their time," (Jack Bush), "a book, an apple on a saucer, a rumpled cloth," (Thyra Davidson). Outside the bus window a Howard Johnson's Motor Lodge flew by—a symphony in orange and blue. On page 31 in Big Letters: THE EMERGING POLICE STATE IN AMERICA SPY GOVERNMENT. "In this book you will learn . . . what an Infinity Transmitter is."

The bus turned off Highway 2, down Orient Way in Rutherford.

I read the blurbs and skimmed through *Earthworks*. The first sentence read, "The dead man drifted along in the breeze." It seemed the book was about a soil shortage, and the *Earthworks* referred to the manufacture of artificial soil. The sky over Rutherford was a clear cobalt blue, a perfect Indian summer day, but the sky in *Earthworks* was a "great black and brown shield on which moisture gleamed."

The bus passed over the first monument. I pulled the buzzer-cord and got off at the corner of Union Avenue and River Drive. The monument was a bridge over the Passaic River that connected Bergen County with Passaic County. Noon-day sunshine cinema-ized the site, turning the bridge and the river into an over-exposed picture. Photographing it with my Instamatic 400

Fig. 6.7. Samuel F. B. Morse, *Allegorical Landscape*, reproduced in *The Writings of Robert Smithson*, ed. Nancy Holt, p. 52. New York University Press, 1979. Courtesy of the Estate of Robert Smithson. Reprinted by courtesy of Nancy Holt and *Artforum*.

Smithson implies, to treat "art" as something wholly detached from the life we actually live. Or, as Malevich puts it in his celebration of "the new life of iron and the machine," "If all artists were to comprehend these monstrous runways and intersections of our bodies with the clouds in the heavens, then they would not paint crysanthemums" (*RA* 126).

Smithson's narrative is, of course, a purposely "flat" version of Malevich's apocalyptic manifesto, but he is given to comparable attacks on what he calls "The Museum of Leftover Ideologies," a museum "run by the robots of The Establishment" and placed on "a sickly lagoon called 'The Slough of Decayed Language'" (*RS* 79). The hyperbole of such passages recalls the Marinetti of the 1909 manifesto, with its dismissal of museums as "cemeteries of empty exertion, Calvaries of crucified dreams" (*FM* 23). Like the Futurists, Smithson wants to replace the conventional landscape painting (in this case the Samuel F. B. Morse) with a work of art that speaks for its own time:

> The bus passed over the first monument. I pulled the buzzer-cord and got off at the corner of Union Avenue and River Drive. The monument was a bridge over the Passaic River that connected Bergen County with Passaic County. Noon-day sunshine cinema-ized the site, turning the bridge and the river into an over-exposed *picture*. Photographing it with my Instamatic 400 was like photographing a photograph. The sun became a monstrous light-bulb that projected a detached series of "stills" through my Instamatic into my eye. When I walked on the bridge, it was as though I was walking on an enormous photograph that was made of wood and steel, and underneath the river existed as an enormous movie film that showed nothing but a continuous blank. (RS 52–53)

Here Smithson's allegorical representation of the nameless bridge (see fig. 6.8) parodically alludes to the Morse painting *Allegorical Landscape* reproduced on the preceding page. The bridge has a steel road, but that road is at least in part an open grating. Further, the steel road is flanked by wood sidewalks, held up by a set of heavy beams. Its "ramshackle network" seems merely to hang in the air. Even when it rotates on its central axis so as to allow a barge to pass through, the bridge seems utterly inert, as does the "inert rectangular shape" of the barge with its "unknown cargo" and the "glassy air of New Jersey" above it. As Smithson observes the North-South rotation of the bridge, he is struck by "the limited movements of an outmoded world." "'North' and 'South,'" he remarks, "hung over the static river in a bi-polar manner. One could refer to this bridge as the 'Monument of Dislocated Directions'" (*RS* 53).

was like photographing a photograph. The sun became a monstrous light-bulb that projected a detached series of "stills" through my Instamatic into my eye. When I walked on the bridge, it was as though I was walking on an enormous photograph that was made of wood and steel, and underneath the river existed as an enormous movie film that showed nothing but a continuous blank.

The steel road that passed over the water was in part an open grating flanked by wooden side-

axis in order to allow an inert rectangular shape to pass with its unknown cargo. The Passaic (West) end of the bridge rotated south, while the Rutherford (East) end of the bridge rotated north; such rotations suggested the limited movements of an outmoded world. "North" and "South" hung over the static river in a bi-polar manner. One could refer to this bridge as the "Monument of Dislocated Directions."

Along the Passaic River banks were many minor monuments such as concrete abutments

The Bridge Monument Showing Wooden Side-walks. (Photo: Robert Smithson)

Monument with Pontoons: The Pumping Derrick. (Photo: Robert Smithson)

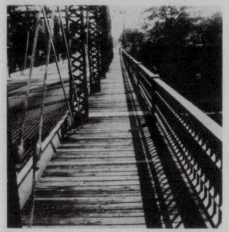

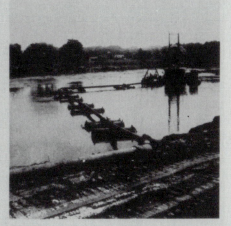

walks, held up by a heavy set of beams, while above, a ramshackle network hung in the air. A rusty sign glared in the sharp atmosphere, making it hard to read. A date flashed in the sunshine . . . 1899 . . . No . . . 1896 . . . maybe (at the bottom of the rust and glare was the name Dean & Westbrook Contractors, N.Y.). I was completely controlled by the Instamatic (or what the rationalists call a camera). The glassy air of New Jersey defined the structural parts of the monument as I took snapshot after snapshot. A barge seemed fixed to the surface of the water as it came toward the bridge, and caused the bridge-keeper to close the gates. From the banks of Passaic I watched the bridge rotate on a central

that supported the shoulders of a new highway in the process of being built. River Drive was in part bulldozed and in part intact. It was hard to tell the new highway from the old road; they were both confounded into a unitary chaos. Since it was Saturday, many machines were not working, and this caused them to resemble prehistoric creatures trapped in the mud, or, better, extinct machines—mechanical dinosaurs stripped of their skin. On the edge of this prehistoric Machine Age were pre- and post-World War II suburban houses. The houses mirrored themselves into colorlessness. A group of children were throwing rocks at each other near a ditch. "From now on you're not going to come to

Fig. 6.8. Robert Smithson, *The Bridge Monument Showing Wooden Sidewalks*, in *Writings*, p. 53. Courtesy of the Estate of Robert Smithson. Reprinted by courtesy of Nancy Holt and *Artforum*.

"The state of the object," says Malevich, "has become more important than its essence and meaning" (*RA* 127). To define this state is, so Smithson implies, the domain of the artist. Just as Cendrars and Barthes discuss the Eiffel Tower chiefly in terms of its emblematic role in Paris and the modern world, so Smithson defamiliarizes the sites (sights) we pass every day so as to bring out their synecdochic function. The "Bridge Monument" with its "dislocated directions" stands for the larger "entropic" landscape, a world consistently made obsolete by the next technological development.

Such obsolescence, far from being, as the cliché would have it, merely "deplorable," has its endearing and revelatory aspects; it produces in the narrator what Barthes calls "des jouissances du symbolique." For this "pre-historic Machine Age" made up of "minor monuments" like the "concrete abutments that supported the shoulders of a new highway in the process of being built" (*RS* 53) lends a certain aura to the pre— and post—World War II landscape of suburban houses, "mirror[ing] themselves into colorlessness." The monotonous suburban sprawl that connects Passaic and Rutherford in one long main street, a seemingly interminable strip of hamburger stands and gas stations, is redeemed precisely by the "found art" of Smithson's monuments. For example:

> Nearby [the reference is to a pumping derrick with a long pipe], on the river bank, was an artificial crater that contained a pale limpid pond of water, and from the side of the crater protruded six large pipes that gushed the water of the pond into the river. This constituted a monumental fountain that suggested six horizontal smokestacks that seemed to be flooding the river with liquid smoke. The great pipe was in some enigmatic way connected with the infernal fountain. It was as though the pipe was secretly sodomizing some hidden technological orifice, and causing a monstrous sexual organ (the fountain) to have an orgasm. A psychoanalyst might say that the landscape displayed "homosexual tendencies," but I will not draw such a crass anthropomorphic conclusion. I will merely say, "It was there." (*RS* 54)

The images that accompany this paragraph (see fig. 6.9) stubbornly resist our desire to make them "fit" the text, for nothing could be less overtly sensuous or sexual than these dreary lengths of pipe, surrounded by sand, debris, and stagnant water. The deflationary effect of the photographic images is, of course, intentional: Smithson wants us to understand that it is only in the artist's imagination that the "Fountain Monument" takes on a sexual life, even as the Futurist poets and painters endowed the simple iron skeleton of the Eiffel Tower with both phallic potency and female orifices.

our hide-out. And I mean it!" said a little blonde girl who had been hit with a rock.

As I walked north along what was left of River Drive, I saw a monument in the middle of the river—it was a pumping derrick with a long pipe attached to it. The pipe was supported in part by a set of pontoons, while the rest of it extended about three blocks along the river bank till it disappeared into the earth. One could hear debris rattling in the water that passed through the great pipe.

thropomorphic conclusion. I will merely say, "It was there."

Across the river in Rutherford one could hear the faint voice of a P. A. system and the weak cheers of a crowd at a football game. Actually, the landscape was no landscape, but "a particular kind of heliotypy" (Nabokov), a kind of self-destroying postcard world of failed immortality and oppressive grandeur. I had been wandering in a moving picture that I couldn't quite picture, but just as I became perplexed, I saw a green

The Great Pipes Monument. (Photo: Robert Smithson)

The Fountain Monument: Side View. (Photo Robert Smithson)

Nearby, on the river bank, was an artificial crater that contained a pale limpid pond of water, and from the side of the crater protruded six large pipes that gushed the water of the pond into the river. This constituted a monumental fountain that suggested six horizontal smoke-stacks that seemed to be flooding the river with liquid smoke. The great pipe was in some enigmatic way connected with the infernal fountain. It was as though the pipe was secretly sodomizing some hidden technological orifice, and causing a monstrous sexual organ (the fountain) to have an orgasm. A psychoanalyst might say that the landscape displayed "homosexual tendencies," but I will not draw such a crass an-

sign that explained everything:

YOUR HIGHWAY TAXES 21
AT WORK

Federal Highway	U.S. Dept. of Commerce
Trust Funds	Bureau of Public Roads
2,867,000	State Highway Funds
· ·	2,867,000
New Jersey State Highway Dept.	

That zero panorama seemed to contain *ruins in reverse,* that is—all the new construction that would eventually be built. This is the opposite of the "romantic ruin" because the buildings don't *fall* into ruin *after* they are built but rather *rise* into ruin before they are built. This anti-romantic

Fig. 6.9. Robert Smithson, "The Great Pipes Monument" (left) and "The Fountain Monument" (right), in *Writings*, p. 54. Courtesy of the Estate of Robert Smithson. Reprinted by courtesy of Nancy Holt and *Artforum.*

But the "future" Smithson projects for his "monuments" is not that of Apollinaire or Boccioni. The "zero panorama" of the New Jersey highway system "seem[s] to contain *ruins in reverse*, that is—all the new construction that would eventually be built" (*RS* 54). The landscape of the used car lot and the Golden Coach Diner seems to have neither past nor future—it is "A Utopia minus a bottom, a place where the machines are idle, and the sun has turned to glass. . . . Passaic seems full of 'holes' compared to New York City, which seems tightly packed and solid, and those holes in a sense are the monumental vacancies that define, without trying, the memory-traces of an abandoned set of futures" (*RS* 55).

It sounds bleak only if we refuse to cast off our nostalgia for a past that may never have existed and an ultimate future that turns out to be a self-canceling reflection of the past. For Smithson, as for the Futurists, their apocalyptic rhetoric notwithstanding, it is, finally, the *present* that most urgently matters. Art, in this context, becomes increasingly theatrical, if by *theatricality* we mean, in Howard N. Fox's words, "that propensity in the visual arts for a work to reveal itself within the mind of the beholder as something other than what it is known empirically to be."[24]

Thus Smithson stages the journey to Passaic as a Journey to Another Planet, with the old bridges, derricks, pipes, and used car lots taking on the role of ever more exotic "monuments" to be photographed and deciphered. Or again, in "Toward the Development of an Air Terminal Site" (1967), Smithson invents a theater based on "instantaneous time" and the consequent "immobilization of space": "The aircraft no longer 'represents' a bird or animal (the flying tigers) in an organic way, because the movement of air around the craft is no longer visible" (*RS* 41). The scale of the art gallery must thus give way to the scale of "the actual land as medium." Sighted from the plane in flight, "Pavements, holes, trenches, mounds, heaps, paths, ditches, roads, terraces, etc., all have an esthetic potential. . . . Consider a 'City of Ice' in the Arctic, that would contain frigid labyrinths, glacial pyramids, and towers of snow, all built according to strict abstract systems. Or an amorphous 'City of Sand' that would be nothing but artificial dunes, and shallow sand pits" (*RS* 44).

"Theatricality," writes Howard Fox, "may be the single most pervasive property of post-Modern art" (*M* 16). The "wholly manifest, self-sufficient object" of High Modernism is replaced by a new emphasis on context, on situation. The reception of Smithson's "nonsites," for example, depends upon the viewer's ability to make the

connection between an object (e.g., a box of sand) to be seen in a gallery and the absent site to which it refers, between the object and the verbal texts and inscriptions that surround it, or again, between "sculpture" and the performative element that activates it for us. Sites like the *Spiral Jetty* (1970) at Great Salt Lake, Utah, are situational and participatory in that they operate in "real" time and "real" space. To visit these sites is to play the role of audience for what are essentially theatrical productions. Similarly, Smithson's verbal "sites" are staged so as to elicit the participation of the reader, who must determine how and why text and image, often quite contradictory, belong in the same semiotic field.

Consider the collage-text called "Quasi-Infinities and the Waning of Space" (1966), in which Smithson "postulate[s]" around four blocks of print "four ultramundane margins that shall contain indeterminate information as well as reproduced reproductions" (*RS* 32). The first such block (fig. 6.10) takes us, via the footnote network, to such related abstract structures as the medieval labyrinth, the prehistoric tower, the model "City of the Future," and finally to alphabet codes, mathematical schemes, and Ad Reinhardt's installation of black paintings. The second block similarly draws upon related images, this time of anatomy and biomorphism—a Renaissance drawing of a cadaver, a Willem de Kooning nude, the "concrete stomach" of the Guggenheim Museum. But on this page (fig. 6.11) margin entries begin to appear that are not numbered in the text, like the quotation from Cage's *Silence* and the extracts from George Kubler's *The Shape of Time* and Norbert Wiener's *The Human Use of Human Beings*. And whatever the order in which we read these entries, the title of the fourth block, "Time and History as Objects," is enacted. It is up to the reader-viewer to decide how to, so to speak, circle the square.

In Smithson's use of collage and manifesto elements and in his staging of "performative" art works, we detect a distinct Futurist echo. For him, as for a growing number of conceptual and performance artists, the Futurist machine (from the reimagined Eiffel Tower to the Tatlin wall reliefs, the sculptures of Boccioni, and Picabia's mechanomorphic Dada portraits of spark plugs and folding cameras, captioned with punning, sexually allusive titles) has once again posed a challenge, although, as Howard Fox says, with reference to the "machineworks" of Alice Aycock and Dennis Oppenheim, the new engagement "is less with the influence of machines on modern times than it is with the 'language,' the morphology, of machines—how they function syntactically, systemically, one part to another—as a

Quasi-Infinities and the Waning of Space

1 The Amiens Labyrinth (France)

2 Built for Fabricus at the University of Padua

For many artists the universe is expanding; for some it is contracting.

By
ROBERT SMITHSON

"Without a time sense consciousness is difficult to visualize." J. G. Ballard, *The Overloaded Man*

AROUND FOUR BLOCKS of print I shall postulate four ultramundane margins that shall contain indeterminate information as well as reproduced reproductions. The first obstacle shall be a labyrinth[1], through which the mind will pass in an instant, thus eliminating the spatial problem. The next encounter is an abysmal anatomy theatre[2]. Quickly the mind will pass over this dizzying height. Here the pages of time are paper thin, even when it comes to a pyramid[3]. The center of this pyramid is everywhere and nowhere. From this center one may see the Tower of Babel[4], Kepler's universe[5], or a building by the architect Ledoux[6]. To formulate a general theory of this inconceivable system would not solve its symmetrical perplexities. Ready to trap the mind is one of an infinite number of "cities of the future"[7]. Inutile codes[8] and extravagant experiments[9] adumbrate the "absolute" abstraction[10]. One becomes aware of what T. E. Hulme called "the fringe... the cold walks... that lead nowhere."

In Ad Reinhardt's "Twelve Rules for a New Academy" we find the statement, "The present is the future of the past, and the past of the future." The dim surface sections within the confines of Reinhardt's standard (60" x 60") "paintings" disclose faint squares of time. Time, as a colorless intersection, is absorbed almost imperceptibly into one's consciousness. Each painting is at once both memory and forgetfulness, a paradox of darkening time. The lines of his grids are barely visible; they waver between the future and the past.

George Kubler, like Ad Reinhardt, seems concerned with "weak signals" from "the void." Beginnings and endings are projected into the present as hazy planes of "actuality." In *The Shape of Time: Remarks on the History of Things*, Kubler says, "Actuality is . . . the interchronic pause when nothing is happening. It is the void between events." Reinhardt seems obsessed by this "void," so much that he has attempted to give it a concrete shape—a shape that evades shape. Here one finds no allusion to "duration," but an interval without any suggestion of "life or death." This is a coherent portion of a hidden infinity. The future criss-crosses the past as an unobtainable present. Time vanishes into a perpetual sameness.

Most notions of time (Progress, Evolution, Avant-garde) are put in terms of biology. Analogies are drawn between organic biology and technology; the nervous system is extended into electronics, and the muscular

3 The Pyramid of Meidum

4 The Tower of Babel

5 Kepler's model of the universe

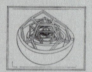

6 Claude-Nicolas Ledoux (1736-1806)

7 "City of the Future"

10 Ad Reinhardt installation (March 1965) Betty Parsons Gallery

9 From Edgar Allan Poe's *Eureka*

```
        0
        0
      1   1
      0   1
    2   2   2
    0   1   2
  3   3   3   3
  0   1   2   3
4   4   4   4   4
0   1   2   3   4
```

8 *A Discrete Scheme Without Memory* by Dan Graham

```
HGFEDCBA
GHFEDCBA
FGHEDCBA
EFGHDCBA
DEFGHCBA
CDEFGHBA
BCDEFGHA
ABCDEFGH
```

B. Non-code based on *The Ars Magna* of Ramon Lull

Fig. 6.10. Robert Smithson, "Quasi-Infinities and the Waning of Space," in *Writings*, p. 32. Courtesy of the Estate of Robert Smithson. Reprinted by courtesy of Nancy Holt and *Arts Magazine*.

11 Any art that originates with a will to "expression" is not abstract, but representational. Space is represented. Critics who interpret art in terms of space see the history of art as a reduction of three dimensional illusionistic space to "the same order of space as our bodies." (Clement Greenberg—*Abstract, Representational and so forth.*) Here Greenberg equates "space" with "our bodies" and interprets this reduction as abstract. This anthropomorphizing of space is aesthetically a "pathetic fallacy" and is in no way abstract.

12 Plate probably drawn for Spigelius (1627)

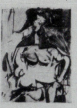

13 Willem deKooning

"Although inanimate things remain our most tangible evidence that the old human past really existed, the conventional metaphors used to describe this visible past are mainly biological." George Kubler, *The Shape of Time: Remarks on the History of Things*

nowhere

,

17

,

nowhere.

.

.

.

.

).

;

the pleasure

nowhere.

let him go to sleep

17

John Cage. *Silence.* Cambridge: M.I.T. Press

"Dr. J. Bronowski among others has pointed out that mathematics, which most of us see as the most factual of all sciences, constitutes the most colossal metaphor imaginable, and must be judged, aesthetically as well as intellectually, in terms of the success of this metaphor." Norbert Wiener, *The Human Use of Human Beings*

system is extended into mechanics. The workings of biology and technology belong not in the domain of art, but to the "useful" time of organic (active) duration, which is unconscious and mortal. Art mirrors the "actuality" that Kubler and Reinhardt are exploring. What is actual is apart from the continuous "actions" between birth and death. Action is not the motive of a Reinhardt painting. Whenever "action" does persist, it is unavailable or useless. In art, action is always becoming inertia, but this inertia has no ground to settle on except the mind, which is as empty as actual time.

THE ANATOMY OF EXPRESSIONISM[11]

The study of anatomy since the Renaissance lead to a notion of art in terms of biology[12]. Although anatomy is rarely taught in our art schools, the metaphors of anatomical and biological science linger in the minds of some of our most abstract artists. In the paintings of both Willem deKooning[13] and Jackson Pollack[14], one may find traces of the biological metaphor[15], or what Lawrence Alloway called "biomorphism[16]." In architecture, most notably in the theories of Frank Lloyd Wright, the biological metaphor prevails[17]. Wright's idea of "the organic" had a powerful influence on both architects and artists. This in turn produced a nostalgia for the rural or rustic community or the pastoral setting, and as a result brought into aesthetics an anti-urban attitude. Wright's view of the city as a "cancer" or "a social disease" persists today in the minds of some of the most "formal" artists and critics. Abstract expressionism revealed this visceral condition, without any awareness of the role of the biological metaphor. Art is still for the most part thought to be "creative" or in Alloway's words "phases of seeding, sprouting, growing, loving, fighting, decaying, rebirth." The science of biology in this case, becomes "biological-fiction," and the problem of anatomy dissolves into an "organic mass." If this is so, then abstract-expressionism was a disintegration of "figure painting" or a decomposition of anthropomorphism. Impressionistic modes of art also suffer from this biological syndrome.

Kubler suggests that metaphors drawn from physical science rather than biological science would be more suitable for describing the condition of art. Biological science has since the nineteenth century infused in most people's minds an unconscious faith in "creative evolu-

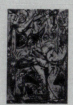

14 Jackson Pollack

15 The biological metaphor is at the bottom of all "formalist" criticism. There is nothing abstract about deKooning or Pollack. To locate them in a formalist system is simply a critical mutation based on a misunderstanding of metaphor—namely, the biological extended into the spatial.

16 *Art Forum,* September 1965. *The Biomorphic Forties*

17 A. The Guggenheim Museum is perhaps Wright's most visceral achievement. No building is more organic than this inverse digestive tract. The ambulatories are metaphorically intestines. It is a concrete stomach.

B. Guggenheim Museum

Fig. 6.11. Robert Smithson, "Quasi-Infinities and the Waning of Space," in *Writings*, p. 33. Courtesy of the Estate of Robert Smithson. Reprinted by courtesy of Nancy Holt and *Arts Magazine*.

structural model for . . . art. The machine *per se* is a non-issue; for [the Postmodern artist] the structure of the machine has left the daily world and entered the repertoire of poetic images" (*M* 18).

It is a question, of course, of whether the "machine *per se* was ever more than a non-issue." Marinetti's manifestos and *parole in libertà*, Russolo's performances of *Intonarumori*, Kruchenykh's expressive chanting of *zaum* poems—none of these represent the attempt to replicate machines or to pay unqualified tribute to the machine's power. Rather, it is, as Fox says, the "morphology of machines," their systemic and syntactic function, that serves as a structural model. "Instead of causing us to remember the past like the old monuments," writes Smithson, "the new monuments seem to cause us to forget the future. Instead of being made of natural materials, such as marble, granite, or other kinds of rock, the new monuments are made of artificial materials, plastic, chrome, and electric light. They are not built for the ages, but rather against the ages" (*RS* 10).

The implication of "machineworks," whether those of the *avant guerre* or of our own time, is that the "aesthetic" domain has been contaminated by the "practical," that the "order" of art is no longer opposed to the "disorder" of life. This is a situation inimical to the tenets of High Modernism, especially the tenets of the New Criticism that continue to haunt discussions of the arts today. Thus Michael Fried's well-known attack on "theatre" in his 1967 essay "Art and Objecthood," his insistence that *"Art degenerates as it approaches the condition of theatre,"* that *"the concept of art [is] meaningful only within the individual arts,"*[25] can be construed as a late variant on R. P. Blackmur's 1935 dismissal of D. H. Lawrence's poetry as suffering from "the fallacy of expressive form," which is to say from the incursions of emotional excess and prose impurities.[26] Indeed, Fried's insistence that the work of art have formal unity, that in successful painting, *"at every moment the work itself is wholly manifest,"* recalls the *Protestation des artistes* of 1887 against the construction of the "useless and monstrous" Eiffel Tower.

In his own such "protestation" (a 1967 letter to the editor in *Artforum*), Smithson pokes fun at Fried's zealous desire to "keep art at 'arm's length'" (*RS* 38). For Smithson, as for Marinetti and Malevich half a century earlier, "Visiting a museum is a matter of going from void to void" (*RS* 58). "Our older museums," he tells Allan Kaprow, "are full of fragments, bits and pieces of European art. They were ripped out of total artistic structures, given a whole new classification and then categorized. The categorizing of art into painting, architecture and sculpture seems to be one of the most unfortunate things that

took place" (*RS* 63–64). The greater the number of categories and *isms*, Smithson argues, the more confusing and useless they become:

> In the museum one can find deposits of rust labeled "Philosophy," and in glass cases unknown lumps of something labeled "Aesthetics." One can walk down ruined hallways and see the remains of "Glory." A sense of fatigue overcomes one in the "Room of Ancient History." . . .

> The "Room of Great Artists" presents a panorama that goes from "the grand" to "the horrible." A continuous film, always being shown in a dark chamber, depicts "the artist alienated from society." It is made in "serial" sections under the titles: "Suffering, discovery, fame, and decline." The film delves into the private-life of the creative genius and shows the artist's conflicts as he struggles ᴜ make the world understand his vision. (*RS* 79–80)

Here Smithson ironizes Marinetti's call, in the *Destruction of Syntax* manifesto, for the "Death of the literary I" (*FM* 100), the demise of the controlling ego. The Romantic myth of the alienated genius *creating* a separate world is what Barthes would call a *mathesis*, and, as such, it no longer obtains. But "most critics," as Smithson says elsewhere, "cannot endure the suspension of *boundaries* between . . . the 'self and the non-self.' They are apt to dismiss Malevich's *Non Objective World* as poetic debris" (*RS* 84).

In defiance of the existing Museum, with its neat organization of art and knowledge into historical and generic categories, Smithson offers us a verbal text called "A Museum of Language in the Vicinity of Art." Ostensibly a discussion of Dan Flavin, Carl André, and other conceptual artists, Smithson's review-essay is, by his own account, "a mirror structure built of macro and micro orders, reflections, critical laputas, and dangerous stairways of words, a shaky edifice of fictions that hangs over inverse syntactical arrangements" (*RS* 67). And he adds:

> The entire article may be viewed . . . as a monstrous "museum" constructed out of multi-faceted surfaces that refer, not to one subject but to many subjects within a single building of words—a brick = a word, a sentence = a room, a paragraph = a floor of rooms, etc. Or *language becomes an infinite museum, whose center is everywhere and whose limits are nowhere.*

The analogizing (a brick = a word), like the substitution of the word "language" for the Christian God in the italicized final sentence, is put forward tongue-in-cheek, but Smithson is quite serious in his belief that the eruption of language into the visual field is essential to the

new art so that we can no longer distinguish between the "verbal" and the "visual" or, for that matter, between "art" and "criticism." Under the subtitle "Inverse Meanings," Smithson cites Barthes: "How can anyone believe that a given work is an *object* independent of the psyche and personal history of the critic studying it, with regards to which he enjoys a sort of extraterritorial status?"[27]

In Smithson's "earthwords,"[28] as in his earthworks, the verbal and the visual have an equivocal relationship. In "Strata: A Geophotographic Fiction" (1972), for example, photographs of geological deposits alternate with blocks of text ostensibly referring to the geological periods listed in the margins, blocks of text that themselves look like stratified layers of verbal sediment but that, when scanned closely, are poetic collages, spliced together from a great variety of sources, whether geology textbooks or literary classics (fig. 6.12). In the course of the "narrative," the literary element is heightened—the final block containing quotations from Ruskin and Henry Adams, even as the photographs disintegrate, in Craig Owens's words, "due to overenlargement, into the photomechanical 'language' of the half-tone screen" (Owens, "Earthwords," p. 123).

In "Strata" we witness the eruption of language into the visual field and the consequent displacement of both. At the same time, Smithson is experimenting with actual physical dislocation in the construction of his site sculptures or "earthworks." Consider the case of *Broken Circle/Spiral Hill*, built in Emmen, Holland, in 1971, a project that was to be Smithson's last completed earthwork before his death. At Emmen, the process of dislocation (and relocation) posed some particularly challenging artistic problems.

In a 1972 interview with Gregoire Muller, Smithson explains his choice of site for *Broken Circle*. The occasion was an invitation from the Sonsbeek international art exhibition to create a work for a park, but, as Smithson notes,

> the idea of putting an object in a park really didn't motivate me too much. In a sense, a park is already a work of art, it's a circumscribed area of land that already has a kind of cultivation involved in it. So I didn't want to impose an object on such an area. . . . I was looking for an area that was somewhat raw because Holland is so pastoral, so completely cultivated and so much an earthwork in itself that I wanted to find an area that I could mold, such as a quarry or a disused mining area. (*RS* 179)

A local geographer found just such a quarry, already slated for reclamation as a recreational site.[29] It impressed Smithson as a "disrupted

Fig. 6.12. Robert Smithson, "Strata: A Geophotographic Fiction" (1972), in *Writings*, p. 130. Courtesy of the Estate of Robert Smithson. Reprinted by courtesy of Nancy Holt and *Arts Magazine*.

situation," surrounded "by a whole series of broken landscapes" like pasture lands, disused mines, and red cliff. "The quarry happened to be on the edge of a terminal moraine. During the last ice age, the glaciers moved down there and deposited all different kinds of materials, mainly sand. The area was made up of red, yellow, white, brown and black earth, with boulders that had been carried by the glaciers and tumbled into a round shape" (*RS* 181).

The quarry, having reached a heterogeneous "entropic" state, was the source of two images: in Robert Hobbs's words, "a broken circle

(formed of a jetty and a canal) which is impossible to circumambulate and a hill whose path, spiraling in a counterclockwise direction, forms an ancient symbol of destruction."[30] *Spiral Hill* (fig. 6.13) recalls ancient burial mounds as well as the Tower of Babel, a tower that, unlike Eiffel's openwork iron grid, is a dark and solid mass, winding centripetally around itself. By contrast (and Smithson was always drawn to dialectical propositions), *Broken Circle* (fig. 6.14) is a centrifugal surface, flat and made of light-colored sand, whose open curve, surrounded by water, challenges the massive solidity of the neighboring tower.[31]

But what are we to make of the huge boulder, placed close to the center of the circle's diameter? Is not this man-made central focal point too pretty, too conventionally aesthetic? The boulder, Smithson tells us, proved to be his nemesis. His original intention was to move it outside the circumference of the circle but he was told that only the Dutch army could do such a thing. Having run out of money, Smithson returned to New York to think over "the riddle of the accidental center":

> Once in New York, after studying photographs of *Broken Circle*, I was haunted by the shadowy lump in the middle of my work. Like the eye of the hurricane it seemed to suggest all kinds of misfortunes. It became a dark spot of exasperation, a geological gangrene on the sandy expanse. Apprehensions of the shadowy point spread through my memory of the work. The perimeter of the intrusion magnified into a blind spot in my mind that blotted the circumference out. All and all it is a cylopian dilemma. (*RS* 182)

The artist could comfort himself with the thought that, from the vantage point of the *Broken Circle* itself, the big boulder is perceived as part of the circle's circumference. But the fact remains that, seen from the apex of the *Spiral Hill* tower, "there is a link-up of two centers." The artist's need to accept the "undesired center," the center that mere chance put in his way, became a kind of parable for Smithson: "Neither eccentrically nor concentrically is it possible to escape the dilemma, just as the Earth cannot escape the Sun" (*RS* 182).

Still, this "dilemma" could be turned into an open situation. Smithson decided that someday he might try to bury the boulder in the center of the circle. Or he might leave it where it was, "as a kind of glacial 'heart of darkness'—a warning from the Ice Age." The film about the project remained unfinished. In the meantime, the artist began to regard the predicament itself as stimulating, prompting all sorts of fantasies of "aerial maneuvers." An airplane, for instance, might make a "clover leaf" maneuver over the site, consisting of four

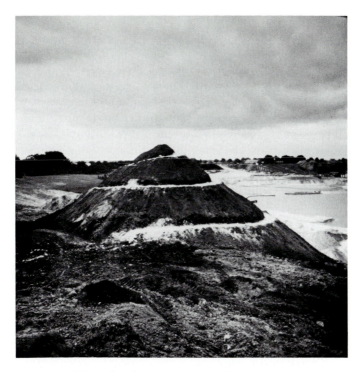

Fig. 6.13. Robert Smithson, *Spiral Hill*, Emmen, Holland, Summer 1971. Courtesy of the Estate of Robert Smithson.

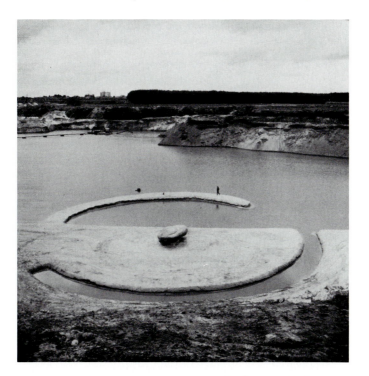

Fig. 6.14. Robert Smithson, *Broken Circle*, Emmen, Holland, Summer 1971. Courtesy of the Estate of Robert Smithson.

loops with *Broken Circle* at the bottom of these loops. Or a helicopter might fly as high as possible over the site and then slowly drop down into its middle. "A work on this scale," says Smithson, "has a way of generating continual movement. Museum shows often neutralize art by taking it out of society—out of circulation—by rendering it 'abstract' and ineffective. Sonsbeek, at least, points toward a new sense of circulation" (*RS* 182).

A new sense of circulation—Smithson's words take us back to Barthes's depiction of the Eiffel Tower as "une sorte de forme anthologique résumant tous ces ouvrages de grande circulation" (*TE* 63), and, beyond Barthes, to Malevich's apocalyptic vision of an art that would encompass "great inventions, conquest of the air, speed of travel . . . the realm of electricity" (*RA* 125):

> And I say:
> *That no torture chambers of the academies will withstand the days to come.*
> *Forms move and are born, and we are forever making new discoveries. . . .*
> The hollow of the past cannot contain the gigantic constructions and movements of our life.
> As in our life of technology:
> We cannot use the ships in which the Saracens sailed, and so in art we should seek forms that correspond to modern life. (*RA* 130)

The oracular voice, the optimistic projection of a Brave New World to come—this side of Futurism inevitably came to an end when the ethos of *avant guerre* gave way to the realities of war itself. The "life of technology" that Malevich speaks of with such enthusiasm has been largely discredited. But in the last few decades, the spirit of invention, of rupture, of the conceptual art work as something that can actually *change* our landscapes and our lives, has once again become important. The machine, in its fantastic and ironized guises, once again stimulates the poetic imagination.

In his "short story" "Tatlin!" (more accurately, a collage-narrative, part fact, part fiction, made up of text and visual image), published in 1974,[32] Guy Davenport reconstructs Tatlin's conception of his famous tower, the so-called *Monument to the Third International* (fig. 6.15), as follows:

> It was at once a building, a sculpture, a painting, a poem, a book, a moving picture, a *construct.*
> In the radio and telegraph station of the tower news of all the inter-

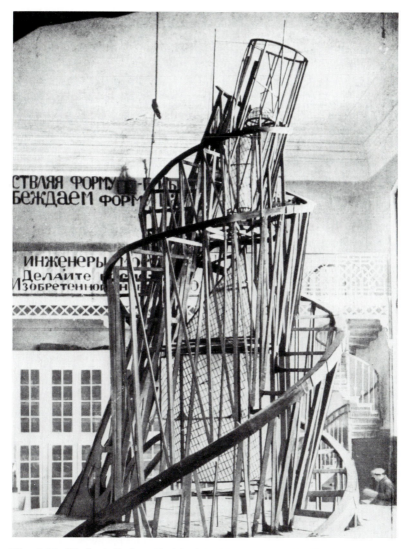

Fig. 6.15. Vladimir Tatlin, *Model of the Monument to the Third International*, 1919–20. From *Tatlin (Against Cubism)*, by N. Punin, St. Petersburg, 1921. Photograph Alfred J. Barr Archive, Museum of Modern Art, New York.

national movements would arrive and be instantly broadcast to all of Moscow. The landlords of Peru are hanging from the lamp posts! The red flag flies over the Louvre! The usurers of New York have been lashed from the Stock Exchange by heroic mothers and noble youths!

The steel spiral rising from a garden of clouds was supported by

tetrahedral struts. In one model of the monument, Tatlin added a second spiral. Within the spirals a central axis held the cube, cone, and cylinder. The axis leaned like that of the earth itself, at a phallic tilt, like the thrust of Tsiolkovsky's rockets leaving the earth for the moon. . . .

It was a hundred metres higher than the Tour Eiffel. (P. 43)

The Eiffel Tower was built precisely according to plan. Tatlin's tower, commissioned by the Soviet Department of Fine Arts in 1919 as a monument celebrating the internationalism of communism, was rejected by the Communist government as impractical and utopian. By 1920, after the watershed of World War I and the Russian Revolution, the Futurist ideology was all but dead. But the stage was set for its re-creation, even if only as a potent fiction.

Commenting on Dan Flavin's "instant-monument" called *Monument 7 for V. Tatlin* (fig. 6.16), parts of which were purchased at the Radar Fluorescent Company, Smithson writes:

> The "instant" makes Flavin's work a part of time rather than space. Time becomes a place minus motion. If time is a place, then innumerable places are possible. Flavin turns gallery-space into gallery time. Time breaks down into many times. Rather than saying, "What time is it?", we should say, "Where is the time?" (*RS* 10)

If time is a place, then innumerable places are possible. The proposition is one that would have fascinated Khlebnikov, whose unfinished book *The Tables of Destiny* tried to "explain" the subjective universe that we inhabit as a function of the mathematical one. For example:

> In the famous old legend the city of Kitezh lay sunk in a deep dark lake in the forest, while here, out of each spot of time, out of every lake of time arises an orderly multinomial of threes with towers and steeples, just like another Kitezh. . . .
> A city of threes with its towers and steeples rings loudly from out the depths of time. An orderly city with numerical towers has replaced previous visions of spots of time. [33]

For Khlebnikov, the free play of numbers offered the possibility of circumventing the disasters of history. "I swore," he wrote in his 1919 memoir, "to discover the laws of time, and carved that promise on a birch tree . . . the day I heard about the battle of Tsushima. . . . I wanted to discover the reason for all those deaths" (*KT* 171).

The battle of Tsushima marked the catastrophic defeat of the Russians by the Japanese in the war of 1905, but no one, least of all

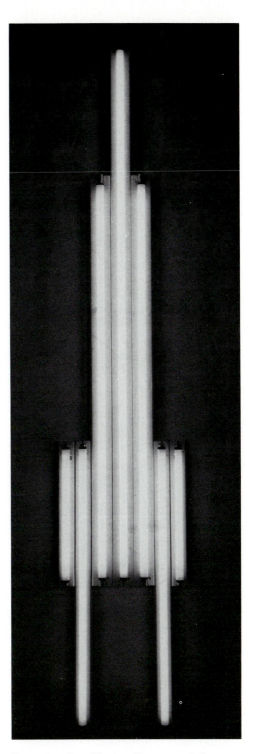

Fig. 6.16. Dan Flavin, *Monument 7 for
V. Tatlin*, 1964–65. Courtesy of the Leo
Castelli Gallery, New York.

Khlebnikov, who died of chronic malnutrition in 1922 without completing *The Tables of Destiny*, was "to discover the reasons for all those deaths." The Russo-Japanese War is also the war to which Blaise Cendrars refers in *La Prose du Transsibérien*, when he remarks prophetically, "Nous disparaissons dans la guerre en plein dans un tunnel" ("We are disappearing into war drawn into a tunnel"). On the other side of that tunnel, in our "monde planétaire" of instant monuments, the language of rupture characteristic of the *avant guerre* reappears as what Smithson calls, in his essay on the *Spiral Jetty*, "the dialectics of site and nonsite . . . where solid and liquid lost themselves in each other" (*RS* 111):

> It was as if the mainland oscillated with waves and pulsations, and the lake remained rock still. The shore of the lake became the edge of the sun, a boiling curve, an explosion rising into a fiery prominence. Matter collapsing into the lake mirrored in the shape of a spiral. No sense wondering about classifications and categories, there were none.

NOTES

CHAPTER ONE

1. Velimir Khlebnikov, "!Budetlyanin!" in *Futuristy: Rykayushii Parnas* (Futurists: Roaring Parnassus), ed. David Burliuk (Petersburg, 1914), p. 82; idem, "!Futurian!" in *The King of Time: Poems, Fictions, Visions of the F ι-ture*, trans. Paul Schmidt, ed. Charlotte Douglas (Cambridge, Mass.: Harvard University Press, 1985), p. 123. *The King of Time* subsequently cited as *KT*.

Kasimir Malevich, *Ot kubizma i futurizma k suprematizmu*, 3d ed. (Moscow, 1916), p. 28; idem, *From Cubism and Futurism to Suprematism* (Moscow, 1916), in *Russian Art of the Avant-Garde: Theory and Criticism, 1902–1934*, ed. and trans. John E. Bowlt, Documents of Twentieth-Century Art (New York: Viking Press, 1976), p. 125. Malevich subsequently cited as *CFS*, Bowlt as *RA*.

F. T. Marinetti, *Guerra sola igiene del mondo* (1915), in *Opere di F. T. Marinetti*, vol. 2: *Teoria e invenzione futurista*, ed. Luciano De Maria (Milan: Mondadori, 1968), p. 260; idem, *War: The World's Only Hygiene*, in *Selected Writings*, ed. R. S. Flint, trans. R. S. Flint and Arthur A. Coppotelli (New York: Farrar, Straus and Giroux, 1972), p. 67. Marinetti subsequently cited as *TIF*, Flint as *S*.

Antonio Gramsci, "Marinetti revoluzionario?" *L'Ordine Nuovo*, 5 January 1921, in *Scritti Politici*, ed. Paolo Spriano (Rome: Editori Riuniti, 1967), pp. 396–97; idem, "Marinetti the Revolutionary," in *Selections from Cultural Writings*, ed. David Forgacs and Geoffrey Nowell-Smith, trans. William Boelhower (Cambridge, Mass.: Harvard University Press, 1985), p. 51. Subsequently cited as *SCW*.

2. There are two very fine reproductions of the whole book: Jacques Damase, *Sonia Delaunay: Rhythms and Colours* (Greenwich, Conn.: New York Graphic Society, 1972), pp. 84–91; Arthur A. Cohen, *Sonia Delaunay* (New York: Harry N. Abrams, 1975), pp. 24–29. The first edition of the poem itself, with Cendrars's original typography and layout, has been reissued by Pierre Seghers for Editions Denoël, Paris, 1957. This otherwise superb edition mistakenly carries the date as 1912 (instead of 1913), evidently because Blaise Cendrars himself, in a telegram sent to Seghers in April 1957, thanking him for the book, mistakenly refers to the original publication date as 1912.

The text of *La Prose du Transsibérien* used here is in Blaise Cendrars,

Oeuvres complètes, 16 vols., ed. Raymond Dumay and Nino Frank (Paris: Le Club français du livre, 1968−71), 1:16−32. This volume also has reproductions of the Delaunay-Cendrars text and other supporting documents in the frontispiece. All subsequent references to Cendrars will be to this edition, subsequently cited as *OC*.

The English translation of *La Prose du Transsibérien* cited here is that of Walter Albert, *Selected Writings of Blaise Cendrars* (New York: New Directions, 1962), pp. 66−99. This text is subsequently cited as *SW*. Many of the other Cendrars text to which I refer are found neither in Albert nor in Monique Chefdor's excellent *Complete Postcards from the Americas: Poems of Road and Sea* (Berkeley: University of California Press, 1976). The translations, unless otherwise noted, are my own.

3. See Cohen, *Sonia Delaunay*, pp. 31−35. For a detailed analysis of the typography and its relationship to the visual forms of Delaunay, see Pierre Caizergues, "Blaise Cendrars: Poète du voyage et voyageur de l'écriture," in *Blaise Cendrars 20 ans après*, ed. Claude Leroy (Paris: Klincksieck, 1983), pp. 57−73.

4. See Cohen, *Sonia Delaunay*, pp. 37−49, and biographical outline, p. 187 ff.; "Sonia Delaunay by Sonia Delaunay" (1967) and "Interview with Sonia Delaunay" (1970), in *The New Art of Color: The Writings of Robert and Sonia Delaunay*, ed. Arthur A. Cohen; trans. David Shapiro and Arthur A. Cohen, Documents of Twentieth-Century Art (New York: Viking Press, 1978), pp. 194−97, 215−25.

5. In December 1913, Cendrars wrote the poem "Hamac" ("Hammock") which was to be included in the *Dix-neuf Poèmes élastiques* (1919). It ends with the lines, "Apollinaire / 1900−1911 / Durant 12 ans seul poète de France" ("Apollinaire / 1900−1911 / For 12 years the only poet in France"). See *OC* 1:69; *SW* 161.

6. Blaise Cendrars, *Une Nuit dans la forêt (premier fragment d'une auto-biographie)* (1927), *OC* 6:140; cf. idem, *Inédits secrets*, ed. Miriam Cendrars (Paris: Le Club français du livre, 1969; published as volume 16 of *OC*), p. 195. This text is subsequently cited as *IS*. For the life of Cendrars, see Jay Bochner's *Blaise Cendrars: Discovery and Re-creation* (Toronto: University of Toronto Press, 1978), esp. pp. 1−67. Cf. Monique Chefdor, *Blaise Cendrars* (Boston: Twayne Publishers, 1980), esp. pp. 1−52.

7. In "Interview with Sonia Delaunay" (1970), in *New Art of Color*, Delaunay tells Arthur Cohen, "I never wanted to go there [America]. I was asked to come in 1926." He replies, "You'll have to compromise one day, I hope." She says no because "I don't like the mechanical side of things there" (p. 219).

8. See letter to August Suter, September 1914, *IS* 398; Jean Breton, "Une Confession inédite de Blaise Cendrars," cited by Bochner, *Blaise Cendrars*, p. 56; Cendrars to Apollinaire, 2 November 1915, cited by Bochner, p. 59.

9. Umberto Boccioni, Carlo Carrà, Luigi Russolo, Giacomo Balla, and Gino Severini, "The Exhibitors to the Public" (1912), in *Futurist Manifestos*, ed. and trans. Umbro Apollonio, Documents of Twentieth-Century Art (New

York: Viking Press, 1973), pp. 45–50; see esp. p. 47. This was the catalog introduction for the Exhibition of Works by the Italian Futurist Painters, Galerie Bernheim-Jeune in Paris (February 1912) and the Sackville Gallery, London (March 1912). Apollonio subsequently cited as *FM*.

10. See Mikhail Larionov and Natalya Goncharova, "Rayonists and Futurists: A Manifesto, 1913," in *RA*, 89–91; Mikhail Larionov, "Rayonist Painting, 1913," in *RA* 95–96. Both of these texts originally appeared in *Oslinyi khvost i mishen* (Donkey's tail and target), and the first is reprinted in Vladimir Markov, ed., *Manifesti y programmy russkikh futuristov / Die Manifeste und Programmschriften der Russischen Futuristen*, Slavische Propyläen (Munich: Wilhelm Fink Verlag, 1967), pp. 175–78. Subsequently cited as *MPF*.

11. See Cohen, *New Art of Color*, pp. 11, 23, 31, 52, 138, 202, 215. Especially useful is Sonia Delaunay's letter of 2 June 1926 (p. 202), in which she explains her use of Chevreul's principle of "simultaneous contrasts."

12. Blaise Cendrars, "Simultanéisme—Librettisme," *Les Soirées de Paris* 25 (15 June 1914): 323–24; cited by Cohen, *Sonia Delaunay*, p. 35.

13. Cf. Arthur Rimbaud, *Une Saison en enfer*, in *Oeuvres*, ed. Suzanne Bernard (Paris: Classiques Garnier, 1960), p. 228:

> J'aimais les peintures idiotes, dessus de portes, décors, toiles de saltimbanques, énseignes, énluminures populaires, la littérature demodée, latin d'église, livres érotiques sans orthographe, romans de nos aïeules, contes de fées, petits livres de l'énfance, operas vieux, refrains niais, rhythmes naifs.

> I liked stupid paintings, door panels, stage sets, back-drops for acrobats, signs, popular engravings, old-fashioned literature, church Latin, erotic books with bad spelling, novels of our grandmothers, fairy tales, little books from childhood, old operas, ridiculous refrains, naive rhythms.

14. *IS* 371; "Contraste" appears in *OC* 1:60; *SW* 146.

15. See Pär Bergman, *"Modernolatrià" et "Simultaneità": Recherches sur deux tendances dans l'avant-garde littéraire en Italie et en France à la veille de la prémière guerre mondiale* (Stockholm: Bonniers, 1962), p. 315. This volume is a valuable history of the concept of simultaneity.

16. See Peter Selz, *German Expressionist Painting* (Berkeley, Los Angeles, and London: University of California Press, 1974), pp. 250–75 for a good account of *Der Sturm*. See also Otto Nebel, *Der Sturm* (Zurich: Kunstgewerbemuseum, 1955); Bochner, *Blaise Cendrars*, pp. 44–48.

17. See Selz, *German Expressionist Painting*, 265–66.

18. Cohen, *New Art of Color*, p. 122; cf. "Letter to a German Friend" (1912), p. 123: "I like light even more. Berlin is *luminous*."

19. *CFS* 28; *RA* 125–26.

20. See Stephen Kern, *The Culture of Time and Space, 1880–1918* (Cambridge, Mass.: Harvard University Press, 1983), chaps. 8 ("Distance") and 9 ("Direction"), *passim*. The whole book is extremely useful for an understanding of the technological revolution of the period. See also Bergman, *Modernolatrià*, pp. 9–13.

21. L. Brion-Guerry, ed., *L'Année 1913: Les formes ésthetiques de l'oeuvre d'art à la veille de la première guerre mondiale*, 3 vols. (Paris: Klincksieck, 1971), 1:10.

22. See John Milner, *Vladimir Tatlin and the Russian Avant-Garde* (New Haven and London: Yale University Press, 1983), p. 79.

23. See Bergman, *Modernolatrià*, pp. 26–27; for Cendrars's response to Charlie Chaplin, see "La Naissance de Charlot," *Actualités* (1926), in *OC* 6:94–96; "Charlot" (1952), in *OC* 15:149–56. Both these short pieces give a moving account of the bittersweet flavor of the early days of the war in France.

24. *The Education of Henry Adams*, in *Henry Adams* (New York: Library of America, 1983), p. 1121.

25. Jean Cocteau, *Carte blanche* (Paris: La Sirene, 1920), p. 105.

26. After the first edition, the archaicized "Jehanne" became "Jeanne." The Denoël edition and the Albert translation use "Jeanne." But since I am referring to the original *pochoir* and the first edition, I retain the original spelling.

27. *Blaise Cendrars vous parle . . .* , *Propos recueillis par Michel Manoll* (1952), in *OC* 13:147. The ballet Cendrars cites is *Petrouchka*, but the date makes clear that he meant *Le Sacre du printemps*.

28. Frank Budgen, *Myselves When Young* (Oxford and London: Oxford University Press, 1970), p. 135; cited by Bochner, *Blaise Cendrars*, p. 102. For a discussion of the parallels between Cendrars and Whitman, see Betsy Erkkila, *Walt Whitman among the French: Poet and Myth* (Princeton: Princeton University Press, 1980), pp. 187–99.

29. Khlebnikov, "!Budetlyanin!" p. 84; idem, "!Futurian!" in *KT* 125.

30. Guillaume Apollinaire, *Les Peintres cubistes: Meditations esthétiques* (1913), ed. L. C. Breunig and J.-Cl. Chevalier, Collection Savoir (Paris: Hermann, 1980), p. 55. Pound, citing this aphorism in *Gaudier-Brzeska: A Memoir* (1916; reprint, New York: New Directions, 1970), perhaps purposely misquotes it: "On ne peut pas porter *partout* le cadavre de son père" (p. 82).

31. Charles Olson, "Projective Verse," in *Selected Writings*, ed. Robert Creeley (New York: New Directions, 1966), p. 17.

32. In his essay on Léger for *Modernités* (3 July 1919), Cendrars writes:

> Dès avant la guerre, ses toiles avaient déjà un aspect "tout autre" que l'aspect général des autres toiles cubistes. Elles étaient directes, souvent brutales, sans jamais aucune recherche de joli, d'arrangé, de fini, et restaient toujours dans le domaine de la representation visuelle. . . . Léger [allait] si loin dans l'étude des volumes et des mesures qu'il donna, d'une part, naissance au rayonnisme russe de Larionow et, d'autre part, influença directement les meilleurs parmi les peintres futuristes italiens. (*OC* 6:46)

> Even before the war, his paintings already had an aspect that was quite different from that of other Cubist paintings. They were direct, often brutal, quite without any concern for prettiness, arrangement, finish, and they remained always within the domain of visual representation. . . . Léger [went] so far in his

study of weights and measures that, on the one hand, he gave birth to the Russian Rayonism of Larionov and, on the other, directly influenced the best of the Italian Futurist painters.

In this context, Léger's five illustrations for Cendrars's "J'ai tué" (1918) are very interesting. See *OC* 6 : frontispiece. See also Hughes Richard, "Fernand Léger," in "Quatre Inédits de Cendrars," *Europe* 566 (June 1976) : 215.

33. It is impossible to convey the syntax of these lines in English. Literally: "Ah! how large the world looks in the lamplight! / In the eyes of memory how the world is small!"

34. Caizergues, "Blaise Cendrars," p. 64: "Dans l'éspace de l'unique page qui sert finalement du support au poème-simultané, paradoxalement, c'est l'axe vertical qui se trouve privilégié alors que tout ici célèbre—images, thèmes . . . —l'horizontalité."

35. See ibid., pp. 64–70; Bochner, *Blaise Cendrars*, pp. 102–4.

36. Walter Benjamin, *Illuminations*, ed. Hannah Arendt, trans. Harry Zohn (New York: Schocken Books, 1969), pp. 241–42. Subsequently cited as *Ill.* For the German text, see Benjamin, *Gesammelte Schriften*, ed. Rolf Tiedemann and Hermann Schweppenhauser, 5 vols. (Frankfurt: Suhrkamp, 1974–82), vol. 1, part 2 (1972), pp. 471–508. This is the second version of the essay; the first (1935) is found on pp. 432–69. Subsequently cited as *GS*.

37. In the German, the last two sentences are italicized in both the first and second versions and read as follows: "*So steht es um die Aesthetisierung der Politik, welche der Faschismus betreibt. Der Kommunismus antwortet ihm mit der Politisierung der Kunst,*" (*GS* 1 : 508).

38. Guillaume Apollinaire, *Calligrammes*, bilingual edition, trans. Anne Hyde Greet, introduction by S. I. Lockerbie (Berkeley and Los Angeles: University of California Press, 1980), pp. 104–7.

39. Edward J. Brown, *Mayakovsky: A Poet in the Revolution* (Princeton: Princeton University Press, 1973), pp. 109–10.

40. See Vahan D. Barooshian, *Russian Cubo-Futurism, 1910–30: A Study in Avant-Gardism* (The Hague and Paris: Mouton, 1974), pp. 50–51.

41. In Khlebnikov, *La Création verbale*, ed. and trans. Catherine Prigent (Paris: Christian Bourgeois, 1980), p. 182. Translation from the French is mine.

42. Quoted by Camilla Gray, *The Russian Experiment in Art, 1863–1922* (London: Thames and Hudson, 1971), p. 219.

43. Kasimir Malevich, *O novikh sistemakh v iskusstve* (Vitebsk, 1919), p. 10; idem, *Essays on Art, 1915–1928*, 2 vols., trans. Xenia Glowachi-Prus and Arnold McMillin, ed. Troels Andersen (Copenhagen: Borgen, 1968), 1 : 94. Subsequently cited as *EA*.

44. See Marcelin Pleynet, *La Systeme de la peinture* (Paris: Editions du Seuil, 1977); trans. as *Painting and System*, by Sima N. Godfrey (Chicago: University of Chicago Press, 1984), pp. 140–41.

45. Leon Trotsky, "Futurism," in *Literature and Revolution* (New York: Russell and Russell, 1957), p. 130.

46. Leon Trotsky, "First All-Russian Congress on Adult Education, 6–19 May 1919," in *Collected Works* (Moscow: Progress, 1965), 29:336. Cited in Pleynet, *La Systeme de la peinture*, p. 142.

47. Charles Russell, "La Reception critique de l'avant-garde," in *Les Avant-gardes littéraires aux XXe siècle (A Comparative History of Literatures in European Languages Sponsored by the International Comparative Literature Association)*, ed. Jean Weisberger, 2 vols. (Budapest: Akademiai Kiadó, 1984), 2:1123–54. Russell's essay has an extensive bibliography on the subject.

48. An important Marxist defense of the avant-garde against the charges made by Trotsky, Lukács, and others is that of Peter Bürger, who argues in *Theory of the Avant-Garde* (1974), trans. Michael Shaw, foreword by Jochen Schulte-Sasse (Minneapolis: University of Minnesota Press, 1984), that "The European avant-garde movements can be defined as an attack on the status of art in bourgeois society. What is negated is not an earlier form of art (a style) but art as an institution that is unassociated with the life praxis of men" (p. 49).

Such theoretical discussions should be supplemented by a number of valuable studies of the actual political thought of the Italian and Russian Futurists and of their place in society:

(1) For an excellent round table discussion of Marinetti's relationship to fascism, see Giovanni Lista, *Marinetti et le futurisme: Etudes, documents, iconographie réunis et presentés par Giovanni Lista* (Lausanne: L'Age d'Homme, 1977). Lista's own essay, "Marinetti et le futurisme politique" (pp. 11–28) is very useful as are the essays, under "Interventions critiques," by Luciano de Maria, Jean Thibaudeau, and Gian Battista Nazzaro. Subsequently cited as *MF*. See also Marizio Calvesi, "Zum Futurismus," in *Futurismus, 1909–1917*, ed. Jurgen Harten and John Matheson (Dusseldorf: Stadtische Kunsthalle, 1974), pages unnumbered; Linda Landis, "Futurists at War," in *The Futurist Imagination: Word + Image in Italian Futurist Painting, Drawing, Collage, and Free-Word Poetry* (New Haven: Yale University Art Gallery, 1983), pp. 60–75; Caroline Tisdall and Angelo Bozzolla, "Futurism and Fascism," in *Futurism* (London: Thames and Hudson, 1977), chap. 11, pp. 200–209; R. W. Flint, "Introduction," *S* 3–36.

Giovanni Lista's introduction, "Un Siècle futuriste," to *Futurisme: Manifestes, documents, proclamations* (Lausanne: L'Age d'Homme, 1973), pp. 15–79, contains a very balanced discussion of the political problem; see esp. pp. 22–33. This anthology also contains key documents by Antonio Gramsci; see pp. 428–30. Subsequently cited as *F*.

(2) The relationship of Russian Futurism to Soviet politics is discussed in various essays collected in *The Avant-Garde in Russia, 1910–1930: New Perspectives*, ed. Stephanie Barron and Maurice Tuchman (Cambridge, Mass.: MIT Press, 1980). The suppression of the avant-garde poets and painters, detailed in this book, is questioned in a recent Marxist critique by Benjamin Buchloch, "From Faktura to Factography," *October* 30 (Fall 1984):83–120. Buchloch argues that Constructivist aesthetic (the new architecture, indus-

trial design, film, and especially photomontage) represented the adaptation of the earlier "Modernist" ideals to the needs of the new proletarian audience. How and why the Stalinist regime was then able to subvert these new modes of production is, however, not persuasively demonstrated.

49. Robert C. Tucker, *Philosophy and Myth in Karl Marx*, 2d ed. (Cambridge: Cambridge University Press, 1972), pp. 157–58.

50. Matei Calinescu, "Literature and Politics," in *Interrelations of Literature*, ed. Jean-Pierre Barricelli and Joseph Gibaldi (New York: Modern Language Association of America, 1982), p. 131. I am indebted to this seminal essay and to Calinescu's valuable bibliography (pp. 123–49).

51. The *Corriere Universitario* article, written while Gramsci was still a student, is reproduced in *SCW* 48–49. For a commentary, see Jean Thibaudeau, "Le Futurisme dans les écrits de Gramsci," in *MF* 115–21.

52. See esp. Lista, "Marinetti et le futurisme politique," in *MF* 11–28.

53. The *Political Program of Futurism* of October 1913, published in *Lacerba* on 15 October, is reproduced in German in Harten and Matheson, *Futurismus, 1909–1917*, pages unnumbered. See also Tisdall and Bozzola, *Futurism*, pp. 203–4.

54. Germano Celant, "Futurism as Mass Avant-Garde," trans. John Shepley, in *Futurism and the International Avant-Garde*, ed. Anne d'Harnoncourt (Philadelphia: Philadelphia Museum of Art, 1980–81), pp. 35–36.

55. Umberto Boccioni, *Gli scritti editi e inediti* (Milan: Feltrinelli, 1971), pp. 386, 391.

CHAPTER TWO

1. Louis Aragon, *Les Collages* (Paris: Hermann, 1980), p. 51, subsequently cited as *Coll:* "One can imagine a time when the painters will no longer have paint spread on the canvas, when they will no longer even draw. Collage gives us a foretaste of that time."

Pablo Picasso, in conversation with Francoise Gilot and Carlton Lake, *Life with Picasso* (New York: McGraw-Hill, 1964), p. 70.

2. Gino Severini to Raffaele Carrieri, cited by Carrieri in *Futurism* (Milan: Edizione del Milione, 1969), p. 117.

3. Gregory L. Ulmer, "The Object of Post-Criticism," in *The Anti-Aesthetic: Essays on Postmodern Culture*, ed. Hal Foster (Port Townsend, Wash.: Bay Press, 1983), p. 84. Subsequently cited as *AA*. Cf. Robert Rosenblum, *Cubism and Twentieth-Century Art*, rev. ed. (New York: Harry N. Abrams, 1976), p. 67.

4. See Rosenblum, *Cubism and Twentieth-Century Art*, pp. 44–46, 67–91; Pierre Daix, *Picasso: The Cubist Years, 1907–1916: A Catalogue Raisonné of the Paintings and Related Works* (Boston: New York Graphic Society, 1979), pp. 94–148; William C. Seitz, *The Art of Assemblage* (New York: Museum of Modern Art, 1968), pp. 9–25; Erika Billeter, "Collage et montage dans les arts plastiques," in *Collage et montage au théâtre et dans les autres arts durant les années vingt*, ed. D. Balbet (Lausanne, Switzerland: L'Age

d'Homme, 1978), pp. 19–23; Harriet Janis and Rudi Blesh, *Collage, Personalities, Concepts, Techniques* (Philadelphia: Chilton Book Co., 1967), pp. 20–21; Herta Wescher, *Collage* (New York: Harry N. Abrams, 1968), pp. 20–29.

5. In *Art of Assemblage*, William C. Seitz argues that the term *collage* is not broad enough to cover the diversity of modern composite art; he adopts the term *assemblage* instead as a "generic concept that would include all forms of composite art and modes of juxtaposition. In both French and English, 'assemblage' denotes 'the fitting together of parts and pieces,' and can apply to both flat and three-dimensional forms" (p. 150). In talking about literary texts, however, I still think *collage* is the better term because any poem or novel could be called an assemblage in the sense of "the fitting together of parts and pieces."

The relationship of *collage* to *montage* is more problematic. It is customary to distinguish between collage and montage: the former refers, of course, to spatial relationships, the latter to temporal; the former to static objects, the latter, originally a film term, to things in motion. Accordingly, *collage* is generally used when referring to the visual arts; *montage*, to the verbal. Again, Jean-Jacques Thomas argues, in "Collage/Space/Montage," in *Collage*, ed. Jeanine Parisier Plottel (New York: New York Literary Forum, 1983), pp. 79–102, that "At the level of principles, collage is characterized by the explicit and deliberate presentation of the heterogeneous nature of diverse components, while montage aims at the integration of the diverse combinatory constituents and, as such, provides unity" (p. 85).

While it is true that montage stresses continuity whereas collage emphasizes fragmentation, it can also be argued that collage and montage are two sides of the same coin, in view of the fact that the artistic process involved is really the same. As D. Balbet puts it in the introduction to *Collage et montage au théâtre*, "Unquestionably, the boundaries between collage and montage are not very precise. Certainly the techniques differ. . . . But it is also true that a collage can be a montage and a montage a collage" (p. 13). Or as Gregory L. Ulmer says, " 'Collage' is the transfer of materials from one context to another, and 'montage' is the 'dissemination' of these borrowings through the new setting" (*AA* 84). My own sense is that *collage* is the master term, montage techniques being an offshoot of early collage practice.

6. See Seitz, *Art of Assemblage*, p. 150.

7. The background of collage in folk art is well documented in Wescher, *Collage*, chap. 1 *passim;* and in Janis and Blesh, *Collage*, chap. 1.

8. Max Ernst, "Au delà de la peinture" (1936), in *Ecritures* (Paris: Gallimard, 1970), p. 256.

9. Group *Mu*, eds., *Collages, Revue d'Esthétique*, nos. 3–4 (Paris: Union Générale d'Editions, 1978), pp. 34–35. Subsequently cited as *Mu*. The passage in question is translated by Gregory L. Ulmer (AA 88).

10. Louis Aragon, "Collage dans le roman et dans le film" (1965), in *Coll* 119.

11. The most thorough and detailed history of this and related collages is to be found in Daix, *Picasso*, especially pp. 94–128. *Still Life with Violin and Fruit* is catalog no. 530 (p. 290).

12. Rosalind Krauss, "In the Name of Picasso," *October* 16 (Spring 1981): 15; reprinted idem, *The Originality of the Avant-Garde and Other Modernist Myths* (Cambridge and London: MIT Press, 1985), p. 33. Subsequently cited in the text as *OAG*. I owe a great deal to this important essay, written in reponse to some of Pierre Daix's assumptions, but more especially in response to Robert Rosenblum, "Picasso and the Typography of Cubism" (1973), in *Picasso in Retrospect*, ed. Roland Penrose and John Golding (New York: Harper and Row, 1980), pp. 33–47.

13. *OAG* 35. Cf. Michel Décaudin, "Collage, montage, et citation en poésie," in Balbet, *Collage et montage au théâtre*, pp. 31–32.

14. Guillaume Apollinaire, *Les Peintres cubistes: Méditations esthétiques*, ed. L. C. Breunig and J.-Cl. Chevalier (Paris: Hermann, 1980), pp. 76–77. The passage in question also appeared separately in a review of Picasso exhibitions in *Montjoie*, 14 March 1913. For this version in English, see *Apollinaire on Art: Essays and Reviews, 1902–1918, by Guillaume Apollinare*, ed. LeRoy C. Breunig, trans. Susan Suleiman (New York: Viking Press, 1960), p. 279.

15. Note that the Group *Mu* critics assume that collage inevitably integrates its objects and preformed messages "dans une création nouvelle pour produire une totalité originale" ("in a new creation in order to produce an original totality"), *Mu* 13. See Ulmer, in *AA* 84.

16. Marianne W. Martin, *Futurist Art and Theory, 1919–1925* (Oxford: Clarendon Press, 1968), p. xxix.

17. Boccioni et al. "Les Peintres futuristes italiens," in *Archivi del futurismo*, ed. Maria Drudi Gambillo and Teresa Fiori, 2 vols. (Rome: De Luca, 1958–62), 1:104; subsequently cited as *AF*; idem, "The Exhibitors of the Public 1912," in *Futurist Manifestos*, ed. Umbro Apollonio, trans. Robert Brain et al. (New York: Viking Press, 1973), p. 46; subsequently cited as *FM*.

18. *Apollinaire on Art*, p. 255. Less than a year later, Apollinaire published his own Futurist manifesto, *L'Antitradition futuriste* in the Italian *Lacerba*.

19. Apollinaire, *Les Peintres cubistes*, p. 80; *Apollinaire on Art*, p. 281.

20. See Carrieri, *Futurism*, pp. 77–78.

21. Rosalind Krauss, *Passages in Sculpture* (New York: Viking Press, 1977), p. 42.

22. *The Technical Manifesto of Futurist Literature*, dated 11 May 1912, appeared in extract form in *L'Intransigéant* (Paris) on 7 July, before it was published in Italy, in *La Gazzetta di Biella* on 12 October. A German translation appeared in *Der Sturm*, no. 133 (October 1912). The text used here is in *Opere di F. T. Marinetti*, vol. 2: *Teoria e invenzione futurista*, ed. Luciano De Maria (Milan: Mondadori, 1968), pp. 40–48; subsequently cited as *TIF*. For

an English translation, see Marinetti, *Selected Writings*, ed. R. W. Flint (New York: Farrar, Straus and Giroux, 1972), pp. 85–98; subsequently cited as *S*.

Destruction of Syntax—Wireless Imagination—Words-in-Freedom appeared in *Lacerba*, no. 12 (15 June 1913). The French version was first read by Marinetti in the course of a lecture at the Galerie La Boétie, 22 June 1913; its contents were widely reported in the Paris newspapers. An English translation appeared in *Poetry and Drama*, ed. Harold Monro, 3 September 1913. See *TIF* 57–70; *FM* 95–106.

23. See David Antin, "Some Questions about Modernism," *Occident* 8 (Spring 1974):21–22; cf. idem, "Modernism and Postmodernism: Approaching the Present in American Poetry," *boundary 2* 1 (Fall 1972):106.

24. *Zang Tumb Tuuum*, with the subtitle *Parole in libertà*, is reproduced with the original print format and title page in *TIF* 563–699. Extracts were published in French and English journals soon after its publication, but there is no complete English translation.

25. For discussion of the "free-word paintings," see Carrieri, *Futurism*, pp. 79–98; Caroline Tisdall and Angelo Bozzolla, *Futurism* (London: Thames and Hudson, 1977), pp. 93–101; Antonella Ansani, "Words-in-Freedom and Cangiullo's Dancing Letters," trans. Darby Tench, in *The Futurist Imagination: Word + Image in Italian Futurist Painting, Drawing, Collage, and Free-Word Poetry*, ed. Anne Coffin Hanson (New Haven: Yale University Art Gallery, 1983), pp. 50–59.

26. Carlo Carrà to Gino Severini, 11 July 1914, in *AF* 1:341.

27. The collage first appeared as an illustration in *Lacerba* (1 August 1914) with the title *Festa pattrioticà—Poèma pittorico* (Patriotic celebration—Poem-painting). See Alfonso Gatto, "Il Creato di Carrà," in *Carrà, tutta l'opera pittorica*, by Massimo Carrà (Milan: Edizioni dell' Annunciata, 1967), pp. 1, 23–24, 259.

28. Max Kozloff, *Cubism/Futurism* (New York: Harper and Row, 1973), p. 209.

29. Benedikt Livshits, *The One-and-a-Half-Eyed Archer*, ed. and trans. John E. Bowlt (Newtonville, Mass.: Oriental Research Partners, 1977), p. 191. Subsequently cited as *OHA*.

30. *OHA* 190; Cf. Vladimir Markov, *Russian Futurism: History and Doctrine* (Berkeley and Los Angeles: University of California press, 1968), p. 150.

31. On the relationship of Russian to Italian Futurism, see the following: Markov, *Russian Futurism*, pp. 147–63; Giovanni Lista, "Un Siècle futuriste," in *Futurisme: Manifestes, documents, proclamations* (Lausanne: L'Age d'Homme, 1973), pp. 15–84; Charlotte Douglas, "The New Russian Art and Italian Futurism," *Art Journal* 34, no. 3 (Spring 1975):229–39; Ellen Chances, "Mayakovsky's 'vse-taki' and Boccioni: A Case Study in Comparable Technique," in *The Ardis Anthology of Russian Futurism*, ed. Ellendea Proffer and Carl R. Proffer (Ann Arbor: Ardis, 1980), pp. 345–52.

32. See Andrei B. Nakov, "Prologue," in *Ecrits*, by Kasimir Malevich,

ed. Andrei B. Nakov, trans. Andrée Robel-Chicurel (Paris: Editions Champ Libre, 1975), pp. 29–73; Susan P. Compton, "Malevich's Suprematism: The Higher Intuition," *Burlington Magazine* 118 (1976):577–85; Charlotte Douglas, "Birth of a 'Royal Infant': Malevich and 'Victory over the Sun,'" *Art in America* 62 (March/April 1974):45–51; and especially W. Sherwin Simmons, "Kasimir Malevich's 'Black Square': The Transformed Self," part 1: "Cubism and the Illusionistic Portrait," *Arts Magazine* 53, no. 2 (October 1978):116–25. Part 2: "The New Laws of Transrationalism" (November 1978):130–41; and part 3: "The Icon Unmasked" (December 1978): 126–41, complete this important story.

33. Donald Judd, "Malevich: Independent Form, Color, Surface," *Art in America* 62 (March/April 1974):56.

34. See Simmons, "Cubism and the Illusionistic Portrait," pp. 116–24, for a detailed account of Malevich's evolving response to the Picassos in the Shchukin collection in Moscow. But for a counterargument, see Rainer Crone, "Malevich and Khlebnikov: Suprematism Reinterpreted," *Artforum* (December 1978): 38–45. Crone argues that the decisive influence on the Suprematist paintings was that of Khlebnikov's poetry.

35. F. T. Malevich, "On New Systems in Art" (1919), in *Essays on Art, 1915–1933*, ed. Troels Andersen, trans. Xenia Glowacki-Prus and Arnold McMillin, 2 vols. (Copenhagen: Borgen, 1968), 1:98, 101. Subsequently cited as *EA*.

36. W. Sherwin Simmons argues that "the pink rectangle floating in the upper part of the composition . . . seems to replace the objective face of the woman. . . . It appears that Malevich wanted to draw an analogy between the pink 'face' of the plane and the face of the woman, for on the left a small collaged photograph of a man's head presses its cheek against the pink rectangle while on the right another photograph of a man dances 'cheek to cheek' with the form" (p. 121). This is, I think, to allegorize the painting, and I would agree with Donald Judd that the pink plane is to be "read" as a pink plane.

37. According to the notes in *EA* 2:160–61, *New Art* (*Novoye iskusstvo*) consisted of a series of lectures, given in 1928–29. The original manuscript was lost, and the articles have been translated from Ukrainian via Russian. The original illustrations have been recovered and reproduced here; their main sources are Apollinaire's *Les Peintres cubistes* and Boccioni's *Pittura Scultura futuriste* (1924).

38. See Nakov, "Prologue," in Malevich, *Ecrits*, pp. 59–61.

39. Guy Davenport, *Tatlin! Six Stories* (New York: Charles Scribner's Sons, 1974), pp. 22–23.

40. Margit Rowell, "Vladimir Tatlin: Form/*Faktura*," *October* 7 (Winter 1978):83–108.

41. See Gilot and Lake, *Life with Picasso*, p. 70.

42. See Rowell, "Tatlin," p. 97; John Milner, *Vladimir Tatlin and the Russian Avant-Garde* (New Haven and London: Yale University Press, 1983), pp. 91–98. Milner's illustrations exemplify the various kinds of reliefs.

43. See Rowill, "Tatlin," p. 97.

44. In the West today, Tatlin's counterreliefs and most of the wall reliefs are known only through photographs, drawings, and reconstructions. See Stephanie Barron and Maurice Tuchman, eds., *The Avant-Garde in Russia, 1910–1930: New Perspectives* (Los Angeles County Museum of Art, 1980), p. 255.

45. Krauss, *Passages in Sculpture*, p. 45.

46. Charlotte Douglas, "0−10 Exhibition," in Barron and Tuchman, *Avant-Garde in Russia*, p. 37.

47. Martyn Chalk, "Missing, Presumed Destroyed: Seven Reconstructions of Lost Works by V. E. Tatlin," in *Configurations, 1910–1940*, Exhibition Catalog (London: Annely Juda Fine Art Gallery).

48. On music collage, see, for example, Jon D. Green, "Music in Literature: Arthur Schnitzler's 'Fraülein Else,'" in Plottel, *Collage*, pp. 141−66.

49. W. B. Yeats, ed., *The Oxford Book of Modern Verse, 1892–1935* (Oxford: Clarendon Press, 1936), pp. xxiv−xxvi.

50. See Reuben Brower, *The Fields of Light: An Experiment in Critical Reading* (New York: Oxford University Press, 1951), *passim*. The quoted phrases are chapter titles; see p. ix. Brower's book is a classic example of applied New Criticism and, throughout the fifties and early sixties, was used in countless university classrooms.

51. Walter Benjamin, "The Work of Art in an Age of Mechanical Reproduction," in *Illuminations*, by Walter Benjamin, ed. Hannah Arendt, trans. Harry Zohn (New York: Schocken Books, 1969), p. 221, subsequently cited as *Ill*; idem, "Das Kunstwerk im Zeitalter seiner technischen Reproduzierbarkeit," 2d ed., in *Gesammelte Schriften*, by Walter Benjamin, ed. Rolf Tiedemann and Hermann Schweppenhauser (Frankfurt: Suhrkamp), p. 477. In the German, the passage in question is italicized. Subsequently cited as *GS*.

52. Fredric Jameson, *Fables of Aggression: Wyndham Lewis, the Modernist as Fascist* (Berkeley and Los Angeles: University of California Press, 1979), p. 73. See also Craig Owens, "Analysis Logical and Ideological," review of *The Originality of the Avant-Garde and Other Modernist Myths*, by Rosalind Krauss, *Art in America* 73 (May 1985):31. Owens writes: "collage . . . represents the moment at which the logic of consumption definitely entered the work of art"; it "participate[s] fully in modernism's fetishism of the code, its fascination with the differential, the systematic, the artificial, the factitious."

53. Gertrude Stein, *Picasso* (1938), in *Gertrude Stein on Picasso*, ed. Edward Burns (New York: Liveright, 1970), pp. 18−19.

54. Charlotte Douglas, "Views from the New World: A. Kruchenykh and K. Malevich: Theory and Painting," in *Ardis Anthology of Russian Futurism*, p. 353.

55. The phrase is Raymond Bellour's in "Pourquoi écrire, poète?" in *L'Année 1913: Les formes esthétiques de l'oeuvre d'art à la veille de la première guerre mondiale*, ed. L. Brion-Guerry (Paris: Klincksieck, 1971), 1:586.

56. Jacques Derrida, "Limited Inc," in *Glyph 2: Johns Hopkins Tex-*

tual Studies (Baltimore: Johns Hopkins University Press, 1977), p. 197. See Gregory L. Ulmer, *Applied Grammatology, Post(e)-Pedagogy from Jacques Derrida to Joseph Beuys* (Baltimore and London: Johns Hopkins University Press, 1985), pp. 58–59.

57. In *Applied Grammatology,* Ulmer carries further the argument in *The Anti-Aesthetic* that advanced criticism has taken over the collage modes of early-twentieth-century art. Ulmer now suggests that grammatology is itself the "differance" of collage carried to its logical conclusion. Accordingly, collage, in its new guise as grammatology, is the form our writing takes.

58. Jacques Derrida, "Entre crochets," *Diagraphe* 8 (1976):100. I am indebted to Ulmer for this reference.

59. Jacques Derrida, *Glas* (Paris: Editions Denoël, 1974), p. 188. The translation is Ulmer's; see *Applied Grammatology,* p. 59.

60. Charles Bernstein, "Introduction," in "Language Sampler," *Paris Review* (Winter 1982):78.

61. Hans Richter, *Dada: Art and Anti-Art,* trans. from the German by David Britt (1965; reprint, New York and Toronto: Oxford University Press, 1978), pp. 152–53. See also Seitz, *Art of Assemblage,* p. 50; William S. Rubin, *Dada, Surrealism, and Their Heritage* (New York: Museum of Modern Art, 1968), p. 53; and, for a superb analysis of the mode of Schwitterian collage, Antin, *Occident,* pp. 22–25.

CHAPTER THREE

1. Umberto Boccioni et al., *Futurist Painting: Technical Manifesto 1910,* in *Futurist Manifestos,* ed. Umbro Apollonio, trans. Robert Brain et al., Documents of Twentieth-Century Art (New York: Viking Press, 1973), p. 28. Subsequently cited as *FM.*

Bruno Corradini and Emilio Settimelli, *Weights, Measures, and Prices of Artistic Genius—Futurist Manifesto 1914,* in *FM* 146.

F. T. Marinetti, Emilio Settimelli, and Bruno Corra, *The Futurist Synthetic Theatre 1915,* in *FM* 193.

2. According to Giovanni Lista, the manifesto in question was *Peinture de la lumière, de la profondeur, du dynamisme;* it remained unpublished until 1963, when Severini included it in his *Témoignages: 50 ans de réflexion* (Rome: Editions Art Moderne, 1963), pp. 30–31. See Lista, *Futurisme: Manifestes, documents, proclamations* (Lausanne: L'Age d'Homme, 1973), p. 18. Subsequently cited as *F.* See also Gino Severini, *La Vita di un pittore* (1946; rpt. Rome: Feltrinelli, 1983), pp. 155–56.

Note that the Futurists, especially Marinetti and Severini, wrote alternately in Italian and French as the mood and audience suited them. Citations are to the language originally used.

3. This letter is reproduced in *Archivi del futurismo,* ed. Maria Drudi Gambillo and Teresa Fiori, 2 vols. (Rome: De Luca, 1958–62), 1:294–95. Subsequently cited as *AF.* Translation, unless otherwise noted, is mine.

4. Lista dates this letter between 1909 and the first half of 1910. See *F* 18–19.

5. A brilliant "performance-lecture" on the *Communist Manifesto* as a poem (or at least a work more "poetic" than Bertolt Brecht's hexameter version of it), was delivered by David Antin at the Humanities Institute, Berkeley, California, November 1984.

6. See Bonner Mitchell, ed., *Les Manifestes littéraires de la belle époque, 1886–1914: Anthologie critique* (Paris: Editions Seghers, 1966), p. 103.

7. Giovanni Lista, ed., *Marinetti et le futurisme: Etudes, documents, iconographie*, Cahiers des Avant-Gardes (Lausanne: Editions L'Age d'Homme, 1977), pp. 32–33.

8. On Marinetti's sources, see the following: Giovanni Lista, "Un Siècle futuriste," in *F* 14–79; Luciano de Maria, "Introduzione," in *Opere di F. T. Marinetti*, vol. 2: *Teoria e invenzione futurista*, ed. Luciano de Maria (Milan: Mondadori, 1968), pp. xix–xxviii; this text is subsequently cited as *TIF*; R. W. Flint, "Introduction," in *Selected Writings*, by F. T. Marinetti, ed. R. W. Flint, trans. R. W. Flint and Arthur A. Coppotelli (New York: Farrar, Straus and Giroux, 1972), pp. 3–36; this text is subsequently cited as *S*; Caroline Tisdall and Angelo Bozzola, *Futurism* (London: Thames and Hudson, 1977), pp. 7–29.

For studies of Marinetti's specific debts to Nietzsche, Bergson et al., see Jean-Pierre Andreoli–de Villers, *Futurism and the Arts: A Bibliography, 1959–73* (Toronto and Buffalo: University of Toronto Press, 1975).

9. See Jean Moréas, *Le Symbolisme*, in *Le Figaro*, September 1886; reprinted in Mitchell, *Manifestes littéraires*, pp. 28–29.

10. Cited by Peter Selz in *German Expressionist Painting*, ed. Peter Selz (1957; reprint, Berkeley and Los Angeles: University of California Press, 1974), p. 95. Cf. Lothar-Günther Buchheim, *Der Blaue Reiter und die "Neue Künstlervereinigung München"* (Karlsruhe: Buchheim Verlag Feldafing, 1959), pp. 58–59.

11. *The Germ: Thoughts toward Nature in Poetry, Literature, and Art* (London: Aylott and Jones, January 1850), back cover.

12. For an account of this "Futurist evening," see Tisdall and Bozzola, *Futurism*, p. 91.

13. Jean Schlumberger, *Considerations* (1 February 1909), in Mitchell, *Manifestes littéraires*, p. 93.

14. R. Canudo, *L'Art cerebriste* (9 February 1914), in ibid., p. 173.

15. Although first published in French, in *Le Figaro*, the most authoritative version of Marinetti's text is the Italian, included in *TIF* 7–13. The opening reads:

> Avevamo vegliato tutta la notte—i miei amici ed io—sotto lampade di moschea dalle cupole di ottone traforato, stellate come le nostre anime, perché come queste irradiate dal chiuso fulgòre di un cuore elettrico. Avevamo lungamente calpestata su opulenti tappeti orientali la nostra atavica accidia, discutendo davanti ai confini estremi della logica ed annerendo molta carta di frenetiche scritture (*TIF* 7).

16. See *F* 86.

17. See *TIF* xx–xxiii. The de Maria introduction is reproduced in French in *MF*; see pp. 80–81.

18. See D. H. Lawrence to Edward Garnett, 5 June 1914, in *The Cambridge Edition of the Letters of D. H. Lawrence*, vol. 2: *1913–16*, ed. George J. Zytaruk and James T. Boulton (Cambridge: Cambridge University Press, 1981), pp. 182–83.

19. Charles Olson, "Projective Verse," in *Selected Writings of Charles Olson*, ed. Robert Creeley (New York: New Directions, 1966), p. 17.

20. See Pär Bergman, *"Modernolatrià" et "Simultaneità": Recherches sur deux tendances dans l'avant-garde littéraire en Italie et en France à la veille de la prémière guerre mondiale* (Stockholm: Bonniers, 1962), p. 64.

21. See Adrian Marino, "Le Manifeste," in *Les Avant-gardes littéraires au xxᵉ siècle*, ed. Jean Weisgerber for Le Centre d'étude des avant-gardes littéraires de l'Université de Bruxelles, 2 vols. (Budapest: Akademiai Kiado, 1984), 2:825–834. Cf. Judy Rawson, "Futurism," in *Modernism*, ed. Malcolm Bradbury and James McFarlane (Middlesex: Penguin Books, 1978), p. 249.

22. See Tisdall and Bozzola, *Futurism*, p. 31.

23. Franz Marc, in *The Blaue Reiter Almanac*, ed. Wassily Kandinsky and Franz Marc, New Documentary edition, ed. Klaus Lankheit, trans. Henning Falkenstein (New York: Viking Press, 1974), p. 252. Subsequently cited as *BR*. For the original German, see *Der Blaue Reiter*, ed. Wassily Kandinsky and Franz Marc, Dokumentarische Neuausgabe von Klaus Lankheit (Munich: R. Pier, 1965); subsequently cited as *DBR*. Marc's prospectus opens as follows: "Die Kunst geht heute Wege, von denen unsere Väter sich nichts träumen liessen; man steht vor den neuen Werken wie im Traum und hört die apokalyptischen Reiter in den Luften; man fühlt eine künstlerische Spannung über ganz Europa" (*DBR* 316).

24. See *DBR* 21–27; and *BR* 55–60. The catalog of illustrations is on p. 268 of *BR*. The two editions differ: in the German (5) and (6) follow the completed text; in the English, they are incorporated into it.

25. Arthur A. Cohen, "The Typographic Revolution: Antecedents and Legacy of Dada Graphic Design," in *Dada Spectrum: The Dialectics of Revolt*, ed. Stephen Foster and Rudolf Kuenzli (Madison, Wis.: Coda Press, 1979), p. 76. See also Jacques Damase, ed., *La Revolution typographique depuis Stephane Mallarmé* (Geneva: Galerie Motte, 1966), pp. xxiii–xxv, 7–13.

26. It is customary to regard the Mallarmé of *Un Coup de dès* (first published in 1897) as the father of the "typographical revolution": see Damase, *Revolution*, pp. lx–lxii; Cohen, *Dada Spectrum*, pp. 76–78; and especially Gerald L. Bruns, *Modern Poetry and the Idea of Language* (New Haven and London: Yale University Press, 1974), pp. 101–17. Bruns writes: "in *Un Coup de dès* typography replaces syntax as a way of establishing relationships among words—that is, as a way of organizing the material of the poem. Syntactical structures are everywhere to be found, but they are radically diffused

by the way the words are positioned on the page" (p. 115). But he also implies that here the thrust is to move from the world of things to a world of pure abstraction, of transcendent Idea, and so Mallarmé's typographical experiment can also be seen as the opposite of Marinetti's. See, on the point, Wendy Steiner, "Res Poetica: The Problematics of the Concrete Program," *New Literary History* 12 (Spring 1981):537.

27. The Italian version of the manifesto is in *TIF* 70–78; the English, in *FM* 126–31. But for the original typography, see the French version in *MF*, unpagined photosection.

28. See *F* 122–24.

29. In reviewing early Futurist exhibitions in Paris, Apollinaire typically made comments like the following:

> Futurism, in my opinion, is an Italian imitation of the two schools of French painting that have succeeded each other over the past few years: fauvism and cubism. . . . Neither Boccioni or Severini is devoid of talent. However, they have not fully understood the cubists' painting and their misunderstanding has led them to establish in Italy a kind of art of fragmentation, a popular, flashy art. (*L'Intermédiare des chercheurs et des curieux*, 10 October 1912)

See *Apollinaire on Art: Essays and Reviews, 1902–1918*, ed. LeRoy C. Breunig, Documents of Twentieth-Century Art (New York: Viking Press, 1972), pp. 255–56. See also pp. 199–205.

30. Cited by Lista in *F* 125:

> Le futurisme a vécu! C'est M. Guillaume Apollinaire, le poète d'*Alcools*, le romancier d'*Hérésiarque et Cie* qui lui a porté le coup fatal en signant le manifeste qu'on va lire. Il faillait trouver ceci: être plus futuriste que Marinetti! M. Guillaume Apollinaire y a réussi, pour notre joie. Voici le document dont nous regrettons de ne pouvoir respecter entièrement l'originalité typographique.

31. Apollinaire's reviews of 1913–14 are much friendlier than the one cited in note 29. See, for example, his comments on Boccioni's sculpture made on 21 June 1913 in *L'Intransigeant*, in *Apollinaire on Art*, pp. 320–21.

32. See *F* 122–24.

33. Guillaume Apollinaire, *Calligrammes: Poems of Peace and War (1913–1916)*, trans. Anne Hyde Greet, introduction by S. I. Lockerbie, notes by Anne Hyde Greet and S. I. Lockerbie (Berkeley and Los Angeles: University of California Press, 1980), p. 62. For the bilingual text of the whole poem, see pp. 58–65.

34. See Antonella Ansani, "Words-in-Freedom and Cangiullo's Dancing Letters," in *The Futurist Imagination: Word + Image in Italian Futurist Painting, Drawing, Collage, and Free-Word Poetry*, ed. Anne Coffin Hanson (New Haven: Yale University Art Gallery, 1983), pp. 50–59. As the title of this collection suggests, all six essays in the catalog have to do with words-in-freedom and collage. The illustrations are especially helpful.

35. Gerald A. Bruns, *Inventions: Writing, Textuality, and Understanding in Literary History* (New Haven and London: Yale University Press, 1982), p. 145.

36. Cf. T. S. Eliot, "Preludes II": "One thinks of all the hands / That are raising dingy shades / In a thousand furnished rooms."

37. Cf. D. H. Lawrence, "Surgery for the Novel—or a Bomb," in *Selected Literary Criticism*, ed. Anthony Beal (New York: Viking Press, 1966), pp. 17–18: "Always the same sort of baking-powder gas to make you rise: the soda counteracting the cream of tartar, and the tartar counteracted by the soda. Sheik heroines, duly whipped, wildly adored. Babbitts with solid fortunes, weeping from self-pity. Winter-Comes heroes as good as pie, hauled off to jail."

38. Michael Fried, "Art and Objecthood," *Artforum*, June 1967; reprinted in *Minimal Art: A Critical Anthology*, ed. Gregory Batcock (New York: E. P. Dutton, 1968), pp. 139, 141. Subsequently cited as *AO*. See also Fried, *Absorption and Theatricality: Painting and Beholder in the Age of Diderot* (Berkeley, Los Angeles, and London: University of California Press, 1980), pp. 92–105, and *passim*.

39. Howard N. Fox, "Introduction," in *Metaphor: New Projects of Contemporary Sculptors* (Washington, D.C.: Smithsonian Institution Press, 1982), p. 15. Subsequently cited as *M*. Cf. David Antin, "Exclusionary Tactics," review of *Absorption and Theatricality* by Michael Fried, *Art in America* 70, no. 4 (April 1982):35–41.

40. Tristan Tzara, *Sept Manifestes Dada* (Utrecht: Jean-Jacques Pauvert, 1963), pp. 9–12. Subsequently cited as *SM*. Ralph Manheim has translated the manifestos into English: see "Seven Dada Manifestos," in *The Dada Painters and Poets*, ed. Robert Motherwell (New York: George Wittenborn, Inc., 1967), pp. 75–98. Subsequently cited as *DPP*.

41. *SM* 13, 24; *DPP* 76, 79:

Pour lancer un manifeste il faut vouloir: A.B.C., foudroyer contre 1, 2, 3. . . .

. . . tout de même chacun a dansé d'après son boumboum personnel, et qu'il a raison pour son boum boum.

42. Blaise Cendrars, "Contrastes," *Dix-neuf Poèmes élastiques*, in *Oeuvres complètes*, ed. Raymond Dumay and Nino Frank, 16 vols. (Paris: Le Club français du livre, 1968–71), 1:60.

CHAPTER FOUR

1. Kasimir Malevich, *Ot kubizma i futurizma k suprematizmu: Novyi zhivopisnyi realizm*, 3d ed. (Moscow, 1916), p. 1. This little (31 pp.) book, which I was able to consult in the British Library in London, is now extremely rare, and I have not been able to locate later Russian editions; accordingly I cite in English (or French) from here on.

The most accessible English translation is that of John E. Bowlt in *Russian Art of the Avant-Garde: Theory and Criticism, 1902–1934*, ed. and trans. John E. Bowlt (New York: Viking Press, 1976), pp. 116–35. This translation of Malevich's essay is subsequently cited as *CFS*; Bowlt is cited as *RA*.

For another English translation, see Malevich, *Essays on Art, 1915–1933*, 2 vols., ed. Troels Andersen, trans. Xenia Glowacki-Prus and Arnold Mc-Millin (Copenhagen: Bergen, 1968). Subsequently cited as *EA*.

A good French translation is that of Andrée Robel-Chicurel, in Malevich, *Ecrits*, ed. Andrei B. Nakov (Paris: Editions Champ Libre, 1975), pp. 185–212.

2. Benois's statement was made in *Rech'*, 9 January 1916; it is reproduced in Malevich, *Ecrits*, p. 141. Translation mine.

3. See Charlotte Douglas, "0–10 Exhibition," in *The Avant-Garde in Russia, 1910–1930: New Perspectives*, ed. Stephanie Barron and Maurice Tuchman (Cambridge, Mass.: MIT Press, 1980), pp. 34–40.

4. See Umbro Apollonio, ed., *Futurist Manifestos* (New York: Viking Press, 1973), p. 52. Subsequently cited as *FM*. Malevich must have known Boccioni's manifesto, which was translated into Russian shortly after it was written; see Charlotte Douglas, "The New Russian Art and Italian Futurism," *Art Journal* 34, no. 3 (Spring 1975): 229–39.

5. John Cage, "On Robert Rauschenberg, Artist, and His Work," in *Silence: Lectures and Writings* (Middletown, Conn.: Wesleyan University Press, 1961), p. 100.

6. Sarah Pratt has pointed out that Malevich's notion of "shedding the hardening skin" is a secular version of Tolstoy's concept of shedding the layers of corruption to get to the kernel of God within the human being. The aestheticizing of Russian Orthodox theological doctrine is common in the Futurist period.

7. P. D. Ouspensky, *The Fourth Dimension* (1909) and his *Tertium Organum* (1911) were studied closely by Malevich and his fellow artists and poets. See, p. 172ff and notes 25 and 26.

8. There are four texts thus titled, all reprinted in the bilingual Russian-German edition, Vladimir Markov, ed., *Manifesti y programmy russkikh futuristov / Die Manifeste und Programmschriften der Russischen Futuristen*, Slavische Propyläen (Munich: Wilhelm Fink Verlag, 1967). This text is subsequently cited as *MPF*. The texts are: (1) Kruchenykh and Khlebnikov, *Slovo kak takovoe* (1913), *MPF* 53–58; (2) a fragment called *Slovo kak takovoe*, published by Kruchenykh in the *Unedited Khlebnikov* (1930), *MPF* 59–60; (3) *Bukva kak takovaya*, another fragment of 1913, published by Kruchenykh in the *Unedited Khlebnikov* (1930), *MPF* 60–61; and (4) *Declaratsia slova kak takovogo*, a pamphlet published by Kruchenykh in 1913, *MPF* 63–73.

For a French translation of all four texts, see L. Brion-Guerry, ed., *L'Année 1913: Les formes esthétiques de l'oeuvre d'art à la veille de la première guerre mondiale*, vol. 3: *Manifestes et temoignages* (Paris: Editions Klincsieck, 1971–73), pp. 360–371. Jean-Claude Marcadé, the translator of these manifestos, also provides a good preface.

An English translation of *The Letter as Such* is found in Khlebnikov, *Snake Train: Poetry and Prose*, ed. and trans. Gary Kern (Ann Arbor: Ardis, 1976), pp. 199–200. All translations of Khlebnikov in this chapter are

found in this edition, subsequently cited as *ST. The Letter as Such* also appears in English translation in Gerald Janecek, *The Look of Russian Literature: Avant-Garde Visual Experiments, 1900–1930* (Princeton: Princeton University Press, 1984), pp. 90–91, subsequently cited as *LRL;* and in Velimir Khlebnikov, *The King of Time: Poems, Fictions, Visions of the Future,* ed. Charlotte Douglas, trans. Paul Schmidt (Cambridge, Mass.: Harvard University Press, 1985), pp. 121–22. Subsequently cited as *KT.*

A small part of the first text and almost all of the fourth are reproduced in English in Vladimir Markov, *Russian Futurism: A History* (Berkeley and Los Angeles: University of California Press, 1968), pp. 129–32. This is still the most thorough and important work on the field in English, and my debt to it is profound. Subsequently cited as *RF.*

9. The drawing called *Reaper* is still essentially Cubist: the faces, arms, legs, and cloaked bodies of the two reapers as well as their scythes and sickles are reduced to geometric planes—squares, circles, cones—but the subordination of figure to geometric grid and the presence of purely compositional elements (i.e., lines and curves that extend beyond the outlined forms themselves) pave the way for the Suprematism of 1915. *Reaper* is reproduced in Susan P. Compton, *The World Backwards: Russian Futurist Books, 1912–1916* (London: British Library, 1978), p. 108. Subsequently cited as *WB.*

10. The word *zaum* is derived from *za,* meaning "beyond," and *um,* meaning "mind" or "reason"; it is an abbreviation of *zaumnyi iazyk* (transrational language) and an extension of *zaumnaia mysi* (transrational thought). See *RF* 44–45, 129–31; *LRL* 83–89; Gail Harrison Roman, "The Ins and Outs of Russian Avant-Garde Books: A History, 1910–1932," in Barron and Tuchman, *Avant-Garde in Russia,* pp. 102–3. For an interesting distinction between Kruchenykh's *zaum,* as the "privileg[ing] of the outer form of the word," and Khlebnikov's, as the faith in sound as natural meaning, see Peter Steiner, *Russian Formalism: A Metapoetics* (Ithaca and London: Cornell University Press, 1984), pp. 144–50.

11. *RF* 130–31; *MPF* 63–64. The first and third ellipses in this text are Vladimir Markov's, as is the bracketed information about pronunciation.

12. *Pomada (Pomade)* by A. Kruchenykh; illustrated by M. Larionov (Moscow, 1913). This and all other books referred to in this chapter were examined by me in the British Library in the fall of 1981, shortly after the newly acquired collection of Russian Futurist Books had been cataloged. The British Library collection is the basis of Susan P. Compton's important survey in *The World Backwards.* Since the editions were usually very small, and many copies have been lost, they are very hard to come by. The British Library is the primary Western repository. For a descriptive bibliography, see *WB* 125–27. See also the table of references in *LRL* 291–308.

13. The translation is Gerald Janecek's: see *LRL* 268, fig. 63.

14. See Viktor Shklovsky, "Art as Technique," in *Russian Formalist Criticism: Four Essays,* ed. and trans. Lee T. Lemon and Marion J. Reis (Lincoln: University of Nebraska Press, 1965), p. 21.

15. Juri Tynyanov, "On Literary Evolution," in *Readings in Russian Poet-*

ics: Formalist and Structuralist Views, ed. Ladislav Matejka and Krystyna Pomorska (Cambridge, Mass.: MIT Press, 1971), pp. 69, 71.

16. Alexei Kruchenykh, *Slovo kak takovoe*, in *MPF* 55; Jean-Claude Marcadé in Brion-Guerry, *L'Année*, 3:364, in French. I translated this and the following quote, neither of which appear in *RF* or *LRL*.

17. *MPF* 56; Brion-Guerry, *L'Année*, 3:365. Here Kruchenykh is probably satirizing Alexsandr Blok's *Prekrasnaya dama* (Beautiful lady).

18. *ST* 199, with some variation ("typeface" rather than "type") based on *LRL* 90; *MPF* 60. See also *KT* 121.

19. See *WB* 23–44; *RF* 34–40; Gail Harrison Roman in Barron and Tuchman, *Avant Garde in Russia*, pp. 102–5; Edward J. Brown, *Mayakovsky: A Poet in the Revolution* (Princeton: Princeton University Press, 1973), pp. 45–56. In 1928, Kruchenykh explained his own move away from painting toward literature as follows:

> In these years [1910–1911], having a foreboding of the rapid death of painting and its substitution by something different, which subsequently took shape in photo montage, I broke my brushes ahead of time, abandoned my palette and washed my hands in order, with a pure soul, to take up the pen and work for the glory and destruction of Futurism—that farewell literary school which was only then beginning to burn with its final (and brightest) worldwide fire. (*15 Let russkogo futurizma 1912–1927*, Moscow, 1928; cited in English in *LRL* 86)

20. Kruchenykh, born in 1886 to a peasant family near Kherson, began his career as an art teacher in a gymnasium for girls. Khlebnikov, born in 1886 into an ornithologist's family in a village near Astrakhan, was a student of mathematics and biology until 1908, when he came to Petersburg to pursue Slavic studies. Malevich, born 1878, came from the southern Ukraine, where his father worked in a sugar-beet factory. He attended art school in Kursk and entered the Moscow Institute of Painting, Sculpture, and Architecture in 1903.

Natalia Goncharova was unique among Futurists in that she came from the nobility; one of her ancestors, Afanasy Goncharov, had invented a loom large enough to make sails for the new Russian navy founded by Peter the Great; the family had entertained Catharine the Great, and an earlier Natalia Goncharova was married to Pushkin. See Mary Chamot, *Goncharova* (London: Oresko Books, 1979), pp. 7–22.

21. Ilya Zhdanevich and Mikhail Larionov, *Why We Paint Ourselves: A Futurist Manifesto* (1913), in *RA* 80–81.

22. See Lucy Adelman and Michael Compton, "Mathematics in Early Abstract Art," in *Towards a New Art: Essays on the Background to Abstract Art, 1910–1920*, ed. Michael Compton (London: Tate Gallery, 1980), pp. 64–89.

23. *Troe* (*The Three*), by V. Khlebnikov, A. Kruchenykh, E. Guro; illustrated by K. Malevich (1913); on microfiche at the UCLA Research Library, p. 2; cited in English in *WB* 102.

24. See, on this point, Linda Dalrymple Henderson, "Appendix A: The

Question of Cubism and Relativity," in *The Fourth Dimension and Non-Euclidean Geometry in Modern Art* (Princeton: Princeton University Press, 1983), pp. 353–65. Subsequently cited as *FD*. Henderson writes:

> The mistake of art historians dealing with Cubism [or Futurism] and Relativity has been to read back into Cubist literature of 1911 and 1912 the development in physics of a non-Euclidean space-time continuum that was not completed until 1915 or 1916. . . . Einstein emerged as a celebrity only in November 1919, when the findings of an English astronomical expedition to photograph the May 1919 eclipse were announced at the Royal Society in London. Such displacement photographed at the rim of the sun had confirmed that light rays from stars were indeed bent by the gravitational mass of the sun. With this observational validation, the General Theory of Relativity suddenly gained a new legitimacy that scientists and laymen alike could no longer ignore. (P. 358)

25. P. D. Ouspensky, *Tertium Organum: The Third Canon of Thought, a Key to the Enigmas of the World* (1911), rev. trans. E. Kadloubovsky and the author (New York: Alfred A. Knopf, 1981), pp. 15–16. Subsequently cited as *TO*.

26. See especially chapter 5, "Transcending the Present: The Fourth Dimension in the Philosophy of Ouspensky and in Russian Futurism and Suprematism," *FD* 238–99; and Henderson's translation of M. V. Matyushin's 1913 manifesto *Of the Book by Gleizes and Metzinger, "Du Cubisme,"* in *Union of Youth*, which appears in Appendix C, pp. 368–75. Matyushin repeats some of Ouspensky's statements almost verbatim.

27. On "Zaklyatie smekhom," Khlebnikov's famous experiment in morphological derivation (the whole poem is made up of neologisms made by adding prefixes and suffixes to the Russian root *smekh-*, "laugh"), see *RF* 7–8. On *World of Art*, see Camilla Gray, *The Russian Experiment in Art, 1863–1922*, abridged ed. (London: Thames and Hudson, 1971), pp. 37–54. See also *WB* 68.

28. Gerald Janecek (*LRL* 73–74) takes the cover design to be a vase of flowers, with floating petals spread about the page. This is a possible reading, given the use of the flower motif on related pages, but I think the anthropomorphism of the drawing is unmistakable.

29. *Starinnaya lyubov* is reproduced in A. K. Kruchenykh, *Selected Works*, ed. Vladimir Markov, Centrifuga, Russian Reprintings and Printings (Munich: Wilhelm Fink Verlag, 1973), pp. 13–28. The poem in question appears on p. 17 (p. 5 of the original book). The translation was made for me by Christine Thomas of the Division of Slavonic Studies, British Library, London. In his introduction, Markov calls Kruchenykh "Russia's Greatest Non-Poet" and characterizes him as "A neoprimitivist, one of the pioneers of the absurd, a *zaumnik*, an originator of 'funk' poetry, a Russian Freudian, a destroyer of taboos, a mixer of genres" (p. 9). See also Markov's incisive comments on Kruchenykh's *zaum* versus that of Khlebnikov and Markov's explanation of the neglect of Kruchenykh's work (p. 10).

30. *RA* 93. The declaration is set in short lines on the right side of the page as if it were a poem.

31. See Charlotte Douglas, "The New Russian Art and Italian Futurism," *Art Journal* 34 (Spring 1975):233.

32. Aside from this stylized drawing of a sword fight (see *WB* 73), Tatlin contributed only two drawings to a Futurist book, both to *Trebnik troikh* (The Service-Book of the Three) of 1913. Lithography was, for Tatlin, only of passing interest, and, besides, he was out of the country for an extended period during 1913, the *annus mirabilis* of the artist's book in Russia.

33. According to Susan Compton, "Each copy has a variation in the shape of the cutout leaf design: some are cut in green or black shiny paper [see fig. 4.8], others in gold-embossed paper, so that each type is individually distinguished from the others" (*WB* 72). Gerald Janecek adds that in some editions, the leaf is mounted above the pasted author-title heading [as in fig. 4.8], while in others, it is below (*LRL* 79). Such variations do not, however, affect the basic relationship of word to image in Goncharova's cover design.

34. This point is made by Susan Compton, in *WB* 19.

35. For a discussion of the technique, see *WB* 72; *LRL* 70–72.

36. Kruchenykh's meter is iambic tetrameter. The translation of this poem and of *Puteshestivie po vsemu svetu* is by Christine Thomas.

37. Here the Futurists are, so to speak, taking literally the meaning of the Russian verb *pisat'*, which is both "to write" and "to paint" (a picture, icon, etc.).

38. Translation mine, but see also *LRL* 268, fig. 54. *Umet* is evidently a lower class or dialect pronunciation of *umet'* (can, be able to); there is no way to render this shade of meaning in English. Janecek's rendering ("INn") is not clear to me.

39. In the traditional analysis of Russian verse, only the stressed *-et*'s would count as rhymes: i.e., "Akhmét," "portrét," "lét," "umét," "poét." By including "dérzhet" and "píshet," Kruchenykh is purposely breaking the rules.

40. Unlike Kruchenykh's earlier books, *Troe* has normally numbered pages, ninety-six in all. The microfiche, available at the UCLA Research Library, gives only indifferent reproductions of the art work, but the text is adequately presented. The British Library has an excellent copy.

41. See Kasimir Malevich, *La Victoire sur le soleil*, bilingual edition (Russian and French on facing pages), ed. and trans. by V. and J. C. Marcadé (Lausanne: L'Age d'Homme–La Cité, 1976), pp. 60–64 (illustrations), and the commentary on pp. 86–87; Charlotte Douglas, "The Birth of a 'Royal Infant': Malevich and 'Victory over the Sun,'" *Art in America* 62 (March/April 1974):45–51.

42. Malevich, *Victoire sur le soleil*, p. 42 (Russian text); *Victory over the Sun*, trans. Ewa Bartos and Victoria Nes Kirby, *TDR/The Drama Review* 15 (Autumn 1971):119. See also *WB* 109.

43. A. K. Kruchenykh, *Troe*, p. 7. The translation was made for me by a

graduate student at USC, Jenny Tumas, who is also a poet. So far as I know, there is no published translation in English. Tumas points out that the word *uglubit'sya* in line 5 of the verse portion "has both the sense of 'being more profound' and of actually physically going or delving into something." Similarly, in line 7, the "I" could be "we" if the subject is a collective noun.

44. Roman Jakobson, *Noveishaya russkaya poeziya* (The New Russian Poetry), (Prague: Politika, 1921), p. 28. The Russian text and a German translation on the facing page are reproduced in Wolf-Dieter Stempel, ed., *Texte der Russischen Formalisten*, vol. 2: *Texte zur Theorie des Verses und der poetischen Sprache* (Munich: Wilhelm Fink, 1972). Subsequently cited as *TRF*. I cite the English translation of this passage from Ronald Vroon, "Velimir Khlebnikov's 'Chadzi-Tarkhan' and the Lomonosovian Tradition," *Russian Literature* 9 (1981): 107.

45. Gerald Janecek writes:

> Since the work was a drama for which Mayakovsky envisioned an immediate stage presentation, a format for an eventual published version was probably not even part of the original conception. . . . Zherverzsheev points out, however, that when Mayakovsky revised his text with a view to publication, "he strove to give the stage directions a significantly more pictorial quality" in order to make up for the absence of various visual features of the production . . . in the printed text. (*LRL* 216)

46. Vladimir Mayakovsky, *First Journal of the Russian Futurists* (*Pervyi zhurnal russkikh futuristov*) (Moscow, 1914), nos. 1–2, p. 15. Translation by Christine Thomas. Cf. Brown, p. 98; *RF* 142–44; *WB* 49.

47. See Martin Esslin, "Modern Drama: Wedekind to Brecht," in *Modernism, 1890–1930*, ed. Malcolm Bradbury and James McFarlane (Middlesex, England: Penguin Books, 1976), p. 552.

48. The English text used is *The Complete Plays of Vladimir Mayakovsky*, trans. Guy Daniels (New York: Simon and Schuster, 1968), pp. 21–26. Subsequently cited as *VM*.

49. Viktor Shklovsky, *Mayakovsky and His Circle* (*O Mayakovskom*), trans. and ed. Lily Feiler (1940; reprint, New York: Pluto Press, 1972), p. 53.

50. This passage, from chapter 4 of Trotsky's *Literature and Revolution*, is cited, significantly, by Roman Jakobson in "On a Generation That Squandered Its Poets" ("O pololenii, rastrativshem svoikh poetov"; 1931), in Roman Jakobson, *Verbal Art, Verbal Sign, Verbal Time*, ed. Krystyna Pomorska and Stephen Rudy (Minneapolis: University of Minnesota Press, 1985), p. 114. I say "significantly" because Jakobson, whose political perspective was hardly that of Trotsky, seems to agree that Mayakovsky's tendency to place himself at the center of the universe posed real poetic difficulties for him. See pp. 111–32.

51. Vladimir Mayakovsky, *Kine-zhurnal*, 27 July 1913; trans. Helen Segal in *The Ardis Anthology of Russian Futurism*, ed. Ellendea Proffer and Carl R. Proffer (Ann Arbor: Ardis, 1980), p. 182. Subsequently cited as *AAF*.

52. Cited by Vahan D. Barooshian, *Russian Cubo-Futurism, 1910−1930* (The Hague and Paris: Mouton, 1974), p. 41.

53. Mayakovsky, *First Journal of the Russian Futurists*, pp. 79−80. Translation by Christine Thomas.

54. Mayakovsky, *Kine-Zhurnal*, 27 July 1913, in *AAF* 181.

55. See "The New Russian Poetry," in *TRF*. We know this term better as *actualization* or *foregrounding*, as it was to be called by the Prague school: see L. M. O'Tolle and Ann Shukman, *Formalist Theory*, Russian Poetics in Translation No. 4 (Oxford: Holdan Books, 1977), pp. 16−17.

56. G. M. Hyde, "Russian Futurism," in Bradbury and McFarlane, *Modernism*, pp. 269−70.

57. Roland Barthes, *S / Z*, trans. Richard Miller (New York: Farrar, Straus and Giroux, 1974), p. 5.

58. I have found no evidence that Barthes read Malevich's manifesto, but the coincidence of phrasing is striking, and, given Barthes's interest in Jakobson and the Russian Formalists, it is likely he knew Malevich's writings.

59. In "On the Generation That Squandered Its Poets," Jakobson gives a moving account of the Futurist sloganizing, the simplistic adulation of the future, that often obscured the real brilliance of Mayakovsky and Khlebnikov. See esp. pp. 122−23.

60. "The New Russian Poetry," in *TRF*.

CHAPTER FIVE

1. Henri Meschonnic, *Critique du rhythme: Anthropologie historique du langage* (Paris: Verdier, 1982), p. 303.

Ezra Pound, "A Retrospect," in *Literary Essays of Ezra Pound*, ed. T. S. Eliot (New York: New Directions, 1954), p. 11. The following abbreviations of works by Pound are used throughout this chapter:

ABC *ABC of Reading* (New York: New Directions, 1960).

C *The Cantos of Ezra Pound* (New York: New Directions, 1971).

CEP *Collected Early Poems of Ezra Pound*, ed. Michael John King (New York: New Directions, 1976).

GB *Gaudier-Brzeska* (New York: New Directions, 1970).

LE *Literary Essays of Ezra Pound*, ed. T. S. Eliot (New York: New Directions, 1954).

P *Personae* (New York: New Directions, 1926).

PJ *Pound/Joyce: Letters and Essays*, ed. Forrest Read (New York: New Directions, 1967).

SL *Selected Letters of Ezra Pound, 1907–1941*, ed. D. D. Paige (New York: New Directions, 1971).

SP *Selected Prose of Ezra Pound, 1909–1965*, ed. William Cookson (New York: New Directions, 1973).

2. *BLAST . . . Review of the Great English Vortex*, no. 1, was published on 20 June 1914. *BLAST*, no. 2, was published in July 1915. There were no further issues because of the war. A facsimile of the two original issues has been edited by Bradford Morrow and published by Black Sparrow Press, Santa Barbara, Calif., 1981. All further references are to this edition, subsequently cited as *B*. Unless otherwise noted, *B* refers to *BLAST*, no. 1.

In his introduction, "Blueprint to the Vortex," Bradford Morrow supplies useful information about the publishing history and background. In *The Egoist*, 1 and 15 April 1914, there are large ads for the forthcoming *BLAST*, promising "Story by Wyndham Lewis, Poems by Ezra Pound" as well as reproductions of drawings, paintings, and sculpture by numerous artists and "Discussions of Cubism, Futurism, Imagisme and all Vital Forms of Modern Art."

3. The eleven signatures are: R. Aldington, Arbuthnot, L. Atkinson, Gaudier-Brzeska, J. Dismoor, C. Hamilton, E. Pound, W. Roberts, H. Sanders, E. Wadsworth, Wyndham Lewis. For the background of this manifesto, see William C. Wees, *Vorticism and the English Avant-Garde* (Toronto and Buffalo: University of Toronto Press, 1972), chaps. 9–11 *passim*; Giovanni Cianci, "Futurism and the English Avant-Garde: The Early Pound between Imagism and Vorticism," *Arbeiten aus Anglistik und Amerikanistik* 1 (1981):17–27.

4. The poems not included in *Lustra* (London, 1916; expanded ed., New York, 1917) were published in the 1926 *Personae*; the exception is "Pastoral" (*B* 50), which was not reprinted. For publishing data and variants, see K. K. Ruthven, *A Guide to Ezra Pound's "Personae" (1926)* (Berkeley and Los Angeles: University of California Press, 1969).

5. See Susan P. Compton, *The World Backwards: Russian Futurist Books, 1912–1916* (London: British Library, 1978), p. 41.

6. For a selected bibliography on the *Calligrammes*, see Guillaume Apollinaire, *Calligrammes: Poems of Peace and War (1913–1916)*, trans. Anne Hyde Greet, with an introduction by S. I. Lockerbie, and notes by Anne Hyde Greet and S. I. Lockerbie (Berkeley, Los Angeles, and London: University of California Press, 1980) p. 509–13. The introduction and notes to this volume are very valuable; see also Jean Gerard Lapachérie, "Ecriture et lecture du calligramme," *Poétique* 50 (April 1982):194–207.

7. *The English Review*, for example, which printed such important Pound poems as "The Return" and "Apparuit" (June 1912), was also given to publishing such poems as Charles Kinross's "Summer," which begins:

If I into the garden chanced,
Was it at roots to delve?

The summer haze around me danced,
The clock half threatened twelve.

 (5 May 1910, p. 200)

A similarly startling mix of poets is found in Richard Aldington's *The Egoist*, which began publication in January 1914, and in Harold Monro's *The Poetry Review* (later *Poetry and Drama*). Even the *Little Review*, which was to become one of the great avant-garde magazines, published, in its first volume (1914), such poets as Sara Teasdale, George Soule, and Eunice Tietjens. Here is the opening of Tietjens's "Sonnet," published in the first issue:

Across the tide of years you come to me,
 You whom I knew so long ago
A poignant letter kept half carelessly
 A faded likeness, dull and gray to see,
And now I know.

 (P. 45)

8. *B* 12. When Pound first came to London, he expressed interest in Bridges's experiments with quantitative verse and consulted him on his own poetry. But he soon tired of this "academic" mode of writing poetry and came to feel that Ford Madox Ford's "prose tradition in verse" had "more in it for my generation than all the groping (most worthily) after 'quantity' . . . of the late Laureate Robert Bridges," ("Ford Madox [Hueffer] Ford; Obit," *The Nineteenth Century and After*, August 1939; reprinted in *SP* 461). Or, as he wrote to Eliot in April 1936, "I can't think Britsches has enough influence to be worth attacking," *SL* 281.

9. See Cyrena N. Pondrom's valuable introduction to *The Road from Paris: French Influence on English Poetry, 1900–1920* (Cambridge: Cambridge University Press, 1974), pp. 4–23; see also Pondrom's note on F. S. Flint, pp. 84–85.

10. Reprinted in Pondrom, *Road from Paris*, pp. 86–145. See pp. 89–92. De Régnier's poem (1911) may be translated as follows: "If I have spoken / Of my love, it is to the slow-moving water / Which hears me when I bend / Over it; if I have spoken / Of my love / it is to the wind / Which laughs and whispers in its branches; / If I have spoken of my love, it is to the bird that passes by and sings / With the wind; If I have spoken / It is to the echo."

11. See Richard Sieburth, *Instigations: Ezra Pound and Rémy de Gourmont* (Cambridge, Mass., and London: Harvard University Press, 1978), pp. 11–36. The whole book is seminal for an understanding of the Pound of 1914.

12. Reprinted in Pondrom, *Road from Paris*, pp. 174–77. Gourmont's strophes may be translated as follows:

Rose with a painted face like a girl of the streets, rose with a prostituted heart, rose with a painted face, make believe you are to be pitied, hypocritical flower, flower of silence.

Rose with the childish cheek, oh virgin of future betrayals, rose with the childish cheeks, innocent and red, open the lids of your clear eyes, hypocritical flower, flower of silence.

Rose with black eyes, mirror of your void, rose with black eyes, make us believe in mystery, hypocritical flower, flower of silence.

13. Ezra Pound, "Dance Figure," in *P* 91. The system of scansion used here and throughout is a modified version of the Trager-Smith prosodic system. A primary stress is marked / ′ /, a secondary stress, / ˆ /, a caesura with a double bar, / ‖ /, a shorter pause with a single bar, / | /.

14. Eunice Tietjens, "The Spiritual Dangers of Writing Vers Libre," *The Little Review* 1 (March 1914):26–27.

15. Tietjens may have been particularly incensed by lines 13–16 of the *BLAST* version, which have an overt anti-Semitic reference:

Come, let us on with the new deal,
 Let us be done with Jews and the Jobbery,
Let us SPIT upon those who fawn on the JEWS for their money,
Let us out to the pastures.

<div align="right">(<i>B</i> 45)</div>

When "Salutation the Third" was reprinted in *Personae* (1926), Pound did expunge these lines. He substituted:

Come, let us on with the new deal,
 Let us be done with pandars and jobbery,
Let us spit upon those who pat the big-bellies for profit,
Let us go out in the air a bit.

<div align="right">(<i>P</i> 145)</div>

There are other minor changes in the *Personae* version.

16. T. S. Eliot, "Reflections on *Vers Libre*," *New Statesman*, March 1917; reprinted in *To Criticize the Critic* (New York: Farrar, Straus and Giroux, 1965), p. 187.

17. In a now famous letter to his father (11 April 1927), Pound declares that the "main scheme" of the *Cantos* is "Rather like, or unlike subject and response and countersubject in fugue," and gives this outline:

A. A. Live man goes down into world of Dead
C. B. The "repeat in history"
B. C. The "magic moment" or moment of metamorphosis, bust thru from quotidien into "divine or permanent world."
Gods, etc. (*SL* 210)

The "bust thru from quotidien into 'divine'" generally occurs rhythmically as well as semantically.

18. In an interesting essay called "The Light of Vers Libre," *Paideuma* 8 (Spring 1979):3–34, James A. Powell rightly suggests that "Traditional English prosody offers little assistance" in explaining Pound's rhythms, but his argument that Pound's prosody is based entirely on Greek metrics does not account for the "prose" rhythms in these extracts from the *Cantos*.

19. Randall Jarrell, "Poets: Old, New, and Aging," *New Republic*, 9 December 1940; reprinted in *Ezra Pound: The Critical Heritage*, ed. Eric Homberger (London and Boston: Routledge and Kegan Paul, 1972), p. 50.

20. See esp. Herbert N. Schneidau, *Ezra Pound: The Image and the Real* (Baton Rouge: Louisiana State University Press, 1969), pp. 3–37, 74–109; Ronald Bush, *The Genesis of Ezra Pound's "Cantos"* (Princeton: Princeton University Press, 1976), chaps. 4 and 5 *passim*.

21. Michael A. Bernstein, *The Tale of the Tribe: Ezra Pound and the Modern Verse Epic* (Princeton: Princeton University Press, 1980), p. 40; see Marjorie Perloff, "The Contemporary of Our Grandchildren," in *Pound among the Poets*, ed. George Bornstein (Chicago: University of Chicago Press, 1985), pp. 211–17; and idem, "Postmodernism and the Impasse of Lyric," *Formations* 1, no. 2 (Fall 1984):43–63; rpt. in Perloff, *The Dance of the Intellect* (Cambridge and New York: Cambridge University Press, 1985), pp. 172–200.

22. See Wees, *Vorticism and English Avant-Garde*, pp. 96–101; Richard Cork, *Vorticism and Abstract Art in the First Machine Age* (London: Gordon Fraser, 1976), vol. 1, chaps. 2, 9, 10 *passim*; Timothy Materer, *Vortex: Pound, Eliot, and Lewis* (Ithaca and London: Cornell University Press, 1979), pp. 24–25, 86–87, 109; Reed Way Dasenbrock, *The Literary Vorticism of Ezra Pound and Wyndham Lewis: Towards the Condition of Painting* (Baltimore and London: Johns Hopkins University Press, 1985), pp. 13–27. I discuss this issue in "The Portrait of the Artist as Collage-Text: Pound's *Gaudier-Brzeska* and the 'Italic' Texts of John Cage," *American Poetry Review* 11 (May–June 1982); rpt. in Perloff, *The Dance of the Intellect*, pp. 35–49. The case is made more fully by Giovanni Cianci (see note 23).

23. Cianci, "Futurism and English Avant-Garde," pp. 3–39. I owe a special debt to this seminal essay with its extensive documentation. The essay first appeared in Italian in *Quaderno* (Palermo), 9 (May 1979), pp. 9–66, a special issue on *Futurismo / Vorticismo*. See also in the *Quaderno* issue, Pietro Cipolla, "Futurist Art and Theory in Wyndham Lewis's Vorticist Manifesto 'Our Vortex,'" pp. 69–89; and Patrizia Ardizzone, "Il Futurismo in Inghilterra: Bibliografia (1910–1915)," pp. 93–115. These essays are followed by important documents including Lewis's "A Man of the Week, Marinetti," from *The New Weekly*, and Ford Madox Ford's "Portrait of Marinetti" in *The Outlook* (11 July 1914). See also Niccolo Zapponi, "Ezra Pound and Futurism," in *Italian Images of Ezra Pound: Twelve Critical Essays*, ed. and trans. Angela Jung and Guido Palandri (Taipei, Taiwan, 1979), pp. 128–38.

The chronology that follows is based on material in Cianci and Ardizzone, and in Wees's *Vorticism and English Avant-Garde*.

24. F. T. Marinetti, "The Founding and Manifesto of Futurism, 1909," in *Futurist Manifestos*, ed. Umbro Apollonio (New York: Viking Press, 1973), p. 21. This text is subsequently cited as *FM*.

25. The word *vortex* appeared for the first time in Pound's work as early as 1908 in the poem "Plotinus" in the collection *A Lume Spento*. A note by Pound in the typescript version of the poem identified the vortex with the

cone: "The 'cone' is I presume the "Vritta' whirl-pool, vortex-ring of the Yogi's cosmogony" (*CEP* 296). See Materer, *Vortex*, pp. 15–16; Cianci, "Futurism and English Avant-Garde," pp. 14–15, 33. Eva Hesse writes, in *Paideuma* 9 (Fall 1980):330, "[Vorticism] has on the whole mainly been considered in isolation rather than within its essential context of Italian Futurism, from which in the last analysis it was derived."

26. Wyndham Lewis, "The Melodrama of Modernity," *B* 142.

27. Ezra Pound "The Book of the Month," review of *High Germany* by Ford Madox Hueffer, *Poetry Review*, March 1912, cited by Brita Lindberg-Seyersted, ed., in *Pound / Ford: The Story of a Literary Friendship: The Correspondence between Ezra Pound and Ford Madox Ford and Their Writings about Each Other* (New York: New Directions, 1982), p. 10.

28. Pound's review of Ford's *Collected Poems* appeared under the heading "The Prose Tradition in Verse" in *Poetry* in 1914. Reprinted in *LE* 371–77, and in Lindberg-Seyersted, *Pound / Ford*, pp. 16–21. Lindberg-Seyersted adds many interesting related documents. Pound praises the "modern cadence" of such poems as "Finchley Road":

> 'As we come up at Baker Street
> Where tubes and trains and 'buses meet
> There's a touch of fog and a touch of sleet;
> And we go on up Hampstead way
> Toward the closing in of day.

but, as Lindberg-Seyersted notes (p. 12), Pound was also given to remarking that, however good a theorist of poetry Ford was, in his own poems he "has rarely 'come off.'"

29. Cianci focuses on this distinction as does Ronald Bush, who demonstrates, in chapter 5 of *Genesis of Pound's Cantos*, that the dramatic turn in Pound's poetry is from "description" to "presentation," from the somewhat prolix syntax of the first Cantos to the specificity and conciseness of the mature work. Bush's account of the evolution of Pound's narrative technique and ideographic style is excellent, but he says nothing about the enormous gulf between the blank verse approximations of *Three Cantos* and the new rhythm of the 1919 Canto IV.

30. *Poetry Review* 1 (October 1912):480–81.

31. Lawrence's interest in Futurism begins about the same time as does Pound's: in a letter to Arthur McLeod (2 June 1914), he writes:

> I have been interested in the futurists. I got a book of their poetry—and a very fat book too—and a book of pictures—and I read Marinetti's and Paolo Buzzi's manifestations and essays—and Soffici's essays on cubism and futurism. It interests me very much. I like it because it is the applying to emotions of the purging of the old forms and sentimentalities. I like it for its saying—enough of this sickly cant, let us be honest and stick by what is in us."

Like Pound, Lawrence objects to the Futurists' wholesale rejection of tradition and their excessive mechanism. But he is pleased to tell Edward Garnett

(5 June 1914) that "the book [*The Wedding Ring* which was to become *The Rainbow* and *Women in Love*] is a bit futuristic. . . . when I read Marinetti . . . I see something of what I am after." See *The Cambridge Edition of the Letters of D. H. Lawrence*, vol. 2:*1913–16*, ed. George J. Zytaruk and James T. Boulton (Cambridge: Cambridge University Press, 1981), pp. 180–82.

I discuss the impact of Futurism on Lawrence's own poetry in "Lawrence's Lyric Theatre: *Birds, Beasts, and Flowers*," in *D. H. Lawrence: A Centenary Consideration*, ed. Peter Balbert and Philip Marcus (Ithaca: Cornell University Press, 1985), pp. 127–29.

32. Ezra Pound, *The Spirit of Romance* (New York: New Directions, 1958), p. 22.

33. *L'Antitradition futuriste* is reproduced in Giovanni Lista, *Futurisme: Manifestes, documents, proclamations* (Lausanne: L'Age d'Homme, 1973), pp. 122–24. Giovanni Cianci, in "Futurism and English Avant-Garde," writes: "The sophomoric division into maledictions ('blasts') and benedictions ('blesses') literally imitates Apollinaire's manifesto" (p. 17), and he details some of the parallels; see also Wees, *Vorticism and English Avant-Garde* p. 161. For a discussion of Apollinaire's manifesto, see pp. 96–100 above.

34. Wees, *Vorticism and English Avant-Garde*, p. 115. See also Cianci, "Futurism and English Avant-Garde," pp. 17–18.

35. The definition is Stephen Fredman's in *Poet's Prose: The Crisis in American Verse* (Cambridge: Cambridge University Press, 1983), p. 30. Although Fredman does not discuss Pound (his main chapters concern Williams, Creeley, Ashbery, and the later "talk poets"), his discussion is very relevant to mine.

36. Northrop Frye, *The Well-Tempered Critic* (Bloomington and London: Indiana University Press, 1967), p. 21.

37. I discuss the structural relationship of these paragraphs in "Portrait of the Artist as Collage-Text," pp. 22–26. For Pound's comment, see *SL* 322.

38. Ernest Fenollosa, "The Chinese Written Character as a Medium for Poetry," ed. Ezra Pound, in *Prose Keys to Modern Poetry*, ed. Karl Shapiro (New York: Harper and Row, 1962), pp. 136–55; see esp. pp. 142–44.

39. Originally published in *Poetry* 10 (June 1917). Revised versions of the first three Cantos appeared in the American edition of *Lustra* (New York: Alfred A. Knopf, 1917). See Bush, *Genesis of Pound's "Cantos,"* p. 13 and chap. 3 *passim*.

40. Bush, *Genesis of Pound's "Cantos,"* p. 142.

41. In Pound's first typescript draft (labeled Manuscript A by Christine Froula), Canto IV opens as follows:

Rise, O thou smoky palace,
 "Troy's but a heap of smouldering boundry stones"

Rise, O thou smoky palace!

See Froula, *To Write Paradise: Style and Error in Pound's "Cantos"* (New Haven and London: Yale University Press, 1984), p. 81. Note that the type-script version embeds a pentameter line in two trochaic three-stress lines, these being characteristic of the strophic *vers libre* Pound was increasingly discarding.

42. Meschonnic, *Critique du rythme*, p. 458: "Historiquement, poétique-ment, linguistiquement, il y a des différences de degré, non de nature, entre *les proses* et *les verses*." Translations are mine.

43. Charles O. Hartman, *Free Verse: An Essay on Prosody* (Princeton: Princeton University Press, 1980), p. 11.

44. This is the argument of Jonathan Culler in *Structuralist Poetics* (Ithaca and London: Cornell University Press, 1975), pp. 161ff. Culler lineates a piece of banal journalistic prose ("Yesterday on the A7 an automobile trav-elling at sixty miles per hour crashed into a plane tree. Its four occupants were killed") and argues that lineation creates a "new set of expectations" so that we read the piece quite differently: "when it is set down on the page as a poem the convention of significance comes into play" (p. 175). This is ob-viously the case, but one can make too much of the binary opposition linea-tion / nonlineation, thus ignoring the many other factors that create rhythmic contours and influence our expectations.

45. Meschonnic, *Critique du rythme*, p. 405: "Le discours parlé est d'un autre ordre (phonologique, morphologique, syntaxique) que les conventions écrites."

46. Frye, *Well-Tempered Critic*, p. 43; cf. idem, "Verse and Prose," in *Princeton Encyclopedia of Poetry and Poetics*, enlarged ed., ed. Alex Pre-minger, Frank J. Warnke, and O. B. Hardison (Princeton: Princeton Univer-sity Press, 1974), pp. 885–86.

47. Meschonnic, *Critique du rythme*, p. 406: "La prose est une notion rhétorique et littéraire. Elle interfère, mais justement ne s'y confond pas, avec les notions linguistiques de code, de registre, et avec l'opposition an-thropologique de l'écrit et de l'oralité."

48. Ibid., p. 614: "La poésie moderne n'a pas seulement destabilisé l'op-position entre vers et prose, elle a aussi défait le poème objet."

49. Michael Beaujour, "Short Epiphanies: Two Contextual Approaches to the French Prose Poem," in *The Prose Poem in France: Theory and Practice*, ed. Mary Ann Caws and Hermine Riffaterre (New York: Columbia University Press, 1983), p. 55.

50. John Berryman, "The Poetry of Ezra Pound" (1949), in *The Freedom of the Poet* (New York: Farrar, Straus and Giroux, 1976), p. 264.

51. Allen Ginsberg, "The Death of Ezra Pound" (Talk show, Webster Col-lege, Station KDNA, St. Louis, Mo., 1 November 1972), in *Allen Verbatim: Lectures on Poetry, Politics, Consciousness*, ed. Gordon Hall (New York: McGraw-Hill, 1974), p. 180.

52. Louis Untermeyer, *New Republic*, 17 August 1918; reprinted in Hom-berger, *Ezra Pound*, pp. 142–43.

53. *Selected Writings of Guillaume Apollinaire*, trans. Roger Shattuck (New York: New Directions, 1971), pp. 227–28, 231; idem, "L'Esprit nouveau et les poètes," *Mercure de France*, 1 December 1918, pp. 481–91.

CHAPTER SIX

1. Roland Barthes, *La Tour Eiffel*, with photographs by André Martin (Lausanne: Delpire, 1964), p. 63; Roland Barthes, *The Eiffel Tower and Other Mythologies*, trans. Richard Howard (New York: Farrar, Straus and Giroux, 1979), p. 3. All further page references are to the Delpire edition, subsequently referred to as *TE*.

The English translation, which also appears in Susan Sontag's *A Barthes Reader* (New York: Farrar, Straus and Giroux, 1982), pp. 236–50, renders only a little more than half of the French original; unaccountably, there is no indication that the text is an extract. I use Howard's translation. (*Eiffel Tower*, pp. 3–17) for the portion available; otherwise, the translation is my own.

2. Blaise Cendrars, "La Tour Eiffel: A Madame Sonia Delaunay," in *Oeuvres complètes* (Paris: Editions Denöel: Le Club français du livre, 1969), 6:52–58. "Tour Eiffel" subsequently cited as "TE," *Oeuvres complètes* as *OC*. According to the editors, this piece was first delivered as a lecture in São Paolo, Brazil, on 12 June 1924; it was first published in *Aujourd'hui* (Paris: Bernard Grasset, 1931). The English translation in the *Selected Writings*, ed. and trans. Walter Albert (pp. 234–39), is less than adequate; I emend it here by referring to Arthur A. Cohen's translation in *The New Art of Color: The Writings of Robert and Sonia Delaunay*, ed. Arthur A. Cohen, Documents of Twentieth-Century Art (New York: Viking Press, 1978), pp. 171–76. In some instances, where neither available translation seems quite satisfactory, I have used my own.

3. *Selected Writings of Blaise Cendrars*, ed. and trans. Walter Albert (New York: New Directions), pp. 142–45. The French and English texts are on facing pages. Subsequently cited as *SW*.

4. Guillaume Apollinaire, *Calligrammes*, bilingual text, trans. Anne Hyde Greet, notes by Anne Hyde Greet and S. I. Lockerbie (Berkeley, Los Angeles, and London: University of California Press, 1980), pp. 90–91. According to the note on p. 393, when "Tour" was first published in *Portugal Futurista* (November 1917), it was spread out laterally and vertically on the page as an emblem of global consciousness.

5. See Apollinaire, *Calligrammes*, pp. 58–64, and the notes on pp. 380–82. Greet and Lockerbie observe:

> The graphic form suggests expanded consciousness in the two circular shapes that dominate the two pages. They represent, first and foremost, radio communication with radio waves departing in all directions from the transmitters in the Eiffel Tower . . . making a strong visual illustration of the theme of the tower as the focal point of the universe.

6. Guillaume Apollinaire, *Le Poète assassiné*, in *Oeuvres en prose*, ed. Michel Décaudin (Paris: Gallimard, Editions de la Pleiade, 1977), p. 242. The English text used is *The Poet Assassinated*, trans. Ron Padgett, illustrations by Jim Dine (New York: Holt, Rinehart and Winston, 1968), pp. 28–29.

7. The illustration is reproduced in Apollinaire, *Poet Assassinated*, p. 47. For an excellent discussion of Dine's photomontages in relation to Apollinaire's text, see Renée Riese Hubert, "Apollinaire and Dine: A Re-Enactment of the Poet's Assassination," *Symposium*, Winter 1980–81, 333–51.

8. Robert Smithson, *Artforum*, December 1967; reprinted in *The Writings of Robert Smithson*, ed. Nancy Holt (New York: New York University Press, 1979), p. 56. This text is subsequently cited as *RS*.

9. See Blaise Cendrars to M. d'Antin, September 1913, in *Inédits secrets*, ed. Miriam Cendrars, in *OC* 16:362.

10. See Joseph Harriss, *The Tallest Tower: Eiffel and the Belle Epoque* (Boston: Houghton Mifflin, 1975), p. 19. Subsequently cited as *TT*.

11. The entire text is reprinted in English in *TT* 20–22. For the French text, see *La Tour Eiffel*, ed. Armand Lanoux, text and documents gathered by Viviane Hamy (Paris: Editions de la Différence, 1980), p. 46. An extract of the *Protestation des artistes* is reproduced as the frontispiece to *TE*.

12. Joris-Karl Huysmans, *Le Fer*, reprinted in Lanoux and Hamy, *Tour Eiffel*, p. 49. Translation mine. Cf. François Coppée, "Sur le deuxième plateau de la Tour Eiffel," in Lanoux and Hamy, *Tour Eiffel*, p. 56. This thirty-three-stanza poem expresses nostalgia for the "bons artisans du passé" and disgust for the "Géante, sans beaute ni style":

La fin du siècle est peu sévère,
Le pourboire fleurit partout.
La Tour Eiffel n'est qu'une affaire;
—Et c'est le suprême dégôut.

13. See Guillaume Apollinaire, "L'Esprit nouveau et les poètes," *Mercure de France*, 1 December 1918, pp. 481–91; "The New Spirit and the Poets," in Guillaume Apollinaire, *Selected Writings*, ed. and trans. Roger Shattuck (New York: New Directions, 1971), pp. 227–37.

14. See Stephen Kern, *The Culture of Time and Space, 1880–1918* (Cambridge, Mass.: Harvard University Press, 1983), pp. 14, 309.

15. According to Joseph Harriss (*TT* 166–67), the "memorable dirigible flight" of (Alberto) Santos-Dumont, to which Cendrars refers, made the round trip around the Eiffel Tower on 19 October 1901, in twenty-nine minutes, thirty seconds, and won the Brazilian coffee heir, whose sixth attempt this was, the grand prize. Gallieni was the commander who won the Battle of the Marne.

16. The opening line of Cendrars's "Crépitements" (1913), one of the "Dix-neuf Poèmes élastiques." See *SW* 162–63.

17. Delaunay's *Tower* paintings are proto-Cubist in their fragmentation of mass and multiple perspective. But they represent recognizable objects in a

"normal" pictorial scheme rather than the unstable structure of dismembered planes in indeterminate spatial positions that we find in Picasso and Braque. Not surprisingly, Gertrude Stein dismissed Delaunay as "the founder of the first of the many vulgarizations of the Cubist idea, the painting of houses out of plumb," in *The Autobiography of Alice B. Toklas*, in *Selected Writings of Gertrude Stein*, ed. Carl Van Vechten (New York: Vintage Books, 1962), p. 92. This is an unfair judgment vis-à-vis Delaunay's later "Simultaneist" color abstractions, but it is true that the *Tower* paintings are relatively traditional.

18. See Robert Hobbs, *Robert Smithson: Sculpture*, with contributions by Lawrence Alloway, John Coplans, and Lucy R. Lippard (Ithaca and London: Cornell University Press, 1981), pp. 62–64. *Four-Sided Vortex* was one of a number of experimental, mathematically conceived "sculptures" using mirrors that Smithson made in the midsixties. In *Enantiomorphic Chambers* (pp. 59–62), steel structures hold mirrors at oblique angles so that they reflect not the viewer, but only other mirror images. *Mirror/Vortex* and *Three-Sided Vortex* similarly exploit asymmetrical mirroring in abstract "crystalline" forms.

19. Ibid., notes, pp. 63–64:

> In the essay "Entropy and the New Monuments," published in 1966, only a year after designing *Four-Sided Vortex*, Smithson links together Lewis Carroll, the fourth dimension, laughter, and crystalline structure. The ordinary laugh is cubic and the chuckle is a triangle or a pyramid, he tells the reader, thus making a work like *Four-Sided Vortex* "solid-state hilarity" or a laughing chuckle.

20. Roland Barthes, "Littérature/énseignement," *Pratiques*, no. 5 (Feb. 1975), observations collected by André Petitjean; reprinted in *Le Grain de la voix: Entretiens, 1962–1980* (Paris: Editions du Seuil, 1981), pp. 224–25; subsequently cited as *GV*. For the English translation, see *The Grain of the Voice: Interviews, 1962–1980*, trans. Linda Coverdale (New York: Hill and Wang, 1985), p. 236; subsequently cited as *Int*.

21. See, for example, Michel Serres, *Le Parasite* (Paris: Bernard Grasset, 1980); Joseph Kosuth, *Art Investigations and "Problematic" since 1965* (Luzern: Kunstmuseum, 1973); Laurie Anderson, *United States* (New York: Harper and Row, 1984); *For the Birds: John Cage in Conversation with Daniel Charles* (Boston and London: Marion Boyars, 1981).

22. Kazimir Malevich, *From Cubism and Futurism to Suprematism: The New Painterly Realism* (1915), in *Russian Art of the Avant-Garde: Theory and Criticism, 1902–1934*, ed. John E. Bowlt (New York: Viking Press, 1976), p. 127. This text is subsequently cited as *RA*.

23. For a discussion of the relationship of Aldiss's novel to Smithson's text, see Hobbs, *Robert Smithson*, p. 89.

24. Howard N. Fox, "Introduction: A Modest Proposal," in *Metaphor: New Projects by Contemporary Sculptors (Acconci, Armajani, Aycock, Ewing, Morris, Oppenheim)* (Washington, D.C.: Hirshhorn Museum and Sculpture Gar-

den, Smithsonian Institution Press, 1982), p. 16. Subsequently cited as *M.* Fox's important essay, which I also cite in chapter 3, has a section called "Deus ex Machina," which provided me with my chapter title.

25. Michael Fried, "Art and Objecthood," *Artforum*, June 1967; reprinted in Gregory Battcock, ed., *Minimal Art: A Critical Anthology* (New York: E. P. Dutton, 1968), p. 141. I discuss this essay more fully in chapter 3.

26. R. P. Blackmur, "D. H. Lawrence and Expressive Form" (1935), in *Form and Value in Modern Poetry* (New York: Anchor, 1957), pp. 286–300. For a counterargument, see Marjorie Perloff, "Lawrence's Lyric Theatre: *Birds, Beasts, and Flowers*," in *D. H. Lawrence: A Centenary Consideration*, ed. Peter Balbert and Philip Marcus (Ithaca: Cornell University Press, 1985), pp. 108–29.

27. *RS* 70. The essay Smithson refers to as "Criticism as Language" actually appeared under the title "Qu'est-ce que la critique?" in the London *Times Literary Supplement* in 1963. The French text is reprinted in *Essays critiques* (Paris: Editions du Seuil, 1964), pp. 252–57. The French text reads: "Comme croire en éffet que l'oeuvre est un *objet* exterieur à la psyche et à l'histoire de celui qui l'interroge et vis-à-vis duquel le critique aurait une sorte de droit d'éxtraterritorialité?" (p. 254).

Smithson's essay, especially the section "Inverse Meanings—The Paradoxes of Critical Understanding," is heavily indebted to Barthes: see especially the discussion of "fiction" on p. 71.

28. The phrase is Craig Owens's: see his excellent review-essay by that title in *The Writings of Robert Smithson* in *October* 10 (Fall 1979): 121–30.

29. See Hobbs, *Robert Smithson*, p. 209.

30. Ibid., and see Hobbs's essay, "Smithson's Unresolvable Dialectics," pp. 19–30. The juxtaposition of forms creates what Hobbs calls, following John Cage, a "both/and" rather than an "either/or" situation (p. 23).

31. Hobbs finds a source for these forms in Piranesi's *Carceri* etchings (1745), of which Smithson owned a facsimile edition. Such elements as island, circular hill, winding staircase, and sharpened beams in Piranesi's drawings are echoed in the pencil and ink drawings Smithson made for the *Broken Circle* project (see ibid., pp. 210–12), but I do not find the Piranesi link quite convincing.

32. *Tatlin! Six Stories by Guy Davenport* (Baltimore and London: Johns Hopkins University Press, 1974), pp. 1–51. The illustrations—pen and ink drawings, after photographs, of Lenin, of Stalin, of Tatlin himself and of his sculptures—are juxtaposed with particular incidents so as to create ironic collocations. Thus the Lenin and Stalin portraits are each identically reproduced three times so as to remind us of the crucial role each played, whether directly or indirectly, in Tatlin's career.

33. See Velimir Khlebnikov, "Excerpt from *The Tables of Destiny*," in *The King of Time: Poems, Fictions, Visions of the Future*, ed. Charlotte Douglas, trans. Paul Schmidt (Cambridge, Mass.: Harvard University Press, 1985), p. 173.

INDEX

(Page references in italics refer to illustrations only.)